THE RESTLESS KINGS

THE RESTLESS KINGS

Henry II, His Sons and the Wars
for the Plantagenet Crown

NICK BARRATT

FABER & FABER

First published in 2018
by Faber & Faber Limited
Bloomsbury House
74–77 Great Russell Street
London WC1B 3DA
First published in the USA in 2018

Typeset by Donald Sommerville
Printed and bound by CPI Group (UK) Ltd, Croydon, CR0 4YY

A CIP record for this book
is available from the British Library

ISBN 978–0–571–32910–6

To my wife and daughters, my queen and princesses.

Contents

THE ANGEVIN AND
CAPETIAN DYNASTIES

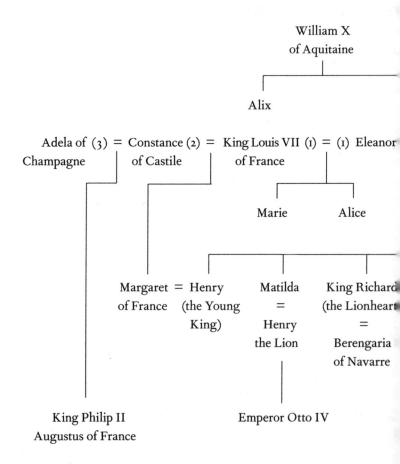

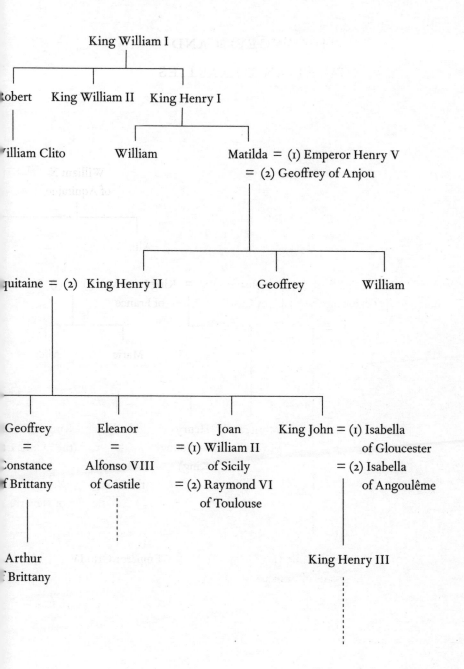

King William I

Robert King William II King Henry I

William Clito William Matilda = (1) Emperor Henry V
 = (2) Geoffrey of Anjou

Aquitaine = (2) King Henry II Geoffrey William

Geoffrey Eleanor Joan King John = (1) Isabella
 = = = (1) William II of Gloucester
Constance Alfonso VIII of Sicily = (2) Isabella
of Brittany of Castile = (2) Raymond VI of Angoulême
 of Toulouse

Arthur King Henry III
of Brittany

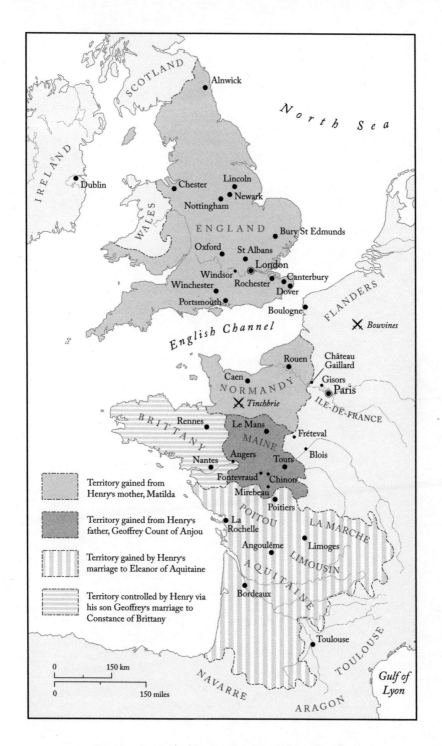

Territories ruled by Henry II and his family

Illustrations

Preface

As a medieval historian by training – my PhD was in thirteenth-century state finance and fiscal history – I've always been drawn to this period, primarily writing about the financial institutions that were created to support the continental ambitions of Henry II and his family. However, my professional career has taken me down some unusual and interesting paths, including various TV projects researching stories about celebrity ancestors. These have demonstrated the fundamental importance of families throughout history. Nowhere do these two worlds collide with the same dramatic impact as in the late twelfth and early thirteenth century.

This book, though, would never have happened without the help of some special people. First, a thank you to Dan Jones, who kindly invited me to the launch party of his brilliant book *The Hollow Crown* in 2014 where I met his editor Walter Donohue, to whom the second vote of thanks must go – for showing faith in my pitch for a new take on this period, and persuading his colleagues at Faber to agree that this was a story worth re-telling. As always, my agent Heather Holden Brown and her team turned the idea into a reality. Yet, the deepest debt of gratitude is reserved till last – for my family of restless children, Elizabeth, Charlotte, Chloe, Alice and Matilda (who at three years old is already displaying some of the haughty confidence displayed by her namesake the Empress), and, above all, my wife Lydia – an inspiration, always.

Introduction

There was an eagle painted, and four young ones of the
eagle perched upon it, one on each wing, and a third
upon its back tearing at the parent with talons and beaks,
the fourth, no smaller than the others, sitting upon its
neck and awaiting the moment to peck out its parent's
eyes. When some of the King's close friends asked him
the meaning of the picture, he said, 'The four young
ones of the eagle are my four sons, who will not cease
persecuting me even unto death. And the youngest,
whom I now embrace with such tender affection, will
someday afflict me more grievously and more perilously
than all the others.'

<div align="right">GERALD OF WALES</div>

Thus wrote the twelfth-century chronicler Gerald of Wales, and
his ominous choice of words proved to be tragically prophetic.
On 4 July 1189, King Henry II of England, Duke of Normandy,
Duke of Aquitaine, Count of Anjou, Lord of Ireland, and poss-
ibly the most powerful man in western Europe, was forced to
make a humiliating peace settlement with his eldest surviving
son, Richard, who had rebelled against him with the support of
Henry's arch-rival, King Philip Augustus of France. Even as he
exchanged the kiss of peace on a hot, dusty summer's day, Henry
whispered into his son's ear, 'God grant I die not before I have
worthily revenged myself on you!' In his heyday this would
have been no idle threat – indeed, the cause of the dispute was
Richard's real fear that he was about to be disinherited. However,

Henry was old, ill and wounded, suffering the effects of blood poisoning brought about by an injured heel, and wearily retired to nearby Chinon castle demanding to know who else formed part of the revolt against his rule. A messenger rode to the castle the next morning, with the news that Henry's youngest and favourite son, John, had joined the rebels. Henry's resolve was shattered; in despair he turned his face to the wall muttering: 'Now let everything go as it will; I care no longer for myself or anything else in the world.' He quickly lapsed into delirium and died the following day in the castle chapel, his last words reputed to be: 'Shame, shame on a conquered king.'

The internecine family struggle between Henry II and his children, played out on a stage that stretched from the foothills of the Pyrenees to the Scottish borders, remains a compelling, tragic drama in its own right – a cross between *Game of Thrones* and *The Sopranos*, with plot twists that would stretch credulity had they been scripted for television. The sixty-two years between Henry's accession in 1154 and the death of John in 1216 included the murder of the archbishop of Canterbury; holy war in the Middle East; the capture and ransom of a king; the loss of a vast swathe of continental possessions, a disaster on the scale of the American War of Independence; and England's subsequent descent into open revolt, civil war and invasion by French forces. Legend stated that the house of Anjou was descended from the devil, and at times it is hard to describe the behaviour of Henry's family as anything other than diabolical as father fought sons, brother betrayed brother, spouses plotted against one another, and a nephew was murdered by his uncle's bare hands. These were violent and ruthless people, even by the standards of an era not known for its gentleness. Yet it would also be a mistake to paint a picture of Henry II and his family in such crude, simplistic terms, as they possessed a broad spectrum of characteristics that made them highly formidable and, after all these years, still intriguing to a modern audience.

They embodied a fierce intelligence and military prowess coupled with an administrative flair that often bordered on genius, as the restless kings raced around their territories to dispense justice, collect revenue and ensure their authority was not challenged – regularly displaying a warmth, humour and even kindness that shone through in their frequent interactions with European peers, leading magnates, and the members of the lesser ranks of society who appeared before their itinerant court.

Equally, it would be wrong to dismiss events from eight centuries ago as an irrelevant if bloody footnote in history textbooks, spanning the period between the Norman Conquest and Magna Carta, as part of an abridged national curriculum: a slice of history when England emerged from the rule of French aristocrats more interested in 'foreign affairs' to develop its own cultural identity, as Victorian historians such as Macaulay and Stubbs would have us believe. In fact, if we are to understand some of the conventions that shape modern British society, we need to revisit the social, constitutional and legal developments that the Angevin kings introduced in England. These arose partly out of necessity whilst they were away ruling their vast continental territories, but also were possible because the foundations for centralised government were already in place, thanks to the unification of England under Alfred and his successors in the tenth century. Unlike most other territories under Henry II's control – or indeed most other European 'states' of the time – England had developed central administrative practices based on a cascading national, regional and local infrastructure rather than a network of semi-independent lordships that relied on castles to secure autonomous power. The collapse into anarchy and private warfare under King Stephen (1135–54), with a rash of unauthorised castles springing up as royal authority vanished, demonstrated a nightmarish alternative version of England more akin to continental practice that Henry was determined to avoid.

The twelfth century saw the birth of many of England's governmental institutions such as the exchequer, the rise of powerful officers of state like the lord chancellor, the emergence of a judicial system dominated by the crown, and the strict enforcement of a 'class' system based on concepts of overlordship and service, all soon to be counterbalanced by the articulation in Magna Carta that no man was above the rule of law – the cornerstone of natural justice still in force on the British Parliament's statute book today. These innovations are a legacy of Henry II and his sons – whether their actions were deliberate or inadvertent. Nevertheless, in one sense Macaulay and Stubbs had a point, as it would be a mistake to think of the story of the restless kings solely in terms of English history. Henry II and his children were culturally European first and foremost, as their dynastic name suggests: if their possession of England gave them their royal dignity and elevated them to the top table of European power brokers, their hearts and minds belonged to their family lands on the continent, centred on Anjou in the mid west of France.

However, the most strategically important territory was Normandy. This was due to the creation in 1066 of a new geopolitical entity that became known as the *regnum Norman-Anglorum*, according to the Hyde chronicler who coined the phrase to describe the cross-Channel possessions of Henry I. Although the Anglo-Norman realm had been divided after William the Conqueror's death in 1087 between his two eldest sons, Robert Curthose of Normandy and William II of England, it was reunited by their younger sibling Henry I, courtesy of his victory over Robert at the battle of Tinchebrai in 1106. We owe the introduction of the English exchequer to this date as well – an expedient means of accounting for revenue from royal lands but which expanded its remit to become one of the two major administrative units of central government alongside the chancery, which itinerated with the king along with his household and the main organ of royal finance, the

4

chamber. The exchequer had an older counterpart in Normandy, but many English administrative practices were exported in the other direction. The intertwined machinery of government is but one example of the close ties across the Channel that developed from the Conquest to Henry II's accession and beyond, with many of the leading families holding land on both sides to create a powerful group of magnates whom we would today describe as 'European' rather than English or French.

Whereas there was a recognised Anglo-Norman realm by the twelfth century, there was no agreed contemporary term to describe the assemblage of lands that Henry II and his heirs governed. Historians following Kate Norgate's work in 1887 have often called the vast swathe of territory an 'Angevin empire', but it was nothing of the sort. Henry's contemporaries recognised two 'empires', the Byzantine Empire to the east – a direct successor to the lost Roman world – and the more recently created Holy Roman Empire to the west, ruled by an emperor crowned by the pope. The title was created in 800 for Charlemagne, who forged the Carolingian empire through conquest and brought together territories across modern France, the Low Countries, Germany, Switzerland and Italy. A portion split away to become the kingdom of West Frankia, which in turn evolved into France, and its kings claimed overlordship for lands that included Normandy, Anjou and Aquitaine. This made Henry and his sons the vassals of another monarch (albeit traditionally independent ones), forced to do homage and agree to terms of service if they wanted to hold on to their lands.

On a practical level, there was no central administrative capital akin to Rome from where Angevin government was coordinated, although Rouen was perhaps the closest to a 'seat of power' that existed. The only thing that territories as far apart as Ireland and Gascony had in common was that they shared the same nominal ruler. Given the extent of these vast lands, Henry II adopted a peripatetic approach to government that his sons also embraced –

the restless kings of the title. Vast distances would be covered in days so that they could deal with the demands of variant judicial systems, customs, cultures, languages and even currencies. The Latin word *imperium* was often used in the context of Henry II's possessions, but usually with the inferred meaning of 'power' or 'rule' rather than 'imperial' control of an empire. In fact, it is likely that the true meaning of *imperium* when used by contemporary writers was perhaps closer to the original Roman meaning of supreme executive power in the state, covering both judicial and military authority.

It is particularly important to compare the Roman imperial model to the way vast tracts of land were accumulated in the hands of one family in later centuries, and then passed on to successors. The tradition in the old Roman Empire was to keep all territories intact, moving from hereditary rule to the rule of the most powerful; it was the central infrastructure based in Rome that allowed the system to endure for centuries. In simplistic terms, Roman emperors were curators of a venerable institution which was expected to outlast them, and this was the system adopted in the Byzantine Empire that continued throughout the middle ages. In contrast, the Carolingian 'empire' of the ninth century was divided and sub-divided between male children in line with earlier Frankish traditions – creating fragmentation and fractious relationships between siblings and their successors that translated into regional enmity as new states started to form. This was the tradition that Henry II adopted when planning how he would provide for his sons, rather than the Roman or contemporary Byzantine system. Yet even these Frankish models of succession were in a state of flux, with a growing preference for hereditary monarchy – often with the heir crowned in his father's lifetime – alongside an elective tradition that was a legacy of the tribes that first moved out of Germania into Gaul. The right to 'elect' a king – and therefore depose him – became a crucial issue concerning both Henry II and John.

Instead of thinking in terms of a territorial 'empire', it is much more appropriate to consider Henry's lands as a huge family business, with component parts assigned to each son to govern, but with autonomy varying dramatically according to the local tradition of each area, and the competency of the man to whom it was delegated. For example, Henry II's eldest son, Henry 'the young king', became the only heir to the English throne to be formally crowned during the life of his father, but was never allowed near the machinery of government – a complete contrast to his brother Richard, who assumed total control of the duchy of Aquitaine and made a success of imposing ducal rule on traditionally independent magnates; or Geoffrey, whose betrothal as a seven-year-old child to Constance of Brittany was a diplomatic device to facilitate the annexation of Brittany into the family firm.

John 'Lackland' – Henry II's youngest son – was eventually assigned the lordship of Ireland, a territory with no previous family ties only recently acquired through a papacy-blessed invasion, situated on the very edge of the Angevin world. The visit of the patriarch of Jerusalem in 1185 had raised John's hopes that he might be offered that kingdom instead, as it was then held by another branch of the Angevin family in the shape of the leprous Baldwin IV. Henry II rejected the idea and instead sent John to Ireland – despite John begging on bended knee for permission to head east. John's ambition was sadly not matched by his ability, and the Irish expedition ended in ignominy, as he managed to unite the local chieftains against him, as well as earn the distrust of the Anglo-Norman settlers. The perception that John was ill-equipped to rule was shared by his brother Richard. John's resentment at this view turned into direct opposition of his older sibling with disastrous consequences.

As we will see, Henry's daughters were also used to cement alliances and extend family influence across Europe: Matilda married Henry the Lion, duke of Bavaria; Joan married first King

William II of Sicily, and then Count Raymond VI of Toulouse; and Eleanor wed Alfonso VIII of Castile, carrying with her the dowry of the duchy of Gascony itself.

When John claimed sole inheritance after Richard's death in 1199, the continental possessions of the Angevin dynasty were at their greatest extent, covering an area equivalent to roughly two-thirds of modern France. Within five years, Philip Augustus had unceremoniously evicted him from the vast majority of these lordships, ending the Anglo-Norman realm that had lasted for a century and a half, as well as severing ties with his patrimonial lands of Anjou. John died in 1216 at the height of an apocalyptic thunderstorm whilst holed up at Newark Castle, embroiled in an increasingly desperate civil war that had been triggered by his failure to recapture his lost possessions two years before, perhaps rather fittingly as the result of a military engagement at which he was not even present.

The battle of Bouvines in 1214 is one of the most important actions in the entangled and often fraught relationship between England and France, and possibly as significant as Waterloo in the wider context of European history. Yet few will have heard of the battle fought in the dusty heat on land just outside the small village of Bouvines on the modern French–Belgian border on 27 July 1214, when a grand alliance of continental powers with common cause against Philip Augustus, assembled by John and largely funded by English silver, was decisively defeated by a much smaller French force. John was ineffectively conducting operations in his remaining territories to the south, but on hearing the news and realising his strategy to divide French forces lay in tatters, he slunk back to England. Awaiting him was a rebellious group of barons, many of whom had refused to serve in the campaign on the grounds that overseas affairs were none of their business. Thus began the road to Runnymede, Magna Carta and ultimately King John's demise.

More importantly, the severance of England's connection with the Angevin possessions has had fundamental effects on its relationship with the continent over the ensuing eight centuries. The origins of the Hundred Years War can be traced directly to the realignment of European politics after John's expulsion from Normandy, with the emergence of national identities for England and France leading first to economic, maritime and political tension and then, in 1337, open warfare that endured for generations. The English conquest and resettlement of Normandy during the fourteenth and fifteenth centuries led to the union of the thrones of France and England in 1422 with the succession of the infant Henry VI. Yet suspicion of continental politics remained, typified by Jack Cade's rebellion in 1450 after the English had been driven from Normandy once more: many of the insurgents claimed that the government's attention was misdirected on affairs abroad rather than towards pressing domestic issues. Despite better relations with France at the start of the sixteenth century, Henry VIII's decision to break with Rome and establish an independent Church of England shattered the union of Catholic nations, but more importantly reaffirmed a national sense of 'them and us' when the threat of French invasion loomed large in the 1540s. Mary I's marriage to Philip II of Spain and closer alignment to Catholic Europe was deeply unpopular.

With the loss of Calais in 1558, England once again adopted a more isolationist stance and the defeat of the Spanish Armada in 1588 was the starting point of a continuous narrative that positioned England (and, after 1707, Great Britain) as a proud island nation making its own way in the world, but which has always been prepared to ride to the rescue of its continental allies during times of crisis – the Napoleonic Wars that culminated in the Battle of Waterloo in 1815; the despatch of the British Expeditionary Force on the outbreak of the Great War in 1914; and the Allied invasion of Normandy in 1944 to liberate France from German occupation. Most recently, on 23 June 2016, Britain voted to leave the European Union, with a slim

majority of the population deciding to turn their backs on mainland politics amid a modern version of the arguments first put forward by the rebellious barons in 1214 – 'It's none of our business.'

Henry II and his family have also left an equally deep mark on England's relationship with its neighbours within the British Isles. The kings of Scotland had traditionally held various English territories, such as Northumbria or the earldom of Huntingdon, as vassals of the kings of England – similar to the arrangement that saw Henry II hold his continental lands from the king of France. However, William the Lion of Scotland joined Henry the Young King in a family uprising against Henry II in 1173; he was sharply brought to account for backing the losing side when captured in 1174 and dragged before Henry II in Normandy. The result was a harsh settlement enshrined in the treaty of Falaise, the terms of which specified that William 'has become the liegeman of the lord king Henry'. The Scottish clergy were included in the settlement, and key castles in Scotland including Berwick, Edinburgh and Stirling were handed to Henry – to be garrisoned at the expense of the Scots. In short, it was an assertion of English primacy over Scotland.

Although Richard I allowed William to purchase his release from the terms of the treaty shortly after his accession, a recently uncovered fourteenth-century text of another important Anglo-Scottish document, the 1209 treaty of Norham (which was the result of John's campaign against William) indicates that Angevin interest in Scotland was not dormant. The text of the treaty suggests that William promised that his son Alexander would do homage to John not just for the lands that he held in England, but also for Scotland itself – a reference to the terms of supremacy imposed by Henry II at Falaise. The treaty of Norham was subsequently revoked by a specific clause in Magna Carta, but the sentiment that Scotland was a vassal state of England underpinned much of the ideology behind the Scottish wars of Edward I's reign and beyond.

The debate still remains alive today with growing pressure for Scottish independence, and secession from Great Britain and the United Kingdom.

The situation in Wales was more volatile and complicated, with an English assertion of supremacy over the native Welsh princes established as far back as Anglo-Saxon times, when England first formed as a united territory in the tenth century and was able to offer some protection to its western neighbours against Viking attack. At the time of the Norman Conquest 'the situation of Wales ... was not one of independence, nor yet was it one of complete dependence; rather it was a case of uneasy involvement.' At Henry II's accession, this statement should be qualified by replacing uneasy with enforced, given the establishment of frontier 'Marcher Lords' such as the earl of Chester or William Marshal and ultimately the Mortimers – families who looked both to protect England from incursions made by the various Welsh princes who were fighting their internal political battles, and to extend their own power bases in the name of the crown. Henry was embroiled in several invasions to enforce English overlordship on Owain of Gwynedd and Rhys of Deheubarth in the first decade of his reign, although it was an uneasy peace that was further destabilised by the royal acquisition of the lordships of Gower and Glamorgan in 1183–4. John was troubled by the emergence of Llewellyn ap Iorwerth, who had designs on a united Wales under his rule and was to earn the title of Llewellyn the Great. Although John inflicted a punishing defeat on Llewellyn in 1211, dreams of Welsh independence continued to flourish throughout the thirteenth century until broken by Edward I's conquering army, and crushed under the weight of the stone castles that were subsequently built as a permanent, physical reminder of England's control over the conquered land.

Unlike Scotland and Wales, Ireland had been beyond the orbit of the Anglo-Norman realm, but was not able to escape the attention of the Angevin kings of England for long. It is possible that Henry II

first cast his eyes westwards as early as 1155, when the archbishop of Canterbury obtained a papal bull from the English Pope Adrian IV, granting permission for an invasion to bring the Irish church under the jurisdiction of Rome. The fragmented nature of Ireland, with various native kings ruling over a people who represented a mix of Celtic and Norse tradition and culture, meant that Henry was unwilling or unable to devote the necessary resources to mount a campaign to assert his nominal overlordship. When adventurers such as Richard de Clare – known as 'Strongbow' – headed west to seek their fortune, establishing a group of Anglo-Norman colonists akin to the Marcher Lords in Wales but with more autonomy from the English crown, Henry finally decided to act and invaded in 1171. Within four years, Henry's dominance was acknowledged by most of the native kings, and although he was forced to confirm the conquests of Strongbow, he established other planter families, and retained royal control over Dublin, Waterford and Wexford with similar governmental machinery to England. Although John's campaign in 1185 was a failure, his next incursion on Irish soil in 1210 not only re-established English lordship, but crushed both native and planter independence alike and can be seen as the real starting point for English dominance over Irish politics for the next seven centuries.

Remarkable as it may seem, we can even gain a far greater understanding of current tensions between Christian West and Muslim Middle East if we look more closely at the history of the Crusades, where once again we see the Angevin influence at work. Henry II's grandfather, Count Fulk of Anjou, became king of Jerusalem in 1131 jointly with his wife Melisende after the death of her father, Baldwin II. The kingdom of Jerusalem was the principal crusader state established after Pope Urban II called for the conquest of the Holy Land in 1095. As a result, a string of fortified states was established along the eastern Mediterranean, collectively known as Outremer, roughly located where modern Syria, Lebanon,

Jordan, Palestine and Israel now stand. The collision of East and West, Christianity and Islam, reached its bloody climax during this period when the Third Crusade was launched to recapture Jerusalem, which had fallen to Saladin in 1187. First Henry II and then Richard I took the cross as a Christian duty, but also to defend their kinsmen in the east. The Third Crusade was where Richard earned his reputation as a fearsome warrior and leader of the Christian army against Saladin's Muslim forces, as well as the conqueror of Cyprus; but it forms part of a much longer continuum of conflict between East and West that starts with the Roman conquest of the Holy Land and, sadly, remains with us today. It is also highly relevant to the fragmentation of the Byzantine Empire into various component parts that eventually formed the states of eastern Europe and Turkey, and why Istanbul is important as the gateway between East and West.

To fully understand the tensions across Europe, north Africa and the Middle East, and how the papacy claimed supreme power over the West, requires a detailed chronology of the collapse of the Roman Empire from the third century onwards that largely lies outside the scope of this story, though key elements that had a direct bearing on the political structure of France during the medieval period will be briefly covered in Chapter 1. However, Roman influence was still relevant and identifiable across Europe on a more prosaic, everyday level – even in an area like England, where imperial forces disappeared quite early and Germanic settlers were able to establish their own traditions. To borrow from Monty Python's *Life of Brian*, the Romans provided a transport infrastructure in the form of strategically connective roads radiating from London to principal provincial settlements; an accounting language (if you've ever wondered where pounds, shillings and pence came from and why they were referred to as Lsd, they derive from the Latin words *librae*, *solidi* and *denarii* – even the word money comes from the Roman goddess, Juno Moneta); the official

language of government – Latin – even though, after the Norman Conquest, French was commonly spoken and increasingly used as a form of written communication at court and in the higher echelons of society; a legal system in the form of Roman law (in which Latin was also deployed to record the business of courts, and continued in many until 1732); an ecclesiastical infrastructure and liturgical tradition based in Rome following Constantine's support of Christianity in the fourth century, with its spiritual head of state the pope. Even the months of the year were Roman. Mind, body and soul were therefore still largely in thrall to a system of government that had not existed in a practical sense for over seven centuries, but still left its mark on everyday life. Land transactions were written in Latin; local administration took place in manorial courts where business was recorded in Latin; Church services and ceremonies were conducted in Latin; and, from the late eleventh century, money was demanded by the pope, based in Rome, from all parishes to defray crusading costs in defence of the Holy Land.

It is therefore perhaps more relevant than ever before to revisit this period of history, given that the current debates about the future of federal Europe, Britain and the Middle East all have their origins here. However, before moving on to the story of the restless kings, it is worth saying a few words about the sources that enable us to tell their tale. There are very few personal archives of the Angevin kings, although some sense of their correspondence with key officials can be gleaned amidst the sources for their administrative machinery in England, mainly the surviving enrolled chancery documents after 1199 and various writs, charters and instructions in the hands of recipients.

Although there is not much in the way of family correspondence, we are fortunate that the actions of the great and good were recorded by various commentators such as the aforementioned Gerald of Wales, who were mainly associated with monastic institutions with a long heritage of keeping chronicles of events

– often with rather acerbic notes and moral judgements about the principal players. Many enjoyed privileged positions within the royal household and personally knew Henry II and his sons: for example, Gerald served as a royal chaplain from 1184 and was therefore a close confidant of Henry II and his family, perfectly positioned to provide a commentary – or at least, to record as much as he dared to. Walter Map knew Henry II from accession to death, and provides a vivid account not only of events, but also of the personality and characteristics of the king. A common theme to the collective writing of the chroniclers was a fascination with the past, and particularly with the story of England and the British Isles, drawing upon the earlier tradition of Geoffrey of Monmouth's *History of Britain*. Although men – and it was usually male authors who committed their histories to parchment – such as William of Newburgh, Gervase of Canterbury, Ralph of Diceto, Roger of Howden, Ralph of Coggeshall, Roger Wendover and even the great thirteenth-century writer Matthew Paris were largely dismissive of the veracity of Geoffrey of Monmouth's work, they still borrowed elements of his ancient narratives and began their accounts with the Romans. Even more pertinent was the emergence of an Anglo-centric focus to their writing quite at odds to the dynastic continental affairs of the king. These are two themes that will recur again and again – the continued legacy of the Roman Empire, and the tension between England's governance and the personal interests of the monarch abroad.

However, we are not restricted to Anglo-Norman sources of information; a relic from a lost age, the Anglo-Saxon Chronicle still provided a voice for those whose ancestors had dwelt in England prior to the Norman invasion and had a different, more anti-establishment, perspective on events. We even have access to contemporary biographies of leading figures such as William Marshal, a legendary character whose career spans the entire period and beyond, as well as written summaries of various reigns such as

Gesta Regis Henricus Secundi and *Gesta Stephani*, which reveals the sorrowful tale of Henry's predecessor. These are nothing like the objective and often dispassionately critical biographies produced today but are still useful for corroborating events and gaining an understanding of the nature of the people in question. Equally, there are chronicles for the Capetian perspective written by men such as Suger, Rigord, William le Breton and Jean de Joinville – all largely biased against Henry II and his sons – plus accounts from other territories in the Angevin dominions and beyond such as Anjou, Poitou and Touraine as well as parts of the Holy Roman Empire, the papal states and, of course, correspondence from the papal curia itself. As a final reminder that this was a global story, we have rich primary source material for European activity in the Middle East, written not just from a Christian perspective by French chroniclers Ambroise, Jacques de Vitry and the chronicle of William of Tyre, but also from some of the Muslim opponents of Richard I such as Baha ad-Din, Ibn al-Athir and Imad ad-Din. The restless kings wandered far and wide, and their deeds and reputations have consequently left a mark throughout the world.

The rise of the Angevins

> The head, which should have worn a crown of gold, was
> suddenly dashed against the rocks; instead of wearing
> embroidered robes, he floated naked in the waves; and
> instead of ascending a lofty throne, he found his grave in
> the bellies of fishes at the bottom of the sea.
>
> HENRY OF HUNTINGDON, 1120

The course of European history would have been very different but
for two shipwrecks. In 1064 Harold Godwinson, one of the most
powerful magnates in the court of Edward the Confessor, set out
from the port of Bosham, Sussex, for reasons unknown and was
blown off course. Eventually he landed at Ponthieu, where he was
captured by Guy I, count of Ponthieu, and held at the count's castle
at Beaurain. It was not long before news reached William, duke of
Normandy, who was preparing his troops for a campaign against
his neighbour and rival, Conan, duke of Brittany. William marched
to Beaurain and ensured that Harold was released into his own
custody – with such a large force at his doorstep, Guy was given
very little choice in the matter – and thereafter Harold accompanied
William on campaign as his 'guest'. During this period of enforced
hospitality, in which Harold performed feats of valour and was
knighted by William, it is alleged that Harold swore the infamous
oath of allegiance to the duke of Normandy, promising to secure
for him the English throne on the death of Edward the Confessor.
The chronicler Orderic Vitalis later claimed that Harold had been
betrothed to William's daughter Adeliza; if the story is true then
this might have been the occasion of the betrothal, further binding

Harold in obligation to the duke of Normandy. Whatever happened in 1064 – and we only have the Norman side of the story, vividly captured in the Bayeux tapestry – William used this as moral, even divine, justification for his subsequent invasion in 1066. Thus England was wrested away from its increasingly Scandinavian orbit and brought directly into the febrile atmosphere of French politics, creating an Anglo-Norman realm with a shared cross-Channel aristocracy, government and administrative institutions.

The second shipwreck caused instant shockwaves to reverberate around Europe, and should be ranked alongside the loss of the *Titanic* as one of the worst maritime disasters in British history. On 25 November 1120, King Henry I left Barfleur to return to England with his family and chief courtiers. He was offered passage on the *White Ship* by its captain, Thomas FitzStephen, but the king had already made arrangements to take another vessel. FitzStephen had enjoyed a close link to the crown – his father Stephen FitzAirad had skippered the *Mora*, the ship that was gifted to William of Normandy by his wife Matilda of Flanders when he sailed to conquer England in 1066. Consequently, Henry wished to ensure that FitzStephen benefited from royal patronage and entrusted the passage of his son and only male heir, William Adelin (German for young prince), and other members of the royal household to the *White Ship*. As Henry set sail, FitzStephen and his crew reportedly enjoyed the hospitality proffered by William and his entourage, who had brought several barrels of wine with them and enthusiastically set about emptying them. Consequently, not only were many of the passengers drunk by the time the ship was ready to leave, so were a large proportion of the sailors – FitzStephen included, according to some accounts. There were over 300 people crammed on board alongside William and his associates, including Henry's illegitimate son Richard of Lincoln and illegitimate daughter Matilda FitzRoy.

Egged on by the rowdy passengers, the crew were encouraged to make haste and overtake the king's vessel, even though it had

already departed – certainly, the *White Ship* was newly outfitted and was reputed to be very fast, so the dare was not beyond the realm of possibility. Such was the mood of bravado on board that, it was later claimed, a couple of priests who had come to bless their voyage were ridiculed – an act that many chroniclers blamed for what happened next. With the light failing and over-confidence amongst the drunken sailors leading to carelessness, the ship struck a submerged rock and capsized. William managed to scramble free in a small boat, but on hearing the cries of his half-sister as she struggled in the water, turned back and tried to rescue her; a mass of people, fighting for their lives, swarmed into the boat, which sank under their weight, taking the heir to the throne with them to their deaths. The significance was not lost on shocked chroniclers such as Henry of Huntingdon, quoted at the start of this chapter.

Another commentator, Orderic Vitalis, claimed there were only two survivors who managed to escape the sinking ship and cling to the rock – Berthed, a butcher from Rouen who had probably been on board to ensure that he was paid for the victuals that he had provided; and Geoffrey de l'Aigle, who died before he could be rescued. According to Vitalis's account, Thomas FitzStephen also survived the capsizing ship but, on learning that William had perished, chose to drown rather than face the wrath of the king. Many of those who had intended to travel, perhaps alarmed by the inebriation of the crew and behaviour of some of the passengers, had already made other arrangements and consequently not boarded the *White Ship*; others were the beneficiaries of circumstances beyond their control, rather literally in the case of the king's nephew Stephen of Blois, who had suffered an attack of diarrhoea and wisely chose not to embark until he was more comfortable. Thus Henry's only son and male heir was lost in a terrible accident at sea, albeit one that could have easily been prevented. The succession was thrown into crisis, with the barons reluctant to embrace the thought that Henry would be followed by his haughty daughter

Matilda; instead they chose to support the rather opportunistic claims of the aforementioned Stephen, with dire consequences.

*

To fully understand quite why the loss of the *White Ship* was such a momentous event, we need to pause and reflect on the state of Europe at the time. This requires us to take a whistle-stop history lesson from the fall of the Roman Empire via the rise of the Carolingians, because the Europe that emerged out of the chaos of Rome's decline was very different to the one we would recognise today, with no nation states enjoying fixed borders in the modern sense – France, Germany, Italy or Spain simply did not exist. Instead, twelfth-century geopolitical entities familiar to Henry II and his contemporaries were the direct legacy of centuries of population migration. We also need to view Europe within the wider orbit of the Roman world, since at the height of its territorial extent in the second century AD, it governed provinces from the British Isles in the extreme north-west, across modern France, the Benelux Countries and parts of Germany into Switzerland, Austria, Hungary, Bulgaria and Romania; south into Italy, Greece and the Balkans; across north Africa including the coastal regions of Morocco, Tunisia, Algeria, Libya and Egypt; through the Middle East into Jordan, Israel, Palestine and Syria and extending through Saudi Arabia, Iran and Iraq to the Arabian Gulf; from the shores of the Caspian sea, covering Armenia, Azerbaijan and Turkey along the Black sea towards Ukraine. Of key importance to our story are the provinces of Britannia, Gaul and Aquitania as they evolved over the centuries to form England, Anjou, Normandy and Aquitaine for Henry II, and the demesne lands of the Capetian kings known as the Île de France.

Several key dates are worth bearing in mind. The Roman Empire split into two halves in 395, a western portion under the control of Rome, and an eastern part governed from Constantinople,

formerly Byzantium but renamed after Emperor Constantine I. Today we call the eastern half the Byzantine Empire, although contemporaries did not refer to it as such; indeed to its inhabitants, it was the legitimate *Roman* Empire, even though in territorial terms it stretched from modern Bulgaria, the Balkans and Greece into Turkey, the Middle East and North Africa as far as Libya and came nowhere near Rome. Incidentally, it was Constantine who had promoted Christianity as the empire's state religion, ordering the construction of the Church of the Holy Sepulchre in Jerusalem; and it was in his name that an imperial decree was forged in the eighth century, purportedly assigning authority over Rome and the western half of the empire to the pope – with political implications that were of vital importance to the medieval period.

By 476, the western Roman empire had been largely overrun by migrating tribes from Germania Magna such as the Lombards, Burgundians, Goths, Vandals and Huns, and in that year the last recognised emperor, Romulus Augustus, was deposed. The most important of the tribes were the Franks, who initially settled in northern Gaul and established small kingdoms at Tournai, Le Mans, Cambrai and Cologne. These were united in the late fifth and early sixth century by Childeric I and his son Clovis I, who established nominal lordship over the old Roman province of Aquitaine (including Gascony and the Basque region), took control of large parts of Germania Magna, and established Paris as the seat of their regime. Their successors – known as the Merovingians – extended their sphere of influence throughout Gaul to form a powerful kingdom of the Franks, absorbing Burgundy in 534 and conquering Provence, as well as extending their borders towards Lombardy in north Italy.

A new empire was beginning to form; but crucially the power of the Merovingian kings was usurped by their deputies, the 'mayors of the palace', who were originally appointed to govern the royal household but increasingly held the reins of power themselves,

leaving the kings as figurehead rulers known as *rois fainéants* or 'do-nothing' kings – not entirely dissimilar to the ceremonial role of the British monarchy today. By the middle of the eighth century, the mayoralty had become a venal office with the title 'duke and prince of the Franks'; one of them, Charles Martel, won great fame as the saviour of Christendom when he defeated a powerful Muslim army at the battle of Tours, near Poitiers, in 732. By this date, much of the former Roman empire in the Middle East and North Africa had been lost to the advancing Muslim caliphates that had formed after the death of the prophet Mohammed. They had gone on to establish complete dominion over modern Spain and then extended their rule across the Pyrenees into Aquitaine, Gascony and Provence. Charles's victory halted this advance, and re-established control over these three formerly independent states.

Charles Martel's successors are known as the Carolingians; they were the real architects of the political structure of medieval Europe and inventors of many of the governmental structures and military techniques with which Henry II was familiar. For a start, they were ruthless: Charles's son Pepin the Short connived with Pope Zachary in 751 to overthrow the Merovingians and claim the crown himself, asking the immortal question: 'Who should be king, he who has the title, or he who has the power?' In return, Pepin provided military assistance and protected the papacy from the Lombards in north Italy, 'donating' key lands and cities that laid the foundations for the temporal Papal States – the source of the church's power base outside Rome for much of the medieval period. Thus was forged a fundamental relationship between church and state, which reached its height under Pepin's son Charles the Great, or Charlemagne, one of the key figures in the history of the Western world. As well as extending Frankish rule throughout modern France, large portions of Germany (including Saxony to the north and Bavaria) and Lombardy, on Christmas Day 800 he was anointed *Imperator Augustus* by Pope Leo III at St Peter's basilica in Rome. However,

this was not a direct revival of the Roman emperors of old, even if Charlemagne had reassembled a large proportion of their western territories; he was to be a *Holy* Roman Emperor, reinforcing the message that the church was now the leader of the Christian world, providing legal validity to the most powerful secular state in the West. The extension of this concept throughout the medieval period was the source of many disputes between kings and popes, not least in England when first William II then Henry I were challenged over their right to ecclesiastical appointment, leading to the greatest argument of all between Henry II and Thomas Becket.

The Carolingians are important to our story for several reasons, since the way in which Charlemagne and his heirs administered their vast lands created a style of government that continued in modified form for several centuries, with a direct influence on the way Henry II managed his own accumulated territories. First, given the distances involved, Charlemagne raced with his court from location to location to ensure his authority was imposed in person, rather than establishing a central administrative power base that would serve as the equivalent of ancient Rome. This was exactly the same 'government on the go' approach that served Henry II well during his successful early career, juggling his roles as king of England, duke of Normandy, de facto duke of Aquitaine and count of Anjou. Key officials for an itinerant household emerged in the ninth century – chamberlain, marshal and seneschal for example – as well as the chancellor, who controlled the chancery or writing-office from where grants or writs were issued. Again, these roles evolved into the mainstays of medieval government and were adopted by Henry II to build a centralised bureaucratic system in England that endures today.

Yet Charlemagne's peripatetic court still required a system of regional government, and therefore several hundred *comtes* or counts were recognised, each of whom presided over a county with semi-devolved administrative and legal powers. Although

appointed by the king, many of these positions became hereditary, with a certain amount of local autonomy that increased over time – in places such as Anjou, Brittany, Maine, Touraine, Poitou, Toulouse, Blois, Flanders, Boulogne and Holland, to name but a few that are relevant to our main story. The relationship between Charlemagne and his leading counts was further defined in terms of contractual service, usually linked to a specific requirement to supply troops for the royal army. Furthermore, a greater proportion of the army were mobile cavalry troops, necessary for travelling long distances and conducting a specialised form of warfare; thus an emerging concept of knighthood can be traced to this period as well. Together, all the component parts were in place for the social system described as 'feudalism', based on the way land was held from an overlord in return for military (or other specified) service, upheld by sworn oaths of allegiance in the name of a Christian god. A variant of this system was imported to England by William the Conqueror and harnessed by Henry II and his sons to control their aristocrats – ultimately leading to a more precisely defined version of the relationship, negotiated between King John and his leading barons in the fields of Runnymede in June 1215.

Yet despite his imperial title, and in line with Frankish tradition, Charlemagne never intended for his 'empire' to remain intact; and his lands splintered amongst his descendants into three main blocs. East Frankia became the heart of the Holy Roman Empire, straddling modern Germany, Austria and Switzerland, and absorbing lands from a second territory, central Frankia, which quickly separated into semi-independent territories such as Lorraine, Burgundy and Lombardy as well as today's Benelux countries. The kings of the West Franks – hereafter referred to as the kings of France – retained lordship over the counties that would coalesce into modern France, but were seen as the junior branch of the family. They were particularly plagued by Viking incursions from the mid ninth century onwards; the raiders used the rivers

Loire and Seine to raid deep inland – tactics that Henry II and his sons would also adopt during their conflicts with the king of France. As a result, West Frankia also began to splinter, with some areas such as Brittany and Aquitaine enjoying virtual autonomy, and powerful counts emerging in Blois, Flanders, Anjou, Provence and Toulouse to challenge royal authority. The situation was complicated still further in 911 when the Viking leader Rollo was granted lands by King Charles the Simple, which would become the duchy of Normandy. The last of the Carolingians, Louis V, died in 987 and the throne was then offered to the count of Paris, Hugh Capet, founding a royal dynasty centred on his lands in the Île de France that was to endure into the twelfth century and beyond. To secure the succession within his family, Hugh ensured that his son Robert was crowned as co-king almost as soon as he had been elected in 987, and the tradition continued when Robert's son Henry I was similarly crowned in 1027 during his father's lifetime – a model adopted by Henry II in England on 14 June 1170 for the only time in the country's history.

In contrast to the increasingly fragmented nature of West Frankia, England underwent a reverse transformation, moving towards a single state in the tenth century; this unified the seven main kingdoms that had emerged after the several waves of migration that followed the withdrawal of imperial forces from the province of Britannia in the early fifth century. In particular, the north-German Saxons and the Angles and Jutes from the Jutland peninsula and Frisian coast usurped the native Britons and created the 'heptarchy' of kingdoms – Northumbria to the north; Mercia in the Midlands; and East Anglia, Kent, Essex, Sussex and Wessex in the south. By the ninth century, Wessex had eclipsed Mercia as the dominant state; and although large parts of England were conquered and settled by Viking invaders in the late ninth and early tenth century, King Alfred and his successors gradually reclaimed the land, at the same time rolling out a single legal code, a central

bureaucratic process, and the extension of Christianity as the sole religion of the country. Yet the dynasty that Alfred had founded was brushed aside in the next phase of Scandinavian invasions at the start of the eleventh century. Æthelred II, nicknamed Unræd because of the poor quality of advice he received (rather than his supposed lack of readiness), was swept from power and exiled in Normandy, only to return in 1014.

Crucially to our story, Æthelred seems to have instigated a tradition of issuing a 'coronation charter' that set out some of the key plans for his rule, based on the threefold coronation oath to uphold peace in the church; to forbid robbery and unrighteousness to all; and to provide justice and mercy in all judgments. When he regained the throne in 1014, the Anglo-Saxon Chronicle notes that he made a pact with his people, reaffirming his commitment to good government, promising he would 'govern better than he did before'. It is here that the seeds of Magna Carta were sown, to bear fruit two centuries later. Henry I adopted a similar tactic to secure the throne in 1100, issuing a coronation charter that was to be revived in 1213 during the growing protests against his great-grandson John. The concept that the king reigned as a result of an agreement with his people to uphold certain standards and govern according to the rule of law runs through the entire story of Henry II and his sons.

Æthelred II is also significant because in 1002 he married Emma of Normandy, niece of Hugh Capet and daughter of Duke Richard I of Normandy – thus entwining the politics of England with both France and the duchy. Æthelred II died in 1016 and England was conquered by Cnut, one of the 'great' kings of his age. He eventually united the thrones of England, Denmark, Norway and parts of Sweden, and enjoyed a high profile in the Holy Roman Empire as well; it was not inconceivable that a powerful maritime Anglo-Scandinavian empire might have formed. In an act of pragmatism, he married the widowed Emma to help legitimise

his invasion with the leading native families. In return, she seized the opportunity to became deeply involved in English politics, interfering with the succession several times after Cnut's death eventually to ensure that her son, Edward the Confessor, claimed the throne in 1042 as the last Anglo-Saxon king – or perhaps, given Emma's origins, the first Anglo-Norman one. Given his years of exile in Normandy, it is unsurprising that Edward brought a few trusted household adherents from the Norman court; however, not for the last time the appearance of 'foreigners' as the king's principal advisors caused resentment with native families, in this case primarily Earl Godwin and his sons who would extend their power across the country in the 1060s. Despite the simmering political tension, Edward's reign was considered a golden age for the rule of law, the inspiration for the *Leges Edwardi Confessoris* or *Laws of Edward the Confessor* that was penned in the twelfth century. It became an important reference work when the baronial rebels were framing their charter to remedy the ills of John's regime, in particular the controversial interpretation that an unjust monarch who had lost the support of his people might be deposed.

*

Thus Harold's shipwreck in 1064 took place against the backdrop of an emerging cross-Channel relationship between the courts of England and Normandy, originally forged by Emma. Normandy itself had been thrown into turmoil with the death of Emma's nephew, Duke Robert, in 1035. After the succession of his eight-year-old bastard son William, it took a quarter of a century before ducal control was fully re-asserted after years of civil war between the leading baronial families. By 1064 William clearly felt strong enough domestically to make a play for England when Edward died, and his subsequent invasion was of fundamental importance for several reasons. First, he united England and Normandy to create a cross-Channel realm, with leading families

from Normandy the principal beneficiaries of the distribution of seized estates from the Godwin family and other Anglo-Saxon earls who fell at Hastings. From this point onwards, the Anglo-Norman families generally preferred both territories to remain in the same pair of hands and, when push came to shove, supported the cause of the claimant who looked most likely to maintain this status quo. William I had adopted the Frankish model and divided his lands between his sons when he died, with his eldest, Robert Curthose, inheriting Normandy and England passing to second son William Rufus. Yet it was the youngest son, Henry, who reunited them after Rufus's death in a hunting accident in the New Forest in 1100, defeating Robert at the battle of Tinchebrai on 28 September 1106. This was one of the most important battles in English history, as it brought both territories under a single ruler once more and cemented Henry's position as a dominant power in the region. In particular, it created great tension with the king of France, Louis VI, who contested control of the important Franco-Norman Vexin border region, and Fulk V, count of Anjou, whose family had long disputed overlordship of Maine with Normandy.

William also imposed a new social hierarchy upon England, a 'feudal' system of landholding in which property was held from an overlord in units known as a *feodum* or fee in return for military service; the management of each fee was via a socio-economic unit known as a manor. The king retained the *terrae regis* (literally lands of the king), royal demesne lands in each county from which he would derive sufficient income for his own needs, and distributed the remainder to his supporters. These were the tenants-in-chief, holding land directly from the crown on specific and clearly defined terms. The relationship was governed by conditions or rights that the king retained, such as the levy of a 'relief' or inheritance fine from the heir of a deceased tenant-in-chief if they wished to retain possession of the family's lands. Should the heir be under the age of twenty-one, the king would hold the lands in wardship and enjoy

the profits until the heir reached the correct age, or sell the right to manage the lands to a third party. The king also exerted certain controls over marriage amongst the ruling elite. Royal regulations over land and family became highly sensitive issues, reflected in Henry I's issue of a detailed coronation charter specifically promising to avoid further royal abuse in these areas. Conversely, John's ruthless exploitation of the financial aspects of these relationships was a principal cause of protest against his regime from 1212 onwards, and the rebels returned to the text of Henry I's coronation charter as the benchmark for good government when drawing up Magna Carta. It is no coincidence that clauses restricting the feudal 'rights' of the crown are near the top of the document.

Finally, William and his sons expanded the royal forests in England to the great dismay of anyone who lived within their bounds. This is perhaps one of the hardest areas of medieval life for a modern observer to understand, but was another major cause of complaint against the later Angevin kings. Indeed, such was the importance of this issue that Magna Carta established an inquiry, which resulted in a separate Charter of the Forest in 1217. The main problem was that regulation of the forest was a royal prerogative, and therefore a separate judicial system operated entirely at the whim of the crown; penalties were harsher and royal officials were often perceived to mete out justice on an arbitrary basis. Once again, Henry I referred to the forest in his coronation charter, but seems to have done little to address the complaints of those caught by the forest laws. Whilst the reign of Henry II was of fundamental importance for an overhaul of the legal system, ensuring it was more equitable through uniform processes with access via royal courts, the forest law was exempt from these reforms. It therefore became the lightning rod for royal malpractice that reached its nadir under John.

*

If the consequences of Harold's shipwreck in 1064 shaped the structure of English society throughout the medieval period, and created a new geopolitical structure, the consequences of the second shipwreck were even more spectacular, leading directly to the rise of the house of Anjou as the dominant power in western Europe. By 1120, Henry I had united England and Normandy under a common administrative system that permitted him to govern effectively, even when he was not present; his reforms of the judicial system and royal household earned him the nickname of 'Beauclerk' or 'good clerk'. Troublesome vassals had been largely put in their place, and the introduction of a new system of managing royal finance via the exchequer vastly enhanced the authority of the crown and its officials. He had even managed to quell the attempts of his near neighbours and feudal overlord to unseat him in Normandy, with his son William Adelin recognised by France's King Louis VI as duke of Normandy and acknowledged as the rightful heir to the English throne – 'rex et dux designatus'.

The *White Ship* disaster was a catastrophe around which western European politics would revolve for a generation: a moment of recklessness that unpicked two decades of work, opening up a succession crisis with the death of Henry's only male heir. As William of Malmesbury explained: 'Many regions looked forward to the governance of this boy ... It was said that now might it be expected that England's hopes, like the tree cut down, would, through this young man, again blossom and produce fruit, and thus put an end to her woes; but God saw otherwise.' Nobody dared to inform Henry about the disaster when he returned to England. Yet according to Orderic Vitalis: 'The magnates wept bitterly in private and mourned inconsolably for their beloved kinfolk and friends, but in the king's presence they struggled to contain their tears.' It was impossible to hide the news forever, and on learning about the loss of his son, 'Immediately Henry fell to the ground, overcome

with anguish.' Given the magnitude of the personal tragedy and its political consequences, it is perhaps no surprise that it was said that Henry never smiled again.

The death of William Adelin in the *White Ship* had created a huge dilemma for Henry I – who should succeed him as king of England and duke of Normandy? The remainder of his reign was spent dealing with growing uncertainty, which threatened to undermine all that he had achieved and weaken royal and ducal authority, as well as stoke the flames of international intrigue. In the hope of producing another male heir, he married for a second time on 24 January 1121 – his first wife had died two years previously. Henry's new bride was Adeliza of Louvain, the daughter of Geoffrey, count of Louvain and duke of Lower Lotharingia; he was a close ally of Henry's son-in-law, Emperor Henry V, who had married Henry's daughter Matilda in 1114. Adeliza was young and beautiful, the 'fair maiden of Brabant'; however, she bore her husband no children. An heir had to be found amongst the existing contenders.

The person who benefitted most from the loss of the *White Ship* was William Clito, the son of Robert Curthose. He had been spared his father's fate of perpetual imprisonment after Tinchebrai thanks largely to Henry's intervention:

> The king looked at the child, who was trembling with fright, and comforted him with kind promises, for he had suffered too many disasters at a tender age. Then, for fear that it might be held against him if the boy came to any harm while in his hands, he decided not to keep him under his own tutelage, but instead entrusted his upbringing to Helias of Saint-Saens.

Troublesome nephews were to be a feature of the Angevin family. In 1202, John was placed in a similar position after his rival Arthur of Brittany fell into his hands, and chose a different path. He brutally murdered his nephew, with terrible consequences.

It seems that Henry also had second thoughts about his initial leniency and tried to seize William Clito in 1110. In the nick of time, the young boy was smuggled to safety as the king approached, and thereafter became a thorn in Henry's side. He found refuge and support at the court of Louis VI, who advocated Clito's claims to be Henry's heir as son of the deposed former duke, and grandson of William I.

Equally, a diplomatic accord between Normandy and Anjou after years of war had only been achieved via the betrothal of Count Fulk V's daughter Matilda to William Adelin. With the heir to Normandy dead, Fulk returned from a visit to Jerusalem in 1121 and demanded that his daughter be sent back to his court, and that all lands that had been handed over as part of her dowry, including key fortifications that probably included the strategic stronghold of Alençon, should pass back to Angevin control. Henry refused; Fulk's envoys were sent away empty-handed from the king's court at Dunstable in 1123, and unsurprisingly the temporary accord collapsed. In an inflammatory move, Fulk married his second daughter, Sibylla, to William Clito later that year and handed them Maine as her marriage portion, until such time that Clito could recover Normandy as his own. Thus Clito had the support of Henry's two greatest rivals, plus possession of a territory that gave him a title in his own right. However, Clito's hold on Maine did not last long, as Henry I successfully appealed to the pope to have the marriage annulled on grounds of consanguinity. Tension in the region was thus ratcheted up to the highest level, and it was not long before conflict broke out – mainly instigated by some of the younger members of the Norman baronage, who rebelled in 1124. Henry ruthlessly suppressed it and meted out particularly harsh punishments as a deterrent: Luke de la Barre, for example, preferred to dash his brains against a wall rather than be blinded. However, it ensured that, for the remainder of his reign, Henry faced no serious internal opposition within the duchy.

Nevertheless, the issue of Henry's succession had become such a distraction to normal political life that it was discussed at a special court held at Windsor at Christmas 1126, when the various options were considered by the assembled magnates and barons. English chronicler Henry of Huntingdon stated an opinion that Clito was Henry's sole and rightful heir and this view appears to have been shared by many others, including Louis VI who seems to have genuinely believed from his vantage point in Paris that Henry might finally accept Clito's claims. However, Henry dashed their hopes and obtained a promise from his barons that they would accept his daughter Matilda as his heir. They were also required to recognise that her legitimate son would succeed her, an indication that not everyone was convinced that she was the best choice. Solemn oaths were taken from the leading members of the Anglo-Norman baronage at a ceremony conducted on 1 January 1127 by Bishop Roger of Salisbury. The consequences were immediate and dramatic.

Louis VI promptly arranged for a marriage between his wife's half-sister, Jeanne de Montferrat, and Clito within weeks of Henry's decision. This time there was no possibility of an appeal to the pope on the grounds that they were too closely related – and, in a gesture every bit as provocative as Fulk V's gift of Maine to Sibylla and Clito, Louis endowed the new couple with the lordship of the French Vexin, part of the disputed border with Normandy. Furthermore, Charles I, count of Flanders, was assassinated on 2 March 1127, leaving no heir; as the county's overlord, Louis intervened in Flemish politics and ensured Clito was installed as Charles's successor, radically changing the balance of politics in the region and leaving Henry 'much distressed'. In retaliation, Henry immediately began stirring up trouble in Flanders amongst the other factions who had not supported Clito's candidacy, in particular Thierry of Alsace. Whilst attacking Thierry's castle at Aalst, Clito received a mortal wound, and died around 28 July 1128; he was only twenty-five years old.

With Clito's death, the vexed question of the succession suddenly appeared much simpler and the way for Matilda was smoothed. At face value, she brought vast political experience and enjoyed the additional benefit of royal descent from both parents. Having been sent to Germany as a young girl aged only eight, accompanied by a huge dowry of 10,000 marks, Matilda had matured into the consort of one of the most powerful men in the Western world. She had received an education in German, not just in terms of language but also the stricter etiquette of the imperial court, in contrast to the more bawdy ways of English or Norman court life. Her husband, Henry V, did not enjoy a peaceful reign and struggled to deal with the political implications of the ongoing Investiture Contest – a bitter dispute with the pope over the right to appoint bishops. He also faced various uprisings and rebellions in the east Frankish lands, which meant he spent a large proportion of his time travelling between Italy and Germany.

Matilda involved herself in the mechanics of her husband's administration, sponsoring royal grants and accompanying Henry when he travelled to Italy in 1116 in an attempt to settle the dispute with the papacy. Indeed, she continued to act as his regent for the imperial lands in north Italy when he left to go on campaign in Germany in 1118, joining him the following year and almost certainly attending the Council of Worms in 1122 when the Investiture Contest was resolved in favour of the papacy. Yet, when Henry V died on 23 May 1125 in Utrecht, his title of king of the Romans did not pass to his nephew Frederick, who had been placed in Matilda's care, but instead went to his erstwhile rival Lothair. This was a major blow to Matilda's hopes of remaining in Germany; but whatever her aspirations might have been for a prolonged role in imperial politics, she played an even more important part in her father's succession plans. She agreed to return to Normandy and joined him there in 1126, before heading to England for the Windsor court at which she was proclaimed Henry's designated heir.

Despite the support of her father, Matilda struggled to win over the Anglo-Norman barons. One factor was her personality; her time in Germany at the imperial court seems to have endowed her with a haughty attitude, so she expected respect by virtue of her status rather than having earned it through any involvement in English or Norman politics. Although there were many precedents for women assisting with the government of the realm, the concept of queenship in its own right was unfamiliar in the twelfth century and treated with suspicion amongst the male warrior classes, who still expected their leaders to set an example on the battlefield – a continued legacy of the Carolingian era. Matilda's imperious manner, bordering on 'insufferable arrogance', seems to have particularly alienated the key figure of Roger of Salisbury – not a sensible move, given that he was in control of the English administration and therefore someone a new monarch might wish to rely upon to ensure a smooth succession. It was perhaps an ironic gesture on Henry's part that saw Roger handed control of the oath-swearing ceremony in January 1127, when the assembled barons paid homage to Matilda as Henry's heir.

Matilda suffered another disadvantage that was not entirely of her own making. Still relatively young – she was widowed at twenty-three – Matilda was one of the most prized heiresses in Europe, and was reputed to have received several offers of marriage from German princes who still considered her to be an influential figure in imperial politics. However, her father had other ideas. To counter the growing threat of Clito, and in yet another effort to prevent Anjou from siding against him, Henry brokered a marriage alliance between his daughter and Geoffrey le Bel, Fulk V's son and heir, shortly after 26 August 1127. The couple were married on 17 June 1128 at Le Mans cathedral, after Geoffrey had first been knighted by his soon to be father-in-law in a lavish ceremony, followed by a week of feasts and tournaments. Despite the diplomatic show of friendship between the king and count, this

was not a popular union for many of those who had been invited to the celebrations, and the king 'in that thunderous voice which none could resist rather compelled than invited men to take the oath' in support of the marriage.

Leaving aside the outright enmity many of the Norman barons felt towards Anjou, Matilda herself was unenthusiastic about the match; by now twenty-five, she was married to a boy of fourteen who was the heir to a mere county – quite a contrast to her first husband who had been proclaimed Holy Roman Emperor by the pope in addition to his title king of the Romans, which made him a direct successor to Charlemagne. Nevertheless, it is important that we do not forget that political status in the West was now tied to the fortunes of other branches of leading families in the East. Many counts in Outremer had gained royal titles and territories far exceeding those they had left behind, albeit held precariously in the face of a dangerous enemy who constantly sought to eject the Christian presence from the Levant. In 1129 Fulk V set aside his role as count of Anjou, passing the title to Geoffrey, so that he could leave western Europe to marry Melisende, daughter of King Baldwin II of Jerusalem, and become co-ruler when his father-in-law died in 1131 – thus adding a royal title to match that of Henry I's in England, and ensuring that the status of the house of Anjou in that region eclipsed Norman influence in other parts of the Mediterranean. Fulk's children by Melisende and their descendants would rule Jerusalem for generations.

Geoffrey was said to have been handsome, red-headed, jovial, and a great warrior, in the words of John of Parmoutier; many contemporaries agreed that he was charming and good company on the surface, but that his cheerful disposition was merely a mask that hid a cold and calculating character. He derived his nickname – 'Plantagenet' – from a yellow sprig of broom blossom that he wore in his hat, locally known as the *planta genet*. Perhaps because he sensed a superficiality about his new son-in-law, Henry seems to

have made no plans to unite Normandy, England and Anjou under Geoffrey by right of his wife (*in jure uxoris*), a common practice to ensure a strong male figure governed a territory where only a female heiress survived. Geoffrey seems to have spent little or no time at Henry's court so that he could familiarise himself with the leading barons, the implication being that he should stick to governing Anjou. Orderic Vitalis interpreted Geoffrey's role as Matilda's 'stipendiary commander in his wife's behalf', providing her with the military might to ensure she inherited Henry's territories, as well as fathering male heirs. This may well have been the real intention behind Henry's strategy – unite the disparate lands under a grandson who had an equally legitimate claim in all territories, or if there was more than one heir then to divide the lands according to custom, despite the problems that this had clearly caused between Henry and his brothers.

Matilda remained an unpalatable choice for many of the cross-Channel baronage, despite their public expressions of support; but where else might an heir be found? Henry might not have produced any more legitimate children, but he was perfectly capable of siring a brood of bastards – at least twenty that he formally recognised. His illegitimate daughters were used to tie members of the Norman and English aristocracy to the crown via marriage, as well as to establish dynastic ties to some of the neighbouring courts such as Brittany or Scotland. However, he also had a number of illegitimate sons, for whom the crown was not an impossible goal after 1120 given their pedigree; their grandfather, after all, started out as William the Bastard before he gained a more respectable title by conquering England. Henry's most prominent son in political terms was Robert, created earl of Gloucester in 1121 or 1122, after the *White Ship* sank. He had lands on both sides of the Channel, mainly thanks to his marriage to Mabel FitzHamon. However, times had changed since William's day when there had been few other viable candidates available in Normandy; and, where possible, a legitimate

child was preferred in any case. Consequently, Robert's position in 1135 was to act as a key military ally of his half-sister rather than a potential rival.

However, there was one other alternative. Henry's sister, Adela, had been married to Stephen Henry, count of Blois, and produced several children. If a grandson of the Conqueror such as Clito was considered eligible for the throne, so too might Adela's offspring, who held the same pedigree, albeit through the 'weaker' female line. Henry seems to have encouraged the rise of the house of Blois, inviting his nephews to court and promoting their careers. Theobald had become count of Blois after the death of his father in the Holy Land in 1102, under the regency of Adela; but Henry supported the careers of Theobald's brothers, Stephen and Henry. The youngest son, Henry, was made bishop of Winchester in 1129, which naturally took him out of the running for the throne. However, Stephen enjoyed a meteoric rise as his uncle bestowed lavish land grants in England such as the honours of Eye and Lancaster, making him one of the three wealthiest men in the realm alongside Robert, earl of Gloucester, and Roger of Salisbury. The generosity was repeated across the Channel, as Stephen was created count of Mortain in western Normandy and entrusted with the strategically important castle at Alençon. Furthermore, in 1125 Henry arranged for Stephen to be married to Matilda, daughter of Count Eustace III of Boulogne and his wife Mary of Scotland, the sister of Henry's late wife Matilda – thus ensuring any children produced from the union would claim descent from the Anglo-Saxon royal family.

However, the marriage was negotiated before the death of Emperor Henry V, so it is likely that any plans Henry might have had for Stephen were superseded by the return of the Empress Matilda and shaped by the course of discussions at Windsor in 1126. Indeed, Robert of Gloucester and Stephen of Blois had playfully contested the right to be the first to swear allegiance to Matilda

as Henry's heir in January 1127, suggesting that at that point they both recognised that any chance of the throne had disappeared.

On 4 March 1133, Henry's succession strategy seemed to have paid off when Geoffrey and Matilda's first son was born at Le Mans, the capital of Maine; he was named Henry in honour of his grandfather. The place of his birth was highly symbolic, given that the county of Maine lay at the heart of a long dispute between the ruling families of Anjou and Normandy; the young boy therefore represented the hope that enmity could be set aside, and peaceful co-existence brought to the troubled region. Another male heir – Geoffrey – was born on 1 June 1134, and a third son, William, would appear after Henry's death in 1136. Henry FitzEmpress, as the oldest boy became known, represented a more palatable future option than a formidable woman, powerful bastard or charming outsider; Henry I spent some time at Rouen celebrating the birth, and the barons were forced once more to swear an oath recognising Matilda as his heir. However, Matilda nearly died after giving birth to William, bringing the precarious nature of the succession into sharp relief once more – the inheritance of an infant heir was always fraught with risk, not least the attendant dangers of a disputed regency.

The one thing Henry needed was time to allow his grandsons to grow up; however, this was about to run out. Henry's relationship with Matilda and Geoffrey started to deteriorate as the king refused to hand over the border castles to his son-in-law that had been promised as part of Matilda's dowry. Instead of heading back to England in the autumn of 1135 as planned, Henry was forced to stay in Normandy to shore up the duchy's defences in response to the growing military tension with Anjou. Whilst out hunting at Lyon-la-Forêt in late November, Henry suddenly fell ill and died during the night of 1 December. Despite his best efforts to secure a settled succession, the old king had not expected the opportunism of his family, and opposition of his barons, to confound his last wishes for

a smooth succession – with disastrous consequences for England and Normandy.

*

News of Henry's death spread fast, sending shockwaves around his lands and throughout the immediate neighbourhood. Uncertainty about what would happen next seems to have fuelled an outpouring of violence in the duchy. The fastest to react was Adela's son Stephen, who was at Boulogne when Henry died and immediately set sail for England. His first destination was London, where the citizens elected him as their king, according to their ancient customs; the promise of further grants of liberties certainly helped with the process. Although the London election held no formal status, it served as a strong indication of support when he moved to the heart of the royal administration in Winchester. Stephen was able to take control of the treasury with the compliance of the justiciar and de facto controller of the royal administration, Roger of Salisbury – very similar to the way Henry I had seized power after the death of William Rufus in 1100. Behind the coup lay the hand of Stephen's brother, Bishop Henry of Winchester, who used his influence to secure the royal castle and persuade Roger to support Stephen.

The troubling issue of the oaths taken by the barons to Matilda, not just in 1127 but twice thereafter, was the biggest stumbling block to Stephen's daring attempt to take the crown. With the support of Henry of Winchester, Stephen's next step had been to ask the archbishop of Canterbury, William de Corbeil, to anoint him as king in return for the grant of extensive liberties to the church; but the archbishop refused, citing the oaths of allegiance. Luckily, the timely arrival in England of Hugh Bigod, who had been part of the late king's household, tipped the balance in Stephen's favour. It was claimed by Stephen's supporters that he carried with him the news that Henry had released the barons from their oaths of allegiance

to Matilda on his deathbed. Despite no other corroborating account – though, in fairness, no one was ever produced who could deny the story either – the archbishop of Canterbury was sufficiently reassured to anoint Stephen as king on 22 December 1135, and, as papal legate, secure the support of Pope Innocent II. Once again, the influence and ecclesiastical networks of the bishop of Winchester worked to his brother's advantage.

The speed of events and sheer audacity of Stephen's coup had left his rivals standing. In Normandy, the barons had gathered at Le Neuberg to discuss offering the ducal title to Stephen's older brother, Theobald count of Blois, who not only was William I's eldest grandson but also had practical administrative experience. Theobald joined the barons, along with Robert of Gloucester, at Lisieux on 21 December to conclude the negotiations only for news to reach them that Stephen was to be crowned king of England the following day. Although an offer was indeed made to Theobald and accepted by him, support quickly ebbed away at the prospect of another rupture in the cross-Channel realm similar to that in 1087 or 1100. Theobald returned to Blois and, somewhat grudgingly, supported his brother's coronation and installation as duke of Normandy – the disappointment eased by the financial compensation of 2,000 marks a year he received from Stephen in 1137.

The new king also had to deal with challenges to his authority from the north of his realm, in particular King David of Scotland, who was Matilda's uncle and had land interests to protect. He marched into England in December, taking control of several castles such as Carlisle, Norham and Newcastle; Stephen went in force to meet him in early 1136, agreeing a treaty at Durham in February which confirmed David's possession of Cumbria and his son Henry's title as earl of Huntingdon. Although the agreement did not hold, in the short term it served to add further weight to Stephen's kingship so that by the time he held his first Easter

court in March 1136, he had secured widespread support from the leading English and Norman nobles and clergy. Indeed, by the end of April 1136, even Matilda's half-brother Robert of Gloucester had recognised the political situation and gave homage to Stephen as king.

Mimicking the steps taken by his uncle in 1100, Stephen further shored up his position by issuing a coronation charter protecting the good laws of Henry I, and Edward the Confessor. First and foremost, he recognised the importance of the church in securing the throne, specifying in a lengthy clause – doubtless drafted by his brother Henry – how he would outlaw simony (the sale of church posts), confirm the jurisdiction of the bishops over ecclesiastical affairs, preserve clerical liberties and set the extent of the church's possessions to the day that William I died. With the church firmly behind him and a platform thus established for good government, Stephen's accession was smoother than that of many of his predecessors.

*

At this point, the chances of the infant Henry FitzEmpress fulfilling his grandfather's wish and succeeding to Normandy and England looked bleak, especially given that Stephen and his wife had a son, Eustace, born in 1130; most of the cross-Channel barons clearly preferred the house of Blois to the house of Anjou, and Geoffrey's decision to oppose his father-in-law in the autumn of 1135 looked increasingly naïve. At the time of Henry I's death, Matilda and Geoffrey were in Anjou. As soon as the news reached them, they marched into southern Normandy and seized castles around Argentan, intending or perhaps even expecting thereafter to progress to Rouen so that they could claim Matilda's birthright. However, the opposition of the barons to Matilda on personal grounds, coupled with outright hostility towards her husband as an enemy of Normandy, made it impossible for her to make any

further headway. As befitted a military campaign that had ground to a halt, pillaging and looting ensued, which further enraged the Normans. Frustrated, and possibly feeling the effects of her third pregnancy, Matilda withdrew to Anjou.

Despite the events in England in 1136 that saw Stephen's coronation and consolidation accepted by most, Matilda challenged Stephen's right to become king in an appeal to the pope on two key grounds. Firstly, she claimed to be the stronger candidate in terms of primogeniture, a growing concept tied into England's feudal system that the closest blood relationship should automatically inherit. Secondly, the sacred oaths should have bound the English and Norman barons to her cause, making perjurers of Stephen and all those who supported him. It was this latter issue that caused so much consternation, and produced a range of reasons why the oaths made to Henry should be abandoned. The importance of oath-taking as a means of enforcing and underpinning feudal relationships in society from top to bottom cannot be overestimated. Oaths were sacred promises made in the sight of God, according to Christian doctrine, and therefore oath-breakers could not be trusted. Not only did they lose their honour, they risked excommunication and eternal damnation.

For the new king to start his reign mired in controversy over the legitimacy of his title – not least because he had jostled with Robert of Gloucester at the 1127 oath-taking ceremony to be the first in line to swear allegiance to his cousin – immediately undermined his authority, and created an aura of doubt about his suitability to be king that proved hard to dispel throughout his reign. Indeed Stephen's questionable legitimacy was a theme that recurred time and time again as his authority unravelled, and this was exacerbated by various mistakes that meant leading barons – both lay and clergy – did not fully trust him. For example, in 1136 the archbishop of Canterbury died and Stephen's brother, Henry of Winchester, fully expected to be elected as the king's candidate. However, Stephen

kept the see vacant for two years – a direct contravention of his coronation oath – and then engineered the election of Theobald of Bec, having first ensured that Henry was elsewhere and thus could not intervene. Not surprisingly, Stephen lost the support of his brother at a crucial period when Normandy was under renewed threat.

Stephen's bright start as king was therefore blighted as a result of his actions. Consequently, people could not help but make comparisons between the style of Stephen's kingship and that of Henry I. The old king would not have stooped to such a low trick as the one used by Stephen in 1139 to break the power of Roger of Salisbury, the mastermind behind the exchequer. He and members of his family were suddenly arrested at court on trumped-up charges whilst under royal protection, and had their property seized. Such an orchestrated political assassination served to illustrate that Stephen was an altogether different character to his uncle. Although he was seen as chivalrous, brave and daring, Stephen was also perceived as weak or malleable – which he demonstrated early in his reign in the way that he treated the rebellious Baldwin de Redvers, who had failed to attend Stephen's court at Easter 1136 to swear allegiance to the king. Having besieged Baldwin and his supporters at Exeter until the castle garrison eventually surrendered in February 1137, Stephen was persuaded by Robert, earl of Gloucester, to let everyone go free, being lenient to the extent that they were permitted to take their possessions with them; Henry would doubtless have mutilated or even executed the leaders to serve as a warning to anyone else who harboured similarly disloyal thoughts. According to Henry of Huntingdon, '[When the barons] saw that Stephen was a good humoured, kindly, and easy-going man who inflicted no punishment, then they committed all manner of horrible crimes.'

Equally, Stephen's approach to Normandy was in stark contrast to that of his uncle, who had quickly realised the strategic importance

of maintaining a harmonious cross-Channel aristocracy if he wanted to safeguard the English throne. In many ways, Stephen's seizure of England was the easy part, notwithstanding the problems he created for himself in the way he treated people. Normandy was actively under assault from Geoffrey and Matilda, and even during times of peace it remained a difficult place to govern, prone to external influences such as the king of France, as well as being troubled by traditionally independent internal lordships or disputed borders with its neighbours. The conquest of England had permitted William I to create a new administrative system virtually from scratch, which Henry I embellished with his reforms and populated with 'new men' whom he had raised from nothing, ensuring their steadfast loyalty. In contrast, the central Norman administration was much weaker, requiring the semi-permanent presence of the duke far more than England needed a resident king.

In fairness, Stephen could not be everywhere at once. Whilst he was securing the English crown, Geoffrey of Anjou had taken the opportunity to invade Normandy again in early 1136, this time supported by William X, duke of Aquitaine – the first sign that the Norman–Angevin wars had started to escalate into a wider struggle for power across the region. From the lands in the Argentan that he had seized with Matilda in 1135, Geoffrey began to raid into other parts of the duchy. To add to the turmoil, internal revolts broke out in the south-east. Despite mounting problems in England, Stephen could not ignore the situation any longer and crossed over in force, landing near Cherbourg in March 1137. First he made peace with his brother Theobald, thus securing the support of Blois, and then met Louis VI in May to be invested as duke of Normandy, agreeing that it should be held as a fief of the French crown; doubtless the aging Louis was concerned about the prospect of a united Anjou and Normandy that would have created a major power bloc that was even more threatening than the Anglo-Norman realm.

By this stage, Geoffrey had mounted another campaign, raided deeper into southern Normandy, and moved to within ten miles of Caen, which was held by Robert of Gloucester. Stephen gathered a large force at Lisieux, but whilst he was marching to suppress the rebellion and recapture the Argentan, a fight broke out between rival factions within his army, with the troops assembled by local Norman barons turning on the Flemish mercenaries led by William of Ypres who had been hired to swell the army's ranks. With many killed on both sides, the Normans left in disgust, and Stephen was unable to persuade them to return – further evidence, if any was needed, that he was unable to assert regal or ducal authority when most needed – and consequently he had to abandon the campaign, securing a truce with Geoffrey at the cost of 2,000 marks a year. Most troubling of all, his credibility was undermined still further by Robert of Gloucester's claims to have discovered a plot by William of Ypres to ambush him – and that Stephen knew about it. Instead of staying to sort out the duchy's problems, rebuild trust and stamp his authority on the region, Stephen 'appointed William de Roumare and Roger the vicomte with others as justiciars of Normandy, commanding them to accomplish what he himself had been unable to effect in person, namely to do justice to the inhabitants and procure peace for the defenceless people'. In other words, he ducked the issue and left others to fight for Normandy on his behalf.

This was another major mistake. Not only had Geoffrey made his intentions clear – the full conquest of Normandy in the name of his wife – but also Robert of Gloucester remained a brooding presence in the duchy, still outwardly loyal to Stephen but acting as a potential lightning rod for any further discontent. Instead of keeping a close eye on his rival, Stephen returned to England in November 1137. It proved to be a costly error; in June 1138 Robert announced his defiance or '*diffidatio*' to Stephen, a term used to indicate that he had formally renounced fealty to his overlord.

Thus Caen and Bayeux fell into the hands of the Angevins, and Robert's vassals in England revolted against the king as the bonds of allegiance started to unravel. England slid towards civil war and anarchy, whilst Geoffrey of Anjou stepped up his invasion of Normandy. On 20 January 1144, the ducal capital Rouen fell and in April, the new King Louis VII of France invested Geoffrey as duke of Normandy. Half of Henry I's intended succession plan had thus been delivered, albeit a decade late and at huge cost to the stability of England and Normandy; it was now time for his grandson to enter the fray.

*

From an early age, Henry FitzEmpress was affected by his parents' struggles to win England and Normandy, as well as the fact that they spent little time together – this was, after all, a marriage brokered out of diplomatic necessity that no one, including the couple, really warmed to. For the first few years of his life, Henry was looked after in his mother's household, mainly in Anjou, although he would have been present during her attempts to win over the Norman barons in the mid-1130s once the succession crisis broke, given that the young boy provided a more palatable alternative to Matilda and Geoffrey's rule. From around 1137 he undertook a formal education that included classical training, with knowledge of reading and writing in Latin; and was based primarily in his father's court of Anjou. Then in 1142 or 1143 – after the final conquest of Normandy had begun in earnest, and Matilda had established a firm base in the south-west of England – Henry was invited to join his mother; this somewhat risky decision seems to have been at the insistence of Geoffrey of Anjou, although Matilda appears to have been equally keen to have her son with her. Either way, Henry was placed into the care of Robert of Gloucester, whose court was also frequented by scholars and learned men, despite the war. We know that 'master Matthew' tutored him in 'letters and manners';

other prominent men included Adelard of Bath, who was probably connected with the early exchequer and corresponded with similar men of letters and learning in Spain. Adelard was therefore able to receive translations of Arabic works on science and lost texts from antiquity; and it was to the young Henry that Adelard dedicated his treatise *On the Astrolabe*, written around this time.

Henry returned to Anjou around 1144 when the conquest of Normandy was virtually complete. During the period after Normandy had been captured, Henry started to learn the art of government at first hand, benefitting from closer proximity to his father as Geoffrey consolidated his hold on the Norman administration, watching and learning about the key figures at court in preparation for his own future career as its leader. Indeed, it is possible to discern and assign several later character traits from influences in Henry's early upbringing, such as a love of intellectual discourse learned from his tutors; military skill (as well as red hair) from his father; and, according to Walter Map, 'all those traits which rendered him unpleasant' from his mother, including some of the expedient talents in the art of prolonging negotiations to derive a more favourable settlement. 'An untamed hawk, when raw flesh is often offered to it, and then withdrawn or hidden from it, becometh more greedy, and is more ready to obey than remain.'

Yet he also had a reckless side (possibly a characteristic inherited from his grandfather) that surfaced in 1147 when, at the age of fourteen, he decided to intervene in the war in England. Henry abandoned his studies, hired mercenaries on the promise of future payment from campaign spoils and, accompanied by his small household, sailed for England to take up his mother's cause, rushing to the aid of magnates he had never met, but hoped one day to govern. It is likely (but not certain) that he landed at Wareham, and attempted to assail Cricklade and Purton in Wiltshire albeit without any success. However, he was unable to pay his troops and appealed to Matilda, and Robert of Gloucester, for money. Both

refused, as they were not in favour of his escapade. In perhaps one of the more remarkable incidents in a war that defied logic, Henry then 'sent envoys in secret to the king as to a kinsman' asking for cash; even more unfathomably, Stephen agreed.

If it was a calculated gamble, it appeared to have paid off. Henry was back in Normandy by 29 May 1147; four months later, on 31 October, Matilda's military commander, Robert of Gloucester, died and she abandoned England in early 1148. From that point onwards, the empress devoted her time to Norman affairs, settling in Rouen at the priory of Notre Dame du Pré where she had special quarters made for her. With his work in Normandy completed, Geoffrey largely returned to internal politics in Anjou, where he had been forced to suppress unrest against his own rule from 1145 stirred up by his younger brother Elias. Thereafter, if Henry wanted to claim his entire inheritance, he would have to fight for it himself. In 1149 he returned to England, this time making an alliance with his relative King David of Scotland – who knighted Henry at Carlisle on 22 May, thus formally ushering him into the ranks of military commanders – and Stephen's enemy Ranulf of Chester. However, Henry lacked the necessary resources to strike a decisive blow against the king, and once more withdrew to Normandy in early 1150.

Even if Henry's campaign had no discernible impact in England, his authority and leadership had impressed his parents; Geoffrey declared his son to be 'of age' and, with the support of Matilda (in whose name he governed), handed control of Normandy to him. As nominal overlord, King Louis VII was unimpressed, doubtless irritated by the fact that the decision was made without his knowledge, and alarmed by the prospect of a unified Norman–Angevin power bloc. Instead of recognising Henry as duke, Louis formally proposed that Stephen's son Eustace should be considered the lawful ruler of Normandy, and Eustace did not hesitate in joining forces with the king of France to wage war against the

duchy. Henry faced the first serious challenge to his authority; whilst Louis and Eustace captured Arques and Séez, the Norman border defences largely held; and Bernard of Clairvaux, one of the most respected ecclesiastical scholars of the era, brokered peace negotiations between Henry and Louis around 24 August 1151, which Henry's father, Geoffrey, strongly advised him to accept. By the end of the month, Louis had invested Henry as duke of Normandy in Paris, with Henry making concessions to his new liege lord in return, ceding any claims on the Norman Vexin (which Louis had possessed since 1144 as part of his recognition of Geoffrey's conquest of the duchy).

Henry appears to have spent some time with his father during 1150, learning more about the politics of Anjou first hand when he accompanied Geoffrey on a prolonged siege of a rebellious baron's castle; they apparently passed the time outside the castle walls reading the classical work by the Roman author Vegetius on strategy and tactics. However, Henry was not able to draw upon his father's advice for long; on 7 September 1151 Geoffrey was stricken with fever and died suddenly at Château-du-Loir, aged only thirty-nine. Henry was proclaimed count of Anjou, Maine and Touraine, unifying these territories with Normandy under one ruler for the first time. However, Henry's inheritance of Anjou was not without terms and conditions; as he lay dying, it was alleged that Geoffrey insisted that his body remain unburied until Henry swore an oath that he would hand Anjou to his younger brother Geoffrey once – if – he ever took possession of England. There are doubts as to the veracity of this story, but Henry certainly spent the remainder of the year ensuring his position in Anjou was secure, thus further postponing any plans to invade across the Channel, for fear Geoffrey might move against him. However, the rivalry between the brothers intensified in the spring of 1152 when both made a play for the same woman; it did not help that she was the recently divorced queen of Louis VII and one of the wealthiest,

most beautiful and formidable women in Europe. Her name was Eleanor of Aquitaine.

*

The duchy of Aquitaine had grown into one of the richest and largest regions under the nominal control of the king of France, occupying nearly one-third of the extent of the modern country but sufficiently far from Paris for the duke to be semi-autonomous – indeed, many of its lords also displayed a similarly independent attitude towards their duke, with Poitou and Gascony often pulling in opposite directions. Given its proximity to Spain, with the heady infusion of Arab influences alongside Christian tradition, the ducal court was a more liberal environment than some of its northern counterparts – which was reflected in the personality of the ruling dynasty.

Born around 1122, Eleanor was the eldest daughter of Duke William X and his wife Aenor of Châtellerault. This was a complicated situation, as Aenor was the daughter of William IX's lover, Dangerose, by her husband Aimery. Indeed the family never lost the whiff of scandal that accompanied William IX's ducal reign. He earned a reputation as a lyric poet or troubadour, boasting in verse of his various sexual conquests, and as a territorial troublemaker after he pressed the claims of his wife Philippa to neighbouring Toulouse, creating problems that would manifest themselves in Henry II's time. As the oldest daughter of William X, and from 1130 the heir presumptive after her brother William died aged only four, Eleanor had enjoyed the benefits of a varied education at her father's court. She learned an eclectic mix of traditional skills required to run a household, including needlework, sewing, spinning and weaving; intellectual scholarship in music and literature, reading and writing Latin, arithmetic, history and the sciences; and the courtly skills of riding, hunting, singing and playing the harp. Indeed, it was said that she was a keen player of

games similar to draughts, backgammon and chess that had been introduced from the Arab world.

On 9 April 1137 William X died, having fallen ill whilst on a pilgrimage to Santiago de Compostela to visit the shrine of St James. As he lay dying, William requested that Eleanor be placed under the guardianship of his liege lord, Louis VI of France. Although seriously ill with dysentery himself, the king duly obliged; however, he ensured that his seventeen-year-old son Louis was betrothed to her first, thus extending the influence of the monarchy to a traditionally distant part of the realm. They were married on 25 July 1137 and Louis took up the titles of duke of Aquitaine, duke of Gascony and count of Poitou by right of his wife – although they were to be kept independent from the French crown, and not absorbed into the royal demesne lands. Within a few days of the marriage Louis VI was dead, and the couple were crowned King Louis VII and Queen Eleanor on 25 December 1137.

By all accounts, Eleanor was beautiful and highly intelligent, but also very independently minded. Eleanor was used to a more relaxed and, frankly, flirtatious atmosphere at court in the south of France, but it was not just her dress and behaviour that provoked dismay amongst the more conservative courtiers in Paris – her family contributed to a growing sense of disapproval. Her sister Alix accompanied the new queen to court, and sparked outrage in 1142 when her dalliance with the married Raoul I of Vermandois, seneschal of France, led him to repudiate his wife, Eleanor of Blois. In a move supported by Louis VII, Raoul completed Eleanor of Blois's humiliation when he wed Alix. The diplomatic fallout was huge, given that Eleanor was the sister of Count Theobald IV of Blois, who reacted furiously and demanded that the new marriage was annulled. Louis was already embroiled in a dispute with Pope Innocent II, who seized the opportunity to excommunicate the king for failing to act in defence of Eleanor of Blois. Louis responded by marching an army into Champagne, of

which Theobald was also count, and was personally involved in the assault of the town of Vitry-le-François – an atrocity in which at least a thousand people were burned to death when the church in which they were seeking refuge went up in flames. Even against the backdrop of the chaos engulfing England and the war raging in Normandy, it was a barbarous act; in the aftermath Louis bowed to the papacy's wishes, withdrew his troops from Champagne in 1144, and the following year agreed to go on crusade to the Holy Land by way of penance.

Such a vow was necessary because the county of Edessa, one of the four main crusader states in the Middle East, had fallen to Muslim Turkish forces led by Imad ad-Din Zengi in 1144, whose encroachment in the region was helped by the death of King Fulk of Jerusalem (Henry FitzEmpress's grandfather) from a hunting accident. According to William of Tyre, Fulk fell from his horse and was crushed by the saddle, causing such trauma to his head that 'his brains gushed forth from both ears and nostrils'. With Christian influence in the area in severe peril of being extinguished, Bernard of Clairvaux was charged by Pope Eugene III to drum up financial and military support for the crusade, and concentrated much of his early efforts in France. Both Louis and his wife took the cross, with Eleanor leading a military contingent from Aquitaine in her own right as their duchess.

Despite Bernard's strenuous efforts, the campaign was not a success on many levels, particularly for Louis and Eleanor. Whilst drawing fulsome praise when they reached the court of the Byzantine emperor, Manuel I Comnenus, at Constantinople in 1147, the residual tension between the crusader states and the claims of the emperor in the region meant that logistical support through Byzantine-held lands in Asia Minor on the route to the Levant was half-hearted at best. The worst disaster came when Louis's army was massacred in January 1148 by a Turkish ambush near the summit of Mount Cadmos, whilst crossing the Phrygian

mountains in modern Turkey; Eleanor's general was widely blamed and Louis VII was lucky to escape with his life.

The remnants of the army limped on to Antioch, which was ruled by Eleanor's uncle Raymond. He requested help from Louis in his struggles against the Turks based at Aleppo, but the king refused, wishing instead to press on towards Jerusalem so that he could fulfil his crusading vows. Eleanor's impassioned pleas to her husband fell on deaf ears, and when she refused to accompany him on the next leg of their journey, Louis threatened to invoke medieval French marriage tradition and force her against her will. Her retort was to question the validity of their marriage on grounds of consanguinity, whereupon Louis arrested her in the middle of the night and carried her off to Jerusalem. At the heart of Louis's behaviour lay a suspicion and jealousy about Eleanor's overly familiar relationship with her uncle, of which rumours of 'excessive affection' began to surface from this point and dogged her for the rest of her life. The remainder of the crusade was a failure, and they headed home in separate vessels, such was the bitter nature of their disagreement. Despite an attempt at reconciliation (to which Eleanor reluctantly agreed) and the subsequent birth of a second daughter, Alice, the marriage continued to struggle. On 11 March 1152 the parties met at the château de Beaugency on the banks of the Loire to discuss a divorce, accompanied by prominent members of the clergy. Ten days later, with the permission of Pope Eugene III, an annulment was granted on the grounds of fourth degree consanguinity and Louis removed any remaining royal troops from Aquitaine.

For Louis, the risk of losing possession of the duchy was out-weighed by the pressing need to produce a male heir, and thus secure the inheritance of the throne within his family. However, he could not have imagined how rapidly events would move after his divorce. On her way back to Poitiers, attempts were made to kidnap Eleanor by Theobald V of Blois and Geoffrey, Henry FitzEmpress's younger brother.

On arriving at Poitiers, Eleanor sent envoys to Henry asking him to come at once and marry her, which he duly did; the couple were hastily wed on 18 May 1152 'without the pomp and ceremony which befitted their rank', according to chroniclers who tut-tutted at the unseemly haste. Roger of Torigny was left uncertain whether the marriage took place 'either suddenly or by premeditated design', suggesting some earlier discussions between Eleanor and Henry had occurred. It is likely that they had met the previous August when Henry was in Paris to be invested as duke of Normandy. Henry, dashing and handsome, had certainly made an impression at the French court, even if he was eleven years younger than Eleanor. Later writers elaborated upon the stories that had emerged from the Middle East, and depicted her as sexually voracious; not only had she 'cast her lascivious eyes' on the new duke of Normandy, but,

> . . . having contrived a questionable divorce, she married Henry despite rumours circulating to the effect that she had already shared Louis's bed with Geoffrey, Henry's father. This, one supposes, is why their progeny, sullied as their origins were, finally came to naught.

Despite the rumours, this was a stunning political coup. By the time Louis had realised what had happened, Henry had taken possession of Aquitaine, and thus two-thirds of France was under his direct control – the largest amount of territory held under one ruler since Charlemagne. Louis was both furious, as the marriage had taken place without his permission, and highly concerned about the rapid accumulation of power in Henry's hands. He renewed his alliance with the house of Blois and, once again accompanied by King Stephen's son Eustace, embarked upon a further invasion of Normandy on 16 July 1152. However, Louis had little success. Henry devastated the Norman Vexin, and Louis (who had fallen ill) withdrew from Henry's lands to conclude a truce. At the same

time, Henry quelled a rebellion in Anjou led by Geoffrey, who also submitted to his brother's will. Meanwhile, in England, Stephen had taken the opportunity presented by Henry's troubles in Normandy to renew his assault on Wallingford, which was of great strategic importance and loyal to Henry. As winter progressed, and with little chance of relief, the garrison contacted the king and agreed to surrender if no help was sent by their lord. Observing feudal etiquette, the message was also sent to Henry who, contrary to expectation, arrived in England with a modest force of 140 knights and 3,000 infantry in January 1153. Gathering his supporters, he attacked Stephen's stronghold at Malmesbury; the king brought his army to relieve it, intending to win a decisive battle in the tradition of Hastings or Tinchebrai. The scene was set for a fight for the kingdom.

However, after so many years of warfare, the leading barons were far from keen on the idea; many had reached private concords with their neighbours after Matilda left England, recognising that they had sworn allegiance to different sides in the conflict but promising not to wage war on one another unless specifically instructed to by their liege lord. Consequently, the principal supporters of each side were reluctant to commit to battle; it seems that the preferred option at Malmesbury was for each side to withdraw to separate parts of the kingdom, a form of truce that held for six months. Robert, earl of Leicester, seized the opportunity to defect from Stephen, allowing Henry to shore up his position in the Midlands, and in late July or early August Henry finally moved to relieve Wallingford. Once again, Stephen gathered 'an inexpressibly large army from every part of his kingdom' in another attempt to engage Henry in battle but the barons prevented conflict on the grounds that it 'meant the desolation of the whole kingdom'. It was stalemate.

With the two armies facing each other across the river Thames, neither Stephen nor Henry appeared willing to compromise, yet were unable to persuade their armies to engage in a decisive

encounter. Instead, Henry moved east, captured Stamford and sacked Nottingham, whilst Stephen gained Ipswich castle. Although negotiations continued behind the scenes, the deadlock was only broken by the death of Stephen's son Eustace on 17 August 1153; Eustace had most to lose from a peace that excluded him from the succession, and therefore had started to raid enemy territory once more in an attempt to rekindle the war. Even so, it took until 6 November before Henry and Stephen finally met face to face at Winchester to explore a diplomatic solution, and it was here that an outline arrangement was brokered. In front of the assembled barons and earls of the kingdom, Stephen acknowledged Henry's hereditary right to England after his death, whilst in turn Henry 'generously conceded that the king should hold the kingdom for the rest of his life'. As part of the settlement, England's war zones would be demilitarised, including the destruction of the private castles that had been erected during the conflict. The arrangement was formalised in a charter issued at Christmas 1153.

Agreeing terms and issuing a charter was one thing; translating intention into practice was quite another. Many regional lords resented having to cede the castles that had given them power and autonomy, and it was even harder to untangle the claims and counter-claims of those who had been disinherited or disadvantaged during the war. The atmosphere had grown so bad, with whispered rumours of assassination plots against the king-in-waiting, that Henry withdrew to Normandy after Easter 1154. In contrast, Stephen embarked upon a progress of the northern lands, 'encircling the bounds of England with regal pomp, and showing himself off as if he were a new king'. Henry might yet have lost his negotiated advantage had Stephen been able to capitalise on his newfound authority, but the king died suddenly on 25 October. Unlike the last two English successions, there was no urgency on Henry's part to rush to England to secure the throne. Accompanied by his wife, the new king sailed from Barfleur on 7 December

and twelve days later was crowned by Theobald, archbishop of Canterbury, at Westminster. At only twenty years of age, Henry was now master of England, lord of Normandy and Anjou and, thanks to his marriage, in possession of Aquitaine.

2

The struggle for authority

I met King Henry, many times. Yet I still remember
the first time I encountered him and looked at him:
and I knew at once this was a man I would not forget . . .
He was usually calm, but if something angered him,
his look would suddenly become fierce; his face flushed
red, while his eyes became bloodshot.

WALTER MAP

On 29 December 1170, a clerk from Cambridge named Edward
Grim joined a few other people inside Canterbury cathedral to hear
vespers, which was normally sung by the monks who lived in the
adjoining monastic buildings. It was a dark winter's afternoon, and
the interior of the church was gloomy, with only flickering candles
providing any illumination.

The service had barely started before the congregation was
disturbed by strange noises coming from the vicinity of the
cloisters; suddenly the cloister door opened and a small group of
people bustled into the main cathedral. Preceded by his cross-
bearer, Henry of Auxerre, and an entourage of household staff
that included his principal advisor and right-hand-man William
FitzStephen, Archbishop Thomas Becket made his way towards
the altar. Clearly something unusual was going on, as the monks
abandoned the service and rushed joyfully to greet their master.
Grim was startled to hear many of the monks urging the archbishop
to bar the doors to the cathedral behind him, and was even more
unnerved by Becket's response:

It is not proper ... that a house of prayer, a church of
Christ, be made a fortress since although it is not shut up, it
serves as a fortification for his people; we will triumph over
the enemy through suffering rather than by fighting – and
we come to suffer, not to resist.

The meaning behind these strange words quickly became
evident to the gathered onlookers, when, moments later, four
armed knights burst through the cloister door and strode into the
cathedral with swords drawn, their leader shouting 'Now, this way!
To me! King's men!' All wore full battle armour, including helmets
that obscured any human features apart from their eyes; they were
Reginald FitzUrse, William de Tracy, Hugh de Moreville and
Richard le Breton, men familiar to Becket as knights of the king's
household. Unbeknownst to many of the watching congregation,
this was the culmination of an argument that had erupted earlier
that afternoon, when the knights had confronted the archbishop
whilst he was finishing dinner with his household staff in a private
chamber within the palace. At first, the knights had waited in silence
for the meal to conclude; then their leader, FitzUrse, listed various
charges made against Becket by the king and forcibly insisted that
he should accompany them to face justice at Winchester. Becket had
calmly denied all their accusations and refused to comply, enraging
the knights to the point where they threatened the archbishop
with physical harm; many observers believed that the knights had
been drinking and did not take their threats entirely seriously. As
more palace staff became aware of the commotion and joined the
archbishop, the knights were forced to withdraw, dragging Becket's
seneschal, William FitzNigel, and another adherent, Ralph Morin,
with them. After a hasty conference, Becket, FitzStephen and a few
others decided to go to the church; by this stage, they could hear the
alarming sound of the returning knights breaking down doors that
had been closed against them.

The appearance of FitzUrse and his companions in a place of worship, possibly drunk and calling for the arrest of the archbishop, provoked an uproar; Grim recalled afterwards that vespers was abandoned and panic broke out amongst the congregation at the sight of the armed knights, who were shouting 'Where is Thomas Becket, traitor to the king and kingdom?' When no one replied, they cried out more loudly, their voices echoing through the cathedral, 'Where is the archbishop?' By this time, Becket had climbed four steps towards the altar, surrounded by the monks. At the sound of the commotion he turned around and, apparently unconcerned by the danger at hand, walked down again. He stood by the nearest pillar and addressed the knights:

> The righteous will be like a bold lion and free from fear
> . . . Here I am, not a traitor to the king but a priest; why do
> you seek me? Here I am ready to suffer in the name of He
> who redeemed me with His blood; God forbid that I should
> flee on account of your swords or that I should depart from
> righteousness.

FitzUrse and his comrades, perhaps mindful of the watching congregation, once again recited the charges from earlier, and repeated their demands that Becket should accompany them to face royal justice; and once more, the archbishop refused. Whether it was Becket's obstinacy or the serene nature of his demeanour that enraged FitzUrse the more is uncertain. However, his patience snapped and he cried, 'Then you . . . will now die and will suffer what you have earned.' Almost as though this was the response he had been seeking, Becket bowed his head and replied: 'And I am prepared to die for my Lord, so that in my blood the church will attain liberty and peace; but in the name of Almighty God I forbid that you hurt my men, either cleric or layman, in any way.'

The knights seized Becket and attempted to wrestle him out of the church, but he grabbed hold of the pillar and refused to move,

continuing to call out to his attackers by name that they were failing in their obligations of faith. William de Tracy raised his sword to strike a blow; shocked at the violent turn of events, and terrified for their own lives, most of the monks and congregation fled for the exits or hid behind altars, with the exception of Grim, FitzStephen and a canon. Without thinking, Grim jumped in front of the archbishop to protect him as the knight's blow fell; it cut through Grim's arm, grievously wounding him whilst slicing into Becket's head. Although Grim remained holding the stricken archbishop, he could not prevent further blows from raining down. Becket sunk to his knees, and cried out, 'For the name of Jesus and the protection of the church, I am ready to embrace death.' Afterwards, Grim recalled the way the knights butchered Becket where he lay. Richard le Breton 'inflicted a grave wound on the fallen one; with this blow he shattered the sword on the stone and his [Becket's] crown, which was large, separated from his head so that the blood turned white from the brain'. The knights prevented any of the shocked onlookers from helping the stricken archbishop. Indeed, they received help from Hugh Mauclerc de Horsea,

> a cleric who entered with the knights. . . [He] placed his
> foot on the neck of the holy priest and precious martyr and
> (it is horrible to say) scattered the brains with the blood
> across the floor, exclaiming to the rest, 'We can leave this
> place, knights, he will not get up again.'

With their bloody work done, FitzUrse and his knights left – lashing out at a French servant of the archdeacon of Sens, who was already grieving for the death of the archbishop – and, with their comrades who were waiting outside the church, ransacked the archbishop's palace. The attack was over in minutes, leaving those left behind almost paralysed with disbelief at what they had just witnessed. No one moved at first, not even to help Grim, who lay bleeding on the ground near Becket's body. Slowly, Becket's

chaplain Osbert approached, and covered the mutilated remains of the archbishop's head. It was at that point that the rest of Becket's party started to weep and wail as the horror sank in. His remains were transferred to a bier, and it was taken through the choir and laid before the altar; the grievous wound was covered with a clean linen cloth.

It was not long before news of the murder broke, and blame came to rest at the door of the man who had once been one of Becket's closest friends, King Henry II. Quite how their relationship had become so toxic can be explained by the dispute that had driven a wedge between them — a struggle for supremacy between church and state that erupted with the king's promulgation of the constitutions of Clarendon, sixteen articles that, amongst other things, asserted the primacy of royal law over ecclesiastics in certain circumstances. For Henry, this was part of a longer campaign to reassert royal authority throughout his realm; as far as Becket was concerned, the constitutions of Clarendon were a direct challenge to the independence of the church in England, threatening to weaken its connection to the pope as the true leader of Christendom. The stakes could not have been higher.

*

Henry faced four main problems when he took the throne in 1154. First, a divided aristocracy needed reconciliation, especially families with members who had fought on different sides during the civil war; a large number of the disinherited or dispossessed were embroiled in disputes over land or inheritance, a situation with origins in the reigns of his grandfather and great uncle but exacerbated by the proliferation of earldoms under Stephen and Matilda. Second, an erosion of the royal demesne through grants of land as patronage had led to an equivalent decline in revenue, with a knock-on impact on the crown's ability to operate effectively. Third, the disruption caused by the civil war meant that the royal

administration did not have a uniform reach throughout the country, and the advances in royal justice made under Henry I had lapsed; disputes were mainly resolved at local level, with no real common practice. Fourth, the authority of the crown had been eclipsed by the rise of ecclesiastical power in England, partly a consequence of the Europe-wide Investiture Controversy but equally as a result of the role played by the church under the influence of Henry of Winchester in the reign of Stephen.

Henry's determination to re-establish royal control is reflected in his proclamation charter issued at the start of the reign. It was a blatant attempt to erase the previous nineteen years of turmoil and return to the status quo enjoyed by his grandfather, Henry I, although it was a very short document – noting merely that he had confirmed all the concessions, gifts, liberties and free customs that had been made in 1100, with the abolition of any 'evil customs'. To succeed, Henry required strong men around him who were able to provide experience and guidance in the governance of a realm that was still largely unfamiliar to him. In the weeks following his coronation, Henry made several shrewd appointments, drawn from the ranks of the nobility, clergy and professional administrators from previous reigns.

His first decision was to place the English judicial system into the hands of Richard de Lucy by making him justiciar; de Lucy was one of Stephen's key officials with a track record of service as both a sheriff and royal justice in Essex. In a shrewd political move, Henry also appointed Robert de Beaumont, earl of Leicester, as co-justiciar alongside de Lucy. Beaumont was another former supporter of Stephen who had switched allegiance in 1153, and can be considered a senior representative of the Anglo-Norman baronage. Thus Richard provided technical experience and Robert sufficient social status to ensure the king's will was enforced. To re-establish the exchequer's position, Henry turned to the family of Roger of Salisbury, who had been removed from authority

by Stephen following the contrived palace coup in 1139. Rather awkwardly, Stephen had used Waleran de Beaumont, count of Meulan – the twin brother of the new co-justiciar – to engineer their downfall. However, any residual animosity was set aside in the name of political expediency, and Roger's nephew, Bishop Nigel of Ely, resumed the position as treasurer that he had first held under Henry I. Although he died on 30 May 1169, he ensured that his son Richard FitzNigel succeeded him as treasurer to continue the family's association with the exchequer.

Perhaps the most intriguing appointment to high office was Henry's choice as chancellor – a pivotal position with responsibility for the royal bureaucracy, ensuring that the chancery operated smoothly by holding and authorising use of the royal seal in the issue of writs, charters, proclamations and letters as well as looking after the royal chapel. This was such an important role that the chancellor was, according to some, second only in authority to the monarch, and attended all the king's councils by right of his office. Traditionally a cleric held the post, and Henry sought advice from Archbishop Theobald of Canterbury, another conciliatory gesture that ensured the church looked upon Henry favourably. Theobald recommended his archdeacon at Canterbury, Thomas Becket – the son of a Norman-born London merchant (Gilbert Becket) who had risen in Theobald's household and studied canon law in Rome. Henry agreed, and appointed Becket in January 1155. He needed someone he could trust implicitly as his right-hand-man – the equivalent today to a media spokesperson, chief of intelligence and head of the civil service rolled into one.

Becket was, in the words of his biographer William FitzStephen,

> handsome and pleasing in countenance, tall of stature, with
> a prominent and slightly aquiline nose, nimble and active
> in his movements, gifted with eloquence of speech and an
> acute intelligence, high-spirited, ever pursuing the path of

highest virtue, amiable to all men, compassionate towards the poor and the oppressed, resisting the proud, zealous for the promotion of his fellows . . . He was liberal and witty, ever on his guard against deceiving men or being deceived by them.

Henry gained not only a capable administrator, with experience of financial affairs, but also someone who very quickly became a close friend. It is clear that they had a genuine affection for one another, and spent a great deal of time together when their relevant duties had been discharged. FitzStephen claimed that, 'When the daily round of business had been deal with, the king and Thomas would sport together, like boys of the same age, in hall, in church and out riding together.'

One notable incident highlighted the relationship between the two men. Once, when they were riding through the streets of London on a cold winter's day, Henry noticed an old man coming towards them, poor and clad in a thin and ragged coat. 'Do you see that man?' said the king. 'Yes, I see him,' replied the chancellor. 'How poor he is, how frail, and how scantily clad!' said the king. 'Would it not be an act of charity to give him a thick warm coat?' 'It would indeed; and right that you should attend to it, my king,' replied Becket. As the pauper drew near, the royal party stopped and the king greeted him pleasantly, asking if he would like a good cloak to keep himself warm. The poor man did not recognise the king, and thought the offer was a joke at his expense. Henry turned to his chancellor and said, 'You shall have the credit for this act of charity,' and tried to pull off Becket's newly crafted scarlet and grey cape to which he was very attached in every sense. The struggle between the two friends continued at an increasing volume, with the servants, knights and accompanying nobles alarmed that king and chancellor would fall from their horses. Becket finally let the king wrest the cape from him – at least, that was the version put

forward by his biographer – and give it to the pauper. As Henry explained what the fight had been about, many of the household staff laughed loudly and offered their capes to the chancellor, as the pauper walked off with his unexpected prize.

One can't help wondering whether Becket saw the funny side of this incident at the time. If FitzStephen is to be believed, the chancellor had taken a high opinion of his role in Henry's administration, bearing the brunt of the routine work of government whilst the king enjoyed other pursuits. Of course, much of this praise was natural bias written to enhance Becket's reputation as a capable administrator, but it seems that there was a general perception that the chancellor held the reins of power in his hands, and that if you wanted to get ahead in the land, you needed to curry favour with him first. This was not just the biased view of someone close to Becket. William of Newburgh wrote in his chronicle that Becket 'performed such signal service to the state, and won the king's affection and regard to such a degree, that he seemed to share the throne with him'.

Although Becket had been ordained a clerk, he certainly enjoyed the secular trappings of his new office – in many ways adopting an ostentatious show of power that Henry often eschewed, preferring more modest attire whilst his chancellor dressed in the finest clothes. This extended to the hospitality shown at his house, where Becket used his new position to build a network and extend his influence throughout the top ranks of society. A stream of earls and barons dined with him, with his rooms furnished with clean rushes on the floor whatever the season, and the finest gold and silver plates and drinking vessels adorning the tables for the sumptuous food and most delectable wines.

This was a complete contrast to Henry's itinerant court, which seems to have been a more chaotic and prosaic experience when compared to the fine hospitality provided by his chancellor at his principal houses. In fairness, the descriptions that have been passed

down to us by contemporary chroniclers reflect both the challenges of a peripatetic lifestyle on the road, as well as the somewhat mischievous nature of the king; it is clear that Henry seemed to enjoy challenging his household servants by altering his plans overnight. As Gerald of Wales wrote, somewhat wearily,

> If the king has said he will remain in a place for a day – and particularly if he has announced his intention publicly by the mouth of a herald – he is sure to upset all the arrangements by departing early in the morning. And you then see men dashing around as if they were mad, beating packhorses, running carts into one another – in short, giving a lively imitation of Hell. If, on the other hand, the king orders an early start, he is sure to change his mind, and you can take it for granted that he will sleep until midday. Then you will see the packhorses loaded and waiting, the carts prepared, the courtiers dozing, traders fretting, and everyone grumbling. People go to ask the maids and doorkeepers what the king's plans are, for they are the only ones likely to know the secrets of the court.

Henry seems to have adapted to life on the road, as well as the discomforts it brought to those more accustomed to a more luxurious standard of living, and spent most of his adult life in the saddle. Indeed, the king was certainly keen to set aside some 'Henry' time, as Gerald of Wales also noted,

> He was addicted to hunting beyond measure; at crack of dawn he was off on horseback, traversing wastelands, penetrating forests and climbing the mountain tops, and so he passed restless days. At evening on his return home he was rarely seen to sit down either before or after supper. After such great and wearisome exertions he would wear out the whole court by remaining on his feet... He

delighted beyond measure in birds of prey, especially when
in flight, and in hounds pursuing wild beasts by their keen
scent, both for their resonant and harmonious voices and
for their swift running.

Henry's approach to the way his court operated differed greatly
to that preferred by troubadours such as Bertran de Born, who
was more used to the sort of environment in which Eleanor of
Aquitaine grew up, and doubtless would have preferred Becket's
establishment. He complained that, at Henry's court, 'There were
no laughs or smiles, no banter either; as for presents and gifts,
you would find neither ... it was vulgarly weary and mortally
dreary.' This might reflect more on the court of Aquitaine, which
was renowned for its approach to entertainment compared to its
northern counterparts. However, it is clear that Henry prioritised
the business of government, and took a keen interest in the work
of his administrators, rather than composing tales of derring-do
and songs of knightly bravery. According to Peter of Blois, Henry
liked nothing better than 'to spend his time in private reading, or
trying to unravel some knotty problem with a group of his clerks
... It was school every day for the king of England, with constant
meetings with the most learned thinkers and discussions on
intellectual issues.'

We know a great deal about this young, ambitious king – his
appearance, his stature, his likes and dislikes – from the writings
of those closest to him, such as Gerald of Wales and Walter Map.
Henry had a reddish, freckled complexion with grey eyes that
would grow bloodshot in anger. He had a fiery temper to match,
when his harsh, cracked voice would be raised to a shout; woe
betide anyone who roused him to anger, though he was normally
eloquent as befitted someone of his education, schooled by some of
the finest thinkers of his day. He was of moderate height but with
the stocky physique of a warrior used to spending long hours in the

saddle – a slightly protruding neck, a broad and square chest, and strong powerful arms. As he aged, he grew slightly stouter, though he tried to compensate by eating and drinking in moderation, and looked after his physical wellbeing through regular exercise as far as possible.

In particular, the king drew praise from Gerald of Wales for his generosity and acts of charity, being a liberal almsgiver, 'a lover of humility, an oppressor of the nobility and a condemner of the proud, filling the hungry with good things and sending the rich away empty, exalting the humble and putting down the mighty from their seat'. It might be easy to dismiss this as the sort of rhetoric that a chronicler close to the court might be expected to write, but there are several examples that support this view. Walter Map recalled an incident in which he was personally involved, while crossing the Channel with the king accompanied by twenty-five ships. A storm scattered the fleet, driving most of them onto the rocks. The sailors faced ruin, but Henry ensured that they were suitably recompensed, 'Learning from each sailor the estimated amount of his loss, he reimbursed him, although he was not bound to do this, and the entire sum amounted to a good deal.' This was clearly viewed at the time as an extraordinary act of kindness.

However, like all people Henry was not perfect. Map was also quick to describe some of the faults that he perceived in the king, although many of his less attractive characteristics were blamed on the way his mother had schooled him in the art of statesmanship – 'an evil, evil woman'. In particular, Henry was 'slow in settling the business of subjects, whence it happened that many, before their affairs were settled, died or departed from him dejected and empty-handed under the compulsion of want' – criticism that the king had broken the promises made at his coronation. Equally, Henry had a habit of withdrawing into his inner chamber and refusing to see petitioners, with the result that he was 'accessible only to those who seemed unworthy of such access' – his cronies and favourites,

rather than petitioners seeking justice. It is perhaps understandable, given that crowds of people flocked to the court as it moved around the realm, all seeking an audience with the king. Nevertheless, despite the constant clamour for attention, Henry never adopted a haughty manner when his subjects were presented to him, and tried to act with fairness and restraint where possible.

What becomes clear from all these accounts is that the king was a very complicated person, committed to his public duties but equally prone to a desire for privacy, during which he would hunt or retire into the inner depths of his court. Despite his best intentions, though, one of the principal characteristics that most commentators agreed upon was that Henry was an oath-breaker, which led to an erosion of trust in his promises. Time and time again, he used the slightest lack of clarity in an agreement or treaty to reach an interpretation that was in his best interests – 'For as often as his affairs became difficult he would repent in word rather than in deed, and so the more easily accounted his oath null and void than his deed.' In an age when oaths were the foundation of trust in society, a public statement of good intent, it was a serious issue and one that would haunt him in later life. The only consolation was that his contemporaries were just as bad, if not worse. In mitigation, this trait came from a clear, overriding desire to uphold the royal rights he had inherited, especially in the aftermath of Stephen's reign when the status of the king had been tarnished by regular broken oaths and duplicitous acts. Although he wanted to distance himself from the behaviour of his predecessor, as far as Henry was concerned the ends justified the means. As a result, the king approached the four main areas of immediate concern that faced him in early 1155 with a steely determination to succeed at all costs.

*

The greatest danger to Henry's position in England was the reaction of the barons to their new young master. Given the proliferation of

private castles that had sprung up during Stephen's reign, linked to the reckless creation of earldoms by both Stephen and Matilda, many of the magnates who had enjoyed semi-autonomous power may have been assuming that Henry would be too preoccupied with affairs on the continent to pay them much attention. They could not have been more wrong. As Gerald of Wales noted, Henry's primary concern was 'to root out all causes for renewal of warfare and to clear away all inducements to distrust', which included an estimated 1,115 castles that had been erected. Equally, the terms of the 1153 peace treaty stipulated that all lands would be returned to their rightful possessors at the time of Henry I – more easily said than done. This restitution of land included the recovery of the royal demesne into the crown's possession, taking back what had been previously raided to provide patronage for Stephen's supporters. Not only was this implicit in the treaty reached with the agreement of the barons at Christmas 1153, but also there was contemporary written precedent for the king to refer to in his drive to reassert the ancient rights of the monarchy – the legal textbook *Laws of Edward the Confessor*, which stated that,

> The king ought to preserve and defend all lands and honours, all dignities and rights and liberties of the crown unimpaired, and ought to restore to their previous condition those rights of the realm that are lost, damaged or strayed, and recover what is owed by all men.

With the confidence of youth, Henry made two bold moves in the spirit of this passage that a more seasoned leader might have ducked. First, he dismissed Stephen's mercenaries hired from Flanders. This was an exceedingly risky gamble, given that their departure had the potential to leave him short of military might should it be needed. However, it confirmed the young king's determination to lead by example, and his staunch commitment to the restoration of peace; it was certainly a move that brought him

instant popularity, given the widespread chaos that roaming war bands had wrought upon the countryside during the worst of the 'anarchy'. Expediency might also have played a part, given that the crown coffers were virtually empty and Henry had been forced to borrow heavily from Jewish moneylenders to finance his early moves in England.

His second act was to announce the reclamation of all royal castles, and oversee the demilitarisation of the countryside. In particular, the king 'ordered the newly erected castles, which had not been standing in the days of his grandfather, to be razed to the ground, with the exception of a few sited in advantageous places, which he desired either to retain for himself or to be maintained in the hands of peaceful men for the defence of the realm'. This was the true test of Henry's intention to carry out the spirit of the 1153 peace, as well as his ability to win a trial of strength with the barons. Within weeks of his coronation, he tackled the issue head on by marching north against William le Gros, count of Aumale, who had been created earl of York by Stephen. William's defiance of the new regime did not last long. In January 1155, 'after long hesitation and seething with indignation, the earl with a troubled mind at last submitted to superior forces and delivered up in great vexation whatsoever crown lands he had retained in possession for several years, more particularly that famous and noble castle called Scarborough' – which Henry then rebuilt as a royal fortress to consolidate crown authority in the region; the earldom of York was allowed to lapse. Henry then marched back south and headed towards Nottingham, where William Peverel was based. It had been rumoured that Peverel had poisoned his rival Ranulf, earl of Chester, one of Henry's supporters; without even waiting for the king's arrival, Peverel fled the country.

This was a highly promising start, and showed that Henry could command respect and exercise royal authority, despite his young age and relative inexperience. Perhaps most impressively,

it was not just former enemies who were on the receiving end of Henry's growing confidence; adherents to his mother's cause were also required to hand over lands or castles that ought properly to belong to the crown, showing there would be no partisan favouritism under his regime. In particular, Roger FitzMiles, earl of Hereford, and Hugh Mortimer, lord of Cleobury and Wigmore – important marcher lords holding the border against the Welsh – were indignant at Henry's demands they relinquish control of key fortifications, expecting their loyalty to be rewarded with greater generosity and trust. The king, though, was determined to treat everyone alike and refused to make any exceptions. Gilbert Foliot, bishop of Hereford, eventually persuaded Roger to hand over his castles at Gloucester and Hereford, probably around March 1155. Roger's death later that year meant the end of the earldom, though Roger's brother Walter was appointed as the sheriff of Hereford and Worcester. However, Hugh offered more resistance and Henry was forced to besiege his castles at Cleobury, Wigmore and Bridgnorth; one by one they fell to the king, and Hugh made a formal submission in front of the assembled ranks of archbishops, bishops, earls and barons at Bridgnorth on 7 July 1155. Shortly afterwards, Bishop Henry of Winchester, Stephen's brother who had done so much to thwart Matilda over the years, went overseas to the abbey of Cluny in voluntary exile, whereupon Henry seized and demolished his castles as well.

By the end of 1155, Henry had consolidated his position as king and shown a desire to place duty before personal loyalties. His first foray into English politics had earned him some breathing space and no little respect; seemingly secure, he departed England in 1156 to deal with family affairs on the continent. On his return the following year, Henry was dismayed to find another challenge to his authority had emerged – another legacy of his predecessor's reign, an escalation of a long-running dispute between Stephen's surviving son William of Blois and Hugh Bigod, two of the most

powerful barons in England in terms of landholding and relative wealth. Both held substantial honours and castles in East Anglia, and both claimed the title earl of Norfolk; Henry had issued a charter in 1155 to confirm Hugh as earl whilst recognising previous grants to William, but this did nothing to limit the growing tension between the two. Henry summoned a great council of the realm to meet at Bury St Edmunds on 19 May 1157 and, in another bold show of authority, he stripped both men of their castles. Henry also seized the opportunity to order the destruction of castles belonging to Geoffrey, earl of Essex, at the same time, ensuring the king asserted his dominance across the whole region. William appears to have accepted the situation with good grace; doubtless his marriage to the wealthy heiress of the Warenne lands and earldom of Surrey cushioned the blow. Despite retaining the title earl of Norfolk, Bigod nursed a simmering resentment towards Henry that was to erupt in 1173 into one of the greatest crises of Henry's reign.

*

Henry's decisive actions between 1154 and 1157 gave him a foundation on which to build his administration. Although not all private castles were destroyed, he had brought the barons back under royal authority and established an opportunity for a fresh start for all by treating friend and foe alike. Furthermore, by involving the great council of leading lay and ecclesiastic magnates at key moments, the king ensured that his decisions were validated by common consent, so that none could accuse him of acting arbitrarily; lessons from Stephen's reign had clearly been learnt. Yet the resumption of the royal demesne did not significantly boost his finances. Revenue from the county farm (the fixed amount drawn from the king's lands and rights in each shire), brought in annually by the sheriffs, audited at the exchequer and recorded in the pipe rolls, averaged a meagre £5,000 a year for the first four years of the reign. Income from this vital source of royal revenue

only began to increase in the early 1160s, but large amounts of alienated land were never recovered. It was a pitifully small amount of money and wholly insufficient to maintain the royal household and administration in England, let alone help contribute towards the family lands overseas.

It was not just the royal demesne that had suffered during the war; expectations had been raised by the 1153 peace settlement that 'the disinherited should be restored to their own'. A large proportion of Henry's early time in England was spent resolving seemingly endless land disputes; no wonder he was surrounded by a scrum of plaintiffs when his court moved around, or that Becket took on many of the ceremonial tasks when the king was embroiled in his role as feudal overlord. By and large, the approach taken when trying to establish the legitimate ownership of land was to go back to the legal possessor at the time of Henry I's death, but a great deal of pragmatism was required as well; not all the grants made during Stephen's reign could be reversed without igniting a new civil war.

This was an important area for the king, as it was not just the peace of the realm that was affected; royal rights were bound up with the effective operation of the feudal pyramid of landholding, in particular in collecting reliefs, wardships and aids as well as the ability to summon the feudal host, should the need arise. Henry required an accurate knowledge of the number of knights' fees held by his tenants-in-chief, and to whom they had granted lands below them. The result was an update of the Domesday Book known as the *Cartae Baronum*, based on an inquisition conducted in 1166 on the king's behalf by the exchequer. If not quite as thorough as Domesday, the data that was produced still suggests a significant exercise of royal authority.

This new, comprehensive survey formed the basis of later attempts to keep track of the feudal obligations of the tenants-in-chief and their sub-tenants, such as the *Liber Feodorum* (or *Book of*

Fees), known colloquially as the *Testa de Nevill*. More immediate and practical use was made in 1168 when Henry levied an aid for the marriage of his daughter, and thereafter when the king wished to redefine the extent of key honours or lordships. The *Cartae Baronum* was a remarkable testament to the recovery and extension of royal authority, capturing information not only about the highest levels of society but also all the way down to squires in impoverished manors, who were clinging to their knightly status after years of war. In many ways, it was this class of society that most welcomed Henry's peace, as it gave them security and clarity – a welcome antidote to the regional power struggles that saw their lands constantly ravaged during the worst period of Stephen's reign. Under Henry, the knights in the shires became an increasingly important part of the royal administration, with plenty to say about how local government should work.

The compilation of the *Cartae Baronum* was only possible due to the re-establishment of a uniform system of local government throughout the realm, as Henry sought to resurrect the exchequer, complete with its retinue of staff in Westminster that oversaw the receipt of royal revenue and associated process of audit, and, by extension, the crown's agents in the field – the army of sheriffs, bailiffs and stewards who ran local government on the king's behalf, offering an employment opportunity to those from a knightly background. Once again, Henry crafted a solution that was a combination of pragmatism, expediency and opportunism. Alongside a constant need for money – and plenty of it – what the king sought most of all was a reliable system that operated without his permanent presence, permitting him to spend time abroad or delegate to his trusted officials – the justiciar, chancellor and treasurer: in short, a semi-autonomous centralised bureaucracy. However, Henry was faced with two immediate challenges: the need to dismantle the dual administrations of Stephen and Matilda and create a unified version; and the requirement to rebuild

confidence and trust in the royal officials as instruments of the king's will, given some of the abuses of power that had occurred during Stephen's reign.

First, though, the exchequer itself had to be reconstituted, which is why Nigel bishop of Ely was brought in as treasurer. His experience under Henry I, before his family's fall from grace under Stephen, was invaluable to the new king – not just in terms of understanding the practices and procedures that had been developed under the guiding hand of his uncle, Roger of Salisbury, but also in the way he cultivated the next generation of capable officials who were able to continue and extend his work. The exchequer relied upon its institutional memory, recorded in intimate detail in the annual pipe rolls as well as a plethora of subordinate documents. One of Bishop Nigel's first challenges was to rebuild its archive, and it is a testament to the work of his staff that the exchequer was able to complete this task within a couple of years of Henry's accession. It is still remarkable that we have a continuous run of documents covering the 1155–6 financial year onwards, recording historic debts as well as new business. Bishop Nigel was succeeded as treasurer by his son Richard FitzNigel, who was introduced to the exchequer by 1160, if not a couple of years earlier. It was he who decided to write down decades of institutional practice in the form of the *Dialogue of the exchequer* – a staged conversation between master and pupil – lest it be forgotten again, especially as the scope of exchequer business had expanded to become far more complicated since it was first introduced under Henry I.

The development of the exchequer under Henry II marked an important moment in the creation of a central administration in England; it is one of several government institutions that survive today. We can also discern the emerging concept of a 'public purse' that was separate from private crown expenditure on the maintenance of the royal household. The chamber had traditionally received all crown revenue as the king moved around, whereas the

exchequer was primarily introduced to ensure the king did not lose out on any revenue via a retrospective process of audit. During Henry's reign, the exchequer gradually began to exert a primacy at the heart of the royal financial administration, driven by a growing expectation that the king should draw down sufficient funds for private expenditure from the treasury into the chamber, and report any additional sums received to the exchequer, rather than collect everything whilst on the road and worry about the details later.

This is a prime example of Henry's systematic approach to government; the volume and scope of business handled this way in the exchequer increased dramatically during his reign, largely in response to the expansion of royal justice as more transactions between monarch and subjects occurred, and – crucially – were recorded as having occurred. The codification of exchequer practice into written form gave an additional sense of gravity to the institution, as did the move to permanent buildings in Westminster and its management of the royal treasury via the lower exchequer of receipt. Furthermore, it wielded real power, with the option to distrain or seize the goods and chattels of non-paying crown debtors via the sheriffs, or indeed anyone accused of embezzlement or malpractice – including former royal officials.

Yet the exchequer was only one part of Henry's system of remote-control government that functioned effectively in his absence. Communications from Westminster to the shires, and from the king and court – wherever they might be – to Westminster were essential. The royal chancery, under the control of Thomas Becket and then, after his appointment as archbishop of Canterbury in 1162, Geoffrey Ridel, played an important part in ensuring Henry's instructions were written and sent out to officials in the shires. The chancellor was responsible for the great seal, the device used to authenticate any royal correspondence, grant, proclamation or legislation; traditionally, the chancery followed the king and his court so that instructions could be written and despatched on the road. There is

evidence that, alongside the location of the exchequer in permanent lodgings in Westminster, the chancery was beginning to establish a base there as part of a central bureaucracy, especially with the growing requirement to supply clerks to support the written output from the exchequer. Westminster can therefore trace its position as the heart of government to this period. Henry oversaw, or at least authorised, other administrative changes as well. After the levy of the danegeld in 1156 (the ancient land tax introduced by Æthelred Unræd to 'buy off' the Vikings), the quality of coins returned was so poor that the king ordered a complete re-coinage in 1158 – always a profitable exercise, but also an opportunity to regulate the way money was produced. The number of places where coins could be minted was gradually reduced so that there were only nine royal exchanges left in operation, staffed by trusted royal officials. Severe penalties were enforced for counterfeiting. Henry did not want to be short-changed, or have others getting rich at his expense.

Yet the success of Henry's reforms of the central administration came at a cost. With the exchequer based permanently in Westminster, coupled with his absence from the kingdom for prolonged periods, Henry was not able to keep as close an eye on the conduct of his officials in the shires as he perhaps would have wished. Walter Map wrote an allegory in which he compared Henry's court to a classical vision of hell, and under the heading 'on night birds', he vividly described the way royal officials reported back to the king all the affairs of the realm:

> There are in hell also children of the night, the owl, night-hawk, vulture, bubo, whose eyes the darkness love and hate the light. These are bidden to go forth, to spy out cunningly and report truthfully all the deeds of ill which have part in the nature of darkness . . . There are sent in like fashion from the court those whom it styles sheriffs, under-sheriffs, beadles, whose duty it is to pry cunningly.

These men leave nothing untouched, nothing untried, and, like bees, they light upon flowers to draw forth some of the honey; they punish what is innocuous, but the belly goes clear of punishment. And yet, at the outset of their office, in the presence of the highest judge, they do swear to serve faithfully and honestly God and their master . . . but bribes pervert them so that they tear the fleece from the lambs, leaving the foxes unharmed, in as much as they win favour by their money, knowing that 'giving requires ingenuity'.

Corruption, profiteering in the form of an over-exuberance to collect revenue, and occasional outbreaks of violence perpetrated by the sheriff's retinue were just some of the common complaints against the king's men in the shires. This news was not to Henry's liking on his return to England in 1170 after an absence of four years, so he instigated a major inquiry into the conduct of all local officials who had been operating since 1166. Various terms of reference were set out in the commission, covering many aspects of local administration – not just the way in which royal officials operated, but also a survey of the state of the manors and lands in their care.

Although focused on a wide range of officials, the inquiry became known as the inquest of the sheriffs. There was an initial assumption that the royal officials would be kept on, albeit with stricter terms of reference and a rap on the knuckles. However, Henry seized the opportunity to complete the work he had initiated at the beginning of his reign, and made sweeping changes to the powers that sheriffs held. After 1170, the role of the sheriff was clearly defined to be part of a centralised royal bureaucracy, acting upon decisions made at the centre, rather than with a mandate to operate semi-autonomously. The move was linked to reforms within the judicial system which moved the operation of justice – and the profits associated with it – away from the county courts, presided over by the sheriffs, towards

new itinerant courts overseen by justices also appointed by the king. As a result, the sheriffs were more closely linked with the work of the exchequer, especially the collection of revenues due to the crown and the seizure of possessions of crown debtors. Furthermore, Henry also took the opportunity to remove twenty of the twenty-six sheriffs, replacing them with new men who, in the main, had previously been associated with the royal administration, another step in the professionalisation of the office and further opportunity for those born of lower social status to rise through the ranks.

Yet this was not just an inquiry into the way the crown's officials were operating; Henry was determined to ensure that if he was going to put his own house in order, so should everyone else. The commission for the 1170 inquest contained the extraordinary stipulation that, 'Likewise let inquiry be made concerning the archbishops, bishops, abbots, earls, barons, sub-tenants, knights, citizens and burgesses, and their stewards and officers as to what and how much they have received from their lands since the above date.' In short, Henry wanted to pry into everyone's private affairs and sought full disclosure of the activities of their officials as well, a position that asserted the primacy of the crown whilst maintaining the fiction that the king was first amongst equals.

Remarkably, the king was able to extract much of the desired information. Although only fragments of the returns survive, we are left with the knowledge that the 'men of William de Courcy at Little Saxham paid nothing to the sheriff and the king's reeves except sixteen pence, which they paid for strengthening the castle at Orford, namely to Walter the reeve and his servants'. This example represents an unprecedented level of detail that Henry had wrung from English society, showing the way lower ranks of society were affected by the actions and demands of those above them – it must have been quite an eye-opener for the king, assuming he had the time to read through all the data that came back to him. Such an exercise would have been unthinkable two decades previously, and

is powerful evidence that Henry had rebuilt and extended royal authority throughout all regions and classes. Furthermore, it set a standard for good government that came to be expected of his successors.

*

Henry's greatest legacy from this period of reconstruction was the creation of a legal system that offered common judicial processes for all his subjects, at the heart of which was the principle that royal justice stood supreme above local or regional courts. This was a direct response to the urgent need to settle the large numbers of land disputes following the civil war, as well as ensure the reintroduction of royal justice throughout the country – a logical extension of Henry's general overhaul of the royal administration, with the added bonus that it reduced the number of people chasing the *curia regis*, the king's court, to secure a personal hearing before the monarch.

According to various chronicle sources the situation facing Henry at the start of his reign was one of turmoil and confusion, with different legal systems in operation around the country and many people taking the law into their own hands through force of arms. William of Newburgh was quick to praise Henry's initial efforts to tackle the problems, as the king 'paid due regard to public order and was at great pains to revive the vigour of the laws in England, which seemed under King Stephen to be dead and buried'.

Henry was fortunate to have two extraordinary men at his disposal, who between them turned his vision into reality. His first justiciar, Richard de Lucy, presided over the major developments and innovations of the reign; after his resignation from office in 1179 as he neared the end of his life, he was succeeded by one of the finest legal brains of the medieval period, Ranulph de Glanville. It was he who compiled the *Tractatus de Legibus et Consuetudinibus regni Angliae* – the *Treatise of the Laws and Customs of the Kingdom of*

England – towards the end of Henry's reign, setting out clearly the various judicial courts, writs, processes and punishments that were in operation. The written codification of the law was an important shift from regional practice, often recalled from memory or oral tradition, towards uniformity via a single corpus upon which future decisions could thus be made.

Glanville's tract reflected various advances made under Henry II that were genuinely ground-breaking. Henry I had been considered a strong upholder of the law and had embellished the work of William I, who in turn had modified Anglo-Saxon laws codified by Alfred the Great in the ninth century. However, through his two justiciars, Henry II introduced fundamental reform to create a new judicial system that was based on the principle of a 'common law' for all. Assizes and constitutions were the main mechanisms that Henry used to introduce new laws – although most of the key legislative measures of his reign were only realised 'with the assent of the archbishops, bishops, abbots, earls, barons of the whole of England' in the case of the 1166 assize of Clarendon, or after 'a great council on the statutes of his realm', as Roger of Howden noted when the assize of Northampton was produced ten years later.

There were several aspects to Henry's legal reforms that were innovative. Perhaps most importantly, the role of the sheriffs was redefined and some of their powers were transferred to justices in eyre, who were assigned specific circuits around which they would travel during a fixed period to hear criminal and civil pleas. This had the effect of encouraging the transfer of legal business from local or regional courts – baronial, borough and county in particular – to crown courts, all operated by the same laws and processes. This was a highly popular move amongst the knightly classes and below, who felt they would receive a fairer hearing in a royal court; the justices were commissioned to act for the king, rather than on behalf of a baronial landowner operating a manorial court.

The first general eyre was conducted between 1174 and 1175; justices set out to visit a series of predetermined locations, announced in advance by instructions from the chancery addressed to the sheriffs for dissemination locally, and accompanied by a retinue of clerks so that they could hold and record daily court sessions. This was a major event in the community, with plaintiffs travelling some distance to have their cases heard by a crown justice – creating a far greater volume of business than the infrequent manorial courts. Furthermore, crown courts started to keep written records of proceedings; clerks would note case details for the justices to refer to, especially as many of the punishments were financial in nature and thus had to be forwarded to the exchequer so that the debt could be formally summoned for payment.

One of the most important pieces of legislation was the assize of Clarendon in 1166, which paved the way for the establishment and widespread adoption of jury trials that used panels of local knights to reach a decision based on evidence – a welcome alternative to trial by combat or compurgations of a case. In particular, jury trials were used increasingly in petty assizes. By the end of the reign, land law was basically the preserve of the king's court – a far cry from the arbitrary property seizures by force of arms under Stephen, and a major advance in the regulation of property disputes. Given that Henry's great-grandfather William had introduced the feudal system of landholding into England, it had taken nearly a century for royal justice to catch up and create a system that dealt with some of the consequences. It also heightened the pressure on the crown to deal fairly with its leading tenants in matters of inheritance and possession of land, if those lower down the chain were to be provided with legal redress against their overlords.

Equally, litigation between patrons about the right to nominate candidates to ecclesiastical benefices when they were vacant – the right to advowson – was regulated by the petty assize of darrein presentment, a key innovation that offered an alternative to an

ecclesiastical court, and thus proved popular amongst members of the laity. Another area where royal justice saw noticeable expansion under Henry and his justiciars was the growing requirement that any disputes about the personal status of a tenant – free or villein – should be settled in a royal court, another deep intrusion into the workings of the feudal system that had been established under William I. Finally, pleas of the crown in major criminal cases punishable by death or mutilation, such as homicide, arson, robbery, rape, treason, forgery of king's seal or coinage were to be dealt with by jury.

The assize of Clarendon was therefore a watershed moment in English history – and the inquest of the sheriffs in 1170 provided an opportunity to check whether the reforms of 1166 had been effective, both in terms of tackling the abuses of the past and ensuring they had not simply opened up a new mechanism for local oppression. Henry thus made clear that he expected justice to be accessible, equitable and incorruptible; and that a written record should be made for reference – a professionalisation that led to the birth of the archive as an important component of government.

However, the king was still required to dispense justice in person, a traditional function of the *curia regis* or king's court that accompanied him on his travels. Even here, Henry oversaw the development of alternative mechanisms that reduced the king's daily burden and placed judicial matters into professional hands. The exchequer had developed a range of its own institutional judicial powers, with the barons of the exchequer hearing cases relating to crown debtors; but from the 1160s, there is evidence that it started to tackle an increasing volume of civil litigation between parties during four clear legal terms – Michaelmas, Hilary, Easter and Trinity. We can also discern the emergence of a court of common bench during this period, evolving out of the itinerant court; as with so many governmental institutions, it became fixed at Westminster.

We have some evidence of Henry's approach to settling disputes and administering justice. Walter Map provides two examples that demonstrate Henry was prepared to listen to the salient points of a case, adopt a neutral stance to ensure fairness to both parties, and take extenuating circumstances into account. As a result, we gain a sense of the king's power and wisdom when sitting in judgment on his subjects – a noble figure far removed from his predecessor Stephen. The first situation concerned William of Tancarville, the chamberlain of Normandy, who perceived that he had received a personal slight at court. Although his was a hereditary position, William had fallen from royal favour and felt he was being marginalised during ceremonial occasions. Contemporary chroniclers agreed, commenting that 'Henry persecuted this good man in many ways, destroyed all his townships as if he were by this means dulling his horns, refused him the just protection of the laws and freedom of action.' Yet when Henry was celebrating Christmas at Caen, with his family and a large assembled crowd of local and overseas dignitaries, William chose this occasion to assert his right to play an important part in the public ritual of hand-washing and purification, striding to the front of the assembly and casting aside the king's household chamberlain who was about to perform the task.

In the ensuing uproar, William's opponents demanded that he be tried for his impertinence, shouting that he had insulted the majesty of the king. However, Henry allowed William to speak. After hearing William make an impassioned and eloquent case, outlining his family's role in serving the dukes of Normandy, Henry said: 'I desire this case to be decided justly in accordance with the evidence we have just heard, so that our decision may not be influenced either by our love or our hate.' The king then proceeded to draw upon a similar episode that he had witnessed when attending the court of Louis VII of France. 'The whole court gave to his act the name of wit, not arrogance.' Henry was

making the point that 'in an equal balance, weigh what you have heard that, although this court may seem to be inferior to that [of the king of France], it may not be judged more unjust'. Despite the enmity between Henry and William, the king bowed to the concept of natural justice and allowed William to recover his position.

This sense of mercy was revealed in a far more serious case that came to his attention; a forger had made a replica of the royal seal matrix using first bitumen and then copper, which in theory then enabled him to produce 'authenticated' documents in the king's name. This was one of the most serious offences that could be committed. Henry's response is interesting:

> When the king was informed of this, he ordered the fellow to be hanged, and then, seeing an old man, just and upright, the brother of the guilty man, standing weeping with covered head, he was immediately overcome with pity, and allowed the goodness of the upright man to outweigh the badness of the accused, and, weeping himself, he restored joy to the weeping brother. However, when the thief had been released, lest his tenderness of heart might seem to be too lax, he ordered him to be sent in a monastery.

The concept of royal mercy – a precedent by which the outcome of a judicial process could be moderated at the personal intervention of the king – is often used to show the kind, compassionate side of the monarch in question. However, it became a double-edged sword under John, who cleverly turned this royal prerogative into his weapon of choice in his battle against the barons, levying huge fines to secure the king's mercy or goodwill, a commodity to be purchased rather than freely gifted.

We have conflicting verdicts when it came to the overall impact of Henry's reforms. Gerald of Wales perhaps rightly assigned

credit to Henry's justiciars and growing body of professional justices, and suggests the king 'showed cautious anticipation and restraint, so much so that the remedy to some extent exceeded the need, and he appeared dilatory in maintaining law and justice'. This is a trifle unfair, as is his assignment of the reforms to Henry's counsellors; Walter Map recognised the innovative spirit that lay behind Henry's agenda, noting that, 'In the establishment of laws and in all reforms of government he showed keen discernment and was skilful to discover unusual and secret ways of judgment.' However, one complaint made by Gerald of Wales – that the king 'pre-eminently turned everything to his own profit' – hits home, as the new judicial system certainly helped swell the crown's coffers at a time of need, with revenue recorded in the pipe rolls from the profits of justice expanding dramatically after 1166.

The system that Henry had crafted went far beyond the realisation of his coronation promise to provide justice for his subjects. Not only had the king restored royal justice to the levels seen under Henry I, the new courts also created 'remote control' administration mirroring that of the exchequer; a common legal system and additional revenue for the crown were a bonus. Furthermore, Henry's measures became embedded very quickly within wider society, especially amongst the knightly class who benefitted the most at the expense of their lords. The sentiment that no one was above the law – even the king – was a key issue at Runnymede in 1215 when John finally confronted the rebellious barons, only a few decades after the concept was first articulated towards the end of the twelfth century.

*

Despite Henry's attempts to introduce a common law system throughout the country, and ensure fairness to all via crown courts operated by royal justices, one legal jurisdiction was off limits for any reform – the royal forest. As a result, it remained an area of

great controversy, during Henry's reign and beyond, especially the often vindictive and excessive conduct of its officials. The biographer of the bishop of Lincoln, St Hugh, noted that,

> The worst abuse in the kingdom of England, under which the country groaned, was the tyranny of the foresters. For them violence took the place of law, extortion was praiseworthy, justice was an abomination and innocence a crime. No rank or profession, indeed, in short, no one but the king himself, was secure from their barbarity, or free from the interference of their tyrannical authority.

It is perhaps ironic that Henry strove so hard to introduce a common legal system for all, underpinned by royal courts and officials, whilst ensuring that the forest operated under its own jurisdiction and punishments as a royal prerogative.

The foresters were the subject of one of the articles of commission in the 1170 inquiry of the sheriffs, suggesting that Henry was at least sensitive to the concerns raised about these officials. However, this was never intended to be a witch-hunt, or an opportunity to reform the law of the forest: the king also used the inquiry to record all the transgressions made against his forests. Henry's attitude towards the forest was made abundantly clear in 1184, when he issued an assize from his favourite hunting lodge at Woodstock and followed this up by a comprehensive forest eyre later the same year. The opening clause stated, in uncompromising terms, 'He forbids that anyone shall transgress against him in regard to his hunting rights or his forests in any respect.'

Given the extent of the forest, it is unsurprising that it remained a major cause of dispute between crown and localities beyond Henry's reign. One of the harshest critics was Hugh, bishop of Lincoln, who was consecrated in 1186 and earned the severe disapproval of the king by excommunicating a royal forester. Henry summoned him to a meeting, whereupon the king went hunting and refused to

speak to the bishop. During a pause in the chase, the king settled down with his huntsmen to sew up a leather bandage that was on his finger. Mindful of Henry's ancestry from William I's mother Herleva, and her family's reported association with tanning and the leather industry, Hugh murmured 'How much you remind me of your cousins in Falaise.' Henry burst out laughing, and the two were reconciled.

*

Henry's ability to reboot the royal administration, extend royal justice and largely settle the outstanding issues from the civil war earned him the title 'Henry the Peacemaker' from the chronicler of Battle Abbey. The irony was that Henry's greatest battle was to be with the church, particularly over the way that his legal reforms clashed fundamentally with the church's own view that justice flowed from God, rather than the king. As a result, Henry's reforms meant that a showdown between church and state – and, in particular, areas of conflict arising from the operation of ecclesiastical courts separate from the royal ones – was bound to happen at some point, given the king's preference for bringing everything under his control.

Henry had enjoyed fairly harmonious relations with the church at his accession, especially with Archbishop Theobald of Canterbury, who had proved instrumental in brokering a peace between Stephen and Henry in 1153, and even acted as regent on Stephen's death until Henry could travel to England to claim the crown. However, the relatively calm start to Henry's reign masked a much longer dispute that had smouldered away for many years and was about to ignite into a blazing row. Behind the friendly façade lay a growing assertion by the Church of Rome that it should be the driving force behind Western society. In particular, the pope cited the donation of Constantine as the moral justification for leading Christendom against the ideological challenge posed by the Muslim forces that

had overrun large parts of the former Roman Empire. Equally, canon law was emerging to challenge the growing regularisation of secular law. Thus the pope continued to claim primacy over the Holy Land and Byzantine Empire, even though the schism with the Eastern Orthodox Church was over a century old. William II and Henry I had both resisted papal demands for primacy in the appointment of bishops during the Investiture Controversy, with the matter eventually being resolved in favour of the church to the detriment of royal power. The influence of Bishop Henry of Winchester over Stephen's early reign clearly raised expectations that the church would continue to enjoy a prominent role in the government of the realm, and probably lay behind Theobald's promotion of Becket's talents to Henry when he was casting his eye around for a chancellor.

However, it was clear that Becket was not going to adopt his former master's policies, and instead embraced the demands of his new role – which meant assisting Henry to recover authority and, in doing so, frame the systems of centralised government that included the judicial primacy of the royal courts outlined above. One issue in particular caused growing tension between church and state – criminous clerks. The main bone of contention was that clergy accused of a serious criminal offence could be tried in an ecclesiastical court, a privilege that was often liberally interpreted and extended to include anyone who mumbled a few words of Latin on the grounds that they had received clerical training. The king and his justices believed that punishments meted out in a church court were too lenient. Usually the convicted criminal was stripped of clerical status and defrocked, whereas a similar conviction in a lay court might bring a sentence of outlawry, mutilation or death. Furthermore, anyone tried in an ecclesiastical court enjoyed an associated right of appeal to the pope in Rome, similar today to appeals on verdicts in British courts to their counterparts in Europe – something that also irked the king's desire to bring all judicial

matters under his control. This does appear to have been a serious matter; William of Newburgh records that,

> The judges informed the king, busy enough with the care of the realm and with ordering evildoers to be banished without fear or favour, that many offences against public order, namely theft, rapine, and homicide were very often committed by clerks, whom the vigorous arm of the secular jurisdiction could not reach. Finally, it was declared in the king's hearing that more than a hundred murders had been committed by clerks within the borders of England during his reign.

The fundamental question was which jurisdiction should prevail? Signs of tension over this issue appeared quite early in Henry's reign. The English Pope Adrian IV wrote to Theobald in 1156, commenting,

> It has come to our notice by common report that the right of appeal is so smothered by you and the king of England that no one dares to appeal to the Apostolic See in your presence or his ... In addition, you are in every way lukewarm and remiss in dispensing justice to those who suffer injustice, and you are said to seek the king's favour so much and succumb to fear of him that, when we send letters to you on behalf of any one that he may have justice, he cannot secure his right through you, as we have heard from the complaints of many.

Although Henry and Theobald did not publicly fall out, the king did turn his wrath towards Theobald's personal secretary, the theologian John of Salisbury, who was a friend of Becket's from their time at Canterbury. However, this personal connection could not save John from royal displeasure in 1156 after he had returned from one of his frequent diplomatic missions to Rome,

earning the suspicion of the king – thanks in part to a report sent back by Bishop Arnulf of Lisieux, who had commented on the close relationship between John and Adrian IV. John complained bitterly that,

> I alone in all the realm am accused of diminishing the royal dignity ... if any among us invokes the name of Rome, they say it is my doing. If the English Church ventures to claim even the shadow of liberty in making elections or in the trial of ecclesiastical causes, it is imputed to me, as if I were the only person to instruct the lord of Canterbury and the other bishops what they ought to do.

This was a clear warning to Theobald about the king's intentions, and the archbishop was rightly nervous. Nevertheless, Henry was quite prepared to take the opportunity to work together directly with the pope when they shared the same ideological aims – the reason for John's mission to Rome was to bring back the bull *Laudabiliter*, which gave authority for Henry II to conquer Ireland with the express intent of bringing the semi-autonomous church in Ireland under papal authority. After Adrian's death in 1159 a papal schism ensued, with Alexander III elected by the majority of cardinals but the remainder choosing Victor IV, the preferred candidate of the Holy Roman Emperor Frederick Barbarossa. Henry sided with Alexander, boosting the pope's position at a critical time but also giving Henry some future leverage in return. Henry's growing confidence can be felt at an ecclesiastical council convened in England in June 1160, to the point where Theobald commented, 'On the issue before us we gave no definite judgment, since that was not permitted; nor did we make any decision to the prejudice of the king's majesty, for that would have been wrong.'

By this stage Theobald was a frail old man, suffering from a long illness doubtless exacerbated by his fear of the king; his death on 18 April 1161 presented Henry with an opportunity to extend

further his growing influence over the church. It was perhaps logical that the king would press the claims of his chancellor, given their close friendship and Henry's assumption that Becket not only understood the royal agenda, but also would actively promote it in his new position. Becket was not the only option – Gilbert Foliot, the bishop of Hereford, was perhaps the stronger and indeed most obvious candidate for the vacancy; he certainly was the only person to oppose the king's choice when Becket was formally elected on 23 May 1162, observing with heavy sarcasm that Henry had performed a miracle in turning a layman and knight into an archbishop – a pointed criticism of Becket's embrace of secular life as chancellor. It is perhaps ironic therefore that Foliot was urged by Becket to accept the king's offer of the bishopric of London in 1163 and became one of Henry's chief supporters amongst the clergy; whereas Becket astounded and angered the king by resigning the chancellorship, became ordained as a priest on 2 June, the day before his consecration as archbishop, and steadfastly placed himself as a barrier to the king's attempts to control the church.

The first sign of the trouble ahead emerged at a council held in July 1163 at the king's hunting lodge at Woodstock. A disagreement broke out between Henry and Becket during a discussion about customary payments made to the county sheriffs, and the king's plan to have them accounted for separately at the exchequer, therefore boosting his own revenue rather than seeing the money disappear into the pockets of his officials. Becket was opposed to the idea, and challenged the king. Henry was furious. 'By the eyes of God, it shall be given as revenue and inscribed in the king's scroll; nor is it seemly for you to gainsay me, when no one would vex your men against your will.' Becket retorted, 'By the reverence of those eyes by which you have sworn, my lord king, not a penny shall be given from all my land or from the jurisdiction of the Church.'

Henry fell silent, realising that something fundamental in their relationship had changed; there may have been similar frank

discussions about secular matters prior to Becket's elevation to Canterbury, laughed off afterwards during a bout of hunting, but no longer. This heated exchange, just weeks after Becket's consecration, drove Henry to redouble his efforts to resolve the situation over criminous clerks; he was riled that Becket thought he could still meddle in royal affairs, and yet insist that Henry's justices should not lay their hands on any cleric accused of a criminal offence. Accordingly, a royal council was summoned to meet at Westminster on 1 October 1163 to settle the vexed issue. By all accounts it was a tumultuous affair, with a palpable sense of tension at the start of proceedings turning quickly to rancour and acrimony, as Becket and his bishops repeatedly refused to bow to the king's demands. Henry came straight to the point, and demanded that criminous clerks should be handed to royal officials for secular punishment – noting that this would be a strong deterrent to prevent repeat offending.

The archbishop withdrew and consulted with his bishops, and then 'made an excellent and convincing answer at some length in a plea for the liberty of the clergy in accordance with the canonical rule of the ancient fathers'. This opposition only served to anger Henry more; seeing this as a direct challenge to his authority, he 'demanded whether they would observe his royal customs. Whereupon the archbishop, after consultation with his brethren, said that he and they would observe them, *saving their order.*' Henry then asked each bishop the same question, and each time he received the same formulaic response. The king was unimpressed, growling 'that poison lurked in the phrase *saving their order*'. In this sense, Henry was right and Becket would not budge from the technical loophole he thought he had found, confirming that the clergy should swear fealty to the king solely for their lay possessions, and would follow royal custom for those alone; church property, church courts, and church men were the preserve of God, the pope and the archbishop – a clear 'hands off'. However, Henry interpreted

this as a major slight to his royal dignity. As the two men glared at each other in the dimly lit room in the palace, Henry's patience snapped and he stormed out of the hall without a formal farewell, clearly enraged. Nervously, the bishops returned to their lodgings and waited to see what the next day would bring.

The friendship between the king and his former chancellor was at an end, in the most public way. When the council reassembled in the morning, Henry made sure that everyone knew that Becket no longer enjoyed his favour, demanding the return of the castles and honours which the archbishop had held from him in the time of his chancellorship. Once again, without acknowledging the presence of the other bishops and prelates, the king left the council and returned to London. Henry took a few days to calm down, and when he was in a more positive frame of mind, he summoned Becket to a private meeting at Northampton to explore whether there was the chance they could still reach an agreement. Because the town was full of the king's men, and the archbishop had brought a large entourage with him, the meeting had to take place in a field. Any remaining shred of ceremonial dignity was removed from the occasion when, facing one another with their principal supporters behind them, both men were forced to change horses as their original mounts bucked and reared, perhaps reacting to the tense atmosphere. Feelings were still running high, and their exchange reveals just how personally Henry had taken Becket's refusal to do his bidding, viewing it as a betrayal of the loyalty the king had shown the archbishop earlier in his career.

'Have I not raised you from a poor and lowly station of honour and rank?' said the king:

> It seemed but a small thing to me unless I made you father of the kingdom and even preferred you to myself. How comes it then that so many benefits, so many proofs of my love for you, well known to all, have so soon been obliterated

from your mind, that you are now not only ungrateful but oppose me in everything?

The archbishop replied,

Far be it from me, my lord. I am not unmindful of the favours which, not you alone, but God who dispenses all things has condescended to confer on me through you; wherefore, far be it from me to show myself ungrateful or to act contrary to your will in anything, so long as it accords with the will of God. Your highness knows how faithful I have been to you, from whom I look but for an earthly reward. How much more then must we do faithful and true service to Almighty God from whom we have received temporal, and hope for eternal benefits! You are indeed my liege lord, but he is both your Lord and mine, to ignore whose will in order to obey yours would be expedient neither for you nor for me. For in the dread Judgment Day we shall both be judged as servants of One Lord, wherein neither of us can answer for the other, and each of us, all excuses being of none avail, will be rewarded according to his deeds. For temporal lords should be obeyed, yet not against God, as said St Peter 'We ought to obey God rather than men.'

The argument grew increasingly bitter, with coded insults flung at each other, as is often the case when two formerly close friends fall out. The king replied, 'I don't want a sermon from you; are you not the son of one of my villeins?' 'In truth', answered the arch-bishop, 'I am not "sprung from royal ancestors"; neither was St Peter, prince of the apostles, on whom the Lord deigned to confer the keys of the kingdom of heaven and the primacy of the whole Church.' 'True,' said the king, 'but he died for his lord.' But the venerable prelate replied, 'And I will die for my Lord when the time

comes.' With these ominous words left hanging in the wind, the parley failed to produce any compromise; Becket refused to retract the qualification 'saving my order' from his declarations of loyalty to the king. Both sides departed even more deeply entrenched in their respective positions.

Despite his anger, Henry remained a cool-headed and wily politician, and on the advice of Bishop Arnulf of Lisieux, he tried a different approach. The king spoke individually to the bishops, and persuaded them in turn to abandon Becket, leaving the archbishop isolated. This was not as difficult as it should have been; many were so frustrated with Becket's obstinate stance that they were prepared to concede ground to the king, rather than risk further disruption to the church. Even more importantly, Henry was a powerful figure on the European stage and called in all his favours at the papal curia. The king secured a visit from an envoy from Pope Alexander III to upbraid Becket for disturbing the peace of the English church. It was made clear to the archbishop that all would be well if he simply withdrew his qualification from the promise of loyalty and homage to the king. Realising he had been outmanoeuvred, Becket agreed to meet Henry at Woodstock in December. There was a partial reconciliation; the archbishop conceded that 'You should know that I will observe the customs of the kingdom in good faith, and in other respects I will be totally obedient to you in all things as is decent and just.'

Henry wanted more. Because Becket's original objections had taken place in such a public manner, the king wanted to summon another council 'so that in the presence and hearing of all this speech should be repeated for my honour' – essentially he wanted an equally public climb-down by the archbishop. The great and the good of the land duly assembled at Clarendon in January 1164 at the appointed time, no doubt wondering what drama would unfold but nevertheless secretly glad to have ringside seats at another political spectacle. The atmosphere was far more volatile than before, with

the lay magnates growing in their hostility towards the prelates as discussions dragged on into a third day. The cause of the prolonged debate was the revelation that Henry had intended to go much further than simply obtain a verbal agreement from the archbishop to remove the qualification 'subject to my order' – the king's legal team, led by justiciar Richard de Lucy, had been instructed to set down in writing the customs that the clergy were expected to adhere to, and then demanded that the bishops' seals were affixed to the resulting document to show their assent.

The sixteen clauses, known now as the constitution of Clarendon, thus represented a formal codification of the relationship between church and state – a precursor to Henry's legal reforms, and the written practices of the exchequer that were to emerge later in the reign. Unsurprisingly, the terms were heavily in favour of the crown. The issue of criminous clerks was dealt with in the third clause, establishing the principle that clergy convicted in an ecclesiastical court should then be handed over to royal justices. However, Henry's 'customs' attempted to bring the entire church under royal control and severely restrict its relationship with the pope. Clause eight forbade appeals to Rome without the king's consent; clause four prevented any clergy from leaving the country without first seeking approval from the king; clause one required that all disputes about ecclesiastical patronage should be heard in the *curia regis*; and, possibly as a parting shot at Becket given their exchange of words at Northampton, as well as an attempt to stop lower ranks of society from escaping the feudal system for the church, the last clause noted that 'sons of villeins ought not be ordained without the consent of the lord on whose land they are known to have been born' – a subtle dig at Becket's own ordination.

Set out in writing, with the full implications clear for all to see, the extent of the customs caused further consternation amongst the clergy who were present – though much of their ire was focused on

Becket, whom they blamed for escalating the dispute into a crisis with dire consequences for the independence of the church. Unable to find a way out, Becket agreed to the constitutions in principle, though he played for time before agreeing to set his seal to them.

Bishop Gilbert of London recalled the matter somewhat differently and, in a scathing letter written after Clarendon, blamed Becket entirely for capitulating in the face of the military threat of the magnates and betraying the interests of the church.

> For three whole days, the point was to obtain from us a promise to observe unconditionally the king's privileges and customs. We stood by you then, because we thought you were standing boldly in the spirit of the Lord. We stood immovable and were not terrified. We stood firm, to the ruin of our fortunes, to encounter bodily torment or exile, or, if God should so please, the sword. What could be more unanimous than we? We were all shut up in one chamber, and on the third day the princes and nobles of the kingdom, waxing hot in their wrath, burst into the chamber where we sat, muttering and clamouring, threw back their cloaks and shook their fists at us, exclaiming 'Listen, you who set at nought the statutes of the realm and heed not the king's commands, these hands, these arms, these bodies of ours are not our own, but belong to our lord the king, and they are ready at his nod to avenge every wrong done to him and to work his will, whatever it may be. Whatever his commands deriving from his will alone, will be just to us; think again, and incline your thoughts to his command, so as to avert the danger while there is still time.
>
> What was the result of this? Did anyone flee? Did anyone turn tail? Was anyone's spirit broken? Let the truth be told, let the light of day be shed on what then happened in the presence of us all. It was the general of our army

who deserted, the captain of our camp who fled: our lord of Canterbury who parted with the company and counsel of his brethren, and deliberating apart for a while, returned to tell us, 'It is the Lord's will that I forswear myself, submit for the present and take a false oath, to do penance for it, hereafter as I may.' We were thunderstruck when we heard it, clinging to each other in astonishment ... When the head is faint, the other limbs faint also, drooping from the same weakness. Our lord of Canterbury himself acquiesced in the royal prerogatives and the ancient customs of the realm, and in their being reduced to writing, and when he had unconditionally sworn to our lord the king faithfully to observe them in the word of truth, he obliged us by force to bind ourselves by a similar pledge of obedience ...

Almost immediately after the meeting at Clarendon had broken up, Becket duly recanted and reneged on his promise, further playing into the king's hands as it made it easier to portray him as both obstinate and untrustworthy – an oath-breaker. In Henry's own words, the kingdom was no longer big enough for both of them and he set about orchestrating Becket's resignation or removal. In September 1164, a routine appeal to the king from the archbishop's court was used as a pretext for summoning Becket to explain the circumstances; when he failed to appear in person, Henry interpreted this as contempt of court and arraigned him to appear before a royal council, which was held at Northampton castle on 6 October, to explain his actions. Becket put forward an argument for his defence, but it was rejected the next day and he was found guilty, with a sentence of forfeiture of his lay possessions demanded by the king.

Yet, while there was agreement about Becket's guilt on the charge of contempt of court, there was a great deal of uneasiness about the motivation behind the trial and a general reluctance to

pass sentence on the holder of the highest ecclesiastical office in the land. The lay magnates tried to pass the buck for the pronouncement of the sentence to the bishops, claiming that Becket was one of their order; but the bishops washed their hands of the matter, stating that the case was heard in a secular court on a secular charge, and therefore responsibility did not lie with them. However, Henry was not finished with the archbishop; contempt of court was just the beginning. The king had been busy working with his team of officials in the exchequer to examine Becket's financial affairs during the period in which he held the position of chancellor, sniffing around for evidence of malpractice. Later that same day, Becket was summoned again, and asked to account for £300 that he had received as keeper of the castles of Eye and Berkhamsted. He claimed he had used the money on the king's business to repair the Tower of London as well as the castles in question, but did not have the documentary evidence with him to avoid a quarrel; instead, he offered to pay it back. However, the earlier forfeiture meant Becket was unable to do so, and had to find sureties from the assembled nobles who would make good the debt. The third day of the council dawned with further requests to account for a loan of 500 marks relating to Henry's campaign in Toulouse in 1159; 500 marks borrowed from a Jewish moneylender, with the king having acted as surety for him; and all the revenues received from vacant ecclesiastical possessions that he had held. Henry's plan was clear – an incessant stream of demands that Becket would be unable to answer, pushing him further and further into the king's debt, ratcheting up the pressure on the archbishop, backing him into a corner where the only option was to resign.

Becket asked to withdraw so he could seek advice from his bishops, and spent the whole of the fourth and fifth days locked in crisis meetings with them to see if there was any way out of the trap that had sprung shut around him. Bishop Henry of Winchester made discreet enquiries to see if Henry would accept a cash

settlement, with a sum of 2,000 marks suggested. The king refused point-blank – he was not after money, but the total destruction and humiliation of his former friend. Bishop Hilary of Chichester gave Becket the clearest indication that the king's preferred outcome:

> ... would [be] that you cease to be archbishop and remain plain Thomas. The king is reported to have said that the two of you could no longer remain together in England, he as king and you as archbishop. It were safe to leave everything to his mercy, lest perchance (which God forbid) he detain you without sureties on a charge of embezzlement of the moneys you received from him as chancellor and auditor of accounts, or lay hands upon you; whence would accrue sorrow to the English church and shame to the realm.

It might have been these words, or the full understanding of what Henry was capable of when roused to anger, or the intimate knowledge of how Henry's new administrative machine would work against him, that finally made Becket understand the peril of his position. He claimed to be seriously ill and did not appear the next day, retiring to his bed. On hearing this news, the king seized on the archbishop's apparent weakness to press home his advantage, and summoned him to answer the charges in full. However, Becket had been using the time to prepare himself for a final showdown with Henry. On 12 October, the seventh day of the council, Becket celebrated mass at the altar of St Stephen, the first martyr – an inflammatory gesture made worse by the fact he insisted on parading to the council chamber in the castle, brandishing his cross in front of him as though it were a weapon. Hugh of Nunant, archdeacon of Lisieux, turned to Gilbert Foliot, bishop of London, and asked in astonishment, 'My lord bishop of London, why do you suffer him to carry his cross?' The bishop answered, 'My good man, he was always a fool and always will be';

at least Becket's clerks had dissuaded him from attending in his mass vestments.

However, there was no final face-to-face showdown between the king and the archbishop. Henry held his council in an upper chamber, and Becket waited serenely in a room on the floor below, with a few of his household staff to accompany him and guarded by the king's marshals; barons and bishops passed between the two men in an increasingly frantic attempt at shuttle diplomacy to broker a resolution to the crisis. However, Becket became more dogmatic and provocative in his answers; he admonished the bishops for judging him to have been in contempt of court in a secular council, and revealed that he had appealed to the pope on those grounds – an appeal that was a direct infringement of the new constitutions of Clarendon, and virtually an act of treason. Having ascertained that Becket stood by his appeal to Rome, and amidst scenes of growing confusion, Henry urged the gathered court to pass further judgment.

The bishops were now caught in a terrible dilemma, forced to choose between a furious king and a steadfast archbishop: a temporal master or a spiritual one. Despite further calls for him to resign, Becket refused to budge from his position, forcing the bishops into a dreadful compromise – they made a bargain with the king that if they were to be excused judgment now, they would collectively appeal to Rome against Becket and seek his deposition. Thinking that this would utterly humiliate the recalcitrant archbishop, Henry agreed and the bishops left. Once they had departed, the remainder of the court were asked by the king to provide their verdict. Yet, as on the first day of the trial, there was a reluctance to do so, with the barons showing a real uneasiness that they were being asked to be complicit in something underhand – more akin to the duplicity of Stephen. The co-justiciar Robert de Beaumont was ordered to go down and tell Becket that he had been found guilty, but he first tried to duck the task and then, when in the presence of

the archbishop and surrounded by his peers, he tried to defer the verdict by embarking on a long-winded recital of all the events that had happened since Clarendon. Becket interrupted him:

> What is this which you would do? Have you come to judge me? You have no right to do so. Judgment is a sentence given after trial. This day I have said nothing in the way of pleading. For no suit have I been summoned hither . . . With respect to this you cannot give sentence. Such as I am, I am your father; you are magnates of the household, lay powers, secular personages. I will not hear your judgment.

Becket stormed out of the castle, his cross clasped before him, and returned to his lodgings at the nearby monastery of St Andrews, where later that night he begged the king's permission to withdraw from proceedings. Henry said he would give an answer in the morning. However, fearing the worst, Becket fled.

What had started out as a trial of strength between two former friends, masked by a wider constitutional attempt to set out the relationship between church and state, quickly escalated into a major international incident. Becket reached the coast and caught a ship to the continent, where he sought refuge with the king of France – Louis initially refused to offer support, given the toxic nature of the dispute, but soon changed his mind when he saw the discomfort it caused his rival. Henry also sent envoys to the pope, but Alexander deferred his decision until he had heard from Becket. He did not have to wait long; a few days later, the archbishop appeared and – with all the theatrical skill he could muster – threw himself at the pope's feet, held out the constitutions of Clarendon and, on the grounds that he had not been properly elected, returned his archiepiscopal ring. In a voice shaking with emotion, Becket said:

> Recognising that my appointment was far from canonical,
> dreading lest the consequences should prove the worse for
> me, realising that my strength is unequal to the burden,
> and fearing lest I should involve in my own ruin the flock
> to which, such as I am, I was given as shepherd, I resign
> into your hands, father, the archbishopric of Canterbury.

Alexander, moved by the show of humility, returned the ring to
the sobbing archbishop and thus confirmed his appointment. With
Becket enjoying the protection of both the king of France and the
pope, Henry escalated the conflict further, becoming embroiled in
1165 with imperial politics in an attempt to destabilise Alexander's
position, especially at a time when a new anti-pope, Paschal III,
was elected. In return, Alexander upbraided the English bishops
for sitting in judgment on their master and declared the sentence
of forfeiture passed at Northampton to be invalid, since Becket's
possessions belonged to the church. Yet, with his own position
under threat and perhaps beginning to regret his impulsive gesture
in handing Canterbury back to Becket, Alexander sought a
diplomatic solution. He wrote to the archbishop in June 1165 urging
him to act with a bit more common sense and restraint.

Alexander had begun to recognise that Becket was, in every sense
of the word, a loose cannon and told him in no uncertain terms to
stop stirring the pot before next spring, thus giving the pope some
breathing space to continue his exploration of the diplomatic options,
as well as shore up his own political standing. Having allowed some
time to elapse in order to take the heat out of the situation, Alexander
made Becket his papal legate to England on 2 May 1166, hoping
to bolster the archbishop's position and provide some additional
protection should Henry agree to his return. Yet the plan backfired,
spectacularly. An emboldened Becket acted as though his new status
released him from the pope's shackles, and he fired off a string of
ill-judged and increasingly threatening letters to Henry, such as this

one in late May: 'Permit us to return freely and in peace and in all security to our see, there to perform the duties of our office as we ought, and right commands . . . Otherwise you may know for certain that you will experience the divine severity and vengeance.'

With no response forthcoming, Becket deployed the medieval equivalent of the nuclear option – on 12 June he excommunicated many of the king's closest officials who, he claimed, had unjustly seized property from his see at Canterbury; this included former colleagues and senior figures in Henry's administration in England, the justiciar Richard de Lucy and chief forester Alan de Neville. Henry summoned a council on 24 June to consider his response, sending written appeals by the English bishops against the excommunications as well as upping the ante diplomatically by renewing his threat to abandon Alexander. There can be no doubt that Henry was seething with rage:

> The king complained exceedingly of the archbishop of Canterbury with sighs and groans; as those who were present afterwards reported, he declared with tears that the archbishop would take from him both body and soul. Finally he said they were all traitors who could not summon up the zeal and loyalty to rid him of the harassment of one man.

These were strong words – a typically passionate response from Henry when roused to anger, but words that would be recalled later when events took a tragic turn in 1170. However, wise heads were present and the bishop of Rouen quietly chided the king for his intemperate comments, and Henry soon simmered down.

1167 dawned with a promise by the pope to send a legation to England to consider the case for Becket's deposition, giving Henry some hope that he had won the argument; but the cardinals had actually been given instructions to broker a compromise, which the king angrily rejected. Thus the stalemate was renewed throughout 1168, until an opportunity arose early in 1169 as part of a complex

series of peace negotiations at Montmirail between Henry and Louis to settle a long-running dispute. The conference expanded to include a delegation from the Holy Roman Emperor, hoping also to broker peace with the papacy and thus end years of enmity. With a spirit of compromise in the air, it was a golden opportunity for a reconciliation between king and archbishop; mediators worked hard with Becket to persuade him to swear allegiance publicly to the king without any qualification, so that he could return peaceably to England. In front of the assembled powers of Europe, Becket approached Henry and Louis, and knelt at the English king's feet to make his peace. 'On the whole matter which is between us, my lord king, I throw myself on your mercy and on your pleasure, here in the presence of our lord the king of France and of the archbishops, princes and others who stand between us.' Then, after a dramatic pause, he added deliberately: 'Saving the honour of my God.' Incandescent with rage, yet with the crumb of comfort that there were at least witnesses to the intransigence that he had been forced to deal with through the long years of the dispute, Henry turned to Louis and yelled: 'Observe, if you please, my lord, whatever his lordship of Canterbury disapproves, he will say is contrary to God's honour, and so will he always have the advantage of me.'

Uproar ensued, with Becket's sponsor Louis berating the unrepentant archbishop for this insult, whilst the assembled French and English barons hurled abuse as Becket serenely returned to his place. The proceedings ended in chaos, ushering a new round of excommunications by Becket on 13 April 1169, including that of the bishop of London, accompanied by the ultimate threat of papal interdict throughout all Henry's realms. Henry retaliated by adopting an even more radical new approach. He issued his own decrees demanding the entire male population over the age of fifteen swear an oath that they would not carry out or obey any papal sentences of excommunication; anyone bearing letters from the pope or Becket would be imprisoned; clergy observing

any sentence of interdict would be expelled; and all clergy who had gone overseas should return at once, or lose their revenues. In short, Henry had removed England from papal authority with his own form of schism.

With the conflict escalating even further out of control, and the king desperate to crown his eldest son Henry in the Carolingian tradition, another attempt was made to bring the two stubborn men together at a conference at Montmartre on 18 November 1169 in the presence of the king of France and the archbishop of Rouen. However, neither party seemed keen on the idea. Becket requested the kiss of peace from the king as a token of his goodwill, but Henry refused with the rather lame excuse that he had previously sworn in public not to do so, and would not now break his oath. As before, the conference broke up in acrimony. Henry then hatched a plan to humiliate Becket further. Although it was the established tradition that the archbishop of Canterbury should perform the coronation of a king, Henry claimed to have letters from Alexander – doubtless secured early in his papal reign when he was grateful for Henry's support – that permitted any prelate of the king's choosing to place the crown on the young Henry's head. Therefore on 14 June 1170, in defiance of papal orders, a solemn ceremony was held at Westminster Abbey and the archbishop of York crowned Henry's son – the only time in English history that an heir was recognised as king during his father's lifetime.

Alexander was furious that Henry had interfered with the rights of the church, and gave Becket the authority to place England under interdict or issue further sentences of excommunication. Yet Henry's assault on the ancient dignity of Canterbury had also wounded Becket deeply; no one could doubt his genuine desire to defend the rights of his church. Therefore both sides were more amenable to a negotiated resolution when they met at Fréteval on 22 July 1170. Echoing the failed attempts at reconciliation at Northampton, the two men met 'in a verdant meadow which . . .

was from ancient times called by the inhabitants "Traitor's Field", midway between the castles of Fréteval and Viefui near Touraine'.

We have several eyewitness accounts of what happened, although no one was close enough to hear what words passed between the two proud men. The king and the archbishop turned their horses away from their attendants so that they could converse together in private. High on Becket's agenda was permission from the king to punish by ecclesiastical censure any of the bishops who had acted with the archbishop of York in the coronation of the young king, seeing this as a grievous injury to both his own status and that of the primacy of Canterbury. With great reservation, Henry gave his assent; and, in gratitude for this concession, Becket immediately dismounted from his horse and humbly prostrated himself at the king's feet in submission. Catching the spirit of reconciliation, Henry then astonished the onlookers by holding the stirrup of Becket's horse as he was about to remount, an act normally performed by a groom and thus symbolic of great humility.

After the public show of friendship, the details were thrashed out. Henry agreed that Becket could re-crown his son, and all property seized from Canterbury would be restored; the constitutions of Clarendon were not mentioned, and Henry doubtless hoped that Becket would now demonstrate some common sense and not disturb the fragile peace that had broken out. The details behind these broad agreements took time to finalise, so it was not until December that Becket finally returned to England, whilst Henry remained on the continent to deal with his own affairs, interrupted by a bout of ill health. All seemed well, but Becket was determined to exact revenge on his tormenters within the church and excommunicated the bishops involved with the coronation of the young Henry – technically within the terms that he had agreed at Fréteval, but nonetheless further evidence (if any were needed after six long years) of his single-minded determination to do what was best for his own dignity and office, regardless of the damage such thoughtless actions

would cause. The excommunicated bishops travelled to France, where they caught up with the king at Bures as he was preparing to celebrate Christmas, and relayed to him what had happened. The king asked the bishops for their advice, and the archbishop of York replied, 'Seek advice from your barons and your knights; it is not for us to say what should be done.' A voice eventually piped up with the advice that 'My lord, while Thomas lives, you will not have peace or quiet or see good days.' According to accounts,

> At this, such fury, such bitterness and passion against the archbishop took possession of the king that they appeared on his countenance and in his gestures. Perceiving his emotion and eager to win his favour, four knights of his household, Reginald FitzUrse, William de Traci, Hugh of Morvile and Richard Brito, so it was said, to encompass the death of the archbishop, quitted his court.

Quite what words Henry uttered is hard to uncover – there is no evidence that he ever said the line usually attributed to him: 'Who will rid me of this turbulent priest?' but he clearly made some angry comment to this effect. According to one source he shouted: 'What idle and miserable men I have encouraged and promoted in my kingdom, faithless to their lord, who let me be mocked by this low-born clerk.' However, unlike his rant in 1166 at the royal council, this time there was no one to calm the king down and his words were taken at face value; the aforementioned knights took matters into their own hands and left for England, without any clear plan of what they would do. Even at the last, they tried to arrest Becket with the hope of taking him to the king in France, or force him into exile, rather than murder him. As we have seen, Becket was prepared for martyrdom and, in resisting arrest, was hacked to death by the altar of Canterbury cathedral on 29 December 1170.

The atrocity caused shockwaves around Europe, with everyone waiting for the reaction of the pope. However, Alexander's hand

was initially stayed because of genuine fears that Henry, overcome with grief, might follow his former friend turned bitter adversary to the grave:

> The king burst into loud lamentations and exchanged his royal robes for sackcloth and ashes, behaving more like the friend rather than the sovereign of the dead man. At times he fell into a stupor, after which he would utter groans and cries louder and more bitter than before. For three whole days, he remained shut up in his chamber, and would neither take food nor admit anyone to comfort him, until it seemed from the excess of his grief that he had determined to contrive his own death. The state of affairs was lamentable and the reason for our grief and anxiety was now changed. First we had to bewail the death of the archbishop; now, in consequence we began to despair of the life of the king, and so by the death of the one we feared in our misery we might lose both.

On initially hearing the news, Alexander had reacted with horror and broke off all contact with England, or indeed anyone who was English – doubtless the baying of French envoys for vengeance played a part in his withdrawal from all negotiations with delegates, hastily despatched by Henry to the papal curia, for over a week. It took until after Easter 1171 before the pope finally announced his punishment – excommunication for the murderers, an interdict on Henry's continental lands, and confirmation of Becket's excommunication of the bishops. However, Henry himself was not excommunicated – just prohibited from entering a church in person until Alexander's legates could establish 'whether the king was truly humbled'.

Many thought Henry had escaped lightly; it took until 17 May 1172 before discussions could start at Savigny to produce the final papal sanctions that Henry submitted to at Avranches four days

later. The king swore that he had not directly ordered or wished Becket's death; he also agreed to go on crusade for three years as penance, providing 200 knights at his own cost. Alexander used the opportunity to strike at the heart of the original dispute, the constitutions of Clarendon, writing that,

> You shall neither impede appeals in ecclesiastical causes to the Roman Church, nor allow them to be impeded, but they are to be made freely, in good faith, without fraud and trickery, so that the Roman pontiff may freely consider and terminate such cases; but in such a way that if any [appellants] are suspect to you, they shall give security that they are not seeking injury to you or your realm ... You shall utterly abrogate the customs that were introduced against the churches of your lands during your time, nor shall you exact them further from the bishops.

Henry's struggle for supremacy over the church was at an end, and a fundamental principle – that the pope was the ultimate ecclesiastical authority in England – had been established that would not be challenged until Henry VIII began his divorce proceedings in the early sixteenth century. Despite all his success in re-establishing royal authority throughout secular society in England, Henry's prestige and reputation on the international stage were heavily tarnished by Becket's murder and the increasingly bitter struggle with the papacy. This came at a time when Louis of France was increasing pressure on his over-mighty vassal; his reaction was particularly forthright:

> The man who commits violence against his mother [church] revolts against humanity ... Such unprecedented cruelty demands unprecedented retribution. Let the sword of St Peter be unleashed to avenge the martyr of Canterbury.

The strong language was echoed elsewhere by Louis's allies, such as the house of Blois – now closely aligned to the king of France by marriage. Count Theobald V wrote that,

> These dogs of the court, these retainers and intimates of the king of England have shown themselves true ministers of his will, and have grievously shed innocent blood . . . To you the blood of that righteous man cries out for revenge. . . May Almighty God grant you the will to avenge him and the means of achieving it, so that the Church, distraught at the magnitude of so unparalleled a crime, may have reason to rejoice at the punishment of it.

Theobald's brother William, the bishop of Sens, went further, proclaiming that,

> For of all the crimes we have ever read or heard of, this easily takes first place – exceeding all the wickedness of Nero, the perfidy of Julian, and even the sacrilegious treachery of Judas.

As a result, those who had been waiting to use the king's humiliation to dismantle his possessions thought that the pope had treated Henry fairly leniently; and Henry might have been forgiven for thinking that, as 1173 dawned, he had weathered the storm and the worst was behind him. However, he could not have been more wrong. The greatest crisis of his reign would break within months, and it came from none of these obvious sources of enmity. Instead, Henry's own family rose up in a great rebellion against his rule.

3

A family at war

On his legitimate children he lavished in their childhood
more than a father's affection, but in their more
advanced years he looked askance at them after the
manner of a stepfather; and although his sons were so
renowned and illustrious he pursued his successors with
a hatred which perhaps they deserved, but which none
the less impaired his own happiness . . . Whether by
some breach of the marriage tie or as a punishment for
some crime of the parent, it befell that there was never
true affection felt by the father towards his sons, nor by
the sons towards their father, nor harmony between the
brothers themselves.

GERALD OF WALES

It was nightfall at the palace of Westminster on 17 July 1174. The
king was resting in his chambers, suffering from both physical and
mental exhaustion. For over a year he had fought against a powerful
coalition of enemies on the continent led by the king of France
and the count of Flanders, brought together in an ultimate act of
treachery by the machinations of his wife Eleanor and eldest son,
Henry 'the young king', as they sought to overthrow him. Henry
had finally been able to return to England ten days earlier, battling
fierce gales to make landfall at Southampton. His presence was
urgently needed to suppress an uprising amongst his most unruly
barons, led by an old adversary, Hugh Bigod; Bigod's grudge
against Henry had been simmering away for nearly two decades.
The king first dashed to Canterbury, where he made a public display

of humility at the tomb of Thomas Becket, scourged with whips as penance for the role he had played in his former friend's death. Now, weary from his long journey back to London, Henry had gone to his room, where a servant rubbed his sore feet as he dozed in bed.

Suddenly, the guards at the palace gate were disturbed by the arrival of a rider, with clothes stained with grime from a long journey. He reined in his horse and wearily dismounted, calling out that he was a messenger called Brien. Explaining that he had ridden hard for three days, barely stopping for food and drink, Brien demanded that he be brought before the king, insisting that he carried an urgent message and important news from the north. Uncertain what to do, the guards escorted him to the door of the room where Henry lay in slumber. The way was barred by the king's chamberlain who, mindful of his master's state of mind, prevented Brien from entering with the cry 'Who are you there?' Brien replied, 'I am a messenger, sent by Lord Ranulph de Glanville in order to speak with the king, for great needs he has of it.' 'Let the business be till the morning.' hissed the chamberlain, trying to stop the conversation from wakening Henry. However, the messenger would not be deterred. 'By my faith! I will speak to him forthwith. My lord has in his heart sorrow and vexation, so let me enter, good chamberlain.' The royal servant was not convinced, fearing his master's wrath: 'I should not dare to do it. The king is asleep; you must withdraw.' However, the noise of the conversation had already disturbed Henry, who hollered angrily from inside the room, 'Who is that, can you tell me?' The chamberlain called back, 'Sire, you shall know directly, it is a messenger from the north, very well you know him, a man of Ranulph de Glanvillle's, his name is Brien.' The king emerged from his room and, having been disturbed from his rest, was clearly not in the best of moods; and now he was further alarmed when he learned the identity of the messenger.

Ushered into the royal chamber, Brien was mindful that he was in the presence of the king, and offered a salute. Despite his tiredness,

Henry was eager for news; he was well aware of the situation in the north of England where William the Lion, king of Scotland, had invaded shortly after Easter, supported by mercenary cavalry and infantry hired from Flanders. The invading forces had captured two royal fortresses at Brough and Appleby, before moving against Carlisle. The frightened citizens had provided assurances that they would surrender to the Scots if no relief came from Henry, allowing William to attack Prudhoe castle on the banks of the Tyne and ravage parts of Northumberland.

Henry's principal supporters in the north had gathered together to repulse the invasion. The sheriff of Yorkshire, Robert de Stuteville, supported by Brien's master Ranulph de Glanville, as well as local lords William de Vesci and Bernard de Balliol, mustered their forces and marched on Prudhoe, arriving on 12 July only to find that William had moved on to assault Alnwick castle. They held a conference at Newcastle to determine what to do next. Henry was unaware of the latest developments, and feared that the sudden arrival of the messenger heralded bad tidings. Growling with anger and pacing around his room, Henry began to bemoan those in whom he had placed his trust to defend the northern border – 'Badly have they served me, so now may they be punished for it!' However, the messenger interrupted the king: 'Sire, hear me a little. Your barons of the north are right good people. The king of Scotland is taken and all his barons!'

The king could not believe this unexpected and wondrous news. 'Do you speak the truth?' Brien replied,

> Yes sire, truly in the morning you will know it; the archbishop of York, a wise, learned man, will send you two private messengers; but I started first, who know the truth, I have hardly slept during the last four days, neither eaten nor drunk, so I am very hungry; but in your kindness, give me a reward for it!

Henry grasped the tired messenger by the shoulders and fixed him with a steely gaze. 'If you have told me the truth, you are rich enough. Is the king of Scotland taken? Tell me the truth!' Indignant that he was being doubted, Brien cried 'Yes sire, by my faith! On a cross may I be crucified, or hanged by a rope, or burnt on a great pile, if tomorrow, before noon, all be not confirmed.' 'Then', said the king, with a broad grin breaking out across his face, 'God be thanked for it, and Saint Thomas the Martyr and all the saints of God!'

Brien was shown to suitable accommodation and given much-needed food, drink and rest at the king's expense. Henry was too delighted to return to sleep, and roused his household knights to share the news that one of his great enemies had fallen into his hands. 'Barons! Wake up. It has been a good night for you. Such a thing have I heard that will make you glad; the king of Scotland is taken! Just now the news came to me, when I ought to have been in bed!' The knights were overjoyed, and cried, 'Now thank the Lord God, now is the war ended, and your kingdom in peace!' As Brien had promised, messengers from the archbishop of York duly arrived the next morning, carrying with them a more detailed account of what had happened.

After their conference at Newcastle – and despite opposition from some of their own number – the northern earls decided to press on towards Alnwick, and set out early the next morning, Saturday 13 July. They travelled at a remarkable speed, bearing in mind they were burdened by weight of arms, covering twenty-four miles in little over five hours. However, they were soon enveloped in a thick fog, which made them pause and reconsider their decision. As they moved forward slowly, the mist cleared and in front of them appeared the castle of Alnwick. To their great surprise, the king of the Scots and around sixty horsemen were on guard in a meadow outside the castle, 'as if in complete security and fearing nothing less than an incursion of our men, while the

hosts of the barbarians together with part of the cavalry were widely dispersed for purposes of plunder', according to William of Newburgh. The Scots were momentarily confused, thinking some of their own number had returned. On realising that the banners were those of the enemy, William the Lion drew his forces around him and prepared for battle. However, the fight did not last long; the king's horse was killed underneath him and he was thrown clear, only to be intercepted and captured. Most of his knights were slain or rounded up. The earls then made their way back to Newcastle the same day with their royal prisoner, and from there he was transferred to Richmond to be kept under close guard until he could be sent south to Henry. Brien was then dispatched to tell the king the good news.

In the bright light of a summer's morning, Henry beamed with joy when he heard the fate that had befallen his enemy. Yet even as he relaxed in the knowledge of victory, he suddenly remembered his conversation with Brien the previous evening. 'Last night I heard the news when I was very irritable; to him who brought it to me a reward shall be given.' After a quick consultation with his exchequer staff working from their offices nearby, Henry ordered a small wooden tally stick to be struck. In the absence of a formal parchment charter prepared by his chancery staff, it noted the personal grant of land worth £10 a year from the grateful king to the messenger who came in the night.

*

The great war of 1173–4 marked Henry's nadir as king, husband and father; yet also represented his greatest triumph, combining military genius with an ability to stay calm in the face of multiple outbreaks of revolt, successfully prioritising his actions when it looked as though all his territories would be swept away by an unprecedented alliance of enemies, and one false move could end in disaster. Although it took a few more months of campaigning

after the capture of William of Scotland to restore peace to all his lands, Henry emerged from a period of unprecedented crisis more powerful than ever, yet mindful that he needed to find a workable solution to provide for the competing demands of his sons, Henry, Richard, Geoffrey and John. Angevin princes were not known to harbour warm family feelings towards one another, and sibling rivalry played a large part in the war against their father. However, at the heart of the dispute lay a festering resentment that Eleanor felt towards her husband – possibly fuelled by the knowledge that his love was reserved for his mistress Rosamund de Clifford, but principally by the fact that Henry had excluded her from any meaningful authority, aside from a few occasions when she was called upon to act as regent during his absence. For a woman who had virtually shared power with her first husband King Louis VII of France, even accompanying him on crusade to the Holy Land at the head of a contingent of soldiers from Aquitaine, this was an unbearable slight on her honour and dignity. The irony of the great rebellion that ripped Henry's family apart was that for the first two decades of his reign he had devoted his energy to creating a system of governance that, by 1169, was publicly geared towards a division of territories between his sons. Indeed, in 1159 Henry compromised his relationship with Louis by undertaking a campaign in defence of his wife's rights in Aquitaine; this was to be a watershed moment, after which an intermittent enmity existed between the kings of England and France that neither could ever quite overcome.

Henry's approach to family is interesting, as he was guilty of abandoning fraternal loyalty for personal gain when he was younger. Once the initial subjugation of England was complete, the main problem facing Henry towards the end of 1155 was the discontent of his disgruntled brother Geoffrey, who continued to spread the story that their father had only granted Anjou to Henry temporarily until the English crown had been placed on his head.

Geoffrey tried to exert pressure on the king of France in an attempt to wrest Anjou from Henry's hands; after all, Louis was still smarting from Henry's coup in marrying Eleanor, and was alarmed by the prospect of one man holding so many territories under his direct control, particularly as the riches of England could be used to bankroll Henry's ambitions on the continent. Supporting Geoffrey's cause would therefore be a natural way to destabilise Louis's over-mighty vassal. Yet to interfere in the Angevin succession would be a declaration of war and spark a conflict that he would probably lose. Therefore, when Henry returned to the continent in early 1156, having brought the English barons to heel far more quickly than anyone might have expected, Louis found it expedient to confirm Henry in all his continental possessions. The two kings met on 5 February 1156 on the border of Normandy, where Henry performed homage for Normandy, Anjou and Aquitaine. Henry then sought out his brother a few days later – an awkward meeting that did not go well; Geoffrey withdrew in anger to his Angevin strongholds, spending money on fortifications in preparation for an armed struggle to regain what he felt was rightfully his. However, if Geoffrey expected to receive widespread support amongst the Angevin nobility, he was mistaken. By the summer, Henry had besieged and captured all Geoffrey's castles and forced his brother to accept an annuity of £1,500, rather than trust him to remain in possession of land. Thus a pattern of behaviour was set that was to be played out in the relationships between Henry's own sons.

Henry's activities in the 1150s and 1160s give us the clearest sense of his vision for the way his lands would be governed, and family was a key motivating force behind his actions. 'Empire' is not the correct word to use to describe the way he perceived his territories – there was to be no centralised administration or 'capital' similar to Rome or Byzantium, let alone a single army, financial system, legal code or sense of common citizenship. Perhaps the best modern equivalent would be the British Commonwealth, a group

of territories ruled by the same nominal head of state but with different internal systems of government.

Henry's first task was to consolidate his position in each territory, as his authority varied from place to place. Having devoted a considerable amount of time creating a system in England that permitted his extended absence, Henry spent much of the early 1160s in Normandy imposing 'direct rule'. During this period, Henry received regular updates from his trusted team of officials in England, and on occasion the co-justiciars would travel to Rouen to provide advice. It is likely that English silver flowed across the Channel as well, giving Henry additional financial security. It was much easier to enforce ducal custom and undertake reform if he was no longer reliant on maintaining the goodwill of local barons because he needed their cash.

At the same time, Henry tried to create a ring of vassal states around his core lands that recognised him as their overlord – Brittany would therefore be subservient to Normandy, likewise Maine to Anjou, Toulouse to Aquitaine, and within the British Isles, the rulers of Wales and Scotland would recognise the overlordship of England. It is perhaps no surprise that Henry's early years were spent in ceaseless travel. Gerald of Wales and Walter Map told stories of a king who never stood still, his restless energy leading him to roam far and wide as he traversed a realm that stretched from the foothills of the Pyrenees in the south, to the borders of Scotland in the north – not quite in the same league as the lands that Charlemagne had brought together in the eighth century – but nevertheless an impressive range of territories that would test the administrative and military powers of a seasoned campaigner, let alone a young man in his early twenties with little previous experience of government. Indeed, Gerald was moved to compare Henry's feats with another young general from antiquity, suggesting that 'our Alexander of the West [you have] stretched out your arms from the Pyrenean mountains to the farthest and most

western borders of the ocean. In these parts you have spread your triumphs as far as nature has spread her lands.'

This was grand rhetoric, but overlooked the fact that all the southernmost territory near the Pyrenees was only in Henry's hands thanks to his marriage to Eleanor; an Angevin ruling in Gascony or Poitou was only slightly less unpalatable than direct rule from Paris had been when Eleanor was married to Louis. It was therefore prudent that Henry was joined by his wife in the autumn of 1156 to accompany him on a tour of Aquitaine, taking the opportunity to eject the viscount of Thouars, one of his brother Geoffrey's supporters, from his lands in Poitou. This was a clear statement of intent with regards to the exercise of the ducal powers that he now claimed as his, as well as a reminder that Henry would not tolerate any further family insurrection against his rule.

Yet, by chance, the opportunity arose both to give Geoffrey a slightly more generous settlement, as well as extend the family's influence in Brittany – an area over which Normandy had a hazy claim of lordship, with the genealogy of the Breton ducal family laced with both Norman and Angevin blood. The two principal seats of power were Rennes and Nantes, the ruler of the latter claiming the title of count; when the citizens deposed the unpopular incumbent, Hoel, in 1156, they appealed to Henry for assistance. Eager to extend Angevin power in the region, as well as secure access to an important seaport at the mouth of the river Loire, Henry agreed – on the condition that his brother Geoffrey was declared count instead. At the same time, one of Henry's vassals, Earl Conan of Richmond, seized Rennes, further bolstering Angevin influence across the region.

When Henry returned to English politics in 1157, his attention shifted to the security of the northern border with Scotland. The old warhorse and staunch supporter of his mother's cause, King David, had died in 1153 to be succeeded by his grandson Malcolm IV. Of particular concern to Henry was the previous

grant of large swathes of northern England to David – the counties of Cumberland, Westmorland and Northumberland, as well as claims to the earldom of Huntingdon; indeed, Henry had sworn to confirm these grants when David knighted him in 1149, should he ever gain the throne. Now the time had come to resolve the issue, and Malcolm was invited to a meeting with Henry in May, at which the king of England appeared in a display of military might. In no uncertain terms, Henry told his royal counterpart that he would not hand over the northern part of his realm – an early example of Henry's growing reputation for 'broken promises' when political expediency required an alternative truth to be forged. Indeed, this tactic of gunboat diplomacy was one that Henry would deploy on many occasions, and it was effective; the king of the Scots 'prudently considering that the king of England had the better of the argument by reason of his greater power' agreed with Henry that the integrity of England should be preserved, and swore homage for Huntingdon alone as a vassal of the king of England.

Next, Henry turned to the west, and in July summoned a council to discuss taking military action against Owain, prince of Gwynedd – one of several Welsh leaders who had refused to acknowledge his authority. The campaign nearly ended in disaster, despite meticulous planning; Henry was caught in an ambush whilst proceeding through marshy yet heavily wooded terrain just outside Flint, and many of his barons were slain. Indeed, the king's own standard-bearer, Henry of Essex, believed his master had also died, and in distress fled from the fighting – causing panic amongst the soldiers that nearly sparked a full-scale retreat. However, Henry had already escaped. He fought his way back to his men, rallied the troops and proceeded far more cautiously thereafter, sending scouts ahead and ensuring that paths were cleared in advance of the main army. Owain sued for peace, and Henry left garrisons behind – not only to check any Welsh incursions, but also to remind the

traditionally powerful and semi-independent earldom of Chester that royal authority was now the supreme power in the area.

With England's borders largely secured, Henry decided to tackle the loss of the strategically important Norman Vexin, which had been conceded to Louis VII by Henry's father Geoffrey in return for legitimising the completion of his invasion of the duchy in 1144, and confirmed when Henry's accession was negotiated in 1151. Whilst still in England, Henry opened negotiations with Louis to find a diplomatic route to recover this lost land – as key to his security in Normandy as the northern counties, recently wrested back from Malcolm, were to the English border. The result was a dynastic union in the form of the betrothal of Henry's son, Henry the younger – not yet four years old – to Louis's infant daughter, Margaret. Her dowry, and Henry's prize, would be the return of the Norman Vexin once the ceremony had been performed at some future date. In the meantime, the lands would be entrusted to the care of the Knights Templar. The union of the two most powerful families in France was a major event in European politics. Louis's continued failure to produce a son was beginning to a turn into a succession crisis that the Capetian royal house had not faced for several generations, and awakened the possibility that a male child of the proposed marriage might, one day, inherit all.

In contrast, Henry's marriage to Eleanor had produced an abundance of children including many sons – the first arrival was William in 1153 (who died three years later), then Henry the younger born in 1155, his first daughter Matilda in 1156, Richard in 1157 and Geoffrey in 1158. After a gap of a few years, Eleanor followed in 1161 and finally John, born in 1166. This brood of offspring represented the makings of a powerful dynasty – plenty of sons to ensure the succession plus two daughters who could be used to secure important marriage alliances. Although the Angevins held vast swathes of land and a crown of their own, the Capetians held the royal title that mattered most in the growing rivalry

between the two families – king of the Franks, and therefore the direct successor to Charlemagne. Not to be outdone, Henry was keen to underline the financial might of the new Angevin territorial bloc. In a show of one-upmanship, Henry's chancellor, Becket, was dispatched to France in the summer of 1158 to conduct further negotiations for the betrothal of the young Henry and Margaret with a magnificent display of riches – a job perfectly suited to the peacock personality of the proud clerk turned royal administrator, who was still revelling in his new-found wealth and status.

No expense was spared in an attempt to impress the residents of Paris as Becket entered the capital of the Île de France, where the talks would take place – 250 footmen, a vast array of hunting dogs, eight wagons drawn by horses with monkeys on their backs, packhorses carrying silver and gold plate, all paraded through the streets. This was just the prelude to the chancellor's own retinue of squires, mounted knights, falconers, and many of the young nobles who were being schooled in the chancellor's household; indeed, the king's own son, the young Henry, would start his education at the knee of Thomas Becket. 'What a magnificent man the king of England must be if his chancellor travels in such state,' commented the citizens of Paris in response to this glittering show of wealth – exactly Henry's intention.

The king then crossed from England in August to set his seal on the alliance in person. However, the visit was tinged with sad news; Henry's brother Geoffrey had died suddenly on 26 July 1158. Whilst this removed any lingering threat to Henry's legitimacy as count of Anjou, it also meant his hold on the area was weakened – especially as Conan used the opportunity to take possession of Nantes after Geoffrey's death, bringing all of Brittany under his control. Technically, Conan should have sought permission from Henry, as his overlord, before doing so; Henry had intended to claim Nantes as his own, as Geoffrey's legal heir. To bolster his authority further, Henry secured the grant of the title 'seneschal

of France' during the marriage negotiations with Louis in August. This was an honour dating back to Carolingian times and the equivalent of justiciar in England, but it gave Henry a mandate to bring Conan of Brittany to heel by whatever means necessary. With Norman forces ominously mustering on the border, Conan hurried to Avranches on 29 September 1158, ceded Nantes to Henry, and in return was confirmed as duke of Brittany.

Henry's attention moved from his northernmost possessions to those in the extreme south. Possibly as a result of the time he had spent with his wife in Aquitaine in 1156, Henry decided to exert claims over Toulouse – a county that had, in Carolingian times, been part of the old Roman province of Aquitainia but by a quirk of fate had passed down the 'wrong' line of Eleanor's family tree a few generations previously. Under the ruling St Gilles family, Toulouse was exercising a growing autonomy in the region, yet was of great strategic importance to Henry. Its ancient Roman roads controlled the trade routes on which Poitou was dependent for access to the Mediterranean ports. However, the diplomatic position was complicated. In 1154 Count Raymond V had married Constance, the sister of Louis VII, after he had struck up a close relationship with Louis during the Second Crusade. In early June 1159 Henry approached Louis and reminded him, in what must have been a somewhat awkward conversation for both men, that when Louis had been married to Eleanor he had exercised a claim over Toulouse as de facto duke of Aquitaine, even going to war in 1141 in an unsuccessful attempt to win the county by force. Henry now wished to revive this claim. Perhaps unsurprisingly, Louis refused to make a decision and the meeting broke up without conclusion. Henry therefore decided to flex his military muscles once more, having used bullyboy tactics to great effect against Malcolm and Conan, and assembled a grand coalition of knights and mercenaries. Malcolm of Scotland and barons from Brittany turned up at the muster at Poitiers, a visible acknowledgement

that Henry was now their overlord, and Henry was able to secure the support of Count Raymond-Berengar of Barcelona – another powerful lord from the south.

The campaign started brightly. In late June, Henry's army marched into Quercy and secured Cahors, the principal town in the region. On the road to Toulouse, Henry paused – hoping that Count Raymond would be sufficiently cowed by the overwhelming military presence on his land that he would submit without armed conflict. As king of France, Louis was left with little choice but to intervene in defence of one of his vassals, and held crisis talks with Henry. What transpired is unclear, but Henry seems to have taken away the impression that Louis was tacitly supportive of his campaign. Nothing could have been further from the truth; the king of France was clearly spooked by Henry's show of force and outright aggression against a fellow vassal, and marched into Toulouse to organise its defence on the premise that he was protecting his sister. Placing himself in Henry's way was a desperate measure, but an effective one. For a vassal to attack his lord was tantamount to treason; yet Henry could not simply abandon the campaign because he was acting in his wife's interests. The chief 'hawk' amongst his advisors was Becket – possibly because the chancellor had invested heavily in the campaign, not only in advocating the appropriation of Toulouse in the first place, but also in generating sufficient cash to bankroll the expedition. Contemporary writers suggest that Becket was advocating the assault and capture of the city, and with it the king of France in person.

This was dangerous and inflammatory advice, and Henry sensibly chose to ignore it. Instead, throughout the remainder of the summer and early autumn his forces raided the area around Toulouse, capturing castles and destroying crops in the hope that the war of attrition would weaken the count. However, the slash and burn tactics failed and in September Henry's army withdrew from the region, leaving Quercy in Becket's hands where he adopted a

ruthless policy of suppression. Henry returned to the north only to find that, in his absence, Louis's brothers had undertaken raids into Normandy; in retaliation, Henry quickly mounted punitive strikes against the French royal demesne. When the dust finally settled with the onset of winter, a truce was agreed – but Henry had suffered real damage in terms of his relationship with Louis.

The Toulouse campaign was the act of an over-confident, over-powerful man and, unsurprisingly, alienated his liege lord – Louis had been shown a glimpse of the future if Henry was allowed to continue unchecked. Doubtless the words of Pepin the Short echoed through the ages to haunt Louis – 'Who should be king, he who has the title, or he who has the power?' – creating an alarming parallel between Henry's relentless rise, and the overthrow of the Merovingian monarchy by the Carolingian mayors of the palace in the mid eighth century. To shore up his position, Louis decided to build alliances that might make Henry stop and think twice before embarking on a repeat military adventure in the south. Thus after Louis's second wife, Constance, died in 1160, he arranged to marry Adela, sister to Theobald count of Blois and Henry count of Champagne. This was a major shift in the diplomatic landscape – alongside the count of Flanders, a formidable power bloc opposed to the Angevin conglomeration had been formed, with an extended front line along the eastern borders of Normandy, Maine and Touraine as well as a hostile coastline that blocked the quickest routes between England and the continent. Not for the first time, Henry used his family to claw back the political advantage. Days before Louis was due to marry Adela, Henry arranged for his young son Henry and Louis's daughter Margaret to be wed on 2 November 1160, and seized control of the Norman Vexin in accordance with the alliance first agreed two years previously. More skirmishes broke out, mainly instigated by the house of Blois; but with all-out war looking increasingly likely in spring 1161 and both sides beginning to mobilise their troops along the border,

the two kings stepped back from the brink and a peace treaty was arranged at Fréteval.

*

Thereafter, the 1160s became a power struggle between the two families and their allies, with flashpoints in areas where Louis's plans for territorial expansion beyond the Île de France clashed with Henry's exercise of dormant or lost rights – not just in the far south, but also in other border regions such as Auvergne and Berry. Although Henry was infuriated with the ongoing Becket affair in England, this was merely an irritating sideshow; for him, the main concern was a growing unrest amongst the various vassal states. Having spent three years putting English affairs in order and suppressing another Welsh revolt, he returned to the continent in March 1166 and would stay for the next four years. The situation had been changed by the birth of a male heir, Philip, to Louis on 22 August 1165, therefore renewing the hopes of the Capetian monarchy and dramatically reducing the importance of the marriage of Henry the younger and Margaret. Emboldened by the change in his dynastic fortunes, Louis began to encourage internal opposition to Henry within his lands, and took every opportunity to cause mischief – such as offering support to Becket in November 1166. In turn, Henry began to use his large family as diplomatic bargaining chips and took increasingly drastic action to shore up his position. Faced with growing discontent in Brittany, Henry marched into the duchy in force during the summer of 1166, deposed Duke Conan and betrothed his third son Geoffrey – aged seven – to Conan's infant daughter, Constance; the Breton barons reluctantly paid homage to their new master in the autumn, but were not happy about the turn of events and discontented mutterings against Henry continued.

The more Henry turned the screw, the greater the opposition he produced. In particular, the situation worsened in Aquitaine,

for several reasons. First, the various component territories within the duchy had never been fully integrated – Poitou and Gascony remained largely separate entities, with key counties opposed to Angevin rule. The duke's authority was therefore similar to that of the king of France – nominal overlordship with few actual powers, making it very difficult for Henry to apply similar governmental practice in the south as he had in England and the north. Indeed, during 1167, the counts of Angoulême and La Marche offered to cede from Aquitanian authority altogether and hold allegiance directly from Louis, whilst the count of Auvergne appealed to the court of the French king rather than Henry's ducal court – ironically mirroring the expansion of royal justice over local courts in England. Henry, however, did not appreciate being on the receiving end of such tactics and invaded in force in April 1167; but diversionary raids by Louis into Normandy dragged him back north, where a truce was eventually concluded in August. Further punitive raids against the mutinous Bretons were brought to a premature halt when news reached Henry that his mother, Matilda, had died on 10 September.

However, another reason for Henry's problems in the south lay closer to home, as tensions within his family began to mount. Earlier in 1167 Henry contracted a marriage alliance between his daughter Matilda and Henry the Lion, duke of Saxony and Bavaria, one of the most powerful German princes in the Holy Roman Empire; the aim was to unsettle the Capet–Blois alliance, as well as exert pressure on Pope Alexander during the Becket dispute. Matilda remained with her mother Eleanor in England for most of the year until September, when it was time for them to leave for Normandy as part of the onwards journey to her new husband's court. However, the departure of their eldest daughter effectively marked the end of Henry and Eleanor's fifteen-year marriage. Eleanor returned to England and, in December, gathered up all her possessions and set sail for Argentan, where Henry held his

Christmas court. We do not know how the conversation between them transpired, but by the end of it they had agreed to live apart; Eleanor headed home to Poitiers, escorted by an armed guard. Henry accompanied her on the road south as he sought to break the power of the rebellious Lusignan family, one of the key dynasties of the region who had long considered themselves to be semi-independent of the ruler of Aquitaine.

It is tempting to portray the split as acrimonious, with the cause of marital disharmony commonly attributed to Eleanor's discovery that Henry was having an affair with Rosamund de Clifford, the daughter of one of his Worcestershire barons, Walter de Clifford. According to many accounts, Henry had become infatuated with 'the fair Rosamund' who was one of the most beautiful women of the age and built for her a labyrinth or 'bower' in the grounds of Woodstock, a favourite royal residence, where she could hide so that he could visit her in secret. It has even been suggested that Eleanor was forced to give birth to John at Beaumont palace, Oxfordshire, on Christmas Eve 1166 because Rosamund had taken up residence at Woodstock. As with all legends, once fact is untangled from the fiction, the reality is somewhat different. Henry did indeed have a relationship with Rosamund, but it is almost certain that he met her after Eleanor had left, at least no earlier than 1170 and possibly as late as 1173. It seems he did build a house for her near Woodstock named Everswell, constructed around a natural spring that fed a series of pools, and surrounded by elaborate courtyards. However, she was only one of many concubines in the years following Eleanor's departure; Henry lived openly with her after the 1173–4 rebellion, not before.

The indiscretions of the king were fairly well known – tales of 'nocturnal activities' at the itinerant court were rife, whores were present and actively 'managed', and several liaisons with noble-born women were suspected, such as with the daughter of Breton magnate Eudo de Porhoet, who refused to serve Henry against

Louis in 1168–9 because his daughter was 'with child'. Henry's first 'natural' son, Geoffrey, was born around the time of his marriage in 1152; Eleanor seems to have to have been sanguine about the situation to the point where Geoffrey was formally recognised and was appointed chancellor in 1181 and, under his half-brother King Richard, rose to become archbishop of York. Consequently, he attracted particular opprobrium from various clerical chroniclers on account of that fact that his mother, named Ykennai, was 'a common harlot who stooped to all uncleanness'. Indeed, after Eleanor had moved back to Poitiers, she was informed of the birth of another royal bastard, William Longespee (the future earl of Salisbury) around 1170, whose mother was Ida de Tosny. Eleanor could hardly boast a squeaky-clean past herself, given the rumours that continued to circulate about her inappropriately close relationship with her uncle Raymond of Antioch, as well as stories that she had slept with Henry's own father, Geoffrey – who pointedly advised his son to steer clear of her.

Instead, Eleanor's decision to return home was fuelled by a much more powerful grievance that had been simmering away since the early days of their marriage, when it became clear that Henry's preferred system of government did not require a powerful regent to act in his place. Prior to her wedding to Henry, and certainly in the early days before the disastrous crusade, Eleanor had enjoyed an exalted position at the French court, virtually acting as co-ruler with Louis. After her humiliation in the Holy Land and subsequent divorce, Eleanor doubtless thought her handsome young husband might be willing to restore her to a position of power. There is some evidence in the pipe rolls that demonstrate she was given English lands in Devon in her own right, thus securing an independent income; and Henry trusted her to authorise documents and royal expenditure with the use of her own seal during some of his absences on the continent during the 1150s. For example, the pipe roll for 1159 (covering the period when Henry was on the

Toulouse campaign) shows that Eleanor used her seal to authorise the transfer of various funds for her children's expenses, and seized the opportunity to purchase robes for herself worth £80 – a vast fortune in today's money, at a conservative estimate around £60,000. Perhaps unsurprisingly, given this extravagant spending, the main responsibility for royal government in England fell to the king's trusted team – the justiciars, chancellor and exchequer officials – leaving Eleanor side-lined and virtually anonymous in the political chronicles, other than appearing as a footnote when she gave birth to yet another royal child.

Eleanor's return home to Poitiers therefore allowed her an autonomy that she had not enjoyed since she was a girl growing up in her father's Aquitainian court; the deployment of his wife as ruler of Aquitaine seems to have been part of Henry's wider strategy to articulate clearly how his lands would be divided after his death. Initially, Henry left behind a military commander, Earl Patrick of Salisbury, to 'assist' with the government of the duchy; despite Henry's attack on the Lusignan strongholds in early 1168, discontent with Angevin rule was still rife. Indeed, Eleanor's return to Aquitaine nearly ended in disaster on 27 March 1168, when Geoffrey and Guy de Lusignan made a daring attempt to capture the duchess while she was out riding with a small party of courtiers. Luckily, a military escort that included Patrick and his nephew, a young knight called William Marshal, accompanied Eleanor as she travelled. Before the ambush could be fully sprung, Patrick scrambled Eleanor and her attendants to safety in a nearby castle; however, on trying to mount his horse to confront the assailants, he was run through with a lance and killed instantly. William Marshal fought furiously, but was eventually captured. On hearing of his valiant defence in her name, Eleanor paid a ransom for William's release and supplied him with horses, arms, money and fine clothes. The reputation of one of the most notable knights throughout the middle ages was thus born.

Eleanor's sojourn in Aquitaine is often linked to another legend – the creation of a 'court of love' at Poitiers, where in the warmer climes, and inspired by memories of her family's colourful and romantic past, Eleanor encouraged an atmosphere that was markedly different to that of the itinerant household of her husband, or indeed the formalities of Louis's court in Paris. In a passage written about her after the 1173–4 rebellion, it was claimed that, 'Once tender and delicate, you enjoyed a royal freedom, you abounded with riches, young girls surrounded you playing the tambourine and the harp, singing pleasant songs. Indeed you enjoyed the sound of the organ, and you leaped to the beating of drums.' Equally, Eleanor is said to have cultivated an atmosphere at court in which troubadours, poets and writers extolled the virtues of amorous behaviour, and encouraged the emergence of a romanticised code of chivalry that her knights would follow.

Sadly, the stories seem to have been an exaggeration. We know she was visited by Bernard de Ventadorn, a leading troubadour and 'master singer'; and Arnaut Guilhem de Marsan accompanied her when she escorted her daughter, also named Eleanor, to the border of Spain for her marriage to Alfonso VIII of Castile. However, beyond the duty to provide young knights with instruction, a function that all courts performed, there is no evidence that Eleanor's court was any more amorous than others, and certainly less so than that of her famous troubadour grandfather, William IX. Instead, Eleanor focused on the business of government, issuing writs, letters and charters under her own seal and travelling around the duchy – doubtless with growing dismay when she saw the impact of her husband's brutal rule on 'her' lands.

Eleanor was able to exert a far greater influence over the upbringing of her children, especially her favourite, Richard, who accompanied her to Aquitaine when she left Henry. From the age of nine, these were formative years in Richard's development and he soon grew to love the lands of the south. Eleanor used his time

at her court to groom him for power as her preferred successor. In contrast, the young Henry and Geoffrey only visited briefly, whilst her other two children, Joan and John, remained in Fontevraud, where they were attached to the monastery for their education. Eleanor's close relationship with her children was very different to that of their father as they grew older.

The root of family discord came, ironically, out of a peace conference held between Henry and Louis at Montmirail in February 1169, an attempt to end two years of increasing warfare along the extended border. As part of the entente, Henry clarified his plans for the division of his lands after his death. His eldest son would succeed him in England (with Scotland and Wales still viewed as client states), Normandy and Anjou; Geoffrey would continue as duke of Brittany, but would be required to pay homage to the young Henry, formally recognising that Brittany was a vassal state of Normandy; Richard was confirmed as Eleanor's successor in Aquitaine and, as such, would hold the duchy directly from the king of France – recognising its independence from Henry's other lands and strongly suggesting that Eleanor's views had at least been taken into consideration. To confirm the arrangement, Louis's daughter Alice was betrothed to Richard and entrusted to Henry's safe keeping until such time as the marriage could be conducted. The French king agreed he would support Henry against his rebellious barons across the various territories in France, should the need arise. Aside from the sour taste left by Becket's attention-seeking performance, the conference could have been a great success.

By clarifying plans for the succession, Henry merely created a rod for his own back. There were several unanswered questions, not least concerning the lack of provision for John – although probably apocryphal, the story that Henry nicknamed him 'lack-land' when he was born carried an unfortunate ring of truth about the situation in 1169. When Henry fell seriously ill in 1170 and feared death, he made his will, confirming the arrangements made at Montmirail but

granting John the county of Mortain in Normandy and entrusting him to the custody of the young Henry, until John was of age to take possession. Matters were made worse when Louis resumed his support for Becket and, increasingly distrustful of Henry, continued to stir up trouble where possible in his lands once more. This included a new tactic, whereby Louis reached out to Henry's sons on the grounds that they would one day be vassals of the French crown. It was against this background, and the increasing diplomatic tension caused by the escalation of the dispute with Becket and the pope, that Henry decided to follow Carolingian tradition and crown the young Henry during his own lifetime. Once again, Eleanor was involved in the decision to proceed and subsequent planning of the ceremony. Indeed, she travelled north to Normandy and was entrusted with a special mission: to prevent Becket or any of his representatives from crossing to England in an attempt to disrupt or even prevent the ceremony from taking place.

Aside from the queen and the archbishop of Canterbury, there was another notable absentee – young Henry's wife, Margaret, was not invited and thus could not be jointly crowned with her husband, despite the fact that £26 – tens of thousands in today's money – had been spent on robes for her and her household as part of the coronation preparations. This was almost certainly a deliberate snub and well-aimed insult towards her father Louis, which had the desired effect of enraging the Capetian king. Yet, despite the diplomatic storm clouds and wrangling over the guest list, the occasion was still solemn and magnificent. The pipe rolls provide evidence of great expenditure on the ceremony, which was conducted at Westminster Abbey. The king authorised the purchase of rich clothes for the courtiers and linen vestments for the new king, with all arrangements placed in the hands of his trusted household administrator Edward Blount. The young Henry's regalia consisted of a crown, sceptre and ceremonial swords; at the age of fifteen, he had not yet been knighted so would not have

had spurs. Nevertheless, he cut a striking figure – 'tall but well proportioned, broad-shouldered with a long and elegant neck, pale and freckled skin, bright and wide blue eyes, and a thick mop of the reddish gold hair'.

In the presence of the archbishop of York, gripping the altar with both hands, the young Henry swore on the Gospels and holy relics that he would uphold the liberty and dignity of the church. He was then anointed with oil of chrism and proclaimed king, with many chroniclers thereafter naming him Henry III. A lavish banquet, with newly gilded plates, was then held in the palace, and the old king honoured his son by serving food to him in person, rather than by a servant. Perhaps it was meant as a jocular exchange, fuelled by a healthy intake of wine, but when Henry commented that it was not always a prince could be served by a king, his son replied that it was nothing unusual for the son of a count to serve the king – a grave insult to his father's dignity and an early sign of the discontent to come. Henry certainly refused to grant the young king any lands in his new kingdom, or involve him in the machinery of government at all.

Henry's mood on his return to the continent was thunderous, if accounts of an argument with Roger, bishop of Worcester, are anything to go by. The bishop was a known supporter of Becket, and Eleanor, with the assistance of the seneschal of Normandy, had prevented him from sailing to England for the coronation. However, he was also 'family' – the son of Henry's half-uncle, Earl Robert of Gloucester, and his absence was noted by the king who confronted him angrily when they met a few weeks later outside Falaise in Normandy:

> 'What a traitor you have proved to be', he said, 'I sent you a personal invitation to my son's coronation, and told you when it would be; but you did not come. You can have no regard for me, or my son's honour. I'll see that you lose the

revenues of your see for this. You are not your father's son. To think that we were both taught by him the essentials of good behaviour.'

'That is fine, coming from you', replied Bishop Roger:

> What do you care that my father, Earl Robert, fought for you sixteen years against King Stephen, and even suffered imprisonment on your behalf. Little good has it done my elder brother. The earldom of Gloucester was worth a thousand knights until you cut it down to two hundred and forty. And as for my younger brother – you have reduced him to such penury that he has had to take service with the Knights Hospitaller. That's how you treat your kinsmen and friends. That is what people receive for serving you. Take my revenues if you will; although I should have thought you might have been satisfied with those of the archbishop and the vacant bishoprics and abbeys – surely that's enough on your conscience.

One of Henry's household then took it upon himself to criticise the bishop, but the king turned on him instead, crying:

> Do you think, you rascal, that if I say what I choose to my bishop and kinsman, either you or any other man may dishonour him with your tongue or threaten him? I can hardly keep my hands from your eyes; neither you nor the others may say one word against the bishop.

The two men finally discussed the reasons why the bishop had been unable to attend; Henry, in great anger, asked if Eleanor and his seneschal were to blame for Roger's non-appearance, and the bishop's reaction provides an insight into the state of relations between Henry and Eleanor: 'Not the queen, lest perchance out of fear and respect for you she suppress the truth and your anger burn

more hotly against me; or if she should confess it to be true, then you might rage madly and rudely against that noble lady.'

Despite the bishop's fears, Eleanor continued to take an active role in family affairs – indeed, she rose to prominence during Henry's sickness in early August 1170 that left him confined to his bed for nearly two months, sufficiently fearful of death that he made his will. During that time, she oversaw the departure of her daughter Eleanor in September; the marriage had been brokered as part of another diplomatic initiative by Henry to isolate the count of Toulouse from Louis by building a ring of strategic allies to hem him in. The young Eleanor's dowry was to be Gascony; although she was probably consulted over the decision, Eleanor senior was not happy that her patrimonial lands were being dismembered around her – even though the bitter pill had been sugar-coated with the caveat that Gascony would only leave Aquitainian control after Eleanor's death. Nevertheless, there was little sign of disharmony at the end of the year, when Eleanor and Henry were joined by their sons at the Christmas court held at Bure le Roi – the fateful occasion when news of Becket's foolhardy excommunication of all bishops who had participated in the young Henry's coronation reached the king, triggering his incandescent outburst that started the chain of events that would lead to Becket's murder on 29 December.

Henry's reaction to the news of Becket's death was almost certainly genuine; but he was not the only member of his family who was deeply shocked and affected. His son, the young king, had been brought up and educated as a boy in Becket's court when he was still chancellor. The young Henry would have received lessons in knightly conduct, at which he clearly excelled given later accounts of his martial prowess at tournaments – and he grew into a dashing, handsome youth loved by all, for which some credit can be laid at Becket's door. Equally, he was instructed in the latest theological and political ideas, including the works of John of Salisbury with whom Becket was close. Notwithstanding the fact that the young

king refused to see Becket on his return to England in 1170, he was deeply affected by the sudden and brutal death of such an influential character, and blamed his father. Indeed, such was the young king's affection towards his old master that he was the first royal visitor to Becket's tomb at Canterbury in 1172, flinging himself prostrate to the ground, 'overcome with feelings of guilt and remorse'.

His father, meanwhile, was equally remorseful but took a different course of action. With the situation on the continent looking perilous, and his enemies baying for his blood, Henry decided to kill two birds with one stone and launch an expedition to conquer Ireland – an attempt to curry favour with the pope, given Alexander's concerns over the state of Irish Christianity, as well as a potential opportunity to gain land for his son John, though he was not yet five years old at the time. The political situation in Ireland was complicated, with the high king nominally ruling over regional or tribal under-kings; however, there was no central administration or common set of laws, with eight different forms of permissible marriage that prompted popes to describe the Irish as 'ignorant and barbarous people'. Henry had indirectly meddled in Irish politics in 1167 when he issued letters patent permitting Dermot, king of Leinster, to recruit 'free lances' in his struggle with the king of Connacht. Various members of the leading Anglo-Welsh marcher families, used to border conflict, crossed to Ireland – particularly younger sons or those who had been disinherited after the anarchy. One man in particular, Richard de Clare, known as Strongbow, flourished – mainly because he married Dermot's daughter and, after Dermot's death in 1171, claimed the title king of Leinster for himself – although he immediately became embroiled in a bitter struggle with Rory O'Connor, the king of Connacht and nominal high king. Strongbow only saved his position by winning a stunning military victory when it looked like the Normans would be ejected from Ireland. It was at this moment – on 18 October 1171 – that Henry landed with a show of force sufficient to ensure

that most of the native kings (with the exception of Rory O'Connor and those in the north) and Strongbow submitted to him. Pope Alexander was delighted at the news. Strongbow was confirmed as king in Leinster, but Henry left behind his own royal garrisons and administration, based in Dublin, and established other Norman 'kings' such as Hugh de Lacy in Meath.

Henry's return from Ireland allowed him to settle his dispute with the pope on more favourable terms than could have been expected in 1171, and he then returned to the management of his continental lands. In Normandy, he conducted enquiries into the lands that his grandfather, Henry I, had held, and ensured that they were returned to his hands, 'and by this means he doubled his income'. Once more, he met up with Eleanor and discussed Richard's inheritance, agreeing that – as with the young Henry – it was appropriate that he should be invested as duke. Accordingly, two grand ceremonies were planned to mark this transfer of power in June 1172. The first took place at Poitiers, where Richard was presented with a lance and banner, traditional symbols of authority; then at Limoges, in a more solemn affair, he was invested with the sacred ring of Saint Valerie, as the bishop placed a golden circlet on his head and handed him a rod and a sword – a reference to the post-Roman times when Aquitaine was first a province, and then a kingdom in its own right.

Yet every move Henry made to confirm his commitment to sharing his lands around the family caused more problems. Henry was unwilling to relinquish the title duke of Aquitaine, so it was not quite the transfer of power that Richard might have expected; he was known as count of Poitou, although Eleanor permitted him to take control of many of the administrative aspects of government. This caused deep resentment between the young Henry and Richard, as the older sibling grew bitterly jealous of the autonomy of his younger brother – he had still not been provided with any lands, and it looked like he was slipping further and further down

the queue; his brother Geoffrey had an equal cause for complaint, given that Conan of Brittany had died in 1171 and he was still unmarried to Conan's daughter Constance.

The year ended with Eleanor and Henry together at his Christmas court in Mirebeau, Anjou; however, like the weather, the atmosphere was frosty – mainly because of yet another attempt to isolate the count of Toulouse through a brokered marriage with a nearby neighbour. This time, Henry suggested to Count Humbert of Maurienne – ruler of lands which bordered Provence – that his daughter should marry John. When Henry met Humbert at Montferrat in late January 1173, the count of Toulouse and the king of Aragon-Barcelona joined the conference and made it known that they were eager to settle their differences. Although the marriage did not take place in the end – the death of Humbert's daughter being one major stumbling block – it had the desired effect; at the betrothal in February, the count of Toulouse recognised Henry as his overlord and performed homage as a vassal of Aquitaine.

This should have been a moment of triumph for Henry, but in reality it was a massive blunder on several levels. First, the count of Toulouse paid homage for the county to Henry and Richard but not Eleanor, an incredibly insensitive insult to her dignity as hereditary duchess, undermining the autonomy that she had been allowed since 1168. Even more damaging was the assignment of the Angevin castles of Chinon, Loudun and Mirebeau to John – a traditional endowment for a second son, and identical to the grant that Henry's own brother Geoffrey had received until his untimely rebellion at the start of the reign. The grant, along with 5,000 marks cash, was made without any consultation with the young Henry, who viewed them as part of 'his' inheritance and further rubbed his nose in the fact that he had been given neither lands nor cash. A bitter quarrel erupted between father and son, in which all the young king's grievances came out. The king refused to extend his allowance or grant him land; young Henry retorted that, at

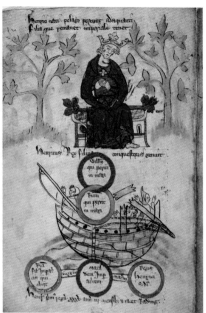
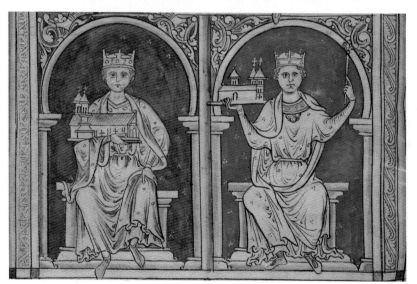

TOP LEFT Three generations of restless kings – Henry II (*top left*), his sons Richard I (*top right*) and John (*bottom left*), and grandson Henry III (*bottom right*). Inset is a depiction of the young Henry, crowned as king of England in his father Henry II's lifetime but never granted any power.

TOP RIGHT Henry I was left devastated by the news that his only male heir, William, had drowned in the wreck of the White Ship outside Barfleur on 25 November 1120.

BOTTOM Henry I (*left*) and his nephew Stephen (*right*), who seized the throne from Henry's daughter Matilda ushering in years of political turmoil and civil war.

TOP John was one of the most restless of the Angevin kings, and inherited a love of hunting from his father Henry II.

BOTTOM Richard I first earned his reputation as a mighty warrior whilst fighting to subdue the Aquitainian lords in the south of France. He was the principal Western leader during the Third Crusade to the Holy Land.

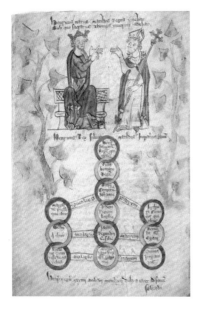

TOP Henry II quarrelled furiously with his former friend Thomas Becket after his appointment as Archbishop of Canterbury. The struggle was for supremacy over the church in England, sparked by Henry's attempts to assert royal rights over criminous clerks.

MIDDLE Becket fled England in fear of his life in October 1164 after he was convicted of contempt of court at a council held in Northampton.

BOTTOM Despite the attempts of the pope and Louis VII of France to broker a peace settlement in 1169, Becket insulted Henry II in front of the assembled crowd of dignitaries, reigniting the feud.

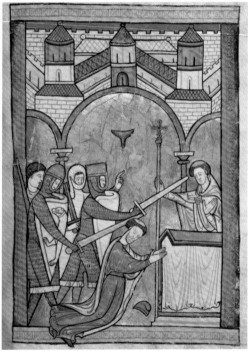

TOP In defiance of the pope, and as a deliberate slight to Thomas Becket, Henry II's eldest son, the young Henry, was crowned king of England by the archbishop of York at Westminster in 1170.

BOTTOM Four of Henry II's household knights brutally murdered Thomas Becket in Canterbury cathedral in December 1170, sending shockwaves around Europe.

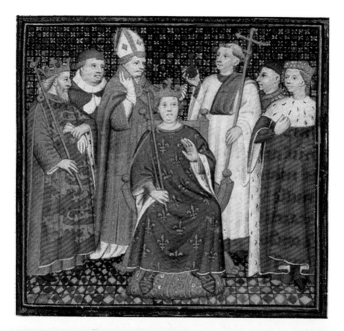

TOP Henry II's support was instrumental in ensuring the accession to the
French throne of the young Philip II, son of Louis VII.

BOTTOM The tomb of King John at Worcester cathedral. During his final hours
at Newark Castle, John insisted he should be buried there.

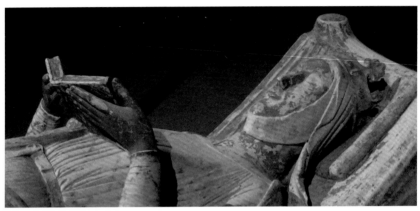

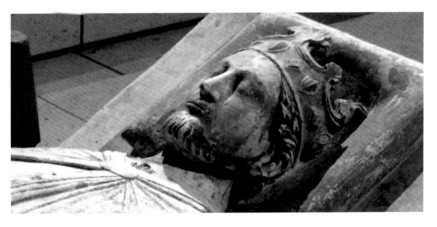

The tomb effigies of Henry II (*top*), his wife Eleanor of Aquitaine (*middle*), and their son Richard I (*bottom*), at Fontevraud Abbey where they are buried.

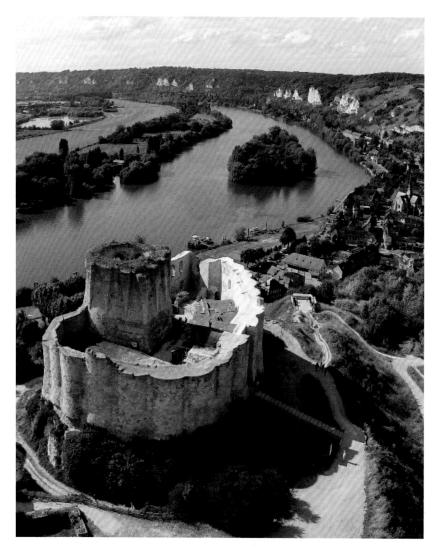

Château Gaillard was built on an island in the River Seine by Richard I, and contemporaries considered it to be impregnable. However, it was captured by Philip Augustus in 1204, signalling the expulsion of John from Normandy.

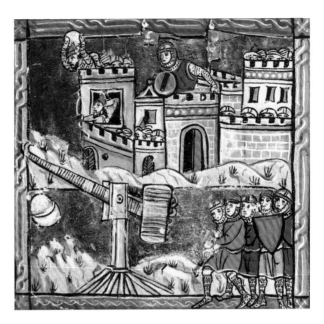

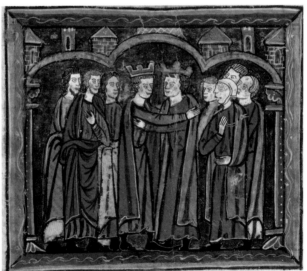

TOP The siege of Acre, which fell to the combined forces of Philip Augustus and Richard I in 1191. The prisoners were brutally slaughtered on the orders of Richard I in one of the worst atrocities of the crusade.

BOTTOM Shortly after the fall of Acre, Philip left the Holy Land. The relationship between the two kings never recovered from Richard's marriage to Berengaria of Navarre, which broke his long betrothal to Philip's sister Alice.

eighteen years of age, he was already two years older than when his father had been invested as duke of Normandy, he was tired of Henry choosing his household staff and courtiers, and the lack of suitable funding meant that he was unable to maintain a proper court for himself and his wife. As with many family arguments, once started it was hard to stop – young Henry demanded that he be given at least one of his father's lands to govern, and followed it up with the real bombshell – this was something that his father-in-law, Louis, supported, as did the barons of Normandy and England. Stunned, Henry turned to the count of Toulouse, who confirmed that he had heard rumours that a plot to depose the king was indeed planned.

Even as his anger cooled, Henry gathered his household knights around him and headed back into Aquitaine as he sought to secure the key castles in case the stories were true, before setting off to Normandy with young Henry, a virtual prisoner. They reached Chinon castle on 8 March 1173, and settled down for the night after a long day's ride. However, young Henry managed to evade the courtiers – or perhaps used his famous charm to persuade them to let him escape – and rode hell for leather to Paris, where he was received warmly at Louis's court. Henry was furious, and sent envoys to his son, but Louis refused to let them speak with young Henry, rejecting out of hand the demand that he should accompany them back to his father. 'Who is it that sends such a message to me?' asked Louis, when he received the formal request from the lead envoy. 'The king of England' was the reply. 'What nonsense,' Louis scoffed:

> Behold! The king of England is here present, and he sends no message to me through you. But even if you still call king his father who was formerly king of England, know that he, as king, is dead. And though he may still act as king, this shall speedily be remedied, for he resigned his kingdom to his son, as all the world bears witness.

Soon after, Geoffrey and Richard left Eleanor's court in Aquitaine and joined young Henry in Paris, where they also swore allegiance to Louis. The family dispute had just turned into a full-blown war.

*

The struggle between Henry and his family was not unique in the history of the post-Roman West; the fragmentation of the Carolingian empire into the splintered Frankish lands was driven by centuries of fraternal conflict as territories broke into ever-smaller blocs. What made the Angevin conflict so noteworthy was that Henry's entire family turned against him, and that so many other powers were dragged into the conflict as a result of interconnected geopolitical alliances, brokered primarily by Louis – the medieval equivalent of the way the balance of power was held in Europe on the eve of the 1914–18 Great War. After Henry's envoys had been summarily dispatched from Paris, Louis summoned a grand council of his leading magnates. Having declared formally that Henry had been stripped of his possessions in France, Louis ensured they pledged to support young Henry in his endeavours and recognised the transfer of power from father to son; equally, as the duke of Normandy and count of Anjou, young Henry swore not to make peace with his father without the permission of his new overlord. Having taken such a drastic step, the only logical way forward was to empower young Henry with the necessary administrative tools; so Louis arranged for a seal to be cut for the young king so that he could issue orders, make land grants and draw up charters within the lands in which Louis had recognised his authority.

However, it was all very well making plans, sat in the luxury and relative safety in Paris; to take actual control required military intervention. Thus young Henry and Louis started to assemble an army. This depended upon the involvement of neighbouring states, partly by drawing on familial ties but also through the promise of the grant of estates across Henry's lands that had previously been

denied them – this drew the support of the counts of Flanders and Boulogne. Louis also turned to his brothers-in-law, who had been baying for Henry's blood ever since Becket's murder. An 'eastern front', from the northernmost tip of Normandy to the Blois–Aquitaine border further south, was therefore primed for military conflict. However, a 'northern front' was cultivated as well, as young Henry reversed his father's renegotiation of the Anglo-Scottish border in 1157 and promised William, king of Scots, the whole of Northumbria as far south as the Tyne.

Yet even with such a broad range of foes ranged against Henry, for the attempted coup to succeed it required the cooperation and support of the leading magnates in the territories over which the young Henry sought to gain control. The chroniclers state that, 'Nearly all the earls and barons of England, Normandy, Aquitaine, Anjou and Brittany arose against the king of England the father.' It was certainly the case that, in some parts of Henry's commonwealth, his brutal acts of suppression or dismantling of old autonomous rights in favour of centralised power had created the right environment for revolt; the young king found support particularly on the Norman–Breton borders, through Maine and in large parts of Aquitaine. In England, some leading nobles took arms against the old king, especially the Midlands earls of Leicester, Derby and Chester; and Hugh Bigod, earl of Norfolk, with his long-standing grudge against the king. Yet this was not a wholesale uprising against a tyrannical ruler, and this is testimony to the effectiveness of Henry's administrative system and its reliance on process and protocol rather than personality. Although many of the rebels still sought greater influence and control of lands they still considered to be 'theirs', the way Henry stamped his authority across England at the start of the reign had snuffed out most sources of grievance that might have been allowed to fester from the time of Stephen – with the exception of Bigod. Nevertheless, the increasing burden of royal authority had created

a general feeling of discontent, and many decided to adopt a 'wait and see' strategy rather than rally round the king: 'There were only a few barons at that time in England who were not wavering in their allegiance to the king and ready to defect,' according to William of Newburgh.

Shorn of his family, Henry turned to his trusted advisors amongst his itinerant court, and key officials in England, to decide what to do – given that war could break out on any front, and the king could not be everywhere at once. So, whilst he took some precautionary steps, such as placing all the royal castles in England on a war footing, he also waited to see what would happen – challenging his enemies to make the first move. The blow fell on Normandy, the heart of Henry's possessions and key to any successful invasion of England. The initial assaults came in May, first at Pacy and then an attack on the castle of Gournay led by the young king at the head of his first army; but these were little more than probing raids. The main assault was unleashed the following month. Philip of Flanders crossed the northern border at Aumale, which fell very easily – raising suspicions that the count of Aumale was part of the conspiracy; Louis invaded further south and besieged Verneuil, with the earl of Leicester and Henry's long-standing Norman opponent William de Tancarville in support. Meanwhile, Breton rebels crossed the border and marched on Avranches, aided by Hugh, earl of Chester, and key Norman castellan Ralph de Fougères. Now that Henry could see what was planned, he coolly assessed the situation and made a flying visit to England on the royal ship *Esnecca*, filling it with coin from the royal treasury at Westminster so that he could hire more mercenaries from Brabant. The Norman defences held; indeed, the fortunes of war swung his way. Philip of Flanders moved on from Aumale to capture Driencourt, but his brother Matthew, count of Boulogne, was hit in the knee by a crossbow bolt and was seriously wounded. Infection set in and, despite medical attention, he died a few days

later. Distraught, Philip abandoned the campaign and left for his own lands in mourning.

On hearing the news, Henry decided it was time to mobilise his army, and in early August he marched towards Verneuil to confront Louis directly in battle – all deference to his overlord shown in the Toulouse campaign was cast aside. Louis decided to despatch an armed party of envoys to see if the rumours of Henry's advance were serious; the unfortunate group encountered Henry on the road, in full military gear, leading a vanguard towards the French camp issuing orders and displaying supreme confidence that he would prevail. When the envoys nervously 'informed him that the king of France wished to receive an assurance concerning the battle, with a fierce countenance and in a terrible voice he replied, "Go, tell your king that I am here in person."' The message was duly relayed to Louis, along with an account of the 'ferocity and stubborn reaction of the monarch who was even then rapidly drawing nigh'. Indeed, Henry's forces mounted the crest of the hill overlooking the town on 9 August, to find parts of it burning as Louis and his magnates broke their siege and beat a hasty retreat; the rearguard of the French army were butchered in the evening twilight.

Having then marched east to secure Damville, Henry next headed for Rouen to regroup, while sending some of his mercenaries west to challenge the Bretons; they, too, retreated under the onslaught, suffering heavy casualties as they hastened to the town of Dol. On hearing the news that the rebels were besieged, Henry covered the distance from Rouen in only two days, appearing suddenly out of nowhere when least expected – his enemies thought he was still fighting in the eastern marches of Normandy. Trapped inside the citadel, the rebels begged for mercy, which Henry granted on 20 August – their lives were spared, but two of the ringleaders of the war, Hugh of Chester and Ralph de Fougères, were imprisoned. With the rebel campaign faltering, the earl of Leicester attempted

a diversionary expedition to England at the end of September, taking a force of Flemings to Suffolk where they landed under the protection of Hugh Bigod and assembled at Framlingham. The opposition to the rebels in England had been led by the justiciar, Richard de Lucy; his focus had been on capturing the chief rebel stronghold, Leicester. However, he had been drawn north by the invasion of William the Lion at the head of a Scottish army that raided through Northumbria into Yorkshire. Having driven them back, de Lucy was forced to march south again to confront the new challenge in East Anglia. In the marshes at Fornham, not far from Bury St Edmunds, de Lucy's army routed the rebels, even though the royalists were outnumbered; many insurgents died in the fighting, some drowned in the bogs as they tried to flee, and the locals literally waded in to the fight in support of the royal cause. As at Dol, another of the rebel leaders, the earl of Leicester, was captured.

Having secured Normandy and, via his deputy, repulsed the initial threat in England, Henry shored up the Angevin defences along the border with Blois by moving into Touraine and ensuring all key castles were handed over into his control. With the main campaigning season in the north over for the year, Henry headed south to Poitiers from Chinon to tackle the rebellious barons of Aquitaine, who were led by his son Richard, as well as confront his wife given his suspicions that she was behind the actions of his sons. Poitevin chroniclers certainly rejoiced at the uprising against Henry – 'Exult, Aquitaine! Rejoice, Poitou, that the sceptre of the king of the North be removed from you!' However, in a surprise attack, Henry took Saintes, where Richard had been based, forcing him to hole up in Geoffrey de Rancon's 'impregnable' château de Taillebourg. Fearing her husband's wrath, Eleanor fled to Fay-la-Vineuse, her uncle's lordship, seeking his protection; but he had already abandoned his lands and gone to Paris. Eleanor decided to follow him, and made careful plans to slip through Henry's

military cordons. 'Having changed from her woman's clothes' to adopt the dress of a man, her luck eventually ran out on the road to Chartres; she was captured, brought before Henry, and then locked up in Chinon castle at the king's pleasure with no hope of release or rescue. Her supporters suffered far worse fates: those that were 'taken from their lands [were] condemned to a foul death, others deprived of sight, others are forced to wander and flee to scattered places'.

There was little more Henry could do in the south, so he returned to his northern lands. Apart from a surprise attack by Louis against Séez in January 1174, which was repulsed by the citizens, there was no further action throughout the spring. The uneasy stalemate continued; whilst Henry remained in Normandy, the allies were unwilling to attack. Diversionary tactics were required to dislodge him, hence the second invasion by William the Lion, with the support of northern rebels led by Roger de Mowbray, shortly after Easter 1174. Part of the Scottish forces marched south under the command of William's brother, David, who reinforced the garrison at Leicester and led successful raids against Huntingdon, Northampton and Nottingham. As already seen, the northern earls led the royal resistance to William's incursions that culminated in his capture outside Alnwick. At the same time Henry's natural son Geoffrey Plantagenet besieged de Mowbray at Axholme; having managed to escape the encircling army, de Mowbray was captured by local peasants on his way to Leicester. To boost the flagging rebel efforts, Philip of Flanders let it be known that he was planning to invade by mid July with the young king, sending over an advance party of Flemings who landed in East Anglia on 15 May and joined up with Hugh Bigod; they captured Norwich. It was under these circumstances that Henry decided that he should return to England, eventually persuaded by the panicked message he received from one of his trusted deputies in England, Richard de Ilchester. However, he ensured that his Norman castles were secure

before sailing from Barfleur on 7 July. His uneasiness was justified; this was exactly the opportunity that the confederates had been waiting for. Philip of Flanders re-joined Louis and together they launched a desperate attack on Normandy, safe in the knowledge that Henry was not present. By 22 July, they were encamped outside the formidable defences of the ducal capital, Rouen.

Henry's business in England had to be concluded swiftly so that he could return to face the crisis in Normandy, which was why the news of William the Lion's capture was so welcome. Freed from the threat in the north and reassured that yet another rebel leader was his prisoner, the king marched to the relief of Huntingdon. The town quickly surrendered when Henry appeared in person outside its gates, so he moved on to Northampton, which also abandoned its resistance. At this point the rebellion in England collapsed, and Henry was able to summon and secure the submission of all remaining nobles.

With the country back under royal control, Henry sailed to Barfleur on 8 August and immediately set out for Rouen. Louis's army was not making much headway, and had not even been able to invest the citadel fully; the western gate was still open and supplies were still entering via the river Seine. A truce had been agreed on 10 August so that both sides could celebrate the feast of St Lawrence; it was, after all, very early in the siege and there were plenty of provisions available for the citizens and besiegers to enjoy the occasion. However, at the insistence of the count of Flanders, Louis was persuaded to use the truce as the cover for a surprise assault. Fortunately two clerks, stationed high up in a church tower within the citadel, noticed activity in the French camp and rang the bell to alert the commander of the defences, just in time to prevent an attempt to scale the walls. It was to be Louis's last chance of capturing the ducal capital; Henry arrived the next morning with a sizeable force of mercenaries, and entered the city. In his mind, there was only one option – to attack. A party of Welsh scouts were

sent to survey the enemy's encampment, and from hiding positions in the woods around Rouen launched a raid on the French supply train, causing great damage. Henry then ordered a ditch between the city walls and the French camp to be filled in so that his entire force of knights could sweep out and attack. For the second time in the campaign, Louis refused to give battle and beat a hasty retreat. The great rebellion was at an end.

*

One aspect of particular note was the absence of young Henry and his brothers from the majority of the fighting, which made peace negotiations somewhat easier to conclude. However, the agreement that was reached on 30 September at Montlouis was between father and sons, and conveniently ignored the role that Louis had played in fomenting family discord in order to eject his over-mighty vassal from his continental lands. This act of diplomatic amnesia was accompanied by generous terms for the defeated rebels, winding the clock back to the status quo fifteen days before young Henry fled to Paris. Henry's magnanimous attitude towards the confederates was criticised in many quarters for its leniency; furthermore, he stuck to the terms of the settlement – in contrast to his somewhat patchy reputation when it came to oath-breaking. The reason for his clemency was that the war had been a wake-up call, forcing him to confront the fact that his sons had indeed grown up and needed more freedom – never an easy moment for a parent, even more so when he has been running the family firm for twenty years. Henry and the young king therefore were publicly reconciled, and although the latter was forced to recognise the grants that his father had made to John – namely the county of Mortain, various sources of revenue from England, Normandy and Anjou, plus the Angevin castles – he was also given two castles in Normandy and an allowance. Geoffrey was granted half the revenues of Brittany, whilst Richard – who, on 23 September, had come from the

south 'with tears to prostrate himself at his father's feet and crave his pardon' – was confirmed as count of Poitou, allocated half the revenues of the county and allowed to hold territories in his own right.

Of more relevance, Henry handed Richard the task of subduing the rebellious nobles in Aquitaine – an irony given that Richard had played a leading part in stirring up trouble in Saintonge and Poitou in the first place. It was a clear sign that power had passed from Eleanor to Richard; yet without his mother's influence, he struggled to make any headway for two years, returning to England in spring 1176 where a family conference was arranged at Winchester to discuss the situation – one of the first signs that Henry was adopting a more conciliar approach to the 'federal' government of his realms. Richard was given funds to hire mercenaries and promised the services of his older brother, Henry. This support, though, turned out to be of little use – having left England in April, the young king spent his time in Paris and only arrived in Aquitaine in midsummer, when he took part briefly in the siege of Châteauneuf before wandering off again. However, Richard proved his mettle, and routed the rebel forces led by the count of Angoulême near Bouteville before capturing the castle at Aixe belonging to the viscount of Limoges. He swept through Angoulême, besieging the city with the rebel leaders inside. After six days, the resistance crumbled and everyone surrendered. Richard sent leading Aquitainian nobles Count William of Angoulême, Viscount Aimer of Limoges, and the viscounts of Ventador and Chabanais to England. They were presented to Henry at Winchester on 21 September 1176: 'Prostrating themselves at the feet of the king the father, they sued for mercy.'

However, there were some exceptions to the king's amnesty. The simmering tension that had been growing between Henry and Eleanor since their separation in 1167 was now out in the open, and she remained in captivity. Once Henry had made up his

mind in July 1174 to deal directly with the situation in England, he summoned his wife and she accompanied him on his voyage from Barfleur on 7 July. Whilst Henry knelt in penance at Canterbury, she was transferred to Salisbury castle, still securely held in royalist hands. For the next fifteen years she remained Henry's prisoner, although it was more a form of house arrest as she moved from residence to residence in England, furnished with every luxury befitting a queen apart from her freedom. During this time Henry openly lived with Rosamund, attracting criticism for his brazen approach to his marital status, until her sudden death in 1176. Henry was genuinely upset, and helped pay for a tomb to be erected in the choir of the monastery church at Godstow.

Having spent so long shaping English government into a form he understood and that suited his needs, Henry was not about to soften his stance once he had regained his authority. As well as ensuring his wife would not politically embarrass him again, Henry could find no immediate forgiveness for some of his barons. The earls of Chester and Leicester languished in Henry's prisons until January 1177, as did Ralph de Fougères; although they were then restored to their previous titles, key castles were withheld to ensure their power was weakened. The wily king also had other ways to impose a measure of vengeance, and he turned the screw in England via the administrative and judicial machinery he had assembled. In 1176, Henry issued the assize of Northampton, setting in train the general eyre of royal justices who were now empowered to impose even harsher penalties for criminal offences. Finally, the king also used the royal prerogative to brutal effect, issuing instructions to his feared chief forester, Alan de Neville, to conduct an enquiry into transgressions in the royal forest that took nearly two years to complete.

The man who suffered the most at Henry's hands was William the Lion of Scotland, who was forced to sign a humiliating treaty at Falaise in December 1174. In return for his freedom, he swore

to be 'the liegeman of the lord king Henry', thus accepting the overlordship of England across Scotland. A public act of submission at York was accompanied by the surrender of five key castles in Scotland to Henry – Roxburgh, Jedburgh, Berwick, Edinburgh and Stirling; to add insult to injury, the king of the Scots would pay for the English garrisons. Henry next turned his attention to Wales and Ireland. In the case of the former, Henry had generally adopted a more cautious approach that had been rewarded with loyalty and support during the war. The two native kings were elevated above all other native rulers and owed allegiance to Henry, as did the marcher English barons who held lands in Wales. Ireland, however, was far more complicated given the competing demands of the local kings and Henry's lack of interest in a military solution. In 1175 the treaty of Windsor recognised Rory O'Connor as the high king, but asserted the principle that he was Henry's vassal. In practice, the agreement proved unworkable as Norman knights continued to cross the Irish Sea to settle as free lances, often supporting Rory's rivals. Henry was forced to intervene in Munster in 1177; the situation remained too unstable for him to carry out his desire to assign Ireland to John, which had to wait a further eight years until the young prince was of age to lead an army himself.

By the end of 1176, Henry was perhaps in the most powerful position of his entire reign, and the restoration of his reputation after the Becket affair was complete. He formally settled his long-standing dispute with the papacy through negotiations with the legate Cardinal Hugh Pierleone, in 1176. Although Henry confirmed the abandonment of some of the more contentious parts of the constitutions of Clarendon, the tone was markedly different from the compromise of Avranches in 1172 – this time, the arrangements were presented as his concessions to the church, and came hedged with qualifications. In particular, Henry ensured that clerics accused of offences under the forest law were to be tried by the royal officials, rather than a church court; in other words, this

area of his prerogative remained intact, drawing sharp criticism from clerical chroniclers.

Henry's court in November reflected his heightened status on the European stage, as it was visited by envoys from the Byzantine Emperor Manuel Comnenus, from the Holy Roman Emperor, and from the count of Flanders. Such was Henry's renown that the king of Sicily, William II, sought an alliance by marrying Henry's daughter Joan in February 1177. Perhaps even more importantly, Henry's new model of 'a family firm', with regular conferences, continued to pay dividends in Aquitaine, where Richard's permanent presence, rather than rule by an absentee lord such as Henry, finally allowed the pursuit of full ducal authority. However, suppressing rebellion was one thing; bringing traditionally autonomous counties such as Angoulême under control was another. Early signs of Richard's military skill, tenacity and tactical awareness can be seen in the way he dismantled the strongholds that supported the count of Angoulême by the end of May 1179, including the château de Taillebourg where he had sheltered from his father's wrath in 1173. The contrast this time could not be greater; after reducing the great castle to rubble, having played a leading role during hand-to-hand combat to wrest control of the gatehouse to gain entry, Richard journeyed to England where he was 'received by his father with the greatest honour' and confirmed as ruler of Aquitaine. Thus was born Richard's reputation as a fearless leader, a warrior with the heart of a lion who was happy to throw himself into the fray alongside his men. As well as a lifelong fascination with the arts of siegecraft and castle-building, he was always looking for opportunities to test his ingenuity against ever more challenging fortresses.

Henry had not forgotten the role played by Louis in stirring up trouble amongst his family, and decided that the time was right to go back onto the offensive, focusing on the contentious areas of Berry and Auvergne – important to Louis as the principal communication

route to the southern portion of his realm, yet vital to secure the borders of Aquitaine. In 1177, Henry demanded the handover of Margaret's dowry – the Norman Vexin – plus lands in Berry for Alice's dowry as part of her marriage to Richard, and backed up his demands by mustering an army. The sabre-rattling worked. Against the background of increasing tension in the Holy Land, and calls for another crusade to provide assistance to the beleaguered Western strongholds which were under assault from Saladin, Louis and Henry signed a non-aggression pact at Ivry in September 1177 on the basis that they would prepare for a joint military expedition to the Holy Land. Furthermore, the spirit of the agreement was of mutual cooperation – 'We are now and intend henceforth to be friends, and that each of us will to the best of his ability defend the other in life and limb and in worldly honour against all men,' removing all claims from each other's lands. Yet Henry was able to manipulate the situation to his advantage, ensuring the status of Berry, Auvergne and Châteauroux was decided by arbitration at Gracay in November. Not only was the verdict in Henry's favour, but he also persuaded the lord of La Marche to sell him his lands, which hemmed in the troublesome Aquitainian lords in Poitou, Angoulême and Limoges and acted as a 'marcher' state with Berry and Auvergne.

Although this was a major threat to French influence in the south, Louis was no longer in a position to act. He was old and worn out from his struggles with Henry; his focus was to ensure that his only son, Philip, would follow him as king. Louis planned to have Philip crowned as his successor when he turned fourteen on 15 August 1179, but Philip fell so seriously ill that it was feared he would die. Postponing the coronation, Louis travelled to England on 22 August, directed to the shrine of St Thomas at Canterbury in a dream. Henry received his fellow king with courtesy, escorting him to the cathedral where Louis prayed for two days. Philip duly recovered and was crowned on 1 November at Reims, with the

Angevins represented by young Henry, Richard and Geoffrey; Louis, however, missed the ceremony – he had suffered a stroke on the return journey from Canterbury and was left paralysed, unable to speak: 'a spectator in the last years of his reign'. He finally died on 18 September 1180 leaving his son at the mercy of court politics. Thereafter followed a power struggle for influence over the new king, with Louis's widow Adela and her brothers, the counts of Blois, Chartres, Champagne and Sancerre, ranged against the count of Flanders, who had previously arranged for Philip to marry his niece, Isabella of Hainault, in April 1180. Philip sided with his bride's family, and Adela fled from court; in a twist of fate, the Blois faction appealed to Henry to intervene and facilitate a reconciliation.

When Philip subsequently turned against the count of Flanders in a dispute over control of the Vermandois, Henry was again called in to resolve the conflict as the 'elder statesman' of Europe. Prior to his departure to the conference, on 22 February 1182 he dictated his last testament as a precaution, sending a copy to the royal treasury at Westminster and another to Canterbury cathedral for safety. Once in France, he presided over the reconciliation process, surrounded by his former enemies; also present with the king of France and count of Flanders was Henry, the young king, and William, king of Scotland. Chroniclers were moved to write that, 'We have read of four kings falling together in the same battle, but seldom have we heard of four kings coming peacefully together to confer, and in peace departing.' Unfortunately, it was to be the last peace Henry was to know.

*

Despite all his efforts, Henry's land-share model for federal government fell apart during the next seven years. It is easy to blame the ageing king for failing to relinquish his grasp on power, but this argument does not hold water. In 1181 he had passed Brittany over

to Geoffrey to govern in person, and permitted Richard a free hand to tackle the Aquitainian lords. However, Richard's hand was too heavy, and soon loud complaints could be heard emanating from the deep south as his tactic of imposing long-dormant ducal rights on traditionally independent lords was criticised amid accusations that he 'oppressed his subjects with burdensome and unwanted exactions and by an impetuous despotism'.

The problem was that the legend of Eleanor's court of love epitomised the romantic ideal of the emerging code of chivalry, but there was a darker side that required knights to prove their mettle in battle, especially 'free lances' that were not attached to the household of a particular lord and could therefore ill-afford to take part in the many tournaments that were held around the counties of France and across the Holy Roman Empire. Troubadours such as Bertran de Born earned their living composing songs of knightly heroic deeds, but during times of peace he sang to a different tune. In a deliberate attempt to cause discontent, Bertran would write political songs inciting violence or mocking the various lords in the hope of stirring up local conflict between them – a medieval version of preachers of hate: 'I would that the great men should always be quarrelling among themselves.' Richard brought peace, and it was not to the liking of Bertran and his comrades. Yet trouble was always just around the corner. After the death of Vulgrin, count of Angoulême, in 1181, Richard attempted to impose northern principles of feudal jurisdiction, and claimed that Vulgrin's infant daughter should be the heiress (and therefore the duke of Aquitaine's ward), when according to southern custom the county should have passed to one of Vulgrin's two brothers. Despite the exhortations of Bertran, who had spotted a chance to make mischief and stir up trouble amongst the local barons, the ensuing uprising was somewhat half-hearted; nevertheless, the noise of further unrest coming from Aquitaine forced Henry to intervene. He called the leading lords to a conference at Grandmont

in the spring of 1182, shortly after his diplomatic mission to France, and, when the results were inconclusive, helped Richard crush the rebellion via a campaign in the Limousin.

This intervention by Henry in Aquitainian politics was an exception rather than the norm and, although he was concerned by some of Richard's methods, Henry was happy to let him continue as ruler. The real cause of the old king's problems was his oldest son, who – unlike Richard and Geoffrey – showed no interest or aptitude for government, yet resented the fact that he held no territory of his own, failing to recognise that hard work, diplomacy and administrative skills were required to wield power. Young Henry had left England in 1176 and headed straight for the glamour of the tournament circuit across France, where he built up a reputation as a dashing, handsome and generous knight who was immensely popular and charming. Young Henry had been assigned to the care of William Marshal, who mentored him in the code of chivalry: 'When in arms and engaged in war, no sooner was the helmet on his head than he assumed a lofty air, and became impetuous, bold, and fiercer than any wild beast.' However, it is likely that the siren calls of the troubadours encouraged him to spend money profligately on lavish feasts and in supporting his retinue of young knights, leaving him impoverished, dependent on his father for funds, yet resentful that he could not enjoy the revenues of the lands that he saw as rightfully his. Young Henry struck up a close friendship with the count of Flanders in the late 1170s, and became equally attached to his brother-in-law Philip of France in the early 1180s.

In 1182, Henry had summoned his oldest son to join the campaign in the Limousin at the siege of Perigord, reinforcing the concept that the family pulled together during a time of trouble; but – as always – young Henry dallied along the way and arrived late. Towards the end of the summer, the young king demanded 'that he be given Normandy or some other territory, where he and his wife

might dwell, and from which he might be able to support knights in his service'. The request was rejected out of hand as impertinent, and young Henry stormed off in disgust to the court of his brother-in-law, Philip. This was exactly the same pattern of behaviour that had led to the war in 1173, and Henry was sufficiently alarmed to relent partially. A string of messengers sent to Paris carried offers of money – 100 livres Angevin (around £25 sterling) per day for young Henry, and 10 livres Angevin for his wife. This overly generous offer seemed to do the trick, with the message sent back that young Henry 'would not depart from his [father's] will and counsel, nor demand more from him'. These proved to be hollow words, and the real reason for his strange behaviour during the summer became apparent when the family assembled for Henry's Christmas court at Caen in Normandy. The peace was disturbed when William Marshal burst into the ducal residence, demanding to be heard. Shaking with anger, he formally requested that he be permitted to challenge the young king in trial by combat as a way of proving his innocence in relation to certain scandalous allegations brought against him – namely, that he had conducted an inappropriate affair with young Henry's wife, Margaret. This was a serious charge, and almost certainly untrue; although Marshal's request was denied and he was banished from court in disgrace, the incident deeply unsettled Henry and raised suspicions about what was really going on within the young king's household.

The family had been discussing matters of great importance. Marshal's interruption and subsequent banishment had clearly added to the tension of the debate. Instead of heading their separate ways, the sons accompanied Henry to his next destination at Le Mans in January 1183. It was here that a huge argument erupted between young Henry and Richard, 'for whom [Henry] had a consuming hatred'. At the heart of the matter was the young king's confession that, 'He had pledged himself to the barons of Aquitaine against his brother Richard, being induced to do so because his

brother had fortified the castle of Clairvaux, which was part of the patrimony promised to himself, against his wishes.' As to who had put such thoughts in his head, it is interesting that Bertran de Born – the notorious troublemaking troubadour – had written,

> ... between Poitiers and l'Île Bouchard and Mirebeau and Loudun and Chinon, someone has dared to build a fair castle at Clairvaux, in the midst of the plain. I should not wish the Young King to know about it or see it, for he would not find it to his liking; but I fear, so white is the stone, that he cannot fail to see it from Matheflon.

Equally, young Henry might have been encouraged by King Philip, a fast learner about the benefits of sowing discord amongst one's enemies – truly his father Louis's son.

Richard was furious; technically, Clairvaux had been under the control of Anjou, but was situated at the very northern tip of Poitou and therefore claimed by his jurisdiction. Furthermore, the confession that young Henry had been actively undermining Richard was tantamount to admitting that he was planning a coup; no wonder young Henry had dragged his feet when summoned to join in the family assault on the Aquitanian barons, with whom he was probably in cahoots or at least sounding out the opportunity for an alliance. Given young Henry's characteristics, he represented a much more palatable proposition to the locals than his iron-willed brother. Henry senior tried to defuse the situation and persuaded Richard to hand Clairvaux over to young Henry, whilst summoning the discontented Aquitainian barons – mainly the Taillefer and Lusignan families – to meet him and his sons at Mirebeau; Geoffrey was entrusted to deliver the message in person.

As the court moved on to Angers, Henry tried once again to resolve matters. However, in trying to provide some clarity over his plans for the division of territories, the king made a terrible blunder. His insistence that they all swore obedience to him and perpetual

peace to one another, as well as acknowledge that his decision to divide the territories, along the lines agreed in 1169, was acceptable; his insistence that Richard and Geoffrey swear oaths of allegiance to young Henry as the future head of the family commonwealth provoked a furious response. Richard angrily refused to comply, on the grounds that they were brothers of equal birth status. As his father grew more exasperated, Richard grudgingly relented – only for the young Henry to refuse unless the oaths were sworn on the Gospels. This enraged Richard still further, and he argued that he held Aquitaine from his mother, not his father, directly from the king of France, so there were no grounds on which he should perform homage to his brother. Having made his feelings clear, Richard stormed out of the conference 'leaving nothing behind him but altercations and threats' and 'returned in haste to his own territory and fortified his castles and towns'.

Henry was 'incandescent from the heat of anger' but, after he had calmed down, the young king approached him and offered to follow his brother to Aquitaine and broker a peace between Richard and the barons. Despite a natural wariness of his eldest son's intentions, the old king was pleased that he was taking the situation seriously and wanted to salvage the succession plans. On these grounds, Henry gave permission for him to travel south. However, this proved to be another catastrophic mistake; the young king immediately sent his wife to Paris for safe keeping, as his intention all along had been to follow up on his conversations with the Aquitainian barons and go to war against Richard. As soon as he crossed the border from Anjou, the young king 'secretly accepted security from the counts and barons that they would faithfully serve him as their lord and would not depart from his service', and prepared to evict Richard from Aquitaine so that he could claim it for his own.

Henry found out about his son's betrayal in February 1183; he had followed the young king into Limoges with a small escort, ostensibly to lend support should it be required. Instead he was

stunned to find young Henry inside the city conversing happily with the rebel leaders – and even more shocked when the residents opened fire on him with arrows, one of which ripped through his cloak. Negotiations between the two sides lasted several days, even though Henry did not have enough men to besiege the city, despite the city's defences still being in a state of disrepair after Richard's previous assault. Yet Henry was even more dumbfounded when a large contingent of Breton mercenaries arrived on the scene, led by Geoffrey – not to help him, but to lend support to the young king's attempted coup.

This was a bitter blow, but completely in character; Geoffrey was said to be 'overflowing with words, smooth as oil, possessed by his syrupy and persuasive eloquence, able to corrupt two kingdoms with his tongue, of tireless endeavour and a hypocrite in everything'. It's likely that Geoffrey had arranged the finer details for the coup when he left court at Le Mans to summon the barons to Mirebeau. Worse still, King Philip – who had grown particularly close to his brother-in-law – saw an opportunity to cause trouble and, declaring an interest in southern affairs as the overlord of both Henry and Richard, moved into the region with armed forces. Other local powers waded into the fray, including the count of Toulouse and the duke of Burgundy. By the spring, Aquitaine was seriously destabilised by the crisis and slid towards anarchy as the various factions struggled for supremacy. For Henry, the similarity with 1173 must have been striking, but things were a little different this time. For a start, not all his sons were ranged against him and Richard was a formidable ally, able to call upon mercenaries of his own to confront the rebels. With restless energy typical of his family, Richard moved across Poitou, routing the Breton forces that had invaded, butchering or mutilating them without mercy. Limoges was besieged, and rebel castles attacked.

Suspecting his position had become hopeless, young Henry slipped out of Limoges to join his allies in Angoulême, before

moving further south in May without any clear strategy. Indeed, he was so short of cash to pay his troops that he resorted to raiding monastic houses and shrines including Rocamadour, one of the most famous in Europe. Around 25 May, he contracted dysentery and slowly made his way back towards Limoges. By 7 June he had reached Martel, but it was clear to his followers that he was dying. Young Henry made his confession and received the last rites, and asked that his father meet him one final time: 'He was smitten with remorse and sent to his father that he would condescend to visit his dying son.' However his duplicity earlier in the year meant that Henry was highly suspicious; the king's advisors were wary of a trick, and he did not go. Instead, Henry did send a ring 'as a token of mercy and forgiveness and a pledge of his paternal affection'. However, it was too late: 'On receiving the ring the son kissed it and immediately expired,' on 11 June. The news of his death was broken to Henry as he sheltered from the hot sun in a humble peasant's cottage, whilst still besieging Limoges. The king was stricken with grief: 'He cost me much, but I wish he had lived to cost me more.' Nevertheless, business came first. Limoges surrendered on 24 June, Geoffrey fled back to Brittany and Philip – no longer able to claim he was supporting his brother-in-law – withdrew, as did the count of Toulouse and duke of Burgundy. Richard and Henry mopped up the opposition; Bertran de Born's castle at Hautefort was among the castles that were seized, probably to the great satisfaction of all who had been on the receiving end of his pithy songs.

The young king's funeral took place at Rouen on 3 July 1183, after which Henry met with his remaining sons at Angers to reconsider his plans for governing the family lands. There is evidence that he was softening his tone towards his captive wife at this time as well, allowing Eleanor to undertake a tour of her dower lands in England, which she gratefully seized. It was a shrewd move to bring her back into the family circle, as it was not long before his sons were quarrelling again; the more Henry tried

to clarify his intentions, the more upset he caused. In September, he unveiled a new model for the division of lands – Richard was to hand Aquitaine to John, and take up the role that young Henry had performed as heir to England, Normandy and Anjou. Unsurprisingly, given his upbringing in the south and the amount of hard graft he had put into the subjugation of Aquitaine, Richard refused – especially as there were grave concerns about John's youthful lack of experience, which was probably the last thing that was required after the turbulence of the last two years. Once more, Richard departed a family conference in anger and headed south.

One can almost hear Henry gnashing his teeth in frustration at the unwillingness of Richard to cooperate; he had misunderstood the passion that his son felt for the land he'd come to think of as home. Despite all the heartache that military intervention had caused, Henry's initial reaction was to challenge John to raise an army and take Aquitaine by force, but Henry's youngest son had no source of revenue and it would appear to have been a half-hearted gesture made in anger. By August 1184 the king was back in England, but no sooner had he left the continent than Geoffrey was stirring up trouble once more, persuading John to raise an army to invade Poitou – although in reality the campaign amounted to little more than border raids in which they 'burned towns and carried off booty', provoking Richard to retaliate and strike back against Brittany. Henry did what any exasperated parent would do and summoned all his children to England for a dressing-down; they stayed with him until the end of 1184, and in December the king 'made peace between his sons'.

It is very easy to focus on a decade of family squabbles, in the way that the Becket affair tends to dominate the manner in which Henry's earlier reign has been depicted. The old king's failure adequately to resolve his succession should not mask the fact that he was still held in high regard internationally, evidenced by the willingness of former enemies to turn to him for mediation.

Perhaps the most powerful indication of Henry II's standing at this time as Europe's elder statesman came in 1185, when the patriarch of Jerusalem visited the royal court at Reading on 29 January and, with theatrical gravitas, approached the king and placed the banner of the kingdom of Jerusalem, complete with the keys to the city, the keys to the tower of David and the keys to the Holy Sepulchre at his feet. He then formally offered the throne to Henry.

For some, this would have been the greatest honour imaginable, and certainly represented a remarkable turnaround in the relationship between Henry and the church from the dark days of 1170. However, this was a poisoned chalice; as Henry was to remark to Gerald of Wales, 'If the patriarch or anyone else comes to us, it is because they are seeking their own advantage.' The situation in the Holy Land was grim. The remarkable rise of Saladin as the leader of the Fatimid government in Egypt, and his subsequent conquest of Syria and much of the surrounding territory, now posed a direct threat to the remaining Crusader states, in particular the kingdom of Jerusalem. Its leader was the ailing Baldwin IV, Henry's cousin – they shared the same grandfather, Fulk V of Anjou, who had settled the county of Anjou on his son Geoffrey so he could marry the kingdom's heiress, Melisende, on 2 June 1129. Baldwin was aware of the military threat to his borders and was looking for a warrior to succeed him; the offer to Henry was a way of continuing the family connection.

However, with the succession of his own lands clearly unsettled, Henry was reluctant to follow the example of his grandfather and abdicate – although in hindsight this might have been the perfect opportunity for him to exit centre stage with his reputation largely undamaged. Instead, the king summoned a council in March to discuss the issue in a suitable setting in Clerkenwell, inside the church of the Knights of St John of Jerusalem. All leading vassals were invited, including William of Scotland and his brother David – making the point that they were considered tenants-in-chief of

the king. The advice that Henry was given in relation to Jerusalem sounds very familiar to a modern audience:

> It seemed better to all of them, and much for the safety of the king's soul, that he should govern his kingdom with due care and protect it from the intrusion of foreigners and from external enemies, than that he should in his own person seek the preservation of Easterners.

To Henry's mind, the uncertainty around the succession and the violent squabbles of his children made it impossible for him to leave. Nor was it possible to extend the offer to one of his children, despite the desperate enthusiasm of his youngest son John who – on bended knee – begged permission to go; Henry had other plans, and dispatched him to Ireland to claim the lordship that had been given him in 1177. However, the campaign was a disaster. John was accompanied by a coterie of young knights who offended the local chiefs, sidelined the Anglo-Norman planter families, spent all the campaign funds on revelry, and united everyone against him. Meanwhile, Henry agreed to confer with Philip of France about aid for Jerusalem, perhaps a tacit recognition of French primacy in the Holy Land: Fulk V had sought permission from his overlord, Louis VI, before accepting the offer of marriage to Melisende and abdicating Anjou. The two kings agreed to offer money to help support an army, but this was not what the patriarch wanted: 'Almost all the world will offer us money, but it is a prince we need; we would prefer a leader even without money, to money without a leader.' Instead, Jerusalem passed to Baldwin's step-father, Guy de Lusignan – thus strengthening the renown and influence of Richard's troublesome vassals in the south of France and reinforcing the view that they were independent lords in their own right.

With Henry making it clear that he was staying to put his own house in order, family divisions surfaced once more with John's

departure to Ireland. Henry had instructed Geoffrey to return to Normandy and hold it in custody, possibly a sign that he intended a new configuration whereby he would formally unite Brittany and Normandy under one ruler, in combination with England and Anjou, leaving Aquitaine as an independent entity. Details of events in the spring of 1185 are somewhat unclear, but it seems Richard had once more mobilised his troops, forcing Henry to return to Normandy in April 1185. To all appearances, Henry was losing control of his lands and his sons, and he took drastic action to wrest control of Aquitaine back from Richard. Henry had brought his estranged wife over to the continent with him and ordered Richard that 'he should without delay render up to Queen Eleanor the whole of Aquitaine with its appurtenances, since it was her inheritance, and that if he declined to comply, he should know for certain that his mother the queen would take the field with a large army to lay waste his land'. With the ultimatum issued, a family conference was arranged in May and Richard, 'laying aside the weapons of wickedness, returned with all meekness to his father; and the whole of Aquitaine with its castles and fortifications he rendered up to his mother'. A form of peace then descended on the family, but as 1186 dawned it is hard to describe their relationship as anything other than dysfunctional, with any appearance of harmony to the outside world no more than superficial.

*

There were many factors behind the decline and fall of the Angevin dynasty in the early thirteenth century. However, we can trace the origins of the long war with Capetian France to 1186, when Philip increasingly sought ways to intervene – many would say interfere – in Angevin affairs. Henry should not have been surprised; from the very outset, Philip had shown an independent spirit in the way he tackled the influence of his mother's family, and then wrested control away from his regent the count of Flanders, during the early

part of his reign. Philip now signalled his intention to undermine the powers of Henry, as part of a longer plan to turn the nominal authority of the king of France over its traditionally independent vassals into a more practical version of reality. In March 1186, Henry and Philip held a conference at Gisors to resolve the outstanding issue of Richard's marriage to Alice, given that they had been betrothed for a well over a decade; Philip agreed that the dower lands of the young king's widow Margaret – the much-prized Norman Vexin – should transfer to Alice, thus providing an incentive for the marriage finally to take place. Henry and Eleanor returned to England, entrusting Richard with yet another campaign in the south, against the count of Toulouse.

The agreement at Gisors spelled trouble for Geoffrey; it seemed clear that Henry had reverted to his original plan of handing England, Normandy and Anjou to Richard. Running out of options within his own family, Geoffrey reverted to the tried and tested tactics and joined his close friend Philip in Paris to stir up trouble once more. He seems to have spent most of the summer at the French court, and it is likely that he was plotting with Philip, allegedly boasting in August, with typical bravado whilst they were preparing for a tournament, that he would lay waste to Normandy. However, tragedy struck; on 19 August, whilst involved in a mêlée during the staged combats, Geoffrey fell from his horse and was trampled to death. Philip was overcome with grief and, at his friend's funeral, his household knights had forcibly to prevent him from flinging himself into the grave as well.

Geoffrey's death marked a hardening of Philip's attitude towards Henry. In September he demanded custody of Geoffrey's two young daughters, and that Brittany be placed into his hands; a third child, Arthur, would be born posthumously in March 1187. He also sought to prevent any further military action against the count of Toulouse, making a veiled threat that he considered Henry's actions tantamount to an invasion against a fellow vassal

of the king of France, thus placing Normandy at risk of attack or even judicial confiscation. Henry backed down and a truce was agreed in October, but Richard was not recalled from the south until the two sides met again in February 1187, when a third cause of complaint was raised – Richard's failure to marry Alice. Fuelled by rumours that Henry had seduced his son's intended bride, and thus besmirched the dignity of Philip's sister, Philip demanded the return of the Norman Vexin. This was now a Cold War turned hot. The disputed territory became the flashpoint for conflict between the sides for the next two decades; mercenaries were brought into the region, raising the tension as cross-border skirmishes became more common. Both sides arrested foreign-born nationals living in each other's territories. Philip marched his army into Berry, where Angevin and Capetian rights and lands were inter-mingled, an act of military provocation that prompted Henry to mobilise his troops in response. The two sides faced each other in the fields outside Châteauroux, in full battle gear, on 23 June; the fate of two kingdoms hung in the balance. Pitched battles in the medieval period were very rare, especially between kings, given contemporary beliefs that trial by battle conferred divine judgment on the outcome; it is why Hastings holds such an important place in English history.

Châteauroux did not result in a decisive armed showdown. This was partly due to the presence of the papal legate Octavian, who was agitating for a truce because the pope wanted to secure the support of both parties for a crusade. The news coming out of the Holy Land had become increasingly grave, and unbeknown to the parties negotiating in the warm fields of France, time had already run out. On 4 July Guy de Lusignan was crushed by the forces of Saladin on the hot, dusty plains of Hattin; the crusader army was annihilated, Guy was captured and Jerusalem fell into Muslim hands, sending shockwaves around Europe. This was still in the future; Henry and Philip had other matters to occupy them

during the shuttle diplomacy between the two armies facing each other at Châteauroux. Neither wished to climb down or lose face; the risk of battle remained real, and the atmosphere tense, as envoys passed between the camps. Many of the potential combatants were well known to one another, having competed on the tournament circuit or through shared family ties, and were therefore somewhat reluctant to engage in a fight to the death. In the end, diplomacy won the day and Henry conceded Philip's right to two of the disputed lordships, and both sides agreed a two-year truce. However, one outcome from the stand-off at Châteauroux was of monumental importance – Philip had fatally undermined Richard's relationship with Henry.

Philip's agent of subversion was none other than the count of Flanders, a cruel irony given Henry's attempts to patch up his relationship with the king of France during the early years of Philip's reign. It was during the various negotiations in the meadows surrounding Châteauroux that the count drew Richard to one side to relay a personal message from Philip:

> Many of us believe that you are acting extremely foolishly and ill-advisedly in bearing arms against your lord the king of France. Think of the future: why should he be well disposed towards you, or confirm you in your expectations? Do not despise his youth: he may be young in years, but he has a mature mind, is far-seeing and determined in what he does, ever mindful of wrongs and not forgetting services rendered. Believe those with experience; I too once ranged myself against him, but after wasting much treasure I have come to repent of it. How splendid and useful it would be if you had the grace and favour of your lord.

Think of the future – four words that struck at the heart of the issue and made Richard realise that he was the next generation, a young warrior compared to his visibly ageing father. His head was turned,

and he agreed to meet Philip in person; when the negotiations were complete, Richard accompanied Philip to Paris where,

> Philip so honoured him that every day they ate at the same table, shared the same dish and at night the bed did not separate them. Between the two of them there grew up so great an affection that King Henry was much alarmed and, afraid of what the future might hold in store, he decided to postpone his return to England until he knew what lay behind this sudden friendship.

As a gesture of political defiance, nothing could be clearer; once again, the king of France had driven a wedge between Henry and his eldest son, and he continued to exert a malign influence over Richard, planting the first seeds of doubt that Henry planned to disinherit him, or marry Alice to John.

In the days that followed the stand-off at Châteauroux, and as news of the fall of Jerusalem reverberated around Europe, attention briefly turned away from dynastic rivalry towards cooperative military and financial action in the Holy Land. Richard took the cross in November 1187, and superficially appeared to return to the family fold; the Saladin tithe was levied throughout England to pay for the upkeep of a crusading army. However, it was not long before Richard returned to his ceaseless battle for control in the south of Aquitaine, where yet another revolt had broken out in early 1188. It was also clear that Richard's relationship with Henry had changed forever and he now acted alone, paying little heed to his father. Henry's determination not to show his hand over the succession did not help; with only two sons left, and a general favouritism towards John, in whom he saw more of his own characteristics, it was now his policy to keep them guessing, further fuelling the sense of mistrust that Richard bore him.

It was in this atmosphere that entirely baseless rumours began to swirl around that Henry had deliberately stirred up new Lusignan

opposition to Richard's rule, which broke out around this time. Normally, Richard would have seen through this nonsense but it seemed that the slightest hint of interference had 'alienated his mind from his father'. Philip turned the screw still further. Having defeated the Lusignans, Richard then continued his war against the count of Toulouse, yet it was to Henry that Philip addressed his displeasure over Richard's actions. Henry responded despairingly that he had totally lost control of Richard and therefore, by extension, Aquitaine as well. Yet Philip could not – or would not – allow his own authority to be undermined by Richard's unauthorised private war against a fellow vassal of the king of France, so in June 1188 he marched once more into Berry, seizing further Aquitainian lands in the disputed province.

This time, the sense of impending crisis refused to go away, despite Philip's withdrawal from Berry after Henry raided his lands to the north. Negotiations failed to produce peace, with both sides raising the stakes; in a show of anger Philip even chopped down the ancient oak at Gisors where the king of France and duke of Normandy traditionally met for peace conferences. A further meeting in October similarly failed to provide a solution, with Richard angering his father by agreeing to have his dispute with the count of Toulouse heard in Philip's court. This also marked the moment when Richard switched sides and

> . . . became reconciled to the king of France because he had
> heard that his father wished to defraud him of the succession
> to the kingdom, in that he intended, as rumour had it, to
> confer the crown of the kingdom upon his younger son
> John. Disturbed by this, and small wonder, Richard tried
> to soften the mind of the French king, that in him he might
> find some solace if his own father should fail him.

The unfolding tragedy was thrown into sharp relief on 18 November at the next conference, arranged by Richard, at

Bonmoulins; it did not augur well that Richard arrived in the company of Philip. The meeting was a tense affair. Although it started amicably enough, sharp exchanges became outright threats, leading knights on both sides to reach for their swords in case matters escalated still further. Philip once again demanded that Henry should arrange for Richard and Alice to be married, and declare Richard to be his heir; Henry angrily rejected the request, refusing to be blackmailed into having his family's succession plans dictated to him by an outsider. At this, Richard turned to his father and asked to be confirmed as his heir, but Henry remained silent. Incredulous, Richard glared at him for a moment and then said, 'I can only take as true what previously seemed incredible' – indicating that he believed that he was about to be disinherited by his father. Slowly, he unclasped his sword belt and knelt before Philip and did homage for Normandy, Anjou, Maine, Aquitaine, Berry and lands in Toulouse – effectively usurping his father's authority. The conference broke up in shock; Richard and Henry walked away from each other in opposite directions without a further word.

Despite an agreement to meet up again in January 1189, this was effectively a declaration of war, and a far more serious betrayal than in 1173 – this time Henry was old and clearly past his prime; Richard and Philip were the future, making it much harder for the old king to rally support. Nervously, he readied the defences of Normandy, Anjou and Aquitaine; but when he held his Christmas court at Saumur, many of the usual attendees decided to stay away. Henry fell ill and cancelled the proposed meeting in January, but Philip refused to believe his excuse was genuine and began to wage war along the borders; the Bretons rose in rebellion, sensing an opportunity to exploit the situation to their own advantage and throw off the yoke of Norman dominance. In desperation, Henry sent envoy after envoy to Richard, entreating him to come back to his father, but by now Richard no longer believed anything that Henry said to him. Finally, another meeting was arranged

on 28 May at La Ferté-Bernard in Maine. Richard and Philip laid down three conditions for peace – to the familiar demands for the marriage with Alice, and recognition of Richard as heir, was added a requirement that John should accompany his brother on crusade. Once again, Henry refused, perhaps believing that the presence of papal legate John of Agnani would help his negotiating position, given the threat of interdict hanging over Philip if he failed to reach agreement. However, Philip was not to be cowed and simply observed that the legate's moneybags were full of English silver. The conference broke up once more, and Henry made his way slowly back to Le Mans.

The conventions of medieval warfare required Philip and Richard to withdraw to the frontier, but instead they seized La Ferté-Bernard and pressed on towards Le Mans, capturing castles as they went. On 12 June, they reached the outskirts of the city and, after a furious assault, broke into the lower town. In a desperate attempt to prevent the enemy forces from capturing the main citadel, the defenders set fire to the suburbs. However, the plan backfired as the wind changed direction, blowing the flames into the heart of the city. Before long Le Mans was a blazing inferno. Henry was able to make a hasty retreat with an armed escort, reaching a small hill a few miles to the north where he sat silently on his horse whilst he watched his birthplace burn; perhaps he was reflecting that the fate of Le Mans was an apt analogy for his relationship with Richard. It was too much for him, and he started cursing God for the fate that had befallen him. However, he did not wait long; although Philip halted the march, Richard continued to pursue his father towards Normandy. Riding hard, he caught up with Henry's rearguard, under the command of William Marshal. Realising the danger, Marshal turned his horse and rode straight at Richard who shouted, 'By God's legs, do not kill me, Marshal. That would be wrong. I am unarmed.' 'No,' replied Marshal, 'let the devil kill you for I won't,' and ran Richard's horse through with a lance, unseating him and making a clear point that

he had spared Richard's life. With the pursuit in chaos, the king's party rode hard until they were within ten miles of Alençon, and the prospect of relative safety behind the stone walls of one of Normandy's great fortresses where they could regroup.

Instead, and despite the exhortations of his closest advisors, Henry changed direction and made his way back south towards Anjou. He was a broken man, and no longer had the stomach for yet another cycle of rebellion, suppression and reconciliation. Whilst Philip and Richard overran Maine and Touraine, Henry finally reached his castle at Chinon, where, exhausted by the dangerous journey through enemy lines and fatigued by the heat, he succumbed once more to illness. On 2 July, French envoys reached Chinon and demanded a meeting so that terms could be discussed. Two days later, after Tours had also fallen, Henry agreed and they met at Ballon. However, he was crippled with pain, barely able to mount his horse; even Philip was moved to proffer his enemy a cloak so he could sit on the ground rather than discuss matters whilst mounted. Proud to the last, Henry refused and listened, propped up in his saddle by attendants, whilst Philip dictated the humiliating terms for peace. Henry was to place himself at Philip's mercy, perform homage for all his continental possessions, recognise Richard as heir, arrange for Alice and Richard's marriage once Richard had returned from the Holy Land, hand over various key castles as a sign of goodwill, and – the ultimate insult – pay Philip 20,000 marks indemnity for the trouble that had been caused. Henry agreed to everything, but Philip was not finished yet; he had to give the kiss of peace to his son. As he leant forward to do so, Henry growled in a low voice into Richard's ear: 'God grant I die not before I have worthily revenged myself on you.' Too exhausted to ride back to Chinon, Henry was borne away in a litter as thunder started to roll overhead, breaking the oppressive summer heat. Two days later, shattered by the news that his favourite son John had joined the rebellion against him, Henry was dead.

4

The loss of Normandy

O ye gods, if these illustrious brothers had been united
by the ties of fraternal love, and had regarded their
father with filial affection, if they had been bound
together by the twofold cords of good will and of
nature, how great, how inestimable, how splendid and
incomparable in the present age, would have been the
glory of the father, and the triumphs of the sons?

GERALD OF WALES

Look to yourself. The devil is loose.

PHILIP AUGUSTUS TO JOHN, 1193

As twilight descended in the south of France on 26 March 1199,
King Richard wandered out of his tent after supper and started to
inspect his troops, sharing a few words or jesting with men with
whom he had campaigned for many years. The king's army was
besieging the castle of his age-old foe, Viscount Aimer of Limoges,
at Châlus-Chabrol just to the south of the viscount's city. This
was familiar territory in every sense of the word: since the 1170s,
Richard had been campaigning in the south of Aquitaine against
the rebellious families of the region. The latest outbreak was part of
an ongoing border war between Richard and King Philip, who had
been such close friends ten years previously but were now bitter
enemies. Although a temporary truce had been arranged to halt
the military conflict in the north of Richard's lands, the southern
barons of Aquitaine who had supported Philip were excluded
from the terms of the armistice and now Richard had ridden to

exact his revenge for their disobedience. He joined Mercadier, a mercenary who had first served Richard in the campaigns of 1183–4 and had risen to be his trusted and feared commander. Together they 'devastated the viscount's lands with fire and sword' before investing the castle at Châlus-Chabrol, bringing sappers to burrow underneath and weaken the walls, protected as they did so by specially adapted shelters whilst Richard's crossbowmen kept up covering fire from a safe distance. Richard had successfully pitted his wits against far more challenging constructions than Châlus-Chabrol; it would not take long before the small garrison would surrender.

Richard continued to stroll amongst his encamped men, observing the latest developments in the siege as the walls started to creak and groan as the sappers continued their work. That evening, he spotted that a lone defender was patrolling the ramparts, armed with only a crossbow and a frying pan to defend himself in a token show of defiance. On a whim, Richard asked the nearest crossbowman for a weapon; he liked to keep his aim sharp with constant practice. Richard was largely unprotected, carrying only his shield as cover against any incoming bolts fired from the walls, but there was little risk; Richard's men were used to dodging the occasional pot-shots that were fired down at them, and they were highly amused that their leader was now going to have a crack at the defender – this was splendid entertainment, the doomed guard pitted against the hero of the Holy Land. As Richard armed himself, the man took aim and fired his shot. Impressed with the accuracy, the king applauded and ducked back behind his shield as the bolt hurtled through the air towards him. However, he slightly mistimed his evasive action and the bolt hit him in the left shoulder. Despite the pain the blow must have caused, Richard made no sound – he did not wish to alarm his men, or give encouragement to those inside the castle; maybe he felt a tinge of embarrassment for his foolish bravado – and made his way back to his tent, where

he tried to pull out the bolt. However, all he succeeded in doing was breaking the wooden shaft, leaving the iron tip embedded in his flesh. As a seasoned campaigner, Richard knew the danger of infection and called for a surgeon. Darkness was now descending, and with only the flickering light of torches to work with, the surgeon cut and probed until he finally managed to extract the remainder of the bolt. However, the king's shoulder was severely damaged – 'carelessly mangled' in the words of one chronicler – as a result of the procedure; the wounds were bandaged up, and all Richard could do was hope for the best.

The siege continued without him as he stayed in his tent – only his most trusted advisers were allowed in to see him. The prognosis grew increasingly bleak by the day; infection had indeed set in and the wound had turned gangrenous. As Richard's health deteriorated, he wrote to his mother, asking her to come and see him before the end. Châlus-Chabrol finally fell, and the garrison were executed; Richard continued to direct operations against the viscount of Limoges from his bed, instructing his commanders that the next targets should be Nontron and Montagut. However, the man who fired the crossbow was brought before the dying king on 6 April; his identity is uncertain, with sources naming him either Peter Basile or Bertrand de Gourdon, whilst some claimed he was little more than a boy. Weakly, Richard muttered, 'What wrong have I done you that you should kill me?' The man replied 'With your own hand you killed my father and two brothers, and you intended to kill me. Take your revenge in any way you like. Now that I have seen you on your deathbed, I shall gladly endure any torment you may devise.' Richard smiled, forgave him, and ordered his release. By now, Eleanor had arrived but there was nothing more that could be done. Richard set his affairs in order, naming his brother John as his heir and bequeathing his jewels to his nephew Otto. As dusk fell, the king's almoner, Milo, heard his confession and administered extreme unction. Richard slipped

away as he lay in his mother's arms, and Milo closed the dead man's eyes and mouth. Mercadier dragged Richard's killer away and, despite his master's dying wishes, he was flayed alive and hanged.

*

In many ways it was fitting that Richard should die on campaign in Aquitaine; it was where his heart and soul belonged, drawn there since his time as a child, growing up under the influence of Eleanor, versed from an early age in the art of war amongst the bellicose and troublesome lords of the south. Most of his adult life had been spent in the saddle on campaign, restlessly pursuing his interests in Poitou and Gascony against stiff opposition whilst fending off the attempts of his family to wrest control away from him. Yet, after his Crusade to the Holy Land, Richard largely turned his back on his southern homelands and devoted the second half of his brief reign to an increasingly desperate struggle to hold the Norman frontier against repeated assaults by Philip, his erstwhile friend and co-conspirator with whom he had plotted to bring down his father in 1189. Indeed, Henry's death at Chinon on 4 July 1189 was a direct result of Richard's merciless pursuit of his inheritance, and particularly his Aquitainian lands. As soon as he found out that Henry had died, Richard rode to Fontevraud abbey, where his father's body had been taken. Dismounting, he entered the building, taking a moment to locate Henry's resting place in the dimly lit interior, a sharp contrast to the bright sunshine outside. Richard strode down the aisle and then stood in thought for a while, silent; then turned and summoned one of the old king's faithful supporters, who had been standing guard in the church wondering what their fate would be, now their master was dead.

The man that Richard called for was none other than William Marshal, the knight who had unhorsed Richard during the pursuit from Le Mans. 'So Marshal, the other day you tried to kill me and would have done so had I not turned your lance aside.' William

protested furiously against this alternative version of the truth, but Richard cut him short – 'Marshal, you are pardoned. I bear you no malice.' In fact, this was an understatement; it seems Richard had been impressed with Marshal's skill as a warrior, a man after his own heart. On finding out that Marshal had been given the hand in marriage of Isabella de Clare, the richest heiress in England, by Henry, Richard exclaimed: 'By God's legs! He did not, he only promised to do it. But I give her to you now.' Marshal virtually ran out of the church and rode for Dieppe at top speed, nearly falling off the gangplank as he boarded the first ship to England such was his eagerness to marry Isabella before Richard changed his mind. From that point onwards, he was one of the new king's most loyal supporters, as well as one of the wealthiest and powerful men in the kingdom as a result of the marriage.

Richard's next act was to send instructions for his mother's immediate release from custody, with full restoration of her rights and a mandate to act as regent until he could travel to England. After spending so long as her husband's virtual prisoner, wheeled out to help resolve family differences, it is no wonder that Eleanor revelled in her freedom: 'Confinement is distasteful to mankind, and it is a most delightful refreshment to the spirits to be liberated therefrom.' One of her first tasks was securing the loyalty of the barons. Perhaps her liberty also slightly affected her judgement, as she ordered the release of captives imprisoned by the king's will alone – 'In her own person she demonstrated how grievous unjust imprisonment was for men, and how release aroused in them joyful revival of spirits.' Sadly, it also aroused a crime wave, with many of 'these pests' rounded up again to face royal justice.

Nevertheless, Richard was keen to draw a line under the recent past, especially his own act of revolt against his father, since he did not want to set a poor example for his new vassals. On a more practical level, the campaign against Henry had resulted in territory passing to Philip that Richard now claimed as his. After

he was sworn in as duke of Normandy at Rouen on 20 July, he went to a hastily arranged conference at Gisors two days later. Philip's demands to Henry, made just over a fortnight earlier, were repeated; Richard agreed to marry Alice, and pay the 20,000 marks with a surcharge of 4,000 marks for 'expenses'. In return, Philip returned all the conquered land with the exception of two lordships. Richard therefore inherited all of his father's possessions virtually intact, and moved quickly to head off any potential challenge from his main rivals, his younger brother John and older half-brother Geoffrey, Henry's bastard son born prior to his marriage to Eleanor. Geoffrey was ushered into the vacant archbishopric at York, thus ending any faint hopes he might have held of taking the crown; John was confirmed in all the lands Henry had promised him, namely the lordship of Ireland and county of Mortain. He also arranged for John to marry Isabella, heiress of the earl of Gloucester, bringing him land in the south-west and Welsh marches – and removing any possibility that he might marry Alice. This may have reflected 'his father's wishes', but deep down Richard probably suspected that John would have considered this provision to be inadequate. There was also the matter of finding land in England worth £4,000 for John; however, further settlement would have to wait until Richard had been crowned.

Richard crossed the Channel and arrived at Portsmouth on 13 August, with his coronation to follow on 13 September. On the day of the ceremony, a delegation of the leading magnates came to escort the king-in-waiting from his inner chamber in the palace of Westminster all the way to the high altar, which had been draped in a woollen cloth in preparation, at Westminster Abbey. Once the relics and regalia had been placed in their proper positions, the ceremony began in earnest with Baldwin, the archbishop of Canterbury, officiating.

First, Richard swore the traditional coronation oath to uphold the peace and honour of the church – particularly poignant given

his father's dispute with Becket – followed by an oath that he would 'exercise true justice and equity towards the people committed to his charge', remove bad laws or customs that had been introduced into the realm, and 'enact good laws, and observe the same without fraud or evil intent' – an important statement that the king was not above the law of the land, but subject to it alongside everyone else. Having sworn these oaths, Richard was then disrobed 'from the waist upwards, except his shirt and breeches; his shirt having been previously separated over the shoulders; after which they shod him with sandals embroidered with gold'. He was anointed with oil on his head, chest and arms to signify glory, valour and knowledge, with the archbishop incanting the appropriate prayers. A consecrated linen cloth was placed on his head, followed by the cap of maintenance, representing the care and duty required of the role. Richard was then dressed in the royal robes, handed the sword of rule 'with which to crush evildoers against the Church', and the gold spurs were placed on his feet. Moving to the altar, Baldwin exhorted him to observe the oaths and vows that he had made; Richard declared solemnly that 'with God's assistance, he would without reservation observe them all'. The crown was placed on his head and he took the sceptre and rod in each hand. Richard was now formally proclaimed king, and took his seat whilst mass was celebrated.

This is the earliest detailed description of an English coronation that now survives, but not everything went as smoothly as it seemed. A bat could be seen flitting around the rafters during the ceremony, and a mysterious peal of bells was heard – both taken as bad omens. Worse was to come; after the procession returned to the palace of Westminster for a sumptuous feast, large crowds of well-wishers gathered outside the gates. A small party of London's Jewish residents attempted to enter the palace, bearing gifts for the king; but, given the crusading fever that had swept the country following the fall of Jerusalem two years previously, shouts and

insults were hurled at them, quickly turning to violence. Several were killed and the rest wounded, driven away in fear of their lives. The rioting spread throughout London, with Jewish residences attacked and burned to the ground. On hearing the news, Richard was furious and rounded up the ringleaders of the anti-Semitic attacks for execution. He also proclaimed the entire community of Jews throughout the realm to be under his personal protection. This gesture of tolerance, at a time of militancy against all non-Christians, may have had a slightly more practical motive. The Jewish community held a monopoly on money-lending, given that usury was forbidden to Christians. Therefore Richard had now seized control of the credit market and was ruthlessly to exploit the fact that the Jews – including their assets and debtors – were essentially his private property and a ready source of cash.

A requirement to raise vast sums of money lay behind Richard's brief sojourn in England; this was coupled with the need to stamp his authority on the 'remote control' government that Henry had created, and ensure it would be sustainable whilst he was absent on crusade. Richard wanted to reward loyalty, but also remove unpopular figures from his father's regime to make room for his own appointments – a tricky balance between continuity and change. For example, Stephen of Tours, the much-maligned seneschal of Anjou, had been accused of financial 'mismanagement' and was dragged to England by Richard in chains, resembling the sacrificial figurehead of a conquered race paraded by a triumphant Roman general. However, he was able to recover his position in 1190 once Richard realised his uses. In England, the career of Ranulph de Glanville was brought to an end; he was imprisoned until he paid a ransom said to be £15,000, after which he took the cross and accompanied Richard to the Holy Land where he died at the siege of Acre. He was replaced as justiciar by two men, the powerful bishop of Durham, Hugh de Puiset; and William de Mandeville – Richard's crown-bearer at the coronation – who died

a few months later. Richard chose to replace him as co-justiciar with his chancellor, William de Longchamp. Longchamp was also rewarded with the bishopric of Ely, and other key clerics in Henry's administration, Richard FitzNigel and Hubert Walter – one of the most capable and imaginative officials of his age – were similarly granted ecclesiastical patronage through their nominations as bishops of London and Salisbury respectively. It was no coincidence that large sums of money changed hands to secure many of these new roles in the administration.

England's borders were also secured, with Richard turning to his family for support. John was sent to Wales to make peace with the native princes, whilst Geoffrey marched north to invite William the Lion, king of Scots, and his brother David, earl of Huntingdon, to meet Richard at Canterbury, where the king was busy exercising his diplomatic skills to resolve a dispute between the archbishop and the monks of the cathedral priory. An agreement, known as the quitclaim of Canterbury, was drawn up and solemnly attested by both Richard and William on 5 December. It formally acknowledged Scotland's independence from England, with Richard returning the castles that Henry had prised from William as part of the treaty of Falaise in 1174; the price of these favourable terms was 10,000 marks, another contribution towards Richard's war chest. Contemporary opinion was divided on the wisdom of this move, with Gerald of Wales calling it 'a piece of vile commerce and a shameful loss to the English crown'. It certainly reversed Henry's model of vassal states surrounding his core dominions, and 'freed Scotland from the heavy yoke of domination and servitude'.

Richard's driving need for money began to knock some of the gloss off his early popularity, as he used his time in England to 'put up for sale everything he had – offices, lordships, earldoms, sheriffdoms, castles, towns, lands, the lot'. Indeed, it was reported that he had quipped, 'I would sell London if I could find a buyer.' The highest bidders were usually Richard's inner circle of favourites,

who scrambled to buy land, status and the opportunity to make money – the old adage, speculate to accumulate. As a result, Richard raised a vast amount of silver, which was expended on hiring ships, purchasing supplies and armour, and recruiting men. Some 25,000 marks was sent to Normandy, presumably finding its way to Philip in lieu of the agreement at Gisors; yet it was estimated that Richard raised 'more than 100,000 marks' in ready cash, at least four times the normal annual revenue the king could expect to receive from the exchequer and nine times the amount that his demesne lands were worth at face value. This was money-raising on an industrial scale, 'the reckless expedients of a negligent king'.

It could be argued that Richard's negligence extended to the way he handled the role of his brother John, who was to stay behind whilst Richard travelled to the Holy Land. First, Richard needed to secure estates for him worth £4,000 in cash in England, so he granted him the counties of Derbyshire and Nottinghamshire, with the honours of Lancaster, Ludgershall, Marlborough, Tickhill, Peverel and Wallingford. If this was not already enough, the counties in the south-west, Cornwall, Devon, Dorset and Somerset, were also handed over in December, making John the largest landowner in England after the king. To observers, this was seen as dangerously generous: 'Many people said, both in public and in private, that if John's innate characteristics were not suppressed, his lust for power might lead him to drive his brother from the throne.' There is a certain truth to this sentiment, even if it was penned several years after John had indeed rebelled against Richard. Despite loading John with lands in England, Richard had given him riches without power. John could not help comparing the way his brother had been permitted to govern Aquitaine during their father's lifetime, or Geoffrey had been recognised as duke of Brittany and handed control of the duchy. In contrast, John held the lordship of Ireland, the most recent acquisition to the family's lands where the title was nominal at best. John's position was not

even comparable to the situation facing the young Henry in 1173, as he at least had been formally recognised as his father's heir in England, Normandy and Anjou.

Put simply, John could not be trusted. His belated support for Richard's rebellion against Henry in 1189, once he'd seen which way the wind was blowing, had raised serious doubts in Richard's mind about his brother's ambitions and he dared not entrust the government of any part of the main family lands into John's hands. Therefore, when Richard left for the continent on 12 December, control of England passed to the co-justiciars, William Longchamp and Hugh de Puiset; Normandy was entrusted to its seneschal, William FitzRalph; Stephen of Tours regained his position as seneschal of Anjou; whilst Peter Bertin received custody of Poitou and Elie de la Celle was charged with Gascony – emphasising once more the divided nature of Aquitaine. John was left to kick his heels, and plot.

*

Richard's departure from England was followed by a slow progress through his continental lands as he made arrangements for his journey to the east, and began the tortuous process of coordinating the campaign with the other leaders, King Philip Augustus of France and the Holy Roman Emperor, Frederick Barbarossa. On 30 December 1189, Richard and Philip met at Nonancourt and agreed a pact of mutual support, cooperation and protection which extended across each other's lands – though the unresolved matter of Richard's betrothal to Alice still lay between them. Whether Philip raised the question of the marriage is uncertain; however, Richard headed south and it is likely that at this point he opened negotiations with King Sancho VI of Navarre about the possibility of marrying his daughter, Berengaria. Diplomatically, securing an alliance with one of the border kings of Spain provided Richard with more security in the perennially troublesome region and –

hopefully – might prevent Count Raymond of Toulouse causing too much mischief. However, this was duplicitous and dangerous behaviour, at odds with Richard's desire to portray himself as a man of honour, mocked by Bertran de Born who wrote that 'he seeks honour and success so intently that his reputation constantly grows and improves'. Indeed, it was Bertran who first alerted the world to Richard's interest in Berengaria as early as 1188, doubtless to stir up trouble. Richard certainly failed to mention any change of heart when he met Philip in March 1190 to coordinate their preparations, which were behind schedule, nor when they finally departed from Vezelay on 4 July – having first agreed 'that whatever they conquered together they would share equally'. Richard's chosen route was from Marseilles to Messina, Sicily, where Joan, his recently widowed sister, lived; yet, despite the fact that his intended bride was now on the way from Navarre, Richard ducked the conversation with Philip about Alice. By now, news had filtered through that the third great Western leader, Frederick, had died whilst crossing the Saleph River in Asia Minor, now modern Turkey. His army limped on towards the northern Levant, under the command of his son, Frederick of Swabia.

Responsibility for the crusade therefore switched to the two kings. After a short delay, caused by the failure of his fleet to arrive from England, Richard set out alone and arrived in Messina, after several adventures along the Italian coast, on 23 September,

> in such magnificence and to such a noise of trumpets and clarions that a tremor ran through all who were in the city. The king of France and his men, and all the chief men, clergy and people of Messina stood on the shore, wondering at what they had seen and heard about the king of England and about his powers.

Philip's nose was firmly put out of joint by such grandeur, and he attempted to continue his journey towards the Holy Land the same

day, but unfavourable winds worked against him and he had to return to shore.

The tension between the two men was now starting to manifest itself openly, and grew worse when both became embroiled in the politics of Sicily. Richard felt compelled to seize control of Messina by force of arms, ostensibly to protect his sister's dower lands as well as defend several of his baronial supporters – ironically, these included Hugh de Lusignan, whose family had given Richard such trouble in Aquitaine. On seeing Richard's banners flying over Messina, Philip was furious and yet another squabble broke out, until the flags were replaced by those of the 'neutral' Templars and Hospitallers. Richard created a further rift by securing Sicily for Tancred of Lecce over Henry VI of Germany, whom Philip supported. Furthermore, he arranged for Tancred's daughter to marry his nephew Arthur and – in a major snub to his brother, and despite the fact that Arthur was still a child – Richard publicly declared his nephew to be his designated heir, until such time as Richard had a son himself.

This was one of a number of key decisions taken about the future of the Angevin lands that saw John's chances of securing any power and influence – or titles of his own – diminish rapidly, fuelling his resentment towards Richard. The crusaders wintered in Sicily, despite the drain on provisions and growing tensions between the Angevin and Capetian contingents. In March 1191, matters came to a head as Berengaria's imminent arrival from Navarre, in the company of Eleanor, meant that Richard finally confronted Philip about Alice. He claimed that he had no wish to discard her, but made the allegation that she had given birth to a son, and that the father was Henry – with reliable witnesses prepared to back this up. There was no way he could now marry her. To save his sister from humiliation, Philip agreed to dissolve the betrothal – his price was 10,000 marks – and also reached an agreement about the Norman Vexin, which would remain with Richard but only pass

through a direct male heir, otherwise it would revert to Philip; once again, John was excluded from the arrangement, showing his utter insignificance in Richard's future planning. This was also the moment when the strained relationship between the two kings finally broke, turning to bitter enmity. In a deliberate snub, the day before Berengaria was due to arrive in Sicily, Philip gathered his troops, boarded his ships, and set out for the Holy Land alone.

*

The legend of Richard, the warrior king, was forged over the next few years in the east, as he pitted his wits against some of the most ferocious opponents of the age. On 10 April 1191 Richard left Sicily with a huge fleet, as he was keen to press on with his campaign – there was not even time to arrange his own wedding. Eleanor had already started her return journey to Normandy, so Berengaria was entrusted to Joan's care, and they accompanied Richard as he sailed eastwards. However, he did not make straight for Acre, where the main crusading armies were heading. Instead, on 6 May, he made landfall in Cyprus, held by the despotic ruler Isaac Comnenus, a descendant of past Byzantine emperors. The island was of key strategic importance; without its support, it would be impossible to supply the Levant and therefore hold any gains made in the kingdom of Jerusalem. However, attempting an amphibious landing and assault was incredibly difficult; Richard's troops made their way to the shore in small boats, buffeted by the choppy waves, weighed down by arms and armour – falling overboard meant certain death by drowning. Before they could even beach their craft, they were showered with arrows and crossbow bolts fired by the defenders. Yet Richard, at the forefront of the fighting as usual, jumped into the shallows and waded ashore, hacking his way up the beach to establish a bridgehead for the rest of his troops. The fighting was fierce, but the defenders were eventually driven from the shore allowing Richard's troops to seize the town of Limassol,

which had been abandoned. Comnenus regrouped and still held a numerical superiority. Nevertheless, Richard led a second attack – this time a surprise assault at night – and inflicted a crushing defeat. Richard had been advised against the move by one of his clerks, who was met with a terse response: 'Sir clerk, you get on with your writing. Forget about fighting and leave the chivalry to us, by God and St Mary!'

It was not until June that Comnenus was finally beaten into submission – his one request was not to be put in irons, so Richard apparently had silver chains made for him. By then, Richard had married Berengaria on 12 May, and received an embassy from the king of Jerusalem, Guy de Lusignan, and his brother Geoffrey. The Lusignan family were some of Richard's oldest enemies in Aquitaine, but held – or at least had held – great power in the east. However, after Saladin's capture of Jerusalem, Guy had been eclipsed by Conrad of Montferrat who had been recognised as the legitimate king by Philip, after his arrival at Acre, to spite the 'Angevin' party. Richard put past differences aside and promised to assist Guy in the recovery of his position; the dislike of the two kings for one another had introduced a new intensity to Western faction fighting in the East, and politicised the crusade. Having promised to sell Cyprus to the Templars, Richard set sail for Acre on 5 June, first stopping at Margat – where Comnenus was left in a secure prison – and then moving down the coast to Tyre, before he reached his destination on 8 June.

Acre's garrison had held out against the joint forces of Guy de Lusignan and Conrad of Montferrat since 1189; in turn, Saladin and his relieving forces had trapped the crusader army on the coast, which is why the arrival of first Philip in April, and then Richard in June, was so important – fresh supplies and reinforcements meant the assault on the city walls could be pressed home. Realising the danger, Saladin tried to parley with Philip and Richard, but both kings fell seriously ill, which hampered any diplomatic overtures –

though Richard insisted that he be brought to the front line on a litter so he could still fire his crossbow in anger. Throughout June and early July, the walls of Acre began to crumble under the sustained assault and, on 12 July, the crusaders finally took the city. The banners of Philip and Richard accompanied those of the Christian kingdom of Jerusalem into Acre, to be flown above the city walls; they were briefly joined by those of Duke Leopold of Austria, who had taken over the remaining forces of the Holy Roman Empire, following the death of Frederick of Swabia in January. However, on Richard's orders, these were hastily torn down – probably with the knowledge and tacit consent of Philip – because they did not want to share the spoils of victory. Leopold was humiliated and withdrew from Acre, returned to his tent, gathered his remaining forces together and departed the Holy Land in anger; for him, the blame lay entirely at Richard's door. It was not the first time that an act in the East had major political consequences in the West.

Philip was not far behind him. On 22 July, the day after Richard moved into the palace at Acre with his wife and sister, the French king announced his plans to leave – primarily so he could claim the county of Artois following the death of Philip of Flanders, though the continued squabbling with Richard over the division of spoils was the public reason. A few loose ends had to be tied up first, though. Guy de Lusignan was confirmed as king of Jerusalem for the remainder of his life, after which it would revert to Conrad; command of the French army passed to Hugh, duke of Burgundy; and Philip swore 'that he would neither do any harm to the king of England's lands and subjects nor permit any to be done by anyone; on the contrary he would see to their peaceful safekeeping'. The French king departed from the Holy Land on 3 August with his dignity in tatters, with most of his nobles choosing to stay behind and fight under Richard.

Meanwhile, negotiations had been going on in the background with Saladin for an exchange of prisoners. By 20 August, the

crusaders' ultimatum for their demands to be met had expired. Richard needed to move south to have any chance of taking Jerusalem, so he took drastic action. Today, we think of the atrocities committed by so-called Islamic State, with films posted online showing the beheading of prisoners; but something far worse happened that hot afternoon on the plains outside the city walls of Acre. On Richard's command, the Muslim prisoners who had surrendered when the city had fallen, numbering some 3,000 or so, were marched out in chains under the guard of the crusader army. In full view of Saladin's forces, the soldiers

> ... fell upon them as one man and slaughtered them in cold blood, with sword and lance ... The next morning the Muslims wanted to see who had fallen, and found their martyred companions lying where they fell. Great grief seized them, and from then on the only prisoners they spared were people of great rank and men strong enough to work.

Without doubt, and viewed with the benefit of hindsight, it was one of the most shameful episodes of the crusade and certainly helped to fan the flames of hatred between Muslim and Christian forces for decades, if not centuries, to come. At the time, however, the massacre made great military sense. Saladin's delaying tactics had bought him time to reinforce the coast to the south; Richard could scarcely afford to spare troops to guard the prisoners at Acre, or take them with him given the limited supplies. It was the act of an utterly ruthless commander; this was now Richard's crusade.

His next target was to capture Jaffa and Ascalon, with the aim of securing the coast before turning inland towards Jerusalem itself. This was more easily said than done; the Turks were adept at mounting lightning raids on the column as it marched south, their fast horses carrying lightly armoured archers who could fire at will into the ranks of the crusaders, who plodded along under the

weight of their chain-mail. However, it was a necessary protection; Muslim chroniclers were astonished at the resilience of their foes: 'I saw some Frankish foot-soldiers with from one to ten arrows sticking in them, and still advancing at their usual pace.' Although they were supplied by the accompanying fleet, the sweltering conditions also claimed many lives as soldiers succumbed to heat-stroke and exhaustion. Richard, as always, was to be found in the thick of the fighting, at one point receiving a wound from a spear. Despite the constant attacks, the crusaders made steady progress; Saladin realised he had to change his tactics if he was to slow the armed juggernaut. Therefore, he drew up a large force to meet the crusaders as they emerged from the forest of Arsuf on 6 September, resulting in a pitched battle the following day. Richard led a series of stunning counter-attacks that saw off the might of Saladin's elite warriors, earning the acclamation of his army – Ambroise of Normandy, admittedly with bias, wrote that, 'You never saw anyone like him. He will always be at the front, always at the place of greatest need like a tried and tested knight' – and the grudging admiration of his opponents.

The victory at Arsuf enabled the crusaders to march on to Jaffa, but they found the city in ruins – Saladin had decided to destroy what he could not hold, and indeed was starting to do the same at Ascalon – so they were faced with a decision about how to proceed. Richard preferred the more daring approach, and wanted to march on to capture Ascalon, whereas more cautious heads advised fortifying Jaffa and then slowly advancing on Jerusalem. Richard was outvoted, and during this period embarked upon prolonged negotiations with his Muslim foes through the winter into early 1192, albeit punctuated by gaps when skirmishes and fighting prevailed. It is as a result of this process that we know so much about Richard's relationship with Saladin and members of his secretariat, such as Baha ad-Din, Imad ad-Din, Ibn al-Athir and Ibn an-Nahhal, as well as some of the suggestions about how peace

might be brought to the region, such as the division of the kingdom of Jerusalem between Christian and Muslim, or Richard's secret proposal for a marriage alliance featuring his sister Joan. Through these exchanges we glean a different perspective of Richard as diplomat and negotiator, trying to prevent further bloodshed in the Middle East, whilst taking a genuine interest in eastern culture, music and cuisine during visits to the enemy camp.

As Baha ad-Din reported, Richard wrote to Saladin and tried to explain the religious significance of Jerusalem from a Western perspective:

> I am to salute you and tell you that the Muslims and the Franks are bleeding to death, the country is utterly ruined and goods and lives have been sacrificed on both sides. The time has come to stop this. The points at issue are Jerusalem, the Cross, and the land. Jerusalem is for us an object of worship that we could not give up even if there were only one of us left. The land from here to the other side of the Jordan must be consigned to us. The Cross, which for you is simply a piece of wood with no value, is for us of enormous importance. If you will return it to us, we shall be able to make peace and rest from this endless labour.

Equally, the Muslim view of the conflict was articulated in return. Saladin wrote back:

> Jerusalem is as much ours as yours. Indeed, it is even more sacred to us than it is to you, for it is the place from which our Prophet made his ascent into heaven and the place where our community will gather on the day of judgment. Do not imagine that we can renounce it. The land also was originally ours whereas you are recent arrivals and were able to take it over only as a result of the weakness of the Muslims living there at the time. As for the Cross,

its possession is a good card in our hand and could not be surrendered except in exchange for something of outstanding benefit to Islam.

Thus the religious impasse was set out clearly for all to see, and in many ways the argument has not progressed any further over the last 800 years.

By January 1192, it was considered too difficult to besiege Jerusalem, so the army focused on securing Ascalon, as Richard had suggested four months previously. However, this marked the beginning of the end for the crusader army; many soldiers were encouraged to go on pilgrimage to Jerusalem under letters of safe conduct authorised by Saladin, knowing full well that once they had visited the Holy Temple, their crusading vows would be fulfilled and they could head back to their homes. Richard also had to contend with the regional politics, and was forced to recognise that Conrad of Montferrat would make a better king of Jerusalem than his vassal Guy de Lusignan. The decision was to have profound consequences for Western politics as well as in the Holy Land. Guy de Lusignan was given Cyprus by Richard (having renegotiated its sale to the Templars) and generous compensation for the loss of Jerusalem, a move that reversed decades of animosity to secure the support of the Lusignan family in the south of France. However, before Conrad could be crowned as king, on 28 April he was stabbed to death by two followers of the 'Old Man of the Mountain', Rashid ad-Din Sinan – the leader of the cult of assassins. Rightly or wrongly, blame for the murder was pinned on Richard and the allegation quickly spread beyond the Levant. In France, Philip used the rumours as an excuse to vilify his enemy, even though there was little evidence to support the claim that Richard had bribed Sinan to undertake the assassination on his behalf. Nevertheless, it was a stain on his reputation and threatened to overshadow his last months in the east, which were filled both with further military

victories and bitter disappointment, when the crusader army finally decided on 4 July to turn their backs on Jerusalem and return to the coast. Nevertheless, the king still added to his growing legendary reputation as a fearless warrior who inspired others to great feats of valour – racing down the coast to relieve Jaffa in the nick of time at the beginning of August, and then repulsing a surprise attack on his camp a few days later when vastly outnumbered, accompanied by a only handful of knights against thousands of Saladin's troops: 'His body was like brass unyielding to any sort of weapon. His right hand brandished his sword with rapid strokes, slicing through the charging enemy, cutting them in two as he met them, first on this side, then on that.'

It was to be the last military act of Richard's war. Shuttle diplomacy continued, essentially brokering a power-sharing structure that would enable the crusader army to withdraw with some modicum of confidence that Saladin would not immediately attack. In a treaty signed on 2 September, Richard agreed to relinquish Ascalon and cede control over key towns, though the remaining Westerners kept Jaffa and Acre under a truce that would last for three years and eight months. Saladin's forces had also been exhausted by the campaign, and he was equally keen to withdraw to Egypt. Richard's nephew, Henry of Champagne, was recognised as the king of Jerusalem and left in charge of the defences. On 9 October, Richard set sail, having failed in his ambition to take Jerusalem, but having cemented his position as the outstanding Western commander of his generation.

*

Aside from the military reality of the situation, another reason that persuaded Richard to leave was the urgent need to return to his Angevin lands. Although Philip had sworn to protect and uphold Richard's interests during his absence in the Levant, no one was under any false illusions about the enmity that Philip bore towards

his fellow crusader. It was therefore unsurprising, but no less worrying, that in late May one of Richard's trusted envoys, John of Alençon, had brought rumours that Philip had been plotting with Richard's brother John to dispossess him of his continental lands – the irony being that this was exactly the same behaviour that Richard had used against his father, which made the threat more real. Furthermore, Philip had used his journey home to hold an audience with Pope Celestine III in Rome – not just to receive absolution for his crusading vows (having failed to reach Jerusalem) but also to request the pope's permission to invade Richard's lands. The pope refused and threatened to excommunicate Philip if he even set foot across the border; however, this did not stop Philip from causing further mischief, reaching a secret agreement with the newly crowned Holy Roman Emperor Henry VI – who was still bitterly opposed to Richard after Sicily. Philip also seized on stories told by returnees from the Holy Land such as his cousin, the bishop of Beauvais,

> [who] spread the word that that traitor, the king of England, had arranged to betray his lord, the king of the French, to Saladin; that he had the marquis's [Conrad's] throat cut, that he poisoned the duke of Burgundy; that he was an extraordinarily savage man, thoroughly unpleasant and as hard as iron, adept at deceit, a master of dissimulation.

By the time Richard departed in October 1192, there was a real threat to his safety given the propaganda that had been circulating across Europe.

Up to this point, Richard's lands had remained relatively undisturbed during his absence, despite Philip's best efforts to stir up trouble. In England, Longchamp had become the dominant member of the administration, and dealt with the fallout of the Messina agreement by promising to help John gain the throne of England, should Richard die. However, Longchamp was ousted

from power in late 1191, undermined by John's supporters in the hope that their master would take control, only for the archbishop of Rouen, Walter de Coutances, to sail across the Channel flourishing letters from Richard, prepared in advance for these exact circumstances, authorising him to govern England. It is understandable why John was such an easy target for Philip's overtures – thwarted in England, excluded from government, and considered by his older brother as a less suitable heir than a small boy. Philip tempted him with all the Angevin possessions on the continent if he married Alice, and it took an intervention by Eleanor in early 1192 to prevent John from heading to Paris to accept. Apart from a brief rebellion in Aquitaine, Richard's deputies held firm, fortifying the border defences and waiting patiently for their lord to return.

What changed the political landscape was Richard's capture and imprisonment by Leopold of Austria in December 1192. Given the range of people he had upset during the crusade, there were no safe routes home across the Mediterranean so Richard gambled on crossing into the lands of his brother-in-law, Henry the Lion of Saxony, via territories held by the king of Hungary, Bela III. However, fate conspired against him, and his ship was blown off course, landing between Venice and Aquileia – an area under the authority of Meinhard of Gorz, loyal to Henry VI and a nephew of Conrad of Montferrat: probably the worst place he could have been shipwrecked. The hunt for the king of England was on.

Clearly the propaganda emanating from the Levant had spread throughout the Mediterranean. It seems that locals set upon the bedraggled king and his supporters in the hope of loot from the shipwreck rather than any reward. In the ensuing struggle, Richard and a few followers escaped. They made it as far as 'Friesach in the archbishopric of Salzburg, where Friedrich of Pettau arrested six more of his knights. Richard himself escaped yet again, this time with just three companions.' Unwittingly, he fled into the territory of Duke Leopold of Austria, trying to disguise himself as a pilgrim.

As he sheltered in a small village on the outskirts of Vienna called Erdsburg, an official spotted Richard's men and they were arrested on 21 December 1192. Having been dragged before Leopold, Richard was imprisoned in the castle of Durnstein, high above the Danube, whilst the duke of Austria informed the emperor of his prize. In turn, Henry wrote to Philip, stating that, 'He is now in our power. We know that this news will bring you great happiness.' What should have been a triumphant homecoming had turned into a nightmare, with repercussions across Europe.

Philip was quick to capitalise on his rival's misfortune. His hand had already been strengthened greatly after successfully claiming Artois in 1192, giving him not just additional revenue but lands in north-east France and lordship over the count of Boulogne – and therefore direct access to the coast opposite England. As soon as he heard the news of Richard's imprisonment, Philip repeated his offer to John; this time, no one could prevent John from travelling to Paris where he did homage to Philip for all Richard's continental lands. In return, John agreed to marry Alice, and hand over the Norman Vexin along with the key strategic castle of Gisors. Philip then amassed a fleet at Wissant, giving John sufficient confidence to return to England to claim the kingdom on the grounds that Richard was dead. However, he made very little headway and forces loyal to the king drove him back until he held only two castles, Windsor and Tickhill. Indeed, when Richard found out about John's treachery whilst still imprisoned in Germany, he remarked sanguinely: 'My brother John is not the man to win lands by force if there is anyone to oppose him.' Meanwhile, Philip had stirred up further revolt in Aquitaine, and personally undertook an invasion of Normandy, succeeding in capturing Gisors on 12 April and marching to the gates of Rouen itself, although by May he had turned away in search of easier castles to capture.

The defences of Normandy had been made porous not just by the uncertainty over Richard's return from captivity but by

Philip's new power base to the north; equally, the prospect of John becoming duke did not fill castellans and local lords with any confidence. This was the greatest threat to the long-term future of the lands that Henry II had brought together, and Richard was only too aware of his vulnerability; no amount of military fortification could protect Normandy from the wavering hearts and minds of the marcher barons, in particular those who held land along the disputed Vexin and could not afford to back the wrong side in the struggle between Philip and Richard. Many owed allegiance to both men, and found themselves in an impossible position. The ease with which Gisors fell – no siege was required, since the castellan surrendered the fortress when Philip advanced – indicated that self-interest was starting to win out over loyalty. Sitting in his German prison, it was a sobering thought that many of the men Richard had fought alongside on the hot, dangerous road between Acre and Jaffa, or in the foothills outside Jerusalem, had turned their back on him and succumbed to the everyday politics of France.

Yet in many ways, the military campaigns on the ground became secondary to the diplomacy surrounding Richard's release – if indeed he was to be released at all. Initially, a marriage alliance between Richard's niece, Eleanor of Brittany, and Leopold's son, was agreed, along with a 'dowry' of 100,000 marks, the release of Isaac Comnenus, and military support for Henry VI's planned invasion of Sicily. In March, Richard was brought before the imperial court in Speyer, where a show trial was held to legitimise Richard's captivity – based on three charges: that he had betrayed the Holy Land, plotted the death of Conrad, and broken promises to Henry. This provided Richard with an opportunity to defend his reputation and honour with great vigour. According to William le Breton – no great fan of Richard's, given he was Philip's court poet – 'When Richard replied, he spoke so eloquently and regally, in so lionhearted a manner, that it was thought he had forgotten

where he was and the undignified circumstances in which he had been captured and imagined himself to be seated on the throne of his ancestors.' Indeed, Henry was moved to drop the legal charade and give Richard the kiss of peace, publicly offering to reconcile him with the king of France – although the financial terms did not change. Richard appointed his close confidant Hubert Walter as justiciar in England who, with the help of William Longchamp and Richard's mother, in April 1193 set about raising the vast amount required through a levy of one quarter of all moveable goods, plus seizures of wool crops and church plate. Hubert's reward for his labours was to be elected archbishop of Canterbury.

Philip grew increasingly fearful that not only was the window of opportunity to achieve major military gains closing, but also that Richard would somehow engineer the situation to his political advantage. He therefore requested a meeting with the emperor on 25 June, in all probability to make a counter-bid for Richard so that he could be transferred to the safety of a French dungeon. On hearing of these plans, Richard upped the stakes to ensure the meeting with Philip did not take place, but at the cost of an additional 50,000 marks on his release. It was hearing about this new deal that drove Philip to write to John, warning him, 'Look to yourself; the devil is loose.' In the meantime, Philip explored increasingly desperate measures to exert further pressure on Richard's territories. In August 1193 Philip brokered a marriage with Ingeborg, sister of King Cnut VI of Denmark and four times great-niece of King Cnut of England, in the hope that his new brother-in-law might be persuaded to invade, or at least provide Philip with a fleet. However, Danish politics were bound up with those of the empire and Cnut was not interested in such a dangerous venture; in any case, he was married to the daughter of Henry the Lion, Richard's close ally. Philip got cold feet about the whole plan the day after the wedding, and tried to send Ingeborg back to Denmark, to no avail. The pope refused to issue an annulment,

so Philip locked her up for the next twenty years until her distant claim to the English throne became useful again in 1213.

Philip's fears were premature, as it took until December 1193 to raise sufficient funds for Henry to set a date for Richard's release. In doing so, the emperor also indicated that he was planning to crown Richard as king of Provence – giving Richard great influence in the empire, and handing him access to the important port of Marseilles. Both Philip and John reacted to the prospect of Richard's imminent return with panic. John made one last desperate play for his brother's lands, offering up all of Normandy east of the Seine (bar Rouen), the key fortresses of Touraine, the independence of Angoulême from Aquitaine and access to other strategic territories. For the first time, John revealed the depths he was prepared to sink to in his pursuit of power. His betrayal of Richard was bad enough; Philip had been banking on fraternal jealousy to drive a wedge between them ever since his return from Acre. However, even he would have been astonished by the concessions that John offered – both Louis and Philip had exploited family tension in the Angevin family, but had not sought territorial gain on the scale John suggested. The very thought that Normandy could be carved up in such a fashion further undermined the duchy's defences and tested the loyalty of its marcher lords to breaking point. This was the crucial moment when Normandy began to slip away from the descendants of Rollo after nearly three centuries.

As much as Philip disliked Richard over his treatment of Alice and general high-handed manner, it was impossible not to respect his military feats. John, on the other hand, generated nothing but distrust, and Philip began to despise him from this point onwards. Nevertheless, it was a golden opportunity to lay claim over land currently beyond his military capability to take should Richard return, so a treaty was concluded between them. There was no going back; a new bid was made to Henry in mid January 1194, a desperate attempt to keep Richard in captivity long enough for

the treaty to be made good – up to 150,000 marks was offered if he would keep Richard in chains for a further year or, better still, hand him over to them. However, this brinkmanship only served to delay the inevitable by a matter of weeks. Henry postponed the date of Richard's release, and summoned a meeting of the principal German princes and archbishops on 2 February to seek their advice; also in attendance were Walter de Coutances, William Longchamp and Richard's mother Eleanor. Philip and John's offer was read out, drawing condemnation from many quarters. Richard's release was finally approved, although he agreed to hand England over to Henry so that he could receive it back as an imperial fief. Whilst this was a shrewd move politically – gaining a powerful overlord he could count on for support – it would have been hugely unpopular back in England, and so was largely covered up. However, it marked a clear change of direction for the complex relationship between England, France and Germany for the next few centuries.

Time was almost up for Philip. On Richard's release from the imperial court on 4 February, Henry wrote to Philip and John stating that they should hand back everything they had taken from Richard during his captivity; the diplomatic position had shifted dramatically in Richard's favour. Instead, Philip launched one last military onslaught to capture the lands that John had promised him in January, and swarmed across the border into Normandy, capturing strongholds such as Evreux and Neubourg before marching once again on Rouen. The citizens drove him off, though; so he ventured south, inciting two more Aquitainian lords to switch allegiance to him. Richard made his way slowly across Germany and down through modern Belgium, looking to cross into England from Antwerp, given that Philip now held the coast across Flanders, Boulogne and the eastern portion of Normandy. Finally, he sailed to Sandwich on 13 March and was greeted by his loyal supporters, including William Marshal, who missed his own brother's funeral to be by the side of the king on his return. The

challenge – not to be underestimated – was to reassert authority across his vast territories. Mopping up resistance in England was relatively easy. Hubert Walter had besieged the last two castles holding out in John's name, Tickhill and Nottingham. The former surrendered without a fight, though the garrison at Nottingham had the temerity to fire upon the king. However, the real problem lay across the Channel, given the fundamental damage John's concession had done to the integrity of Normandy; in essence, Richard had to win his lands all over again. The key to success lay in converting English silver into stone castle walls to protect Normandy's borders.

*

King Richard's second and final visit to England, lasting only a few short weeks between March and May 1194, had profound and long-lasting effects. The administrative machinery of government created by Henry II had largely withstood the pressures of Richard's campaign and captivity. However, two additional burdens had been placed upon the growing bureaucracy that Henry had created around the law and the royal administration – the extraordinary taxation for the crusading tithe in 1188, and Richard's ransom in 1193. Whilst money was extracted from other territories, the burden primarily fell upon England, thanks to its relative wealth and the financial systems that were in place to assess and gather the money. Neither measure was popular, but the need for them was at least acknowledged. The hope, if not expectation, was that Richard's return from captivity might see an easing in the financial demands of the crown. In fact, the opposite occurred: English treasure was more important than ever, and a series of measures were discussed and introduced during a 'council of state', held over four days from 30 March, in which Richard's plans for the kingdom were made clear. First, new sheriffs were appointed in nineteen counties; however, the terms on which many of them held office

were changed, so that they accounted for a fixed 'increment' payable above the level of the county farm. The ambition was to address the increasing devaluation of the county farm as a source of crown income, given the amount of land that had been given away in the form of patronage (*terrae datae*) and the drop in revenue from the county court over which the sheriff presided, thanks to the rise of royal justice. In effect, it made the position of sheriff less profitable, with the unfortunate consequence that money was extracted more ruthlessly from the shires to cover the additional payments whilst ensuring the sheriff was not out of pocket – leading to growing noise about the rising levels of abuse perpetrated by royal officials that Henry II had tried so hard to stamp out.

Additional financial measures were also introduced. A form of taxation on land known as a carucage probably raised a few thousand pounds, as did the levying of scutage (the payment in lieu of providing military service in person) for those who were unable to accompany Richard to Normandy on the much-needed campaign to recover the lands captured by Philip. John's lands were taken back into crown hands, as were those of his supporters; to account for the revenue, special officials known as escheators were appointed, with separate jurisdictions for land either north or south of the Trent. The policy to sell inheritance, wardship, marriages and office to the highest bidder was continued, and profits from justice continued to flow in. When totted up, revenue audited at the exchequer for 1194 stood at over £25,000 – twice that of the previous year. Furthermore, the vast majority – over 90 per cent – was in silver pennies, which meant it could be transported overseas. This was not a one-off raid, though; Richard needed the steady stream of money to continue whilst he tackled the problems John had created in Normandy.

To ensure that the administration operated efficiently, he turned to Hubert Walter, who as archbishop of Canterbury, justiciar and – from 1195 – papal legate, was the most powerful man in the

kingdom. Acting on Richard's instructions, he was a remarkable administrator and oversaw many innovations relating to royal government. He reorganised the judicial circuits, with more involvement for knights in the day-to-day administration of the shires, both in terms of enquiries, keeping the peace and recording information. The introduction of the practice of creating duplicate copies of royal instructions and letters from the chancery, in the form of annual parchment rolls, generated an archive on a par with that of the exchequer and ensured accountability and thus enforcement. He also regulated dealings between Jewish money-lenders, their creditors and the crown. Yet this was all done in consultation with Richard, who took a keen interest in the affairs of state whilst he was abroad. The results were plain to see. The level of money coming into the exchequer continued to remain around £25,000, hitting £28,000 in 1196. Complaints continued to grow louder as the reign progressed. This was an unsustainable level of exploitation on the back of unprecedented demands, and as a result Richard's popularity began to decline.

The reason why Richard needed so much money was the realisation that the Norman border – the key to his continental lands – was fatally compromised by John's offer to Philip, not because this carried any legal weight, but because it had weakened the resolve of the marcher barons who faced far greater exposure to the king of France than ever before. A semi-permanent solution required three elements: the expulsion of Philip from the lands and castles he had taken; the creation of new defensive lines guarded by castellans that Richard could trust; and resolution of the succession, given the way John had compromised his integrity and trustworthiness in his dealings with Philip. On 12 May Richard set sail for Barfleur from Portsmouth – an emerging base from which treasure was regularly sent across to Normandy – and was enthusiastically greeted. However, Richard's continental lands were in disarray. First, he headed towards Verneuil, which was under siege from Philip. On

his way to confront his enemy, Richard stopped at Lisieux, staying in the house of his envoy John of Alençon. Word of his arrival had obviously reached the ears of his brother John; he abandoned Evreux, which he was holding for Philip, and made his way to where Richard was staying with some degree of trepidation. The owner of the house was waiting to receive him, and told John in no uncertain terms: 'The king is straightforward and merciful, and kinder to you than you would be to him.' John entered the room where Richard was resting, and rushed forward to fling himself at his brother's feet, begging forgiveness. The king was mindful to show mercy to his brother, even if his response was tinged with contempt: 'Don't be afraid, John, you are a child. You have got into bad company and it is those who have led you astray who will be punished.'

By this, Richard meant Philip and he continued onwards towards Verneuil in an attempt to drive all Capetian forces from his land – though his distaste for John was probably exacerbated, not reduced, when his younger brother returned to Evreux and massacred the French garrison there, having tricked them into believing he was still loyal to Philip. Thus followed a cat and mouse chase around Normandy, with Philip abandoning Verneuil to mount a punitive raid on Evreux, and John fleeing to the safety of Rouen. Whilst Richard secured Verneuil, taking the French king's siege train in the process, Philip advanced on Rouen, captured the nearby castle at Fontaine, and seized one of Richard's principal supporters, Robert, earl of Leicester. However, Richard continued to progress the war, retaking key castles and towns in Touraine, and with the support of his ally Sancho of Navarre, moving south to suppress the revolt in Aquitaine. Philip followed, allowing Richard the opportunity to win yet another humiliating victory over his rival. Finding his route blocked by Richard's forces as he moved towards Aquitaine, the French king turned tail and fled, with Richard in hot pursuit. Although Philip escaped, he lost his wagon train at

Fréteval – including campaign funds, military equipment and the royal chapel, complete with the Capetian archives containing important information about those whom Philip considered to be potentially disloyal to Richard. With Philip's army in shambolic retreat, Richard was able to complete the restoration of his authority in the south, defeating the count of Angoulême and his allies in a series of devastating raids.

However, the main theatre of war was Normandy, and it was here that Richard spent most of his time and money over the next five years. A truce was reached on 23 July 1194, but one that recognised the status quo – thus leaving Philip in possession of key border fortresses such as Vaudreuil and Gisors; the Norman Vexin; large parts of the north-east; and pockets in the west of the duchy. Other areas had been devastated by Philip's forces and, with only a few exceptions, Richard was forbidden by the terms of the treaty to rebuild his fortifications. Yet over the course of the next twelve months, Richard painstakingly exerted pressure on the lordships and castles that were now in Capetian hands, reducing the ability of each garrison to control the area in which it stood, thus adding to the cost of keeping them defended in terms of supplies. He also expended cash on re-fortification work, even if it was against the terms of the treaty; and received support from Henry VI, once he had spent Richard's ransom on the successful conquest of Sicily in November 1194. In tackling the thorny issue of disloyal marcher barons, Richard turned to the Lusignan family – his erstwhile foes before the crusade – and granted various members some of the disputed border areas such as Aumale and Eu, challenging them to wrest control from the men that Philip had installed. Despite these advances, Richard must have cursed John with every pound spent; however, the policy of little by little paid off, and by the time the truce expired in July 1195, Philip was prepared to abandon all his conquests bar the Norman Vexin and several important castles. Indeed, Richard had also gone on the offensive, taking possession of

castles in the Auvergne and Berry to the south. By the time a more permanent treaty was agreed at Louviers in January 1196, Richard held the upper hand and had recovered most of his lost lands.

The story of the next few years was one of continued diplomatic initiatives punctuated by raid and counter-raid, with most of the fighting taking place along the disputed Norman border regions, with the occasional foray into Berry or Auvergne. Several factors should be highlighted, though. First, Richard tried to intervene in Brittany, but only caused a rebellion which he then had to crush. In doing so, Richard drove his young nephew Arthur into the hands of Philip, who received him in Paris in April 1196 and provided him with protection – yet another member of Henry II's family who had been turned against his kin by the king of France. The rupture with the 'next generation' of Angevins, given Richard's failure to produce any legitimate children, had serious consequences in the light of Richard's earlier declaration that Arthur was to be his heir. Second, the growing military tension between Philip and Richard began to take on an international dimension. Philip was still able to mobilise his northern allies, the counts of Flanders, Boulogne and Ponthieu, into a powerful bloc to exert continual pressure on the north-eastern border of Normandy, with Richard suffering several setbacks in the region during 1196. It also made the support of the emperor more important and thus linked the Norman wars to the wider politics of Germany and Italy. However, Richard at least had one breakthrough – in 1196 he arranged for his sister Joan to marry the new count of Toulouse, Raymond VI, the son of the long-standing enemy of Aquitainian power in the south. Richard gave up his claims to Toulouse, and ceded the county of Agen as Joan's dowry. As a result, peace was finally brought to the region, encouraging trade to flourish and allowing Richard to concentrate his military resources in the north.

Nevertheless, the reverses of 1196 in Normandy persuaded Richard that he needed to go on the counter-offensive and take the

war to Philip, as well as reinforce his defensive position, with a new phase of castle-building – the third and perhaps most important factor that emerged during this period. Central to this plan was the vastly expensive project to fortify the island of Andelys on the Seine, crowned by the castle on the rock known as Château Gaillard or 'saucy castle' – perhaps the most sophisticated series of fortifications of its generation. This was the culmination of all that Richard had learned from his years of castle-breaking, both in Aquitaine and during the crusade, and marked the introduction of the latest military technology into the Norman war. This was his pet project: 'He took such pleasure in the building that, if I am not mistaken, if an angel had descended from heaven and told him to abandon it, that angel would have been met with a volley of curses and the work would have gone on regardless.' Nor should Château Gaillard simply be seen as an isolated outpost; Richard clearly planned to link it with the emerging naval base in Portsmouth as a means of supplying his Norman lands via newly constructed galleys, which would find shelter at Les Andelys in a deep-water harbour – another lesson learned from his time in the Middle East on the coastal march from Acre to Jaffa, when the presence of the crusader fleet kept his troops fed and watered.

Yet this ambitious project to join Portsmouth with the Norman front line via the Seine came at a shattering cost, and was the reason why so much money was required from England; Norman finances were simply not as capacious or reliable for various reasons. Based on surviving material from 1195 and 1198, it seems that 'ordinary' revenue from the duchy was roughly half that of England. Consequently, Richard embarked on a ruthless campaign of forced loans and tallages imposed on the urban areas in central Normandy, which doubled his income from the duchy in 1198. The bill for Château Gaillard highlighted this need for extraordinary revenue, which came in at a staggering £12,000 across two years – the equivalent of the entire annual income from the duchy.

Furthermore, the cost of fully garrisoning all the key Norman fortresses would have exceeded this figure, making the whole system unsustainable in the long run. Richard therefore gambled everything on winning the war.

Whilst Château Gaillard was rising above the waters of the Seine, the military campaigns continued through 1197, further draining Richard's coffers. Added to the ongoing cost of keeping troops in the field throughout the campaigning season, as well as the army of workmen at Les Andelys, was further expenditure on diplomacy. Nevertheless, it was money well spent, as Richard was able to persuade Baldwin, count of Flanders, to switch sides in the summer of 1197, in exchange for the payment of a pension and a 'gift' reputed to be 5,000 marks. In addition, this allowed Richard to undertake a two-pronged assault for the first time since his return, rather than being on the receiving end of one. Baldwin raided Artois to the north, whilst Richard attacked Berry in the south. Philip was forced once again to agree a truce in September, with signs that Richard had pushed the Norman frontier back further.

Although the peace was meant to last until early 1199, the sudden death of Emperor Henry VI on 28 September meant that both Philip and Richard had a vested interest in the election of his successor, given the state of the rival factions in Germany. Henry VI's son, Frederick, was too young to be considered as an effective option, so one party of German magnates elected Henry VI's younger brother Philip of Swabia – the Capetian candidate – whilst another faction chose Richard's nephew, Otto of Brunswick, who had been inducted as count of Poitou in 1196 and was closely associated with the Angevin court. Indeed, given the uncertainty over Richard's preferred heir, it was not inconceivable that he might stake a claim for the Angevin lands if Richard, or indeed John, failed to produce a child. Otto was crowned at Aachen in July 1198 and mobilised a bloc of German princes in the lower Rhineland, reaffirming

the wisdom of the count of Flanders's decision to switch support to Richard.

As was so often the way, once the tide started to run in favour of the Angevins, more defections from the Capetian side followed. On 27 September, Richard raided into the French Vexin and then pursued Philip and his relieving army, chasing the Capetian forces so hard that the king himself fell into the river Epte as he raced for the safety of Gisors; many of Philip's best knights were captured during the ignominious scramble for the door. Fighting continued up and down the disputed border regions, with the count of Flanders invading Artois once more, securing the surrender of St Omer. In both military and diplomatic terms, as 1198 closed it was clear that Philip was losing the war.

In desperation, Philip appealed to the pope. Celestine III had died in January 1198 and was succeeded by Innocent III. This was a risky move on behalf of the French king, as Innocent was long suspected – correctly – of favouring Otto of Brunswick in the disputed German election. However, Philip judged the mood of the new pope to perfection, in that Innocent wanted to reconcile the warring parties to pave the way for the crusade that he had recently called to recover the Holy Land. To this end, Innocent sent a papal legate, Peter of Capua, to persuade Richard to agree terms. The result was a stormy encounter, with Richard reminding Peter that he was merely trying to recover what had been unjustly seized from him the last time he did the pope's bidding in the east. However, Richard consented to a five-year truce, grudgingly conceding that it applied to the lands held by Philip at the time – including the important castle of Gisors, where Richard was starting to exert more pressure. Peter also asked for the release of the bishop of Beauvais, 'one of the men Richard hated most in all the world' given the damage he had done to Richard's reputation on his return from crusade; he had been captured in 1197 and had remained in prison ever since. At this request, Richard's patience snapped:

Sir hypocrite, what a fool you are! If you had not been an envoy I would send you back with something to show the pope which he would not forget. Never did the pope raise a finger to help me when I was in prison and wanted his help to be free. And now he asks me to set free a robber and an incendiary who has never done me anything but harm. Get out of here, Sir traitor, liar, trickster, corrupt dealer in churches, and never let me see you again!

Despite these fearsome words, a truce was agreed in January 1199, and once more Richard adopted the policy of throttling the life out of the castles held by Philip in Normandy, for example ensuring that the garrison at Gisors were unable to support themselves by sending Angevin troops to occupy the surrounding land. Meanwhile, Mercadier was despatched to Aquitaine to deal with the viscount of Limoges and count of Angoulême, who had been excluded from the terms of the peace and continued to rebel against Richard, who himself then headed for Anjou. It was here that alarming news reached him – John had once again defected to Philip. For once, John was blameless but it speaks volumes that Richard initially believed that his brother had betrayed him again, ordering the confiscation of John's estates on both sides of the Channel. However, it was yet another piece of propaganda spread by Philip to cause disharmony and the lands were restored.

Further proposals for a lasting peace were circulated in February and March, centring on Philip's continued possession of Gisors but with a range of concessions offered in return, such as the formal cessation of his interest in Tours and a switch of allegiance in the German election from Philip of Swabia to Otto of Brunswick. Richard's deputies in Normandy were still discussing possible terms in April when dreadful news reached them; the king had been killed whilst besieging Châlus-Chabrol. The military and diplomatic situation was thus transformed overnight, with the

advantage swinging firmly towards Philip now that his great rival
was dead.

*

In an age when reputation mattered, John started his reign at a huge
disadvantage. Even with Richard's dying confirmation that his
brother should inherit his lands, there was no guarantee that John
would do so, such was the low opinion of him held by his potential
vassals on the continent. Many blamed John for the years of warfare
that had impoverished the duchy; few trusted him to keep his
word; his military record left much to be desired when compared
to that of Richard, and those with longer memories compared
him unfavourably with young Henry, thinking him 'more given
to pleasures than to arms, to dalliance than to endurance . . . The
tree which bends its boughs downwards cannot strike deep roots.'
Yet the only credible alternatives were Otto of Brunswick, who
was embroiled in his struggle for the imperial crown with Philip
of Swabia; and John's nephew Arthur of Brittany, with whom –
ironically – John was staying when news of Richard's death filtered
through. There was no real feudal precedent as to whether the
younger brother, or the son of an older brother, should succeed.

The difficulty of the decision is reflected in a conversation that
took place at Vaudreuil on 10 April, when news of Richard's death
reached William Marshal. Staying nearby was Hubert Walter,
who had resigned the justiciarship in 1198 but continued to play
an important part in the Angevin government as archbishop of
Canterbury. The two men debated the merits of both candidates.
Walter's initial reaction was to support the claim of Arthur. Marshal
replied: 'To my mind, that would be bad. Arthur is counselled by
traitors; he is haughty and proud; and if we put him over us, he
will only do us harm for he does not love the people of this land.
Consider rather count John: he seems to me the nearest heir to the
land which belonged to his father and brother.' The archbishop

remained concerned; 'Marshal, is this really your desire?' 'Yes my lord, for it is just. Undoubtedly, a son has a better claim to his father's land than a grandson; it is right that he should have it.' The archbishop sighed. 'So be it then, but mark my words Marshal, you will never regret anything in your life as much as this.'

Several factors worked in John's favour – the fact that Arthur was still a boy, only twelve years old; and that John's mother, Eleanor of Aquitaine, supported the claims of her son over her grandson. Even at seventy-seven, she was a formidable political figure and helped mobilise support for John. Speed was of the essence; as soon as he heard news of Richard's death, John set out for Chinon and secured the Angevin treasury, before riding to pay his respects at his brother's funeral at Fontevraud. Yet even this rapid action was nearly insufficient. Whilst John had gone to Chinon, Arthur's mother, Constance, had appealed for help from her native Bretons, entrusting Arthur to the protection of Philip. Having raised an army, Constance marched to Angers and, on 18 April, held a council of leading nobles from Anjou, Maine and Touraine. When asked who they would prefer to be their new count, the general acclaim was for Arthur. John gathered his own forces and moved to Le Mans, hoping to take possession of the city, which had been rebuilt after the fire of 1189. However, the citizens and garrison refused him entry and, with news that Philip was approaching with an army of his own, John beat a hasty retreat and slipped across the border to Normandy.

Despite everything that had happened, John found a far warmer welcome there and at Rouen on 25 April he was invested as the duke – John was, after all, preferable to a Breton and had partially redeemed himself during the last few years of Richard's life, taking the fight to Philip in an attempt to reverse the damage he had done in 1194. Meanwhile, William Marshal and Hubert Walter had crossed to England. Putting aside any remaining misgivings, they summoned a council of barons at Northampton and proposed

that John should be king. The general mood was apathy at best – again, memories were long and it was only a few years since John had stirred up trouble and unrest in the kingdom during Richard's absence. However, the justiciar Geoffrey FitzPeter also spoke in John's favour, and the assembled magnates were persuaded to take an oath of fealty to John, paving the way for his coronation on 27 May 1199.

It looked highly probable that the lands that Henry II had assembled might split into three distinct segments – England and Normandy under John's rule, resurrecting the Anglo-Norman realm of William the Conqueror and Henry I; with the young Arthur, under the protection of Philip, taking Brittany, Anjou, Maine and Touraine to form a Breton-dominated power bloc; Aquitaine, to the south, remained in the hands of Eleanor. Henry II had always imagined a form of division, and Richard had also considered making Arthur his heir in 1190. However, John was determined to take possession of all his brother's lands, and his mother had similar aspirations for him. Eleanor gathered together Richard's last army from Aquitaine and, entrusting military command to Mercadier, marched north towards the Breton-held towns across Anjou, Maine and Touraine – in particular Angers and Tours, which held particular strategic importance. John returned from England and concentrated his efforts in Normandy, where he secured Richard's alliances with Flanders and Boulogne in August. Similarly, John received a message of support from his nephew, Otto of Brunswick. With these powerful supporters in place, he marched south and captured Le Mans by 22 September. Here William des Roches, one of the most powerful Angevin barons and leader of the Breton faction, deserted Arthur's cause – it was claimed that he was slighted by the high-handedness of Philip's approach to the campaign – and brought Constance and Arthur to Le Mans, where they formally acknowledged John's right to inherit all Richard's lands. Philip was outmanoeuvred, and agreed

to a temporary truce until January 1200, when more detailed and permanent terms would be agreed. It appeared as though John's resolve, coupled with the legacy of his brother's diplomatic alliances and his mother's command of Aquitainian forces, had won the day.

This might have seemed like another reverse for Philip, but in reality it proved to be a masterstroke, giving John's new vassals and allies time to really get to know their preferred duke. Almost at once, John began to make mistakes that showed his poor grasp of man-management, misreading the political temperature at Le Mans on 22 September. Having secured the formal submission of Constance and Arthur, the most pressing question was what to do with them? Richard's most successful tactic, when dealing with powerful enemies that he could not force into submission, was extreme generosity – hence the gift of Cyprus to the Lusignan family, and the lavish expenditure on the northern counts to bring Flanders, Boulogne and Blois over to his side. This might have been an option with Arthur; but rumours immediately started to circulate that John was planning to put his nephew in prison. John made a tense atmosphere worse by demanding that Aimery, viscount of Thouars, hand over Chinon – a sign that John did not trust him. Again, his suspicions might have been well-founded, given the desertion of Anjou to Arthur's cause, but his timing was poor. Therefore, on the same night, Aimery slipped away, with Constance and Arthur in his care, seeking out Philip – a clear sign that John was still considered untrustworthy. A second blow fell in November, when at a tournament held by the count of Champagne, many of the leading nobles finally agreed to sign up to Innocent III's crusade – including the counts of Blois, Perche and Flanders. Thus John was stripped of his northern alliance, exposing Normandy's border once more.

This gradual erosion of John's position was the backdrop to the peace negotiations conducted on 15 January 1200 and later formalised in the treaty of Le Goulet on 22 May. On the surface,

it would appear that John had safely overcome the threat posed by Arthur, and was praised by contemporary English and Norman chroniclers for bringing peace to his realm – a veiled criticism of Richard, whose reputation as the hero of the crusade was intact but was less popular for his sustained financial exactions. Philip abandoned his support for Arthur, and received homage from John for all Richard's continental lands, excepting a few border areas that Philip was permitted to retain, including concessions within the county of Berry. Arthur was acknowledged as John's vassal in respect of Brittany, confirming the predominance of Normandy that Henry II had established. Angoulême and Limoges were brought back into the Aquitainian fold.

However, the treaty came at a cost, both financial – John was required to pay 20,000 marks as relief – and political. For the first time, the exact feudal relationship between the king of France and his most important vassal had been defined and, in specifying terms, it gave John far less room for manoeuvre than his father and brother. Furthermore, John was forced to disavow his alliance with Flanders and Boulogne, since they were also vassals of the French crown. This was an assertion of strength by Philip, setting out a legal framework in which the nominal overlordship of the past was refined into terms and conditions that could be enforced with greater justification. No wonder the French chroniclers considered it to be a triumph for their king. Finally, the treaty was to be sealed by a marriage alliance between Philip's son Louis and John's niece, Blanche of Castile. Eleanor had already been asked after the initial negotiations in January to travel into Spain to arrange the details, but as she departed Poitiers she was ambushed and captured by Hugh de Lusignan, who demanded La Marche in return for her freedom; she was forced to agree, and John acknowledged Hugh's homage. The trip to Castile passed without further incident, but having returned to Bordeaux in March 1200, Eleanor's chosen bodyguard, Mercadier, was killed by a rival in the city – thus

robbing the Angevins of their most powerful commander. Still in shock, she retired to Fontevraud, 'aged and wearied by her long journey'.

Despite these setbacks, John had managed to inherit virtually everything intact – not bad for someone his father had nicknamed 'Lackland'. Displaying the energy and vigour that marked the restless nature of his family, John then embarked on a grand tour of his new lands during the summer of 1200, moving south from Normandy in June through Maine, Touraine and Anjou, before heading into Poitou and Gascony in July and August. During his southern sojourn John reflected on the need to strengthen his position in the area – he had little political capital in Aquitaine beyond his mother's name, given the hold Richard had exerted upon the region. John's solution was to form an alliance with the count of Angoulême, marrying his twelve-year-old daughter and sole heiress Isabella on 24 August. Leaving aside the fact that John already had a wife called Isabella – that marriage was easily annulled on the grounds of consanguinity – there remained the problem that Isabella of Angoulême was already betrothed to Count Hugh de Lusignan. From this situation there could be no winners. John was naturally alarmed at the prospect of a Lusignan–Angoulême marriage, but in displacing Hugh he alienated one of the most powerful barons in the region, with connections stretching throughout the Mediterranean and Middle East – his uncle Aymer was now king of Cyprus and Jerusalem. The diplomatic fallout far exceeded the benefits of the new alliance, and shattered the status quo in the south, stirring up further unrest. Unknown to all at the time, it was the catalyst in a chain reaction that led directly to the fall of Normandy.

After the wedding, John continued to progress around his lands, accompanied by his new bride. In October he crossed to England and was jointly crowned with Isabella, before conducting an extensive tour of the country that continued until June 1201.

However, during this prolonged absence from the continent, trouble was brewing in Aquitaine. Eleanor, now ailing and semi-retired at Fontevraud, was so alarmed by the rumours of discontent emanating from the Lusignan lands that she summoned Aimery of Thouars and made peace with him on John's behalf, thus also reconciling Constance of Brittany; she wrote to her son at Easter, entreating him to return as soon as possible to quell the rumbling sound of unrest. John would not be hurried, and managed to make matters worse with his response to Eleanor's concerns, issuing the inflammatory order to confiscate the county of La Marche from Hugh de Lusignan.

John had spectacularly misjudged the mood, highlighting his inexperience of Aquitainian politics. Hugh appealed above John's head to Philip, complaining that John had failed in his duties as overlord, viewing the confiscation of La Marche as an unjust attack. The situation immediately exposed the weakness of Le Goulet – it provided the king of France with legal justification to interfere in Angevin affairs. However, due to domestic difficulties of his own, Philip opted for an uncharitably diplomatic solution more in keeping with the spirit of peace between the two leaders, and invited John to Paris at the end of June to discuss the matter. What could have been an awkward confrontation turned into a lavish state visit between mutual friends, not a formal summons by an overlord to a vassal, and smoothed the way for an agreement whereby John would formally hear Hugh's concerns in his court in Aquitaine.

By this date, Isabella's father had died, leaving John in possession of Angoulême. Emboldened by this acquisition, John was flushed with confidence and used the legal process to accuse the Lusignans of treason, rather than permitting them to air their grievances before their peers. Quite what John hoped to achieve from humiliating such powerful magnates is hard to fathom; perhaps it was an attempt to avenge his mother after her capture

by Hugh when she was on her way to fetch Blanche from Spain, or maybe the new king was trying to prove to the world that he could succeed where his brother and father had failed. Either way, it was a catastrophic mistake as it provoked a second appeal to Philip, who was forced to step in and demand that John offer them a fair trial. This was now a legal battle of wills, with John reluctant to back down for fear of making himself look weak, and Philip not prepared to allow one of his vassals to defy him.

Throughout the remainder of 1201 the brinkmanship continued, with John offering every excuse to avoid holding the trial, until Philip finally lost patience. At Easter 1202, he summoned John to appear before the king's court in Paris to face judgment on the charge that he had failed to provide justice to his vassals; John was also required to surrender key castles as security. The appointed date, 28 April, arrived but John failed to appear. In front of his magnates, Philip declared that John was forfeit of his continental lands – there is disputed evidence whether Normandy was included, but that did not stop Philip from invading, having first knighted Arthur of Brittany and invested him as John's successor in Anjou and Aquitaine. Normandy itself was earmarked for the king, to be absorbed into his personal demesne. Thus war erupted once more, with Philip invading Normandy, with Arthur – now fifteen and capable of leading an army in his own right – marching out to take possession of Anjou and Aquitaine.

The situation was somewhat similar to the one that faced John on his brother's death in 1199, although the absence of the northern alliance made his position in Normandy far more vulnerable, and he no longer had Mercadier marshalling his troops in the south; that burden fell to Eleanor, but she was in failing health and had retired to Fontevraud. Arthur and his army, complete with all the rebel leaders from Aquitaine including Hugh de Lusignan, intercepted her as she made her way to Poitiers, and trapped her inside Mirebeau castle and waited for her inevitable surrender. For once,

John moved with decisive speed and, trusting in the strength of the Norman defences and the leadership of William Marshal, brought an army south accompanied by William des Roches. John appeared at Mirebeau on the night of 31 July 1202, surprising his enemies as if he had 'pop[ped] up as through a trap door, with the suddenness of a demon king' in the memorable words of one historian. The assault began early the next morning, taking Arthur and his forces by such surprise that Geoffrey de Lusignan was captured whilst dining on a breakfast of pigeons. The besiegers were now caught in a trap, and Eleanor led her forces from the keep to complete the victory. The daring rescue had turned into a stunning triumph, and all John's principal enemies were captured in one go. Such was his elation that he wrote to his English barons, joyfully extolling the completeness of his victory.

The prisoners were dragged back to Normandy in chains; Arthur and Geoffrey de Lusignan were sent to Falaise, Hugh de Lusignan ended up at Caen, and the majority of the rest were sent to English castles. Shortly afterwards, Viscount Guy of Limoges was also captured. It was as comprehensive a victory as any enjoyed by his illustrious family, and should have stopped Philip's advance in its tracks. However, this was John – unlike his brothers, he was unable fully to trust his deputies or leading magnates, and became suspicious of anyone who seemed to be too powerful or autonomous. As a result of his chronic lack of governmental experience, John had failed to realise that the only way he could successfully hold his lands together was via delegation to key officials.

William des Roches, the seneschal of Anjou, was just such a man John should have cultivated as a key advisor, yet the way he was treated epitomised John's inability. Des Roches had agreed to accompany John on his march south to Mirebeau on the condition that he would be involved in any decisions over the future of Arthur, his former charge. As a result, his knowledge of the town and castle helped deliver John his stunning victory, but when Arthur's fate

was being discussed, des Roches was excluded from the decision-making in a deliberate snub, intended to show who was the boss. The result was des Roches's defection to Philip's cause, along with Aimery de Thouars, in September; rebellion was thus rekindled as the confederates seized Angers. John panicked, and appointed mercenaries to key positions across his lands, rather than the local magnates – further undermining trust in John's leadership amongst his subjects. Worse still, John decided to release the Lusignans early in 1203 in the hope that clemency would spark loyalty. This was a second spectacular mistake; no sooner had Hugh and Geoffrey been released and sworn homage to John, than they too joined the revolt.

John had undoubtedly handed the initiative back to Philip, and the situation continued to worsen. In November 1202 he marched south to assess the seriousness of his position, and was so concerned that he returned to Normandy to gather an army for a major campaign. However, having left his wife at Chinon, news reached him in January 1203 that she was under attack, so he dashed south to relieve her. Having passed through Alençon, John was informed a few days later that the count had defected to Philip – potentially cutting off his route back to Normandy. John halted at Le Mans and sent his mercenaries to fetch Isabella, and then made his way back to Normandy by a different route. Essentially, John had lost possession of the southern half of his lands.

The deteriorating military situation led him to make perhaps the worst mistake of all. At some point in either late 1202 or early 1203 – the exact date is unknown – John finally decided to mutilate his troublesome nephew in an attempt to prevent him from becoming the focal point for rebellion, and ordered Hubert de Burgh to blind and castrate him. Horrified by the order, de Burgh refused and John angrily moved Arthur to Rouen, where he disappeared from public view. No one knew for certain what happened, but rumours started to spread that he had been murdered. The full story only emerged

after 1207, when Matilda, the wife of William de Briouze, one of John's close associates at the time, revealed what had occurred on 3 April 1203. John was staying at Rouen that night and was drunk; one of his dark rages had fallen upon him, the sort of anger when no one could reason with him. Accompanied by some of his closest followers, including William de Briouze, John ordered his prisoner to be brought to the top of the castle tower. 'Possessed by the devil, he slew him with his own hand, and tying a heavy stone to the body, cast it into the Seine.' According to some accounts, Arthur's body 'was discovered by a fisherman in his net, and being dragged to the bank and recognised, was taken for secret burial, in fear of the tyrant'. Whatever the reality of the situation, the story that John had murdered his young nephew with his bare hands gained currency throughout 1203. In an age of brutality, it was still considered to be a barbarous act and removed what little remaining trust people had in John.

The loss of control of the southern lands, the disappearance of Arthur and the growing suspicion of John combined to give momentum to Philip's assault on Normandy, as well as creating the appearance of only one inevitable conclusion – thus hastening further defections to the French cause. Such treachery eroded John's confidence and made him indecisive. The only people he could trust were those that he paid, but John's mercenaries such as Gérard d'Athée, Brandin and Lupescar were despised and hated, as many contemporaries commented. 'Do you know why King John was unable to keep the love of his people? It was because Lupescar maltreated them, and pillaged them as though he were in enemy territory.' As a result of this catastrophic breakdown in the relationship between ruler and ruled, the resistance to Philip's onslaught against Normandy's eastern defences started to crumble. Conches was captured, Vaudreuil surrendered, and by August 1203, Philip had brought his siege engines and army to tackle the main pillar of Normandy's defence, Château Gaillard.

As with any medieval siege, there were three possible outcomes — the besieging forces either took the castle by storm or starved out the garrison, or a relieving force came to break the siege. Richard had designed the castle to be impregnable against any attack, so Philip came prepared for a long campaign. The French forces first took the town of Les Andelys, prompting the defenders, under the command of Englishman Roger de Lacy, to destroy the bridge linking the island fortress to the river bank. To gain a foothold on the island, a brave Frenchman named Galbert undertook a daring mission. Sealed clay pots of 'Greek fire' — a combination of naptha, pitch and other chemicals that burst into flame on exposure to air — were strapped to his body, and he swam across the river under the cover of darkness. The pots were deployed around the protective palisade and then uncovered, unleashing a firestorm that shattered the outer defences. The French forces were then able to construct a pontoon of boats, protected by floating towers, to bridge the river and fill in the castle's protective ditch. Once they were entrenched on the island, the main task of finding a way through the formidable walls could begin, whilst ensuring no supplies could reach the defenders trapped inside.

John came up with an equally daring plan to break the blockade, combining a night-time amphibious assault on the bridge of boats with a simultaneous raid, led by William Marshal, on the land-based troops. The plan relied on the element of surprise coupled with perfect timing. However, the naval forces found the current was stronger than they had thought, so fell behind in their progress up the river, which meant that Marshal's land forces attacked on their own, initially with some degree of success. However, without the river-borne forces to split the French army, the besiegers were able to scramble back across the island and drive off Marshal's troops, so that when the naval detachment finally began their attack, they faced the entire French army. The pontoon remained unbroken, and such was the loss of life amongst John's naval forces that 'the river ran thickly with blood'.

The failure of the assault stripped John of any belief that he could break the siege directly, and thereafter he left Philip largely unmolested to continue his work. The surrounding hilltops were levelled off, so that various catapults could fire rocks at the walls of the castle. Covered tunnels were dug, so that sappers and miners could begin work on the walls. A small town of tents and huts was constructed to house the besieging army. Having seen John's attempt to relieve the siege fail, Roger de Lacy had no idea when more provisions might arrive so he took the decision to expel all non-combatants from the castle. However, the French army refused to grant them safe conduct, hoping that the garrison would then be forced to take them back in. There was no chance of that; the doors were firmly barred against them, and for the next few weeks several hundred wretched souls were left in no-man's-land, dodging the French missiles whilst scavenging around the walls of the castle in the vain hope of finding any scraps of food to eat. Watching them starve to death day by day was more than Philip could bear, and he eventually relented, ushering the weakened survivors through the ranks of his soldiers where they dispersed like skeletal wraiths across the Norman landscape.

Instead of bringing all his forces to bear on the relief of Château Gaillard, John attempted a diversionary raid against Brittany; it failed. Philip was not to be distracted, knowing the importance of shattering Normandy's defences. John seems to have suffered some form of breakdown as his courage deserted him; he decided to return to England, ostensibly to gather reinforcements. However, the nature of his departure led many to believe that they would not see him again:

> When he left Rouen he had his baggage sent on ahead secretly and silently. At Bonneville he stayed the night in the castle, not in the town, for he feared a trap, believing that his barons had sworn to hand him over to the king of

France . . . in the morning he slipped away before daybreak while everyone thought he was still asleep.

This description of John's flight from Normandy encapsulates everything that had gone wrong; these were the actions of a man in meltdown, totally stripped of confidence and unable to make a decisive stand. Fight or flight was never an option for an Angevin prince, because the second option was unthinkable – until now. Yet on 6 December 1203, John made the crossing to England and abandoned Château Gaillard to a long, hard winter.

Military operations on the site continued throughout the following months, as hunger took its toll on the defenders – they were forced to kill their precious horses to feed themselves as they slowly starved to death. By February, Philip had assembled a range of siege engines to batter the walls, which had already been weakened by the constant work of the miners. Yet it was a far more traditional – and dangerous – technique that ultimately brought the breakthrough. Wave after wave of French attackers flung scaling ladders against the outer walls, scrambling to reach the ramparts as the exhausted defenders hurled anything they could to knock them back down again. The fighting was bitter, hand-to-hand combat at great height, resulting in enormous loss of life amongst the ranks of the attackers. However, to Philip at any rate, the sacrifice was worthwhile. The sheer weight of numbers meant that several parts of the walls were taken. When it became obvious that the outer bailey of the castle could no longer be held, the defenders withdrew to the inner bailey. This was meant to be the hardest part of the castle to storm, given Richard's attention to detail in constructing the 'perfect' defence. Ironically, John had chosen to modify the structure, adding a chapel that created a weak spot. A French soldier swung himself across via a scaling ladder and gained entry through the chapel window, securing the ladder so his comrades could climb up. With the defences breached, the remaining defenders bowed to

the inevitable and, on 6 March 1204, the unassailable castle created by Richard was indeed finally surrendered.

With the fall of Château Gaillard, the whole of Normandy lay at Philip's feet. However, instead of marching towards Rouen – where he had been repulsed several times before, Philip turned west and started to mop up the remaining defences, making any resistance from the ducal capital futile. John cowered in England as, castle by castle, Normandy was prised from his feeble grasp. It was perhaps a mercy that the matriarch of the family, Eleanor, died on 1 April 1204 before the curtain finally fell on her late husband's territorial commonwealth; Fontevraud was, of course, now in 'enemy' hands. In desperation, John turned to diplomacy in an attempt to halt the inevitable. Later in April he sent a delegation of his leading officials, led by Hubert Walter and accompanied by William Marshal, Earl Robert of Leicester, and the bishops of Ely and Norwich, to broker a truce with Philip; the king refused to travel himself, given that Philip would only guarantee safe passage so that John could face justice in the French king's court. Philip was under no pressure to negotiate a settlement – why would he, when Normandy's defences were shattered – and instead used the opportunity to demand the safe return of Arthur and his sister Eleanor, suspecting by now that John had disposed of his nephew. The embassy returned to England empty-handed.

Having mopped up most of the remaining Norman strongholds still in the possession of lords or mercenaries loyal to John, Philip finally wheeled his siege engines towards Rouen. However, no final onslaught was necessary. Despite noises emanating from England that John was preparing to return, the conquest of Normandy was all but inevitable. On 24 June 1204 the garrison and citizens of Rouen opened the gates to their new master and Philip rode in, unchallenged. The consequences were momentous – the political map of Europe had been redrawn, with dramatic results for the evolution of England and France. The Capetian monarchy was now

one of the strongest and richest in western Europe, with Normandy added to the royal demesne and Anjou, Maine, Touraine and Brittany under greater control than ever before. The seemingly all-powerful Angevin family had lost their homelands and most treasured possession, Normandy. The Anglo-Norman realm was no more. For the first time in 140 years, England was cast adrift from the continent and about to face the harsh reality of direct rule by an autocratic monarch.

5

The road to Runnymede

Foul as it is, Hell itself is made fouler by the presence of
John.

To no one will we sell, to no one will we deny or delay,
right to justice.

CLAUSE 40, MAGNA CARTA, 1215

Perhaps nothing better sums up the ignominious end to the
Angevin realm than John's attempts to cross a river. On 11 October
1216 the king left Lynn in Norfolk, travelling to Wisbech where he
spent the night, so that he could conduct some business – possibly
talking to a few of his local officials about securing provisions. This
was no pleasurable tour of the kingdom similar to the one he had
undertaken at the start of his reign; John was embroiled in a terrible
civil war, fighting for his continued right to be king. Haste was of
the essence, as the Fens were full of rebels. He concluded his affairs
in Wisbech, and set out for his next destination – Swineshead –
early the next day, planning his onwards route towards the safety
of Newark Castle. Accompanying him was his baggage train,
complete with the royal chapel and associated archives; clothing
and necessary equipment for a campaign on the road; and silver
and gold plate, including goblets, flagons, basins, candelabra,
jewelled belts and other riches that had been hoarded in monastic
treasure houses. Perhaps most importantly of all, the coronation
regalia were entrusted to the safe keeping of the baggage train for
fear they might fall into enemy hands, including family heirlooms

such as his grandmother Matilda's regalia and vestments that she had worn when anointed as empress – the great crown, robes of purple, a gold wand and the sword of Tristam. John was perhaps the most restless of the Angevins, always hurrying from place to place with a rapidity that would have exhausted even his tireless father. It would appear that John rode on ahead, not wanting to be slowed down by the pace of the baggage train, which was forced to take a different route across the estuary of the Wash, crossing the Wellstream as it flowed out to sea. There may well have been another reason for John's desire to be out of his saddle as quickly as possible – he was increasingly plagued by feelings of sickness, the result of an illness he had picked up in Lynn.

Dangerous waters coursed along the Wellstream, which was only passable at low tide – likely to have been around noon on 12 October. However, the baggage handlers and servants of the king were more fearful of their master than the difficult conditions, and 'hastily and incautiously' attempted the crossing early, before the waters had fully drained away. It was a fateful mistake. Even when fully drained, the secure paths across the Wellstream were surrounded by quicksand, and it required skilled local knowledge to traverse the route successfully. Attempting to cross before all the excess water had gone made it hard to spot the safe areas. As a result, the baggage train quickly ran into difficulties, with many of the packhorses being sucked into the muddy riverbed because it had not fully dried out. As the handlers tried to extricate the panicking animals from the stream, they too became stuck, struggling as they began to sink deeper and deeper into the liquid ground. Before long their plight became desperate; those too far gone to help were abandoned to their fate, whilst the remaining servants vainly tried to salvage some of John's possessions from the wreckage. By now the tide was turning, and the rising waters claimed 'his chapel with his relics' and almost certainly 'the treasures, precious vessels and all the other things which he cherished with special care', which

were sucked down by 'bottomless whirlpools' along with 'many members of his household'. It is unknown how many people were able to escape the chaos to bear news of the disaster to the king, but it was a major blow to John's already tarnished dignity and faint hopes of striking a decisive military victory over his enemies, given the amount of treasure that had been lost. By now the effects of his illness – almost certainly dysentery – were starting to take effect and the remaining members of his household slowly accompanied him to Sleaford; John was barely able to mount his horse, such was the pain he was in. The party rested there for a couple of days, before wearily completing the journey to Newark. By 19 October, the king was dead, perishing in the night during an apocalyptic thunderstorm.

*

John had brought the fortunes of his family full circle. Having inherited the territories of his father and brother virtually intact in 1199, he lost most of the continental possessions in 1204; furthermore, by 1216 the crown of England was in jeopardy, challenged by a rival claimant – very similar to the wars of Stephen and Matilda, with the difference being that John was now cast in the role of the hapless Stephen, and his opponent was the young Prince Louis, son of John's nemesis, King Philip of France. The disaster that had befallen John, though, was a collapse on an altogether different scale to Stephen's abandonment of Normandy. Despite the rapidity with which John's position disintegrated in 1203, it was not inevitable that his losses were irreversible. Normandy, Anjou and Maine were annexed to the French crown, with the latter two counties subsequently granted to junior branches of the royal family. However, in 1204, these outcomes were not necessarily permanent. For a start, Philip's conquest of the Angevin lands was not all-encompassing. Following the death of Eleanor, he turned south in an attempt to claim Aquitaine as

well. Whilst Poitou was quickly overrun, save the sea port of La Rochelle, the county of Angoulême was technically held by John through the dynastic right of his wife Isabella, preventing Philip from invading – no matter how tempting it must have been. Equally, the mood of the lords further south in Gascony was far more hostile towards Philip than John – partly due to growing trading links with England, but mainly because an absent lord was preferable to direct rule from Paris. John still had a toehold on the continent, albeit a long way south of where he would have preferred to be. Large sums of money – 28,000 marks – were sent across the sea in 1204 to raise a Gascon army, ready for John to sail across and start the counter-offensive.

It should come as no surprise that the military operation never materialised – or at least when John did finally mount a campaign, it was several years too late. John's return to England in 1203 had been greeted with a sense of deep unease by a proportion of the leading barons and, if the chroniclers reflect the views of people living within their sphere of knowledge, the general population were also concerned, prompted by a growing resentment that the flow of cash from England to Normandy had not slowed down during John's early reign. In fact, with Normandy in mortal peril, John showed for the first time that he was even more innovative than his father or brother when it came to extracting money. Whilst still in Normandy in 1203, he called for an extraordinary tax whereby one seventh of the value of all moveable goods should be paid to the crown. It is hard to estimate quite what this yielded, but the fact that it was demanded and raised some money is telling. Unlike the Saladin tithe or the taxation to raise Richard's ransom money, there was no real feudal precedent for the request; many people in England were naturally apathetic about the plight of John's continental lands, compared to that of the Holy Land, for example. Yet, under the direction of Hubert Walter and justiciar Geoffrey FitzPeter, the exercise was a moderate success, although

given the panic that seems to have affected John's judgement during 1203, it was probably a case of too little, too late.

Hubert continued to tinker with the administrative machinery during John's early years, for example introducing reduced fees for confirming charters that increased business and overall yield, generating a new set of records – the charter rolls – and fewer forgeries. We are also indebted to him for the great rolls of state, the patent and close rolls, which survive from this period. Geoffrey was Hubert's successor as justiciar and was another of Richard's astute appointments, continuing to serve as the lynchpin of John's administration until his death in 1213. Together, they formed the bedrock of John's early government whilst he was still primarily based abroad. John's arrival in England in late 1203 prompted further innovation, as he sought to gather together sufficient treasure for a campaign of reconquest.

One reason why England was perceived as a country flowing with riches was due to its burgeoning trade with the continent. With an uncanny sense for sniffing out money-making schemes, John introduced the notion of an indirect 'trade tax' and reorganised the old customs system of imposing a surcharge on goods coming into English ports. First, a levy at the rate of one fifteenth was introduced in July 1202, running until November 1204, until the system was farmed out to local collectors in the principal ports, generating regular revenue for the crown estimated at around £2,000 per year. Whilst this was not as sophisticated nor extensive as the system developed by Edward I in the 1270s, it was still a major step forward in exploring alternative avenues of income. At the same time, John oversaw a radical overhaul of the coinage through 1204 and 1205, generating further profit from the exercise whilst re-establishing royal authority over the process of minting coins.

John's need for money to support an immediate campaign of re-conquest was exacerbated by the financial imbalance that the losses of territory had now created. The situation after 1204 was

clear – the Capetian absorption of the Angevin lands into the royal demesne had given Philip a significant advantage that was only going to strengthen as he started to take hold of the machinery of government that Henry and Richard had created; thus, for John, speed was of the essence.

There was another reason to strike back as soon as possible before Philip consolidated his gains. The severance of the Anglo-Norman realm forced many of the leading barons who held estates or had family connections on both sides of the Channel to choose between the two kings. This was a terrible decision to make, since both John and Philip adopted an aggressive tactic of sequestrating land from anyone who abandoned their cause; the Anglo-Norman baronage was thus forcibly ripped apart, with the decision usually based on where they held the most land rather than any sense of loyalty. Three men in particular who chose England over Normandy faced massive losses – Ranulph, earl of Chester, the former husband of Constance of Brittany; William Marshal, earl of Pembroke; and Robert de Beaumont, earl of Leicester. The latter two men had used the diplomatic mission to Philip in April 1204 to reach an agreement whereby their lands were exempt from confiscation for a year and a day, on the payment of 500 marks. This was of little use to Robert, who died childless a few months later in October 1204. William quickly realised that the chances of military success were slim, and urged John to reach a diplomatic solution with Philip. However, many others families faced ruin, and throughout 1204 preparation for war turned to wrangling over the best way forward. Soon the campaigning season had passed, and autumn turned into one of the coldest, most bitter winters anyone could remember. Crops failed, prices soared, rivers froze over, the ground was too hard to prepare for the next season, and many people died. It summed up John's prospects perfectly.

The misery of England's population was reflected in growing resentment towards the king amongst the leading subjects, and as a

result John's fears of treachery grew. The earl of Chester, for example, was suspected of colluding with the Welsh leader Gwenwynwyn and in December 1204 was stripped of his estates. Having already lost his Norman lands, Ranulph couldn't afford to be on the wrong side of the English king and made a great attempt to demonstrate his loyalty to the crown. He was quickly reconciled and proved to be one of John's most loyal supporters for the remainder of the reign, rewarded in turn with honours and riches. Even a stalwart of the Angevin family such as William Marshal fell out with John during that miserable winter; the king seems only to have really trusted his half-brother, the earl of Salisbury William Longespee, and William de Briouze – the likely witness to the murder of Arthur at Rouen in 1203 and therefore quite literally his partner in crime. The majority of the English barons were suspicious of the king, and the feeling was mutual. John did not help himself by forcibly seducing many of his magnates' wives. Even his key trusted officials were not safe from John's voracious sexual appetite; at Christmas 1204, Hugh de Neville's wife offered 200 chickens to spend the night with her husband, long assumed to be a reference to the fact that she was being forced to sleep with the king. Nevertheless, John placed his trust in his administrative team, often 'lesser' men raised from humble origins, or hired mercenaries, rather than the native noble-born magnates. Only a limited circle gained access to the king's patronage, and a pattern was set that was to endure for the remainder of John's reign. Yet, despite John's apparent lack of inter-personal skills, he could also show disarming charm and incredible generosity, and that was part of the problem. No one knew exactly where they stood, and thus any semblance of trust was always eroded by uncertainty and doubt.

It did not help John's position that rumours started to circulate that Philip was planning to invade during the spring of 1205. John took several steps to shore up his defences, including the order that every adult male in the country should swear an oath of allegiance

to the king in January 1205, backed up with a general reorganisation of the 1181 Assize of Arms according to which local levies were prepared 'for the general defence of the realm and the preservation of the peace'; anyone who failed to take part 'against foreigners and other disturbers of the peace' was taken to be an enemy of the crown, and had his estates forfeit. For once, John's fears were justified; Philip had stirred up the count of Boulogne and duke of Brabant by suggesting they might cross to England and claim their wives' old family estates – they were granddaughters of King Stephen who had been disinherited by Henry II. John placed the southern ports on high alert and stepped up his own preparations for a campaign of re-conquest. Throughout April and May, John spent money building siege engines and other supplies for war – gathering copious amounts of crossbow bolts, arrows, tackle for horses, provisions – and then moved them to the coast. His base of operations was Portsmouth, which had served his brother as the main supply port for Normandy. Now, with the severance of the Anglo-Norman realm, the Channel had become the new frontier between the warring kings. It was essential for John to secure the sea-lanes, not just to ensure the safety of England but also to enable a successful invasion of France. For the first time since the age of Alfred the Great, an English king invested heavily in the creation of a navy, a vast fleet that could patrol the waters of the Channel, for the same reason that Richard had invested in the stone castles along the Norman border.

However, the one man who could have turned John's plans into reality also stood to lose the most from the prospect of war. William Marshal's truce with Philip had come to an end and, in an attempt to save his Norman lands, he persuaded the king – against the advice of Hubert Walter – to allow him to visit Philip. The cover story was that he was exploring peace options, but in reality it was an excuse to broker a new deal that would protect his family estates. The formula that was concocted gave William a modicum

of security, but created a most unusual feudal precedent. William performed 'liege homage on this side of the sea' to Philip, which meant that he had divided his allegiance between two lords. Whilst he was in England, he was John's man; however, the moment he crossed to France, Philip could claim his loyalty. Needless to say, John was unimpressed at this attempt at diplomatic neutrality.

William reported back to the king who, as usual, was watching over the construction of his fleet at Portsmouth in the company of some of the leading barons. When told what had happened in France, John was furious as he grasped the consequences of the deal that William had struck. In a voice shaking with anger, and laced with sarcasm, the king shouted: 'Come with me and fight for my inheritance against the king of France to whom you have performed homage!' William replied that he was unable to do this; prompting John immediately to call on the assembled barons to pass judgment on William on grounds of treason. There was a moment of silence, before William turned to his peers and appealed to them directly, playing on the lack of trust they clearly felt towards their king: 'Let this be a warning to you: what the king is planning to do to me he will do to every one of you when he gets the upper hand.' His words were effective, and none of the barons would respond to John's repeated demands for judgment. 'By God's teeth, it is plain to see that none of my barons are with me in this, I must take counsel with my bachelors.' With these words, John withdrew to speak to his entourage of young household knights, leaving William standing alone. However, William's reputation was such that John's supporters pointed out that, whilst William had undoubtedly acted in his own interests, he had the right to claim a judicial duel should John persist with his accusation. No one dared faced the greatest knight in the country, and John angrily stormed off rather than pursue the matter further.

The very public row between John and William undermined the whole expedition, as it made clear that no one wanted to go to France.

John's contrary character was now shown in sharp relief. Having failed to demonstrate any courage and backbone in 1203, he was now gripped by a reckless determination to launch a naval assault into Aquitaine, and refused to accept any advice to the contrary. Preparations continued apace, until the wrong wind prevented John from sailing. William Marshal and Hubert Walter confronted him once more, trying to persuade him from undertaking such a foolish mission, given the threat of invasion from Boulogne and Brabant, and the lack of resources he could mobilise against Philip. They even tried to play on his fear of treachery, pointing out that the Poitevins were notoriously fickle and might just as easily hand John over to Philip as fight for him.

When reasoned argument failed, the two men – Hubert by now aged and ailing – fell to their knees 'swearing that, for certain, if he would not listen to their entreaties, they would forcibly detain him lest the whole kingdom be thrown into confusion by his going'. This was no idle threat; the king was virtually wrestled to the ground and, weeping with frustration and shame, was dragged off to Winchester. John was not to be stopped and returned to Portsmouth the next day – the common sailors were hugely impressed by their commander in chief's determination to fight, and John set out on the royal galley on a cruise up the Channel. Yet it was clear that he did not have the support of the barons and their knights and, after three days, John was forced to abandon the expedition. Instead, a small force was sent to Poitou and another, under the earl of Salisbury, went to reinforce La Rochelle. It was already too late, though. The last two strongholds that had valiantly held out for John, Chinon and Loches, were forced to surrender; their garrison commanders, Hubert de Burgh and Gérard d'Athée, were ransomed by John and brought back to England as loyal men he could trust.

However, the stress and strain of resisting John had proved too much for Hubert Walter; the grand servant of the Angevin cause and architect of English bureaucracy breathed his last on 13 July

1205. His final legacy was to help John overhaul the management of the royal demesne by introducing a new system of accounting for the county farm. One of the reasons that the office of sheriff remained desirable, despite the erosion of sheriffs' rights under Henry and Richard, was that it was lucrative. Even with the imposition of increments in the 1190s, a sheriff could expect to make money as the income generated from the crown lands usually outstripped the fixed annual payment. From 1205, however, the sheriff was expected to account for this profit above the farm rather than pocketing it. The complexity of the process bears testimony to the sophistication and power of the royal exchequer, for the first time under the direct control of the king; the shift to custodial sheriffs bore instant financial dividends. John spent the rest of 1205 and the early part of 1206 building up his fleet and laying down more stores of arms and treasure.

As well as constructing his own ships, he commandeered those sheltering in English ports, writing to his military constables on the coasts:

> Detain for service all vessels fit for passage that are able to carry eight or more horses. Man them with able seamen at our cost and send them to Portsmouth, so that without hindrance they be there on the eve of Pentecost, or if possible earlier. And be careful that each ship be provided with ladders and hurdles. And remember to enrol the names of the owners of the ships and the number of seamen in each ship, also the number of horses which each ship can conveniently carry.

This letter is a perfect example of John's greatest skill – a natural talent for administration, with the attention to detail required for such an ambitious undertaking. Two men in particular oversaw the development, growth and management of John's navy – William de Wrotham and Reginald de Cornhill, although it was John's

half-brother William Longespee once more who had command of the fleet.

After final preparations throughout May, John finally embarked for the continent – two years after Normandy had fallen. A fleet of several hundred ships set sail from Portsmouth, arriving at La Rochelle on 7 June. Remarkably, many local lords declared their support for John, enabling him first to relieve the beleaguered city of Niort and march on towards Poitiers, before heading south in July to besiege the rebel-held Montauban. This was a formidable place to take; however, John displayed an adeptness at castle-breaking more closely associated with his brother Richard, and reduced the defences to rubble. With the south of Aquitaine largely secure, John marched north and returned to Niort by August, raiding into Berry and persuading the viscount of Thouars, now Philip's seneschal of Poitou, to switch allegiance back to John. Emboldened by having gained the entire county back into his hands, John then raided deep into Anjou, reaching Angers by 8 September and daring to move close to the border with Maine. By this stage, Philip had decided to march south and brought an army to the Poitevin border. A truce was agreed on 26 October, recognising the status quo at the time. Thus John had regained most of Poitou and given Philip something to think about. It was a start.

*

If John wanted to reclaim the remainder of his lost lands, it was clear that he would have to do it the hard way; and any plans he might formulate boiled down to a simple need to generate a vast fortune to hire an army of mercenaries. For the first time, the country was to feel the effects of the Angevin machinery of government running at full speed. Henry may have created the chassis, and Richard and his ministers refined the bodywork, but John slipped into the driving seat and put his foot firmly to the floor. Over the next six years, John embarked on the greatest exploitation of royal rights ever seen in

England and extracted enormous amounts of money from the shires. Revenue reached £47,500 in 1210, £43,300 in 1211 and £38,600 the following year – vastly more than at the start of the reign.

Three areas in particular raised the political temperature in England to boiling point, mainly because they either directly impinged upon the core relationship between king and leading magnates, or highlighted the increasingly arbitrary and punitive nature of John's kingship. The perennially unpopular forest became a major cause of discontent as fines and amercements (similar to modern fines) from John's zealous officials flowed into the treasury, causing misery to thousands caught up within the jurisdiction of the royal forest. The hard winter of 1204–5 had been followed by steadily rising prices, forcing many to gamble on poaching protected game or clearing wasteland to grow crops. More regular forest eyres saw money from this source of revenue top £3,000 in 1212 alone, and by 1214 the prerogative powers of the crown over the forest had come to epitomise the worst of Angevin government. Equally, John increasingly exploited the number of feudal incidents that arose during his reign, and either created a bidding war for lucrative wardships or marriages, or levied huge relief fines to permit heirs to inherit. The practice of buying land or status was not new, but the amounts that John demanded were truly eye-watering. Geoffrey de Mandeville, for example, met John's asking price of 20,000 marks to marry his former queen, Isabella countess of Gloucester, and therefore control the rich family lands. Interestingly, complaints were raised that the dice were loaded against those outside John's circle of cronies. No one forced bidders to contract for these opportunities, but it was at the king's discretion whether the full amount was demanded; many of his favourites secured status and title at the expense – literally – of the native aristocracy, further deepening the divide between John and his barons.

The most incendiary part of John's management of feudal incidents related to the level at which relief fines were set. Henry I's

coronation charter was still seen as the benchmark of good practice, and it had become standard to demand £100 to inherit a barony, scaled down appropriately depending on the size of the land in question. Under John, there was no fixed tariff and the sums demanded rose and rose, particularly if the family in question had fallen out of favour. For example, John de Lacy was charged 7,000 marks in 1211, and the king demanded 10,000 marks (£6,666) from Nicholas de Stuteville for his inheritance in 1205; the lands were worth £550 per year. This was a financial sword of Damocles. The fear that the king would call in the full debt was intended to ensure the cooperation and good behaviour of his subjects, a choice between loyalty and financial ruin. In fiscal terms, though, the result was brutally effective. Prior to 1207, feudal dues generated around £2,500 per year; thereafter this doubled, with nearly £7,000 paid in cash in 1211.

In a similar manner, the pipe rolls become littered with fines 'for the goodwill of the king' – a turn of phrase that marked a sinister meaning, whereby those suspected of plotting against the king would be hit with an arbitrary, and usually steep, fine to regain his goodwill – a nasty twist on the king's right to grant judicial mercy. In particular, these rose in number and size from 1210 onwards, when the disconnection between John and an increasingly large proportion of his barons started to widen into a gaping chasm. As with relief fines, only on rare occasions was the full amount demanded; it was the fear of full imposition that was meant to keep people in line. Ultimately, there would be a huge political backlash against these arbitrary, unpopular and divisive measures.

What is perhaps the most astonishing aspect of the period between 1207 and 1212 is the use of the exchequer to carry out the systematic extraction of revenue. Payments were collected by royal officials in response to a summons issued by exchequer clerks; paid over to either the treasury in Westminster or, more likely, one of a number of regional treasuries located in secure royal castles around

the country that John established; and then audited before the formidable barons of the exchequer. This was the most concerted bureaucratic exercise in English history since the compilation of the Domesday Book, and certainly the most sustained in scope and intensity. The exchequer provided an established legal and administrative framework for this activity. Its growing archive allowed no debt to go unrecorded; the powers of summons and distraint, enforceable via the network of sheriffs and other officials, gave a coercive back-up to John's demands. But John could claim that the process was a legitimate part of government. This was perhaps the first time that the exchequer was systematically used in this way – a powerful extension of royal will – and such an exercise was only possible because John 'ruled indefatigably', ceaselessly roaming around England, balancing his love of hunting with a personal interest in the business of government.

Several stories exist that show John in a more reflective light as a king going about his business, granting alms to the poor and intervening directly in legal cases, sitting with his judges to dispense justice and showing the true meaning of mercy. On one occasion, a case came before him concerning a small boy who had thrown a stone and accidentally killed another. John 'was moved to pity' and granted a pardon. With written records from the courts starting to appear for the first time, we see decisions being referred directly to the king, or discussions about the 'law and custom of the realm'. The wholesale extraction of money was only possible with a permanent king who was prepared to knuckle down to the minutiae of administration, something that had not been possible prior to this point, given the long absences of Henry II and Richard.

*

Overall, John had amassed a massive war chest by 1214. It is almost impossible to provide an accurate figure for the amount he had assembled, yet just using exchequer data, John received £157,000

in cash between 1210 and 1212 alone; and if a Jewish tallage is included, based on chronicle accounts that suggest over £44,000 was accumulated, the figure would be in excess of £200,000. Over half came directly from the shires, and this did not even include money expended on various military projects locally. Yet perhaps the greatest cash windfall came from a most unfortunate source, flowing from the death of Hubert Walter in 1205. John's attitude to the church was somewhat ambivalent, with many indications that his alms-giving was in response to repeated breaches of church rules; he was prone to making witty if irreverent or downright blasphemous jokes about religious doctrine, including the implausibility of the resurrection. John recognised the importance of the high-ranking clerics within his administration, raised to prominence by his brother and continuing to serve him well. Bishop Hugh of Lincoln – who famously upbraided his father – was a particular favourite before his death in 1200. However, on other occasions John's attitude was disrespectful, bordering on the unhinged. In 1207, the archbishop of York sought a personal audience with the king to protest against the levy of the thirteenth from his lands, and fell at John's feet begging for exemption in a show of humility. 'The king, in truth, threw himself at the archbishop's feet and laughing and jeering said "Look, my lord archbishop, even as you do, so do I."'

John's preferred candidate to succeed Hubert as archbishop was the bishop of Norwich, John de Gray – a man who was closely associated with John's administration prior to his accession as king and thereafter served within the royal chancery, securing the position of lord chancellor for his nephew Walter in 1205. However, the monks of the cathedral chapter at Canterbury had other ideas, claiming the right to elect their own leader, and proposed their prior, Reginald. John went to Canterbury in an attempt to persuade the monks to see his point of view – and failed. Both sides agreed to defer the decision until the end of November but John sent envoys to the pope, preparing the way for John de Gray's candidacy, and

as soon as word of this reached the monks, they hastily elected Reginald and sent him to Rome to seek Innocent III's approval. John was furious, and marched back to Canterbury, forcing the monks to hold another election at which John de Gray was declared the victor. The king then sent an envoy to Rome on 11 December 1205 to announce the decision, and in early January a second party of monks arrived to overturn the claims of Reginald and his supporters. The pope was frankly unimpressed with the situation, and decided to intervene.

On 30 March 1206, having secured fresh representatives from all parties – king, bishops and monks – the pope ruled against the right of the bishops in the process, quashed the previous elections of both Reginald and John de Gray, and commanded the monks to hold a new election on the spot in his presence, much to the consternation of the royal delegates who realised this would set an important precedent for papal authority. When the monks failed to choose between either Reginald or Gray, Innocent calmly set both candidates to one side and proposed his own man, Stephen Langton – an English cardinal, appointed to San Crisogono, who had until recently taught at the University of Paris. Given they were in the presence of the pope, the monks unanimously elected him. Everyone was happy, apart from John, who engaged in a furious exchange of letters with the pope expressing his outrage and dismay that he had not been involved, pointing out that Langton had been closely associated with the court of his bitter rival, Philip. He forbade Langton entry to England, and expelled the monks from Canterbury, forcing them to find refuge in various monasteries in France. Thus John blundered his way into yet another continental power struggle, this time running up against Innocent III's determination to assert the primacy of the church over secular customs. In the case of the English church, this meant building on the concessions gained from Henry II in the aftermath of the Becket affair. John's actions were also a personal blow to the

honour and dignity of the pope, and the stage was set for a bitter fight that escalated over the next few years.

Innocent gave John twelve months to cool off – but John was a chip off the old block and was as stubborn as his father when it came to matters of the church. Consequently, the pope consecrated Langton on 17 June 1207 and wrote to the bishops of London, Worcester and Ely the following month in an attempt to persuade the king to accept the result of the election, granting them the power to publish the general sentence of interdict, permitting no ecclesiastical office, save the baptism of infants and the confession of the dying, if he did not comply. John remained unmoved. Innocent changed tack, and tried to exploit the rift between king and magnates in November 1207, writing to the English barons:

> Because you should so order your loyalty to your earthly king so as never to offend the heavenly king, you ought to be on your guard to save the king from a policy which he has seemingly adopted in enmity to God – that of persecuting our venerable brother, Stephen archbishop of Canterbury . . . Do not fear displeasing him temporarily in the cause of justice – for conduct so upright will not injure you by exciting him to hatred, but will in time work to your benefit by winning his love.

This was an incendiary letter, inciting the magnates of the realm to force the king to submit to an outside power, albeit the leader of Christendom – essentially providing papal backing for opposition to the king. John seized upon it and turned the situation to his advantage, outwardly open to talks with Langton's brother Simon whilst portraying himself as the victim of persecution; as a result, 'All the laity, most of the clergy and many monks were on the king's side.'

However, by March 1208, it was apparent that John had no intention of negotiating a settlement, and Innocent therefore was

left with little option but to place England under an interdict, suspending all church services. Such measures, whilst drastic, were not unknown; indeed, Philip Augustus had suffered a similar fate during the stand-off surrounding his marriage to Ingeborg. John, though, was not going to back down and had been preparing for the pope's move. On 24 March, when the interdict was formally declared, John's army of sheriffs and local officials marched into churches, monasteries, cathedrals and abbeys around the country and seized all the property they could find, taking control of the vast estates that provided so much of the church's income. Some clergy were allowed to pay for the privilege of regaining their lands, provided they submitted to the king and paid their profits to him; other property was handed to baronial families with local connections, on the payment of the appropriate fine. In short, the interdict provided John with an enormous cash windfall. A large proportion was paid into the exchequer, or expended locally on royal projects; the remainder almost certainly disappeared into the chamber, and onwards into the castle treasuries. To add insult to injury, John used his temporary position as *de facto* head of the church to embarrass those parish priests who were brazenly flaunting the strict rules of celibacy. The king rounded up the clergy's 'concubines, hearth mates and lady-loves' and held them for ransom. Countless parish priests paid up.

When it was clear that the interdict had merely made John richer, Innocent was left with only one more weapon – the threat of personal excommunication against the king, which was carried out in November 1209. This had far more serious implications, building on the veiled threat contained in the letter to the barons in 1207. Leaving aside the religious sanctions that imperilled John's soul – not that he seemed unduly bothered at the time – the sentence was intended to outlaw the recipient from the Christian community and undermine their oaths. Whilst this was not formal deposition, nor a disavowal of any oaths of allegiance taken to the

king, excommunication weakened the bond between John and his magnates that was already strained by the financial demands and general dissatisfaction with his style of kingship. Church services were an integral part of daily life, and ceased during the interdict. Bodies could not be buried in consecrated ground, or marriages conducted in church; but people found a way to continue, and there was no sign of any popular discontent against John's rule, aside from the natural criticism he received from ecclesiastical chroniclers who lamented the closure of churches around the country. However, in the minds of the barons watching John's ruthless suppression of the church and the departure from England of many leading bishops, there grew the nagging feeling that they might be next. Many of them were right to be fearful.

*

Having harnessed the power of the royal administration, and seized control of the church, John continued to govern England ruthlessly, focusing on ways to raise even more money. To do his bidding, he needed men he could trust who were divorced from local sensitivities – in short, campaigners and adventurers. Increasingly, loyal adherents like William Marshal and William de Briouze found themselves frozen out of government, their advice no longer heeded. Worse, they had become part of the problem, especially as they held strategic marcher lands on the Welsh border. Marshal was stood down as sheriff of Gloucester and custodian of Cardigan, for example, replaced by John's mercenaries, and found his estates in Ireland were assaulted at John's encouragement. William de Briouze also fell foul of the king's suspicious nature. The official reason retrospectively provided by John was that de Briouze had failed to make regular and sufficient payments towards a 5,000-mark fine levied to acquire the lordship of Limerick in Ireland. Once again, the power of the exchequer was deployed to distrain de Briouze's estates, and in March 1208 John demanded hostages from

him – a tactic regularly deployed against other leading magnates to ensure their continued good behaviour. However, de Briouze refused to comply; when royal officials turned up at his residence, it was alleged that:

> Matilda, the wife of William, with the sauciness of a woman, took the reply out of her husband's mouth and said, 'I will not deliver up my sons to your lord, King John, because he basely murdered his nephew Arthur, whom he ought to have kept in honourable custody.' William was so alarmed at his wife's rash tongue and rebuked her saying, 'You have spoken like a stupid woman against our lord the king; for if I have offended him in any way I am ready to make amends without the security of hostages according to the judgment of my fellow barons in his court, if he will fix a time and place for my doing so.'

It may be that this story is untrue, but John's reaction – following up the original demand for hostages by sending in a small army under the command of the sheriffs of Gloucester and Shropshire – suggests that his reported fury was sparked by a personal motive rather than a financial one. It is also entirely in keeping with Matilda's strong, independent personality – 'a beautiful lady, most wise, most worthy and most energetic. She was never absent from any of her husband's councils. She carried on warfare against the Welsh in which she conquered a good deal.' In desperation, William offered the staggering sum of 40,000 marks for the goodwill of the king, but John refused until Matilda had been brought to him, confirming that she was at the heart of the king's anger. Realising that the king was implacable, and fearing for the life of his wife and children, in the autumn of 1208 William fled to Ireland, where he held some lands and, more importantly, the sympathy of many of the Anglo-Norman barons including the Lacy family and William Marshal, who had also prudently removed himself from England.

The resulting political storm from de Briouze's public fall from grace resulted in three military campaigns that transformed the intra-national relationship within the British Isles between England, Wales, Ireland and Scotland, as well as highlighting the increasingly arbitrary nature of John's rule. If former stalwarts such as Marshal and de Briouze could be treated so harshly, what fate lay in store for the others? Mistrust of the king led to John becoming more suspicious of his barons, thus exacerbating the situation. Indeed, John deployed a network of informants in the royal court to find out what was going on – Henry of Pomerania and Alan of Dunstanville later revealed that, as members of the royal household, they had been told that 'if they hear anything hostile to the lord king they were to report it to him'. Thus John had created the medieval version of an Orwellian 'Big Brother' state, with spies whispering rumours of discontent into his ear, prompting punitive fines for the king's goodwill, hostage-taking and armed suppression in the shires – the medieval equivalent of a military dictatorship. It is perhaps no wonder that in this climate of fear, the first whispers of rebellion could be heard.

Despite his determination utterly to crush William de Briouze and silence his wife, John was unable to follow him to Ireland immediately after his flight from England because another threat to his position had materialised. Encouraged by the pope's enmity towards John, Philip was stirring up trouble on the international stage. In 1209 he reached out to William the Lion, king of Scots, and explored the possibility of linking up with the Irish malcontents as part of an invasion plan. As always, the issue of Scottish claims to northern counties was sufficient incentive for William to listen to Philip's scheme, given John's failure to provide a definitive resolution at the start of his reign. John decided on a show of military strength and marched a large army north to Norham in August, demanding William's total submission and the grant of three castles to secure his loyalty, along with payment of 15,000

marks for the goodwill of the king and the delivery of William's two daughters as hostages – the elder, Margaret, was earmarked as a future bride for John's infant son Henry, though the marriage never came to pass. A long-forgotten text of the treaty of Norham has since been rediscovered, which lays bare the scale of William's submission to John. To confirm the peace, William was forced to do homage to John for his lands in England – the same terms as he had performed in 1200, reflecting Richard's reversal of the treaty of Falaise. However, John was looking to the future relationship between England and Scotland. In a letter distributed to his English magnates, John wrote that William's son Alexander 'has done us homage as William, king of Scotland, did homage to the lord Henry, king of England, our father'. Thus when William died, Alexander would inherit Scotland as a vassal state of England, reverting to the status quo of 1175. This was a huge concession, showing John's military power in 1209; having dealt with Scotland, he then turned towards the fugitives in Ireland.

John had despatched John de Gray, bishop of Norwich, to act as justiciar and run the Irish government from Dublin – a convenient move for all parties, as it meant that the bishop could avoid the strictures of the interdict whilst John gained a trusted and capable administrator. De Gray, however, had not reckoned on the fragmented political situation in Ireland. A different set of rules applied when dealing with the Anglo-Norman adventurers. For example, de Gray demanded that William Marshal hand William de Briouze over to the royal officials, but Marshal refused, stating that in Ireland de Briouze was his lord because he held some lands from him, and therefore it would be a breach of his feudal duties to hand de Briouze over to another lord. In short, English royal authority did not apply in the same way across the Irish Sea. The opposition of the native Irish lords and kings compounded the complexity of the situation. Large parts of Ireland completely refused to acknowledge the legitimacy of the Anglo-Norman claims of

overlordship; even those that had been forced to were looking for ways to unsettle the regime in Dublin. Therefore, in the spring of 1210, John brought his army across to bolster de Gray's authority, as well as hunt down de Briouze and his family. Months of preparation went into the campaign, with stores assembled from all across England and Wales and mercenaries hired from Flanders. The fleet sailed from Pembroke and landed near Waterford, progressing through Marshal's lands in Leinster to Dublin. Walter Lacy was dispossessed of Meath; Hugh Lacy, who was protecting Matilda de Briouze, was forced to flee to Scotland as his Ulster fortifications fell before John's all-conquering mercenaries. William de Briouze fled to Wales, thus losing control of Limerick. By the time John sailed back at the end of August, his grip on Anglo-Norman Ireland was stronger than ever.

Meanwhile, de Briouze had begun to stir up trouble in Wales, allying himself with the main prince, Llewellyn – later to earn the epithet 'the great' for his consolidation of native power in Wales. However, devastating news soon reached William – his wife and son William junior had been captured in Scotland and handed over to John's officials. In desperation, Matilda offered 50,000 marks for her freedom whilst William broke cover and tried to reach the king to beg for his family's lives. Neither appeal was successful. John released a document detailing his dispute with the Briouze family, legitimising his actions by setting out the financial reasons that led to his distraint 'by the custom of the kingdom', witnessed by barons including William junior's father-in-law, Richard de Clare. William senior was made an outlaw, and fled disguised as a beggar to France, where he died the following year. However, a terrible fate awaited Matilda and her son. They were imprisoned at Windsor and then Corfe, where the king's officials from the exchequer paid them a visit to collect the first portion of the 50,000 marks she had promised. Needless to say, Matilda had nothing of the sort – a few personal belongings and £16 in cash. Having

defaulted on the payment, her life was deemed to be forfeit, and, on the king's orders, they were left to starve to death:

> After eleven days, the mother was found dead between her son's legs, still upright albeit leaning forward against her son's foot. Her son, who was also dead, was found sitting straight, bent against the wall. So desperate was the mother that she had eaten her son's cheeks.

The horrific treatment of Matilda and William junior, and the destruction of the family's fortunes at the blink of an eye for a fairly innocuous reason, served as a chilling warning to the barons and marked the moment when many decided they could no longer serve under John. The most immediate impact was to provoke Llewellyn to revolt, despite the fact that he had married John's illegitimate daughter Joan in 1205. The relationship between them had been fairly good up until that point, especially when John had arrested Llewellyn's chief rival Gwenwynwyn in 1208. However, the fall of de Briouze provided an opportunity for the extension of Llewellyn's power that he could not resist, building castles and encroaching on areas of royal influence. Having subjugated the Scots and brow-beaten the Anglo-Norman lords of Ireland, John marched his army into Wales in May 1211, uniting with other native lords who were opposed to the growing authority of Llewellyn in the region. Like ghosts, Llewellyn's men disappeared into the misty Welsh mountains around Snowdonia, forcing John to withdraw, having run out of food during the pursuit. It was only a temporary reprieve; John returned in force in July, building forts along the way both to ensure a supply line and establish a military presence in the region – a tactic that his grandson Edward would adopt to great effect seven decades later. Llewellyn was forced to come to terms – or at least, he sent his wife to agree terms with her father, not trusting John sufficiently to leave his mountain stronghold. He was required to cede all land west of the river Conwy; hostages

were handed over to John, with an agreement that if there were no legitimate heirs from Llewellyn's marriage, John would march back and take all his remaining lands.

With his authority asserted over Wales, John had established his credentials as the master of the British Isles. 'There was now no one in Ireland, Scotland or Wales, who did not bow to his nod, a situation which, as is well known, none of his predecessors had achieved,' showing that with sufficient troops and cash John was perfectly capable of undertaking successful military operations. He reinforced this impression in early 1212 when he marched north to the defence of William the Lion, providing troops to crush a rebellion instigated by a pretender to the Scottish throne, and then held his Easter court at Cambridge, which Llewellyn attended.

With his domestic enemies subdued, John's focus shifted to the long-delayed campaign of re-conquest. He summoned all knights throughout England to serve in Poitou, backed up by an investigation into the shires to ensure that no one dodged the draft. In a final attempt to squeeze money for the campaign, a forest eyre was conducted, raising £3,100 in cash. Yet the appearance of domestic security proved to be little more than a mirage, as John's preparations were suddenly thrown into confusion by news that Llewellyn had persuaded his erstwhile rivals, including Gwenwynwyn, to join forces in an attempt to destroy John's line of fortresses. Crucially, Llewellyn had received encouragement from the pope, who by the summer of 1212 was stirring up active opposition to John's rule. According to Innocent, the oaths the Welsh leaders had sworn were rendered invalid and the pope lifted the interdict in the areas they controlled. Reluctant to abandon his plans to invade France, John intended to send an advance detachment of troops under the command of Brian de l'Isle. When it became clear that Llewellyn was making sizeable gains, John hastily changed his mind and decided to deal with the matter in person, issuing commands in early July throughout England

to gather together an army of occupation that would make the fortresses from 1211 into permanent stone garrisons. The expedition to France was cancelled.

Under normal circumstances, this would not have proved more than an inconvenience and possibly provided John with the chance to impose Angevin rule across the whole of Wales. However, Llewellyn's revolt had ignited a spark of mutiny amongst the English barons. When John reached Nottingham, heading towards the campaign rendezvous at Chester planned for 19 August, alarming news reached him – if he went to war in Wales, there were plans to assassinate him on the campaign trail under the cover of battle, or seize him for delivery to Llewellyn's men. Then, the throne of England would be offered to the French nobleman Simon de Montfort, lord of Montfort l'Amaury and leader of the repressive Albigensian crusade that was being waged in the south of France. According to some sources, the informants passing this intelligence to the king were John's daughter Joan – Llewellyn's wife – and messengers from the court of William the Lion of Scotland, suggesting that the conspiracy was widespread. John was horrified; the campaign was halted, and his young son Henry entrusted to loyal guardians and placed in protective custody.

There can be no doubt that the plot was real. The two main conspirators, Robert FitzWalter and Eustace de Vesci, fled England for France and Scotland respectively – the latter accused by John of plotting 'our death, betrayal and imprisonment'. Both were powerful men, and both had personal grievances against John, who stood accused of seducing FitzWalter's daughter and de Vesci's wife. Indeed, there was history between Robert and the king. When John had threatened to execute FitzWalter's son-in-law following an argument at the royal court, Robert was alleged to have replied: 'You would hang my son-in-law? By God's body you will not. You will see two thousand laced helms in your land before you hang him.' This was the sort of man that John had turned into an enemy.

John took drastic action against the fugitives. Both were out-lawed; FitzWalter's castles were razed to the ground, and John marched into de Vesci's strongholds of the north to suppress any further thoughts of rebellion. However, John suspected others of involvement, though none broke ranks. The list of names included Richard de Umfraville, William de Warenne, Richard de Clare – the father-in-law of the murdered William de Briouze junior – David of Huntingdon and, perhaps more incongruously, the canon of St Paul's, Gervase of Howbridge, who was exiled along with Robert FitzWalter. His involvement may have been to investigate the legal precedent for the deposition of a tyrannical king, contained in the *Leges Edwardi Confessoris* that were in his possession.

Another hapless soul to fall foul of John's repression was a deranged hermit named Peter of Wakefield, who had been wandering the countryside proclaiming that John would not reign past his fourteenth year – namely Ascension Day 1213. In the febrile atmosphere, John's advisors urged his arrest as a threat to public order, but doing this only made his prophecy even more popular. As the day of the prediction dawned, John held a public open-air feast to show he was still in power, and then had Peter dragged from Corfe castle to Wareham and hanged.

Despite the crackdown, John realised that his unpopular means of government now posed a risk to his safety and scaled back the worst of his exactions, for example by bringing the forest eyre to a halt. Just when he needed a show of loyalty, the ever-faithful William Marshal appeared with the support of twenty-six Anglo-Norman barons from Ireland who said they were 'ready to live or die with the king, and that till the last they would be faithful and inseparably adhere to him'.

Marshal's greatest advice was to bring the interdict to an end, given the damage it was doing to John's legitimacy. One of the rumours doing the rounds in the autumn of 1212 was that Innocent had indeed deposed the king – and whilst this was not true, the

very possibility that it might happen was undermining his authority both at home and abroad. For once, John was prepared to listen to the seasoned politician and in November 1212 a delegation was sent to Rome to negotiate a settlement. He was not a moment too soon; as the initial discussions began, Innocent remained unconvinced of John's sincerity – 'it often happens that a ruthless foe, finding himself cornered, treacherously pretends peace and after the peace attempts treachery' wrote the pope, and prepared secret letters sanctioning John's deposition and replacement by Philip that were handed to Stephen Langton when he visited Rome at Christmas 1212. However, John's envoys managed to persuade Innocent of John's sincerity; the papal legate Pandulph was hurriedly sent after Langton to ensure the sensitive material was not published, and then in February 1213 Pandulph crossed to England to begin the hard bargaining, armed with an ultimatum – comply with the pope's demands by 1 June, or face deposition.

The threat was not necessary. The machinations of Robert FitzWalter, who had arrived in France claiming to be a martyr at the hands of an excommunicate king, had helped Philip make up his mind to advance his plans to invade England and break the last of the Angevins once and for all. With rival armies massing on either side of the Channel, on 15 May John not only agreed to accept Langton as archbishop, relinquish his stranglehold of the church and repay in full the amounts he had extracted (although only a fraction was ever returned) but also – in a stunning diplomatic move that caught everyone by surprise – offered to hand over England to Innocent to be held as a papal fief:

> We wish it be known to everyone by this our charter . . .
> having offended God and our mother Holy Church in many
> things . . . we desire to humble ourselves . . . and inspired
> by the grace of the Holy Spirit – not induced by force or
> compelled by fear, but of our own free and spontaneous

will, and by the common counsel of our barons – we offer
and freely yield ... to the lord pope Innocent and his
catholic successors, the whole kingdom of England and the
whole kingdom of Ireland ... so that henceforth we hold
them from him and the Roman Church as a vassal.

An incredulous and delighted Innocent accepted, issuing a golden
bull to confirm the arrangement, and the interdict was lifted.

Although seen within a generation as a humiliating act, there
was little condemnation in England at the time of John's surrender
of the kingdom into the hands of the pope – and the move proved
to be a masterstroke, immediately securing Innocent's support in
John's struggles at home and abroad. Having encouraged Philip
with the prospect of deposing John in England, Innocent moved
quickly to forbid the king of France from attacking the newest
papal vassal. The appeal fell on deaf ears. In April, Philip had called
a council to agree that a naval invasion should take place and to
decide the fate of the conquered land; it was to be handed to his son
Louis. Preparing for a naval assault, Philip summoned his feudal
host, but in doing so alienated Ferrand, count of Flanders, having
already lost the support of Renaud, count of Boulogne, in 1211.
Ferrand refused to serve, and appealed to John for support as Philip
wheeled his forces into Flanders to exact revenge. The Flemish
envoys reached the king whilst he was holding a conference at
Ewell on 25 May and, buoyed by the defection, John decided to take
the fight to his enemy. Once more under the command of William
Longespee, the English fleet, comprising 500 ships, was unleashed
on 28 May and sailed across the Channel to the harbour of Damme
on the river Zwyn, where Philip's entire navy of 1,700 ships,
complete with provisions for the planned invasion, was stationed
as part of the suppression of Flanders. Hardly believing their luck,
the English fell on them on 30 May, destroying hundreds of vessels
and setting more adrift, having first raided them for loot. It was

an overwhelming victory for John, ending any realistic threat of invasion and showing once again that he could be a military force to be reckoned with. The financial reward was considerable too: 'Never had so much treasure come into England since the days of King Arthur.' John was ready to capitalise on the momentum he had gained – but just as it seemed as though he had landed a devastating blow on his Capetian rival, John was undermined once again by troubles at home as the situation in England lurched once more towards uncertainty and unrest.

*

The main cause of John's discomfort came from the terms agreed with the pope for the lifting of the interdict. One of the conditions was the safe return of Robert FitzWalter and Eustace de Vesci, who had linked their cause with that of the church. Not fully understanding the nuances of English politics, Innocent had included them amongst the clerical exiles who had fled the country and they had returned to continue their opposition to John. The interdict was formally removed at a solemn ceremony at Winchester cathedral on 20 July 1213 at which John reaffirmed the promises made in his coronation oath – not only to defend the church, but also to bring back the good laws of his ancestors and abolish bad ones, ensure justice was extended to all men equally in his court, and protect the rights of all men. Under normal circumstances, this would have been a formulaic acknowledgement of the standards expected of a king, but John's actions over the previous years since his return from Normandy, and the most recent examples of brutality meted out to the de Briouze family, had generated a cynicism towards the king that now manifested itself as open opposition.

Following the success at Damme, John pressed ahead for a full campaign against Philip, renewing the feudal summons issued in May. However, with FitzWalter and de Vesci back in England, discontent and disquiet about the expedition now transformed

into disobedience, and the majority of the barons from the north refused to serve on the grounds that the terms of their tenure only covered military activity in England, where they held their lands, not overseas. John was forced, once again, to abandon his planned crossing and, in considerable anger, gathered his mercenaries in readiness to march north. His mind was changed by the intervention of Langton, intercepting the king at Northampton and then pursuing him to Nottingham, all the while reinforcing the message that the king ought not to act injudiciously towards his magnates and instead bring the matter to court. Once more, the threat of excommunication was issued and that seemed to stay the king's hand.

A period of mediation between king and northerners then ensued, lasting throughout the winter and into the spring of 1214, with discussions largely brokered by Langton and the papal legate Nicholas of Tusculum, who remained in England to look after the pope's interests in his new realm. The fact that John had been prevented from imposing his hallmark 'fines for the goodwill of the king' or worse, seems to have emboldened the opposition and it is during this period that a remarkable document was drawn up – in part a list of complaints against John's regime, but also a series of proposed remedies to ensure better and more accountable governance. It is clear that the demands were intended for the king, but they were never put to him. Indeed, we are uncertain who the authors were, since only one copy of the document – known to posterity as the 'unknown charter' – has survived to the present day, tucked away in the French royal archives. Indeed, 'charter' is perhaps too grand a word; the contents represent a thought process that drew together concepts from the coronation charter of Henry I, which was clearly seen as the benchmark of good government since it was recited in full at the start, followed by draft 'concessions' in response to the perceived problems blighting the relationship between John and his leading barons.

First and foremost, the text stated that, 'King John concedes that he will not take men without judgment, nor accept anything for doing justice, nor perform injustice.' This fundamental doctrine that the rule of law trumped the will of the king was to appear in Magna Carta, and shows the climate of fear and uncertainty that John had created with his use of the legal system to destroy or hamstring his magnates. The next few clauses related to John's relationship with his barons – setting a reasonable level of relief when an heir inherited a parent's estate, the involvement of four local knights to prevent royal officials plundering an estate when an heir was under age, granting more power to the family of a female heiress in the choice of her husband, protecting the rights of barons to dispose of their personal property at death, and ensuring women received their dower payments. Three clauses regulated the forest, calling for deafforestation of any new forests created by Henry II, Richard and John, plus a reduction in the severity of punishments for forest offences. Most pertinent to the situation in late 1213 and early 1214, a clause stipulated that no one should serve outside England save in Normandy or Brittany – both in French hands – and that the level of scutage be restricted to one mark per knight's fee, half the amount John levied for his campaign in Poitou. Aside from de Vesci and FitzWalter, leading northern barons such as Richard de Percy, William de Mowbray, Nicholas de Stuteville and Peter de Brus were opposed to John and may have played a part in the formulation of grievances into a written format.

Despite the tension in England, John saw out the winter and settled on February as the date for his expedition to Poitou. However, once again the depth of opposition to the king became clear as many of the northern barons and their knights failed to appear at the muster. A prudent man would perhaps have tried to address some of the concerns first, but John had been thwarted too often to postpone his expedition another time. He entrusted the government of England to his principal loyalists – Peter des Roches,

bishop of Winchester, was now justiciar; William Brewer, drawing upon a long career as forester, justice and baron of the exchequer, was placed in control of many of the counties as a form of super-sheriff; William Marshal conveniently stayed behind to help, a tacit recognition that he would not fight against Philip on French soil; and Stephen Langton represented the interests of the church. John set sail for Poitou on 6 February with 'few earls, but an infinite multitude of low-class soldiers of fortune'. He was accompanied by his family, as befitted a lord coming home, along with 'an incalculable treasury of gold, silver and precious stones' to be spent liberally on the campaign. Meanwhile, William Longespee, earl of Salisbury, headed to Flanders with a similarly vast fortune, where he met with the allies that John had been cultivating since 1212. Not only did they include the counts of Flanders and Boulogne, but also William, count of Holland, who had also become concerned about Philip's growing power in the region. John had turned to family as well and re-formed his alliance with the Holy Roman Emperor Otto IV. Imperial politics had become increasingly complicated; Otto had fallen out with Innocent, who had encouraged his deposition by the key German princes in favour of Frederick, the young king of Sicily and son of Otto's predecessor Henry VI. With John rallying to his nephew's cause, Philip naturally threw his support behind Frederick – dragging some of the local magnates on the French–German border into the dispute. To complete the international forces ranged against Philip, the count of Toulouse and King Pedro of Aragon offered their support to John in the south – natural allies against the French king as a result of the Albigensian crusade that was upsetting the balance of power in the region.

The war of 1214 was therefore a conflation of at least three separate regional disputes into a wider international conflict, with Philip of France as the common enemy. John's cash had been spent to good effect, subsidising plans for an assault by his allies in the north,

whilst he invaded from the south in the hope of dividing Philip's forces – a pincer movement that had worked so effectively when he was fighting to gain his inheritance back in 1199. John's early foray was intended to establish a bridgehead for a push on Anjou and Normandy by securing his position in Poitou. John initially stayed close to La Rochelle, hoping that his arrival would generate an outpouring of support; however, only a few barons came to him to swear fealty. Instead, John was forced to campaign through the region, marching into his wife's county of Angoulême, across into the Limousin and devastating the Lusignan lands in La Marche. He then turned south in April to secure his position in Gascony before returning to Poitou in May, inflicting further crushing defeats on his Lusignan opponents to the point that they finally performed homage – cementing the relationship with a marriage contract. John was now ready to start the main assault on Anjou, and moved north in June. Initially, he made strong progress, raiding along the Angevin–Breton border and capturing Nantes, having defeated a French garrison stationed there. As an added bonus, Philip's cousin Peter of Dreux, the new count of Brittany, fell into his hands. Emboldened, John marched on towards Angers, the capital of Anjou and the family seat. He secured the city without a fight – its citizens clearly felt the tide of war was flowing in John's favour.

Despite this apparent success, there were still strongholds blocking John's complete mastery of Anjou, for example the nearby castle of Roche-au-Moine held by William des Roches, Philip's choice as seneschal of Anjou. This was the key to securing a base from which to assault Normandy, and John laid siege to the fortress. The tactical importance was not lost on Prince Louis, who had been entrusted with the southern part of Philip's army whilst his father moved to counter the growing threat to Normandy posed by the coalition forces across the border. Louis brought his troops towards Roche-au-Moine to lend support to the defenders. This was John's chance; he planned to engage Louis in battle – a make or

break tactic that, if successful, would open the way to Normandy. However, disaster befell him before he could even set out. The Poitevin barons who had joined the army, led by Aimery de Thouars, informed John that they would not take part in a pitched battle. Gathering their supplies, they abandoned the military train and set out for home. John was furious, but with a large part of his army marching in the wrong direction, he was left with little choice but to abandon the siege, along with all his hard-won gains, and head back to his base at La Rochelle to seek reinforcements from England. The sense of desperation is clearly apparent in a letter he sent, begging for troops from his barons on 9 July:

> We earnestly entreat those who have not crossed with us to come to us without delay, being assiduous for our honour, to help in the recovery of our territory . . . doing so much in this matter that we are bounden in perpetual thanks to you. Assuredly, if any of you should have understood that we bore him ill-will, he can have it rectified by his coming.

However, John's fickle nature and arbitrary behaviour now returned to bite him. No one came, and he was left helpless, watching from the sidelines as the fate of his dynastic lands rested upon the actions of his allies in the north.

They, too, had encountered a few problems, mainly due to the delayed arrival of Otto and his supporters from the Rhineland. William Longespee had been in the field for many months, hunting French forces with little success. As a result, Philip had been given sufficient time to gather his feudal host together, and marched into Flanders to stop Otto reaching the rest of the coalition on the coast. He was too late; the emperor had arrived in the third week of July and the allies had finally joined forces, moving on to Valenciennes. Philip was forced to turn back, and drew up his army on a dusty plain situated just outside the small village of Bouvines, located on what is today the border between France and Belgium. On 27 July,

the coalition army arrived and, in the heat of the summer's day, the two sides clashed in a battle that would decide the fate of several European dynasties. Such was the importance of the occasion that several detailed chronicle accounts were written, which we can use to piece together a sense of the ebb and flow of the conflict.

Amidst the dust clouds that were kicked up during the day, the fighting broke down into a series of mêlées and skirmishes between nobles, knights and their retainers, who were often well acquainted with one another from peace-time tournaments or trips to the Holy Land. Yet this was no war-game or competition between comrades: the risks were real, the stakes were high. At the start of the battle, the Flemish cavalry on the left of the allied formation charged against their counterparts on the French right, but were quickly driven back; their leader Count Ferrand was eventually captured. However, the imperial cavalry had far more success, charging through the ranks of the French feudal host and endangering the life of Philip himself, who was unhorsed and nearly trampled to death as he led a desperate action to preserve the centre of his army under severe pressure from the infantry of the Low Countries. Only the swift action of his bodyguard, dragging him to safety, prevented disaster. The French left swung across and gradually turned the tide. Otto was then unhorsed and had an equally lucky escape, but his forces were in retreat and he fled the field, hotly pursued by his enemies. Only the allied right stood firm, defending the Bouvines bridge against the forces of the bishop of Beauvais, under the joint command of William Longespee and Renaud of Boulogne. Yet as the French gained mastery of the rest of the field of battle, the remaining allied forces found themselves surrounded. Longespee was eventually captured; Renaud carried on resolutely, surrounded by a thicket of 700 pikemen from which he mounted lightning raids with his cavalry until the sheer weight of numbers overwhelmed them — it took a desperate charge of 3,000 French infantry finally to break his resistance, whereupon he too was taken prisoner.

This was a resounding victory for Philip – one of the few battles in medieval history that was utterly decisive in its political outcome. Thousands lay dead or dying, but the biggest casualty was John's hope of regaining his lost lands. Otto fled back to his lands in Germany to lick his wounds, but his hold on power had been broken in the dusty fields outside Bouvines. The imperial standard had been salvaged from the battle wreckage by Philip and sent to Frederick; Otto formally abdicated in 1215. As a result, the Hohenstaufen dynasty was confirmed as political masters of the empire. The victory also established the Capetian monarchy as one of the leading powers in Europe, consolidating the gains of 1204 and creating the basis for a more powerful central state. However, Philip refused to complete his defeat of his Angevin rival by marching south and seizing Aquitaine. Under pressure from the pope to unite against the threat posed to the Holy Land, a truce was agreed that would last until Easter 1220.

Throughout the autumn John put his continental affairs in order as best he could, with his cash largely spent and his hired troops starting to drift away. He could delay his return to England no longer and, doubtless aware of the reception facing him from the correspondence he received from his leading officials, landed at Dartmouth on 13 October 1214 to face the music.

*

It is always tempting to ponder the 'what ifs' of the past, and the outcome at Bouvines is one of those key moments when the course of history could have been very different. There is no doubt that the political climate in England was toxic, a result of John's actions and the growing alienation of the native barons. However, if Otto and his allies had bested Philip at Bouvines, John would have been in a much stronger position to have reclaimed Normandy, Maine and Anjou and thus turn back the clock to 1200. Of course it does not follow that defeat at Bouvines would have rendered Philip incapable

of mounting a stern defence of Normandy, but the dynamic of the situation would have been fundamentally altered. Any concessions made by Philip to the allies as part of a diplomatic solution would have encouraged John to remain on the continent for much longer, helping to defuse the tension in England. Furthermore, the scent of success may well have encouraged more of John's barons to cross the Channel in support, especially as the focus would have shifted from the south to the north where their interests lay.

Instead, the failure of John's campaign removed any flickering hope that Normandy might be recovered, and made clear to all parties that John's residency in England was likely to be permanent – an unpalatable prospect to many, if not most, of the barons. Equally, because of the issues that had surfaced during the muster of troops for the expedition in 1213 and 1214, John's remaining continental lands were now clearly seen to be his own private affair and not connected to the business of governing England – a very different situation applied to Normandy, where there were historic family ties within the English aristocracy. It merely heightened the sense that England was now being governed by 'foreigners'. The political temperature was raised further by John's defeat, as it was no longer possible to tolerate the abuses of kingship and exorbitant financial penalties in the hope that it was a temporary measure until Normandy had been regained. Reform was needed, and the opposition from 1213 was now in the ascendancy.

One of the reasons why feelings against John were running stronger in October 1214 than twelve months previously was the governance of John's foreign-born administrators, especially Peter des Roches. In the shires, resentment against rapacious officials had extended beyond the nobles and barons to the knights; threats were made against collectors of scutage and the flow of money into the exchequer dried up virtually overnight, plunging back to levels not seen since the start of the reign. Some of this was due to a deliberate easing of measures following the assassination plot

and political tension over the summons to Poitou, but it is clear that large elements of the knightly class were now stirred to anger – possibly encouraged by their baronial overlords. Yet sporadic outbursts of violence, or resistance to exchequer summons for payment, were very different from the organised, coordinated opposition movement that would be needed to impose change on a monarch who, though defeated abroad, still held considerable power in England. John's network of royal strongholds remained in the possession of loyal mercenaries, who relied entirely upon John's favour to stay in power and thus had little to gain from changing sides; they would receive no thanks from the rebels, only a one-way ticket out of England. Equally, although most of his war chest had been expended abroad, the castle treasuries still held cash reserves to maintain an army in England. Finally, it would be wrong to present the opposition to John as comprehensive and united. The king still enjoyed the support of many of the key baronial families such as William Marshal, William Longespee (who was ransomed and returned to England) and the earls of Arundel, Derby and Chester – powerful local figures in their own right with estates across the country and their affinity of knights to call upon.

The first outbreak of discontent between king and leading magnates seems to have been sparked by John's immediate recriminations against those who had chosen not to heed his summons in February, primarily the northern barons. They fell back on their defence that they were not accustomed to serve overseas; John retorted that they or their ancestors had done so for his brother and father, using the argument of precedent to justify his stance. Whilst John prepared to tour his restless kingdom, beginning in Kent, the leaders of the movement met in Bury St Edmunds – probably on 19 or 20 October, certainly 'around the same time' that the king returned to England. In a radical step, they formed themselves into a sworn confederation against the king. We do not know any details of the meeting, or who was present; and

scant details of the oath that was sworn survive. Chronicle accounts suggest that 'all the leading men of England and all the princes of Wales' were involved, but that was not the case. Nevertheless, sufficient numbers from outside the northern group were involved for the act to provoke John to describe it as an act of war – *bellum* in Latin – when informed of what happened a few days later. It is likely that Stephen Langton knew of the discussions even if he was not actually present; the cause was to be taken forward in defence of the church, with one of its leaders, Robert FitzWalter, describing himself as the 'marshal of the army of God and the holy church'. Equally, the coronation charter of Henry I became the benchmark of good government around which the rebels based their case for open opposition to the king, their own version of 'ancient custom' that John was so fond of harking back to when summoning them to serve overseas. A crucial difference to the previous plots of 1212 and 1213 was that this time the barons swore 'that if the king refused to grant them the said liberties, they would go to war against him, and withdraw their allegiance, until he should confirm by a charter under his own seal everything they should require'.

Abandoning his plans in Kent, the king immediately issued letters to secure some of his key castles at the end of October, and then dashed to Bury St Edmunds in early November to find out what was going on, still in the dark about who was involved. However, he was several days too late and the barons had dispersed. John returned to London to reflect on the state of the country and what little intelligence he had gathered about the confederates. His response was to issue a charter granting freedom of elections to the church on 21 November – a major concession, given the stance he had taken against the pope that provoked the interdict, and probably intended to separate Langton and the bishops from the barons. The following day, the archbishop was granted custody of Rochester, including the castle. John's charter also served to curry favour with Innocent III, who was kept informed of events

via correspondence from his legates in England. Throughout December, tension remained high and the confederates used the time to prepare for their next move. In accordance with the oath they had sworn at Bury St Edmunds, they decided to break cover and marched to London in January 1215 to confront the king in full battle array, accompanied by their men at arms. Robert FitzWalter and Eustace de Vesci were amongst the main ringleaders. Other northerners with long-held grievances, often financial in nature, stepped forward, as well as Giles de Briouze, bishop of Hereford and the surviving son of Matilda, who had met such a terrible fate at John's hands. The rebels also drew strength from the eastern counties and around London.

John was at the New Temple, and received them coolly – offering them the king's peace whilst discussions took place in the form of a council at which his own supporters were present. He confirmed the November charter acknowledging free elections to the church and, with little choice in the matter, listened to the grievances of the nobles. Whilst John acknowledged the importance of Henry I's charter, he rejected any suggestion that 'novelties' should be added and called for a general oath of fealty from the assembled barons. The result of the council was inconclusive, and both sides agreed to meet again on 26 April at Northampton to consider the matter further. John agreed to extend his peace to the armed confederates until the conference was concluded, with Langton, seven bishops and four key royalist earls acting as guarantors that the king would keep his word. Both parties used the intervening period to prepare their positions; appeals were sent to the pope setting out their respective grievances. John despatched his 'free elections' charter to Innocent for confirmation, with a covering letter explaining the situation in England. To boost his credibility further, on 4 March he publicly announced that he would take the cross and undertake a crusade to the Holy Land – although this provoked a somewhat negative reaction from the barons, who saw it as an attempt to renege

on his promises to address their concerns, especially as John used his crusading vows as a smokescreen to start recruiting mercenaries from Poitou in case the situation in England turned ugly. However, it was a timely piece of politicking; the baronial envoys had arrived in Rome at the beginning of March, requesting support from Innocent in their attempt to have their 'ancient liberties' while trying to undermine John's position as papal favourite.

Both sides had to wait for Innocent's response. Although letters dated 19 March setting out his position were sent in triplicate – one to John, one to the barons and a third to Langton and the bishops – it took until the end of April before they arrived. By this stage it had become clear that John was unwilling to meet at Northampton, raising the suspicions of the barons that he was playing for time because he had something up his sleeve. Equally, the baronial clerks who had been sent to Rome to negotiate a favourable response had arrived back ahead of the formal reply carrying bad news – Innocent had backed his vassal. The letters confirmed the extent of the pope's support. Although John was exhorted to consider the baronial case without prejudice, the barons were instructed to break their 'sworn confederation', drop their 'conjurations and conspiracies', remove the military threat and make their case 'in humility and loyal devotion' under threat of excommunication if they did not comply. Significantly, Langton was upbraided for not providing support to the king. All this was music to the king's ears, but highly inflammatory in the charged atmosphere.

Given the lack of any external support, the barons decided to try to provoke the king into a violent reaction, in the hope that an armed response might draw more supporters within England to their cause. As a result, they held a muster at Stamford and, having gathered an army, marched towards Northampton in force, reaching Brackley on 27 April the day after the scheduled peace talks. Instead of face-to-face negotiations under the king's protection, demands were issued at the point of a sword. We do

not know what was requested from John, but it is likely that it was a version of Henry I's coronation charter plus an expanded list of requirements above and beyond what had been prepared in the form of the unknown charter. Either way, we know they were unpalatable enough for John to reject them out of hand. However, the king did offer to abolish any evil customs that he or his brother had introduced, and draw upon the counsel of his faithful men to investigate those of his father, as long as his overlord the pope agreed. Unsurprisingly, the royal counterproposal was also rejected as unacceptable. When the king demanded that Langton enforce the pope's threat of excommunication, the archbishop refused – caught in an invidious position between sympathy for the barons, and the orders of the king. Stick or twist, that was the stark choice facing the barons at the end of April. Having come this far, they decided to gamble on the tacit support of Langton and, on 5 May, reneged on their homage to the king to take up a position of *diffidatio* or defiance. This moved far beyond the unauthorised armed muster at Stamford; it was an open act of rebellion, amplified by an assault on Northampton castle, held by the king's men. Once again, in the escalating crisis John kept a calm head and played the role of the diplomat. On 9 May he left London and travelled to Windsor where he issued a charter 'to our barons who are against us that we shall not take them or their men, nor disseise them, nor go upon them by force of arms, except by the law of our realm or by the judgment of their peers'. This concession addressed the fundamental complaint that had been raised against John, and his conciliatory tone won over some of the wavering barons.

With the rebel assault on Northampton making no headway, and feeling confident about the level of support that he now enjoyed, John decided to go on the offensive. On 12 May he ordered his sheriffs to seize the lands of his enemies, and summoned his mercenaries to tackle the rebel army, whilst William Longespee was instructed to secure London. However, Longespee moved

too late – on the morning of Sunday 17 May, whilst the citizens were at mass, a party of barons scaled the wall with the help of some conveniently placed stone blocks that had been left outside during repair work. Having gained access, they opened the gates for their colleagues, who rushed inside to take control of the city. Although John still held the Tower, London was lost to him; it was a catastrophic blow, and at a stroke changed the nature of the conflict. Not only had the rebels gained control of any riches and resources John had stored there, but they had disrupted the business of government. The exchequer shut down, meaning that the regular flow of money into the treasury also ceased; and in areas where the king's will was challenged, it was unlikely that John's unpopular sheriffs would be able to be exert any authority or extract the usual rents. Furthermore, John's seizure of rebel lands in contradiction of his charter persuaded many of the undecided barons to support the confederates, who embarked on a propaganda war and:

> ... sent letters throughout England to those earls, barons, and knights who appeared to be still faithful to the king exhorting them with threats, as they were mindful of their property and possessions, to abandon a king who was perjured and hostile to the barons, and to form a united front with them in a fight for liberties and peace; and that if they declined to do so they would be treated as public enemies, war made upon them, their castles brought down, their homes and buildings burned, their warrens, parks and orchards destroyed.

The momentum was now firmly with the rebels, as more and more leading barons and their knights joined the cause and royal castles were attacked or occupied. By 25 May, John was desperately trying to stem the tide flowing against him, offering safe conduct to envoys from the baronial side in an attempt to broker a meaningful settlement. Two days later, Langton met the

king at Staines to discuss the conditions under which peace could be negotiated. John's frustration was expressed in a letter written to the pope on 29 May, in which he bitterly set out the opposition he faced from his rebellious subjects. However, it was futile railing against the situation to an overlord who was in Rome and preoccupied with affairs in the east; events were moving too fast for any help from Innocent. By Monday 8 June, John was forced to confront the reality that major concessions were necessary, so further letters of safe conduct were issued that would last for three days, permitting John to meet the principal baronial representatives at Runnymede – the meadow between Windsor and Staines. However, once news had spread that the conference was to commence, large numbers of barons and their retinues travelled to the field. John had little option but to continue with the conference, despite the implicit military threat that the barons posed. 'The king with his men dwelt in the same meadow in pavilions,' according to Ralph of Coggeshall; however, this is not strictly true. Although the negotiations took place in the fields at Runnymede, the king returned to the safety of Windsor Castle at night where he continued to witness charters and receive visitors, just in case a hot-headed young baron decided to return to the solution mooted in 1212 and kill the king.

Despite the tension, discussions progressed relatively smoothly between the representatives from each side who conducted the daily business, drafting the various clauses that required redress. The leaders of the 'army of God' were clearly driving the baronial argument, but it seems that John was also actively involved and helped shape the parameters of the emerging document that he would be asked to support. By 10 June, the king was sufficiently happy to extend the peace process until 15 June, and it is at this point that he signed off on the draft version of the final charter – the 'articles of the barons', which contained forty-eight clauses in the form of heads of discussion, followed by a security clause that was

intended to ensure the final agreement was adhered to by the king –
twenty-five barons would act as guarantors, supported by Langton
and the bishops to prevent the king appealing to the pope for an
annulment. No matter what John might have privately thought,
he affixed his great seal to the articles to show his commitment,
allowing the next phase to begin. Attention switched from scoping
the broad areas for agreement to the provision of detail in each. This
took somewhat longer to achieve, with further shuttle negotiations
between the respective teams until an expanded final version had
been drawn up for John to approve on 15 June, containing sixty
clauses and a refined security clause – the basic text of Magna Carta,
although technically it was referred to as the charter of Windsor for
the first few years of its existence.

On the surface, Magna Carta was a damning indictment of
John's appalling relationship with his barons. However, it was
also a deeper unpicking of Angevin kingship and administrative
practice in England that had developed since the reign of Henry II.
In particular, Magna Carta set out the parameters within which
the king ought to operate, not just in the regulation of the feudal
relationship with his leading subjects, but also in stamping out
arbitrary malpractice, epitomised by long-held grievances about
the forest that were so contentious that a parallel process was
required to tackle them. The main clauses we treasure today
relating to the importance of the rule of law were part of this
process, but they were buried deep within the text because the
baronial priorities lay elsewhere. Befitting a document promoted
by the 'army of God', the first clause protected the liberties of
the church. Thereafter, nine of the next ten clauses related to the
principal ways in which the king could extract money from his
barons as a result of the feudal system. Set rates were imposed
for relief – £5 per knight's fee, £100 per barony – that drastically
curtailed the ability of the crown to profit from the death of
a tenant-in-chief. More protection was offered to widows, in

particular over their ability to control future marriage, and under-age heirs who had found their estates plundered during the worst years of John's regime. Given equally high prominence was a fundamental statement that taxation – be it a feudal aid or scutage – had to be granted with the common consent of the realm, via a council summoned at a specified location with forty days' prior notice. This was a radical step, but a principle that underpinned the emergence of the modern tax state.

If these were the two key areas of baronial grievance, under-standably so given John's exploitation of both during his reign, priorities three and four were intermingled in terms of sequential clauses, but can roughly be categorised as the regulation of royal justice, and restrictions on the crown's local officials. In this sense, many of Henry's judicial and administrative reforms were validated, albeit in a modified format. Clause seventeen required that common pleas should be held in a fixed place rather than itinerate with the king – highlighting the importance of a permanent seat of royal criminal justice – followed up in the next clause by ensuring petty assizes of novel disseisin, mort d'ancestor and darrein presentment (together relating to various matters of property law) were held in the relevant county court four times each year in the presence of royal justices and four county knights. Clause twenty stipulated that amercements had to be in proportion to the offence committed, and the status of the accused. Clause twenty-one ensured that barons would henceforth be amerced by their peers, rather than by royal justices; clause fifty-five stated that the council of twenty-five barons would address any unjust fines or amercements.

Also high on the baronial agenda were some detailed regulations concerning the malpractice of royal officials, especially around distraint of property and the unauthorised requisitioning of materials in the name of the crown. Perhaps more controversially, many of the crown's ancient rights were trimmed – especially new practice introduced by John to extract as much as possible from the

royal demesne. John's chosen administrators were also attacked. No one could hold office if they did not know the law, a direct reference to the king's reliance on hired mercenaries.

We have to scroll down to clauses thirty-nine and forty to find the fundamental principles of the rule of law that we still cherish today – 'No free man is to be arrested, or imprisoned, or disseised, or outlawed, or exiled, or in any way destroyed, nor will we go against him, nor will we send against him, save by the lawful judgment of his peers or by the law of the land'; and 'To no one will we sell, to no one will we deny or delay, right to justice.' Although these were important summaries of the sentiment that lay behind many of the technical clauses that had preceded them, these two clauses can be linked specifically to the case of William de Briouze, and thus the presence of his son Giles de Briouze amongst the rebels; whilst we can almost hear the voice of William Mowbray pipe up to suggest the second clause, given he had offered a fine of 2,000 marks to the king to secure a lawsuit against William de Stuteville, and then had to watch in disbelief as John permitted the court to produce a verdict against him. In the meantime, John would return any lands that he had taken without recourse to due legal process, and previous seizures under Richard and Henry II would be deferred for judgment.

Alongside these broad areas of grievance relating to the way the crown conducted its business, we can find some specific interest groups emerging. The citizens of London, for example, had been instrumental in turning the tide in favour of the barons in May, and now revealed the prize for their support – confirmation in clause thirteen that the city would have its ancient customs and liberties, although in fairness this was extended to other cities and boroughs as well. Equally, the political pressure in England allowed Llewellyn to extract concessions from John, whilst Alexander II of Scotland, who had succeeded his father in 1214, used the opportunity to renegotiate the disadvantageous terms of

the 1209 treaty of Norham, essentially ensuring that he no longer held his kingdom as John's vassal.

One issue that could not be resolved in the meadows of Runnymede was the forest. Whilst John was prepared to concede that men outside the forest should not be brought before the forest justices, and agreed to deforestation of any new creations made during his reign, a fundamental overhaul of this unpopular remnant of the royal prerogative was not possible. Instead,

> All evil customs of forests and warrens, and of foresters and warreners, sheriffs and their ministers, riverbanks and their keepers, are to be immediately inquired into in each county by twelve sworn knights of the said county . . . and within forty days after the inquiry has been made, they are to be wholly abolished by them, so that they are never revived.

The resulting inquiry would produce the charter of the forest in 1217, or 'little charter' as a chancery scribe wrote, going on after a moment's reflection to redefine the charter of Windsor as the 'great charter' or '*magna carta*' to differentiate between the two, hence its title today. Yet the barons did not get things entirely their own way. As a reminder that they were also under some pressure from their own knights, the final substantive clause required that, 'All these aforesaid customs and liberties, moreover, which we have granted to be held in our kingdom, both clerks and laymen are to observe, as much as it pertains to them, to their men.' In this clause we can detect echoes of Henry II's inquiry of the sheriffs in 1170. Some embraced the spirit of reform; Ranulph, earl of Chester, issued his own version of the charter specifically aimed at his tenants, although others were far more grudging, preferring not to practise themselves what they had preached to the king.

As a package, Magna Carta represented a fundamental change in the way the king was to operate in future, placing clear boundaries

around royal power and making it clear that the leading families of the realm should have a say in how business was conducted. Equally, the knights of the shire were given a defined role in the operation of local government. Leaving aside our modern preoccupation with Magna Carta as a beacon for the rule of law, its importance in the early thirteenth century was to articulate the victory of consensual decision-making between ruler and subject over arbitrary monarchy. It was a radical step, and one that no king would willingly make unless under severe duress, as John undoubtedly was throughout the negotiations. This was recognised by the barons, who had built a security clause in their original articles and, controversially, left this in Magna Carta as clause 61. A council of twenty-five barons – crucially, chosen by the barons, and therefore packed with diehard opponents of the king – would ensure that the clauses were upheld. If any were broken, then four of them would make enquiry and enforce compliance, with the power to distrain the king's goods until the status quo was restored. In short, it was a licence to wage war on the king for the slightest breach of the terms and conditions of Magna Carta. Furthermore, the king promised to 'obtain nothing from anybody, by us nor by another, by which any of these concessions or liberties may be revoked or diminished; and if any such thing is obtained, it shall be invalid and void, and we shall never use it'. None of the barons dared spell it out in full, but this was a clear reference to the fear that John would appeal to his overlord the pope.

Therefore although John affixed his seal to the document, making it clear that the concessions had been 'given by our hand in the meadow which is called Runnymede on the fifteenth day of June', no one really believed that the peace would last. Indeed, the charter was addressed to his 'faithful subjects' – thus omitting those who were in revolt against him. It took a further four days of haggling before John gave the order for engrossments, or chancery-produced copies authenticated by the royal seal, to be

drawn up and sent out. The intervening time was used to wring more concessions from the king in an attempt to prove he was serious about change, the most important of which were plans to ensure royal officials swore an oath of allegiance to the baronial council of twenty-five. This was a major blow to John's authority, and – if it had gone ahead – would have seen the adoption of an even more radical model of government than the charter suggested at face value. Only with these additional safeguards in place was the charter ready to go out, accompanied by letters instructing the sheriffs to swear allegiance to the twenty-five and comply with the election of local knights to inquire into any malpractice. Finally, the barons agreed to renew their oaths of allegiance to the king and become his faithful subjects once more.

*

The first engrossments were handed over on 24 June and, with little choice in the matter, John began to address many of the issues that had been raised during the negotiations, instructing his over-worked chancery staff to send out writs that granted lands and castles to the principal baronial supporters. He had already been forced to dismiss his overseas mercenaries, in the hope that the barons would also disarm. Yet mutual distrust only grew in the aftermath of Runnymede. Many barons refused to set their seals to the document that bound them by oath to the king and took steps to fortify their castles with stores, provisions and arms; technically, therefore, they were in breach of Magna Carta, a point that John used to his advantage when trying to justify his own position. Yet John was still relatively powerless to throw off the shackles that had been imposed on him at Runnymede. The exchequer seems to have ceased its normal functions around the collection of royal debts in the shires – royal officials were prevented from operating in their normal way. There was a partially completed record of audit for 1215, showing that barely any money was received.

Indeed, a glimpse of the dysfunctional nature of government under the 'commune' of twenty-five barons was provided at a council held on 16 July at Oxford. John demanded restoration of his treasure from London, as well as the formal restoration of peace; the barons sought to extend their power over institutions such as the exchequer, whilst presenting further claims for restoration of lands from the king and intervening in the appointment of local officials to secure favourable terms. We are told that by the end of the council, John was suffering from severe gout and was unable to walk. Although the king was bedridden, the twenty-five barons refused to enter his chamber to discuss business, and instead he was brought to them on a litter. In a further slight to his dignity, none of the barons rose to greet him. There was no more powerful signal that John had lost control of the kingdom, and that night, still crippled with gout, he summoned his loyal supporters to his chamber to discuss what to do. On 23 July, John wrote a strongly worded letter to the men of Yorkshire, covering all ranks, to hand back possessions they had seized from him by 15 August – the same date that London was to be returned to the king. In the new political climate an independent outburst from the king was not tolerated; the council ended abruptly and the barons left 'with great rancour'. Behind this public show of strength, John had pinned his hopes on a secret mission that had been sent to Rome with letters addressed to the pope, appealing for Magna Carta to be annulled. This was in direct contravention of the terms he had agreed at Runnymede and a desperate gamble, but John felt he now had nothing left to lose.

It was the last time that the two sides met under diplomatic circumstances. John gathered together his remaining funds from the castle treasuries and based himself on the south coast, securing as many ports as possible to await the return of his mercenaries. He also wrote to Peter Mauclerc, count of Brittany, offering him the honour of Richmond which had long been associated with his family, in return for military support. Although the offer was

rejected, it demonstrates the desperate measures that John was prepared to countenance, given he had raided Brittany during his failed continental expedition the previous year. Langton and the bishops tried in vain to prevent the drift to war, summoning another council meeting at Oxford on 16 August once it had become clear that the barons were not going to relinquish control over London. The king, however, refused to attend because the twenty-five came 'in armed array'.

Then the barons received a nasty shock. Letters from the pope, written on 7 July in response to John's missive of 29 May, had arrived and were read out to the assembly; they made clear the depth of Innocent's anger. Even if his invective was directed towards the bishops, his words could equally have applied to the barons:

> We are driven to express amazement and irritation that when the king of England has, to a greater degree than might have been expected, made amends to God and the Church and especially to Stephen archbishop of Canterbury and his fellow bishops, some of them . . . have shown him neither help nor favour against the disturbers of the realm . . . They thus appear to be accomplices, if not sharers, in a wicked conspiracy . . . They are worse than Saracens for they are trying to unseat a king who, it was especially hoped, would succour the Holy Land . . . Lest their insolence should have the effect of endangering the realm of England and of ruining other realms, and above all of wrecking the Crusade, we excommunicate all such disturbers of the king and kingdom, together with their accomplices and supporters, and we lay their lands under interdict . . . If any bishop should avoid obeying our order, let him know that he is suspended from episcopal office.

The commissioners for this sentence were Peter des Roches, the legate Pandulph, and the abbot of Reading – all supporters of John.

This was political dynamite. Even if Innocent was referring to a situation that had long been superseded by events, the message was clear – John was protected by the pope, and his enemies were to be cast out from the church: so much for the 'army of God'. Langton summoned another meeting of the bishops and leading barons between 26 and 28 August at Staines to decide how to respond, and vaguely issued a statement of excommunication that failed to name anyone in particular. In contrast, John's reaction was decisive and clear. On 5 September, he ensured that the papal commissioners wrote to the leading baronial opponents and excommunicated them; and, in what was probably a first, the entire city of London suffered the same fate. Langton was suspended for his failure to enact the pope's demands in full. Yet John used the opportunity to portray his own innocence, claiming that the new council was pursuing its own agenda without recourse to the king, breaking the spirit of the charter. It was an exercise in bluster and obfuscation, and no one believed him; but the charade was not required for long. The pope's letter, written on 24 August in response to John's appeal for support after the July council, finally arrived, and it was even more unequivocal in its condemnation of the baronial cause than before.

However, Innocent's fire and brimstone rejection of Magna Carta was irrelevant as the time lag between Rome and England meant that events on the ground moved faster than medieval international diplomacy could handle. Between the Staines meeting at the end of August and the sentence of excommunication issued by the papal commissioners in early September, the baronial opponents realised that all pretence of a peaceful solution was dead, and took the unprecedented step of deposing the king, turning the theoretical discussions of 1212 into political reality. Although there would clearly be no support from the papacy for the move, the legal advisors for the barons had little trouble finding a loophole when it came to John's coronation oath in 1199, stating that he had been anointed as king 'by the unanimous consent and favour of the

clergy and people'. Therefore, so the argument ran, John's position as king depended not on royal birth, but the tacit agreement of his people; consequently, what had been given could be taken away again. The barons called an assembly of all the chief men of the kingdom, and put the question to them: given his abuse of power, should John remain king? According to chronicle accounts, some voices were heard in his favour but were overwhelmingly shouted down, and a sentence of deposition was acclaimed. Having removed John from the throne, the next issue to be resolved was his replacement, and the crown was offered to Louis, son of Philip of France. Although Louis was to claim a hereditary link via his wife, Blanche of Castile, the main reason for choosing him was the likelihood of success, given the resources of the Capetian monarchy that the barons hoped would be diverted to their cause. Thus the long-running feud had passed to the next generation, with England as the prize.

The collapse of Magna Carta meant open warfare. Whilst John waited for his reinforcements to arrive from the continent, the rebels seized Rochester castle, nominally held in Langton's name by Reginald de Cornhill, who seems to have opened its gates far too easily. John was incensed, and marched a small force from his base at Dover to retake it. This was a daring move, and one to which his military advisors were opposed. Yet John showed once again that when he screwed up his courage for a decisive strike he was usually successful. The castle was besieged and battered through the deployment of hastily constructed siege engines; the walls were undermined, a corner of the keep collapsed, and the garrison surrendered on 30 November. As the barons waited desperately for support to arrive from France, they tried to establish their own government in the parts of the country where the council of twenty-five still held sway, particularly across the north and east.

At this point, the whole situation hung on who controlled London. However, John decided not to besiege the city; having

held a council at St Albans on 20 December, he split his army, leaving some forces under William Longespee to keep watch on London whilst he marched the remainder of his army against the estates of his enemies. Months of pent-up frustration were expended on the hapless peoples of the north and John wrought terrible vengeance upon them – nothing was more fearful than an angry Angevin king bent on revenge. Alexander of Scotland, who had invaded during the troubles, was harried back into the Scottish lowlands and John made good his promise to 'chase the red little fox cub to his lair'; many rebel castles and towns surrendered rapidly when he approached their gates. Even staunch adherents such as Eustace de Vesci were forced to sue for peace by the threat of John's approaching army. Throughout the winter months of January and February 1216, John continued to regain lost ground, moving south after his Scottish incursion into the eastern counties with similar effect. By March 1216, large swathes of land formerly held by the rebels was either back under royalist control, or reduced to smoke and ash.

However, John's chance to take London and strike a decisive blow had gone. Longespee was unable to prevent French troops from arriving during the winter to bolster the garrison, and by April it was clear that Louis, with his father's somewhat reluctant support, had decided to mount an invasion. John fortified the Kent coast and made his ships ready to mount a pre-emptive naval strike of the sort that had worked so well at Damme. But on 18 May the wind rose into a fearsome storm, and his fleet was either lost or wrecked along the coast. It was a disaster, made worse by the fact that three days later Louis's own army was able to cross unscathed, and landed at Pegwell Bay on 21 May 1216. John's nerve deserted him once more, and instead of trying to crush the French before they could establish themselves, he turned round and marched to Winchester. As a result, Louis was able to overrun the southern counties, leading to major defections from John's ranks. The most

grievous and surprising loss was that of William Longespee, the backbone of John's army – perhaps in disgust at the king's decision to flee once again, rather than meet the enemy head on.

Although John's position was severely weakened, it was not fatally compromised. Adherents still held key castles, and their loyalty remained strong to the end. Thus Dover was staunchly defended by the justiciar Hubert de Burgh, despite being besieged by Louis and his army from July to October – should it have fallen, there was a real possibility that the old link between Normandy and England would be re-forged once more, this time under Capetian rule, given its strategic position controlling the Channel sea-lanes. John was forced back into the west Midlands where William Marshal and the earl of Chester continued to fight for him.

Slowly, as the summer wore on, John's position began to improve and many of the defections were quickly reversed, with William Longespee and the earl of York returning to his side – presumably with useful intelligence about the French camp and the baronial plans. The deaths of Eustace de Vesci at the siege of Barnard Castle, and Geoffrey de Mandeville – accidentally killed in a joust – were also blows to the rebel cause. Furthermore, tensions grew between French and native troops, and 'day by day adherents of the Frenchmen dwindled'. In September, John took the fight into enemy territory and marched south, before looping back into the eastern counties – relieving the siege of Lincoln that was held in his name, before heading to Lynn in early October. It was there that he successively contracted dysentery, suffered the personal indignity of losing his baggage train whilst crossing the Wash, languished at Sleaford on 14 and 15 October, and limped into Newark castle. During the evening of 18 October, the wind picked up and turned into a terrible storm, with violent thunder crashing overhead. Wracked by severe abdominal pain, and despite the best efforts of the abbot of Croxton to heal him, John realised that he was dying. The king had just enough energy to dictate his last will:

> Being overtaken by a grievous sickness, and so incapable
> of making a detailed disposition of my goods, I commit
> the ordering and execution of my will to the fidelity and
> discretion of my faithful men whose names are written
> below, without whose counsel, were they at hand, I would
> not, even in health, ordain anything.

These executors included various ecclesiastics, along with faithful supporters such as William Marshal and Ranulph of Chester. Notable by their presence in the inner circle of the king were mercenaries such as William Brewer, Savary de Mauleon and Fawkes de Bréauté. John then instructed that his body be buried at Worcester. The abbot of Croxton heard the final confession of all his sins, and read the last rites. John died at some point during the early hours of 19 October; although one chronicler described the scene very differently, claiming that as the wind continued to howl around the castle John was 'personally summoned to Hell by the Devil'.

*

The last of the restless kings lay dead; ironically, John's demise probably saved his dynasty from extinction. Once the news reached the royalist supporters in the west, John's nine-year-old heir, Henry, was whisked from the safety of Devizes castle to Gloucester, where he was crowned in the abbey church on 28 October by the papal legate Gualo. Marshal was present, and agreed to act as regent, promising to carry the young king on his shoulders, 'one leg here, one leg there', until he had won back his kingdom. Some of the fight went out of the opposition. Throwing off allegiance to a tyrant who had deprived people of their rights was one thing; but Henry was unsullied by his father's reputation and it was hard to hold a personal grudge against a mere boy. The rebel cause was further eroded by an act of momentous political significance. On

11 November, the regency government issued a modified version of Magna Carta, signalling that the new regime would adopt the reform programme but dispense with the controversial council of twenty-five, thus seizing the initiative from the rebels. At a stroke, it removed the other main cause of revolt and promised a genuine opportunity for a new relationship between the king and his leading magnates.

Even so, many barons remained unconvinced and pondered alternative visions of the future. Having experienced direct rule by a permanently resident king for the first time since Edward the Confessor, the prospect of remote-control government by Louis of France – who after all would succeed Philip in his continental lands – was possibly more palatable, since it was a system they were used to and potentially offered the prospect of greater baronial autonomy. Furthermore, it would mean the reunion of the Anglo-Norman realm, albeit under Capetian rule, and the ability to reconnect with branches of the family that had been estranged for over a decade. Ultimately, Henry's fate was to be decided by the sword. Marshal inflicted a crushing defeat on Louis's forces at Lincoln on 20 May 1217, whilst a fleet of French supply ships bringing reinforcements and victuals to London was intercepted by Hubert de Burgh's navy off the coast at Sandwich on 24 August, and driven back to France. Louis quickly agreed a negotiated settlement to extricate himself from the increasingly awkward situation, and promised to leave England under the terms of the treaty of Lambeth signed on 12 September.

Once the dust had settled, the political landscape within the nations of the British Isles and across Europe looked radically different. The royal adoption of Magna Carta had a profound effect on the way the political elite, and indeed those who served at a local level further down the social pyramid, expected the realm to be managed. After 1216, there was a general feeling that the first priority of the king of England should be the government of England,

and that the way business was conducted had fundamentally altered. Henry II's construction of a new system of government, professionalising both the legal and financial administrations and establishing a central bureaucracy, gave key tasks to lower ranks – the introduction of social mobility into a system dependent on birth. Whilst the intrusion of royal administration had proved initially unpopular, by the close of the twelfth century its benefits had been welcomed. However, John had unleashed the full potential of the machinery of government, and shown where it was open to abuse; Magna Carta was the remedy. The regents acting in Henry III's name were advancing the cause of their peers, and the minority period enabled the spirit and ethos of Magna Carta to take root throughout the land – namely that the king was subject to the rule of law, with clear codes of conduct for local officials. Arbitrary actions were considered taboo. It was no coincidence that one of the earliest decisions of the new regime was to complete the review of royal officials in the shires and undertake a sweeping survey of the royal prerogative in the forest, resulting in the charter of the forest in 1217. Kingship remained a family business, but now was conducted more as a dialogue with the political community of England rather than a series of instructions issued from abroad. The legacy of the Angevin kings was therefore the foundation of England as a nation state rather than a component of a larger commonwealth.

Part of the readjustment in the balance between royal power and good government came in the way the king was able to raise revenue. Magna Carta closed a number of loopholes that Richard and John had exploited, with the introduction of defined financial parameters to regulate feudal relationships, in particular the levels of relief. Although some of the more contentious clauses in Magna Carta were removed, the principle that the king could not raise extraordinary taxation without the consent of the realm had become embedded. When Gascony came under threat in 1225, Henry III was forced to summon a council to ask permission for

the grant of a tax at the rate of one fifteenth of moveable goods to fund an expedition. The price for approval was the reissue of Magna Carta, thus reinforcing the message that good government was inextricably linked to the provision of consent for taxation. Yet the consequences of the crown's inability to fund itself did not disappear, and indeed only worsened during Henry III's reign. It was left to his son Edward I to overhaul state finance, reforming the customs revenues into a more robust system that was farmed out to Italian banking houses, who in turn provided lines of financial credit to the crown. Equally, the concept of regular extraordinary taxation in the form of levies on moveable goods began to take hold towards the end of the thirteenth century to fund the next cycle of wars with France.

There was another important change that had occurred between the start of Henry II's reign, and that of his grandson. The concept of a family-run Angevin commonwealth of territories had been brought to an end, ground into the dust at Bouvines and buried with John's corpse in 1216. Although Henry III was to retain control of Gascony, it was seen as an extension of his family lands, with useful benefits for English trade, but not a natural concern for the king of England – the sentiments expressed by the northern barons in 1214. A new set of Anglo-centric priorities dominated the minds of the English barons, now that the prospect of the resumption of the Anglo-Norman realm was gone. Henry III, however, had other ideas and continued to hold on to dreams of resurrecting his family's position on the European stage. This growing conflict of interests arose again and again throughout Henry's reign, starting in 1224 when La Rochelle was lost to Louis VIII whilst Henry was embroiled in suppressing the revolt of Fawkes de Bréauté at the siege of Bedford. With the last Angevin family outpost gone, Poitou was absorbed into the growing Capetian demesne.

Further campaigns in France, encouraged by overtures from rebels in Normandy and Brittany in 1230, and when the Lusignans in

Poitou turned to Henry for support against King Louis IX in 1241, were little more than costly failures. The government of Gascony was eventually entrusted to Simon de Montfort junior, who was to prove Henry's nemesis as leader of the baronial reform movement from 1258. It was his exasperation with Henry's incompetent handling of the expedition to Poitou in 1242 that led de Montfort to call for Henry to be locked up like the ancient French king, Charles the Simple. His wish came true in 1264 after the battle of Lewes, when Henry was imprisoned and de Montfort implemented his own vision of government, including the first representative parliament in 1265. Henry had already been forced to recognise in the 1259 Treaty of Paris that the loss of Normandy, Anjou, Maine and Poitou were permanent, and now formed part of the patrimony of Louis IX. Despite Henry's retention of Gascony, we can date the nascent enmity between nation states, as opposed to dynastic rivalry, to this period. England and France were now separate entities, and Gascony was to provide the flashpoint that sparked over a hundred years of warfare from the fourteenth century, and continued to colour Anglo-French diplomatic relations right up to the *entente cordiale* in 1904.

<p style="text-align:center">*</p>

The story of the restless kings is therefore one of tragedy and loss as the Angevin family tore itself apart, falling from its position as the most powerful dynasty in the West. The impact on Europe was profound, creating the circumstances out of which France emerged as a nation state, setting up centuries of enmity against England and sharpening France's boundary with the German lands of the Holy Roman Empire. The legacy of these momentous shifts in the balance of power are still with us today; indeed, the search for ever-closer European union merely reflects the aspirations of the Angevin and Capetian successors of Charlemagne during this period, who in turn had partially rebuilt the old Western Roman Empire – the

first entity to embrace the concept of universal citizenship for all. Equally, Western involvement in Eastern affairs stirred up centuries of religious tension across the Middle East, with Richard heavily involved in the Third Crusade. Closer to home, Henry II created the foundations for today's centralised bureaucratic state, which his sons pushed to the limit. The backlash resulted in the imposition of regulations on the monarch, and the creation of the concept of the 'community of the realm' that was to lead directly to parliament. In this sense, John inadvertently shaped a version of England that still pervades society today, underpinned by the belief that justice is equally applied to all. If you are ever asked to perform jury service, remember that you have Henry II and the baronial protesters in 1215 to thank. John also defined England's relationship with its neighbours within the British Isles. He forced its leading barons to choose whether they were French or English; and he seized control of state religion in the face of papal excommunication in a way that no monarch dared to repeat until the time of Henry VIII. We also have John to thank for modern taxation, customs duties and the navy. One family, six decades; these remarkable people may have lived and died over eight centuries ago, but their influence is still with us after all this time.

Further reading

As you will have noticed, this is not a biographical account of the lives of Henry II, Richard I, John and their surrounding family; nor is it an attempt to revise current historical debate about the infrastructure of the so-called Angevin Empire. There are plenty of excellent academic books that tackle these subjects in far more depth than can be usefully achieved here. However, you may want to explore these topics in more detail, so I have suggested some of the key works that were instrumental in the preparation of this current volume.

In terms of stand-out biographical studies, you should look no further than the works of W. L. Warren and John Gillingham on Henry II, Richard I and John, part of the Yale *English Monarchs* series published in the 1970s and updated in the late 1990s. The second edition of Gillingham's *The Angevin Empire* remains the best – and most succinct – publication on this complicated topic. Recent scholarship on aspects of the reigns of Henry II and John has been brought together following conferences in the *New Interpretations* volumes, for those interested in more technical aspects of the debate. Matthew Strickland's work on *The Young King* explores the troubled life of Henry II's eldest son, and other principal characters have their own recently published biographies – Ralph Turner on Eleanor of Aquitaine, Thomas Asbridge on William Marshal and John Guy on Thomas Becket, for example.

The recent anniversary of Magna Carta has also produced many new works on King John and the great charter including those of David Carpenter, Dan Jones, Marc Morris and Stephen Church, although the writings of the late J. C. Holt still stand the test of

time as the main contribution to our knowledge of this pivotal period of history. The aftermath of John's reign under Henry III's regency council is best understood in David Carpenter's *Minority of Henry III*, and his work *The Struggle for Mastery* tackles the history of the constituent parts of the British Isles up to 1284.

For greater insight into European history, Robert Bartlett's work *The Making of Europe: Conquest, Colonization and Cultural Change, 950–1350* provides a strong introduction to the complicated politics, though David Bates and Anne Curry's *England and Normandy in the Middle Ages* and the work of Dan Power on Norman frontier politics are essential reading. Jim Bradbury's biography of Philip Augustus remains the most accessible English-language summary of the nemesis of the Angevin kings. For the complicated politics of the Holy Roman Empire, Peter H. Wilson's recent work *The Holy Roman Empire: A Thousand Years of Europe's History* is a good place to start.

If you want to understand the longer history of Europe in the context of the Roman world, Mary Beard's *SPQR: A History of Ancient Rome* takes the story up to the second century AD, after which there are many works looking at the fall of Rome and the Dark Ages – for example Gibbon's classic account of *The History of the Decline and Fall of the Roman Empire*, edited in a more accessible abridged form by David Wormersley; military historian Charles Oman's works on the Dark Ages and the Byzantine Empire, supplemented by George Finlay's writings on the latter topic; and Rosamond McKitterick's more recent *Charlemagne: The Formation of a European Identity*. More directly relevant to the main story of the restless kings are the crusades, their stories well told in particular in publications by Thomas Asbridge, Steven Runciman and Christopher Tyerman, though you might want to read Amin Maalouf's work *The Crusades through Arab Eyes* for a very different view of these conflicts.

Index

Toulouse, 128–30; Irish campaign,
12, 142–3; knighted, 49; land-share
model for federal government, 154,
159, 167; lands, 7, 122–4, 137, 143;
legal reforms, 83–9, 100; Limoges
siege, 165–6; marriage to Eleanor,
55, 124; mistresses, 133; mother's
death, 132; new model for division
of lands, 167; news of victory
against William the Lion, 117–20;
offered throne of Jerusalem, 168–9;
peace conference (1169), 137; peace
settlement with Richard (1189), 1,
178; peace settlement after sons'
uprising, 153–6; peace treaty (1153),
57, 72, 73, 76, 91; peace treaty
with Louis (1161), 131; plans for
division of lands, 137, 167, 171,
219; problems faced on accession,
63–4, 71–2; proclamation charter,
64; relationship with barons, 71–5;
relationship with Becket, 63, 66–7,
92, 97–8, 104, 110–11; relationship
with brother Geoffrey, 121–2, 124;
relationship with church, 91–5,
249; relationship with Eleanor, 121,
132–3, 140–1, 154–5; relationship
with Louis VII, 122, 126–31, 157–8;
relationship with Philip, 159, 170–1;
relationship with Rosamund de
Clifford, 121, 133, 155; relationship
with son Richard, 161, 165, 167,
170, 173–8; relationship with
sons, 1, 116, 121, 144–5, 153–4,
157, 161–5, 166–7; reputation on
international stage, 156–7, 168;
reputation as oath-breaker, 71, 125,
153; response to Becket's death,
113–14; royal chancery, 79–80; son
Henry's betrothal, 126, 127; son
Henry's coronation, 7, 25, 110, 111,
138–9; son Henry's death, 166; son

Henry's marriage, 130, 131; titles,
1, 23, 50; tomb, 182; Vexin issues,
126, 130, 172; war of 1173–4, 116,
120, 146–53; Welsh campaigns, 11,
125–6; will (1170), 137–8, 141; will
(1182), 159; wooing Eleanor, 50
Henry III (son of John), 255, 259,
291–5
Henry VI, king, 9
Henry VIII, king, 9, 114, 296
Henry I, king of France, 25
Henry of Auxerre, 59
Henry of Blois, bishop of Winchester,
38, 40–1, 43–4, 64, 74, 92
Henry duke of Brabant, 240
Henry of Huntingdon, 17, 19, 33, 44
Henry the Lion, duke of Saxony and
Bavaria, 7, 132, 201, 204
Henry of Pomerania, 254
Henry 'the young king' (son of
Henry II): appearance and
character, 139, 141, 161, 163;
betrothal, 126, 127; coronation
7, 25, 110, 111, 138–9; death, 166;
education, 127, 141, 161; finances,
161, 162, 166; flight from besieged
Limoges, 165–6; flight to Paris,
153; friendship with count of
Flanders, 161; lands, 139; Limousin
campaign, 161; marriage, 130,
131, 161–2; planned inheritance,
137, 144; powers, 7, 139; present
at Vermandois peace conference,
159; relationship with Becket, 127,
141–2; relationship with brother
Richard, 143–4, 146, 154, 162–4;
relationship with father, 139, 144–5,
153, 161–2, 164–5, 189; relationship
with mother, 137; relationship with
Philip, 161, 162, 163, 165; support
for Aquitainian barons, 162–3, 164;
supported by Louis VII against